TOWARDS A NEW ART

TOWARDS A NEW ART

essays on the background to abstract art 1910-20

THE TATE GALLERY

BARRON'S
WOODBURY, NEW YORK
PRINTED IN GREAT BRITAIN

ISBN 0 905005 17 1 paper 0 905005 22 8 cloth
© 1980 The Tate Gallery
Published by the Tate Gallery Publications Department,
Millbank, London SW1P 4RG
Designed by Sue Fowler
Printed in Great Britain by Balding + Mansell, Wisbech, Cambs

Contents

Cover/jacket
František Kupka 'Amorpha Fugue in Two Colours'

Preface

By the beginning of this century, artists had been struggling for hundreds of years to represent what they saw about them. This did not mean only that they sought means of imitating what they perceived but that they had to perceive what had not been perceived before. It was necessary to adapt old practices continually to find ways of depicting previously unconsidered objects or effects but it was also essential to find ways of expressing both new and personal concepts, values or insights.

This is what had come to be called 'Art'; the same tradition both fostered and hindered the appearance of abstract art some seventy years ago. It was easy to make amorphous or geometric shapes, after all both had been in use in the decorative arts for many millennia, moreover it was recognised that these could have expressive power. But it was difficult to discard the means, the recognisable images, by which these shapes could be made significant in the world of ideas and objects in which we live. Some argue that it has not been done, for example Charles Harrison in this collection of essays. Stephen Bann writes on the way in which insights developed from the study of language can help our understanding of the problem.

Professor Lynton sets out the ambitions and options that made up the context from which the new art emerged at the beginning of the new century. Three essays discuss ways in which the developing abstract art was enriched and motivated by ideas drawn from other arts and disciplines: music by Peter Vergo, the science of colour perception by John Gage, mathematics by Lucy Adelman and myself. They all consider the theme of mystical and anti-materialist ideas for which there is no separate essay. Jane Beckett deals with the connection between abstract art and decoration, focusing on the idea of a total expressive environment which was a feature of the period. Christopher Green explores, through the case-histories of artists, why in Paris, which was the undisputed centre of world art, so many artists went to the brink of abstraction only to revert to figurative modes. The remaining two essays, by Susan Compton and Sara Selwood, show how ideas and images circulated in such a way that, feeding off the breakthrough in Paris, abstract art bloomed almost simultaneously throughout the Western world.

My thanks are due above all, of course, to the contributors, to those who have made photographs available, and also to my own colleagues at the Tate Gallery, Vicki Elliott, Ruth Rattenbury and Caroline Odgers who have helped in every way.

MICHAEL COMPTON, Keeper of Exhibitions, Tate Gallery

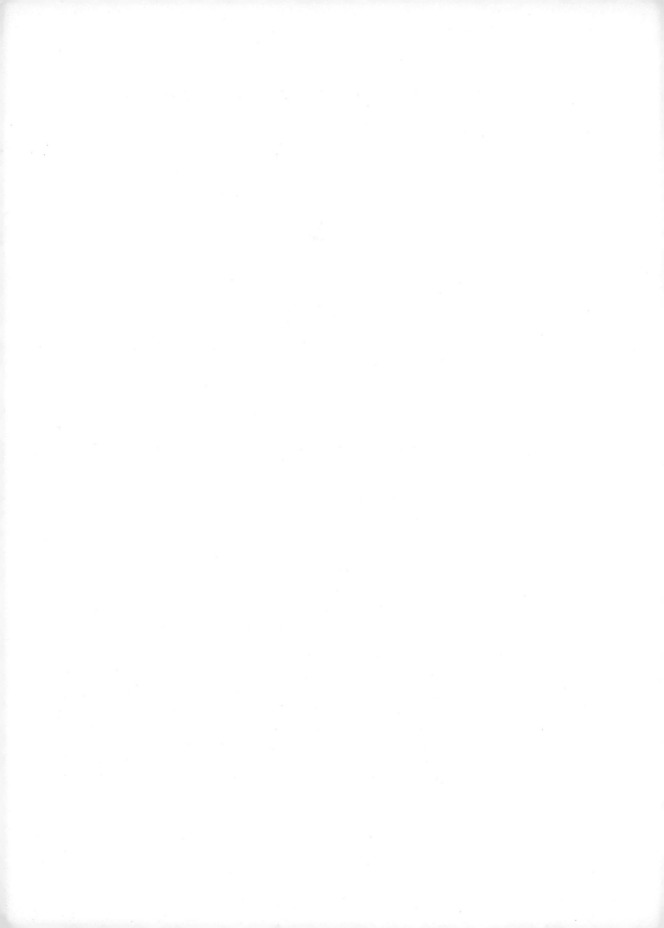

The New Age: primal work and mystic nights

Norbet Lynton

'Pioneers! O Pioneers!' Walt Whitman serves to symbolise and summarise the aspirations gathering towards the coming 'new age'[1] of the twentieth century. Even in this one relatively short poem we meet many of them:

> Have the elder races halted?
> Do they droop and end their lessons, wearied over there beyond the
> seas?
> We take up the task eternal, and the burden and the lesson,
> Pioneers! O pioneers!
>
> Lo, the darting bowling orb!
> Lo, the brother orbs around, all the clustering suns and planets,
> All the dazzling days, all the mystic nights with dreams,
> Pioneers! O pioneers!
>
> All the past we leave behind,
> We debouch upon a newer mightier world, varied world
> Fresh and strong the world we seize, world of labor and the march,
> Pioneers! O pioneers! . . .
>
> These are of us, they are with us,
> All for primal needed work, while the followers there in embryo wait
> behind
> We today's procession heading, we the route for travel clearing,
> Pioneers! O pioneers!

Urgent, enthusiastic calls to the young and to the young nations to act corporately, to live in tempo with 'All the pulses of the world', labouring not 'for delectations sweet', not hoping to arrive but 'the route for travel clearing' – it all fits well into the chorus that greeted the millennial dawn. Whitman celebrates toil, the power of machines as well as of nature and human muscle, the power of wide-ranging love and of imagination, the power of the individual to experience the vast world, to act upon it and to embrace it. Around the turn of the century his poems washed over Europe. There had been some resistance – Whitman seemed no more than a rowdy demagogue to some, his poetry without form or taste – but by 1900 this had almost vanished. Translations, often a little bowdlerised to avoid moral and also political issues,[2] after 1900 became more direct and also more stimulating. So fertile was the inundation that everyone could find in it what he wanted.

Chesterton, for example, in 1904 could criticise Whitman's rejection of metre as a civilising restraint (metre, countered Chesterton, is 'something

quite wild and barbarous'), and his lack of modesty ('To conceal something
is the first of Nature's lessons'), yet still proclaim Whitman as 'a great man
who has been the sole spiritual support of me and many others. . . . the
ablest man America has yet produced . . . one of the greatest men of the
nineteenth century'. And even more than that: 'Ibsen is all very well, Zola
is all very well and Maeterlinck is all very well; but we have begun already
to get to the end of them. And we have not yet begun to get to the beginning
of Whitman.' In the same year the first Russian translator of Whitman,
Konstantin Balmont, published an essay in which he stressed the poet's
indifference to European traditions of literary form and beauty, offering
Whitman to Russia as one who 'takes us to the morning of world-making',
who sings 'of freedom, of his young country chaotically moving towards
the building of new forms of life . . . the simple powerful ego of a young race
. . . of individuality, of unlimited life, and a harmonious joining of all
separate personalities with the Universal One'. In 1904 also (the year that
saw the first production of *Peter Pan*, with costumes by William Nichol-
son), a boy called Julian Huxley astonished the distinguished visitors to
Speeches at Eton by declaiming 'Pioneers! O Pioneers!' in place of the
expected sample from the classics. Huxley's generation was to carry
Whitman into the trenches – in English, French, German, Italian and
Russian – and also into the Russian Revolutionary struggle and counter-
struggle. More aptly, perhaps, pacifists and neutrals honoured and quoted
his reiterated calls to international brotherhood; Jules Romains had
steeped himself in Whitman, and his influential 'Unanist' faith – stressing
the psychical and practical interrelatedness of modern city dwellers – was
rooted in the American's glowing visions of conviviality. In 1904 a second
Russian Whitman translator and champion had launched his campaign to
publicise the prophet of democracy with an article in *Odessa News*. After
further preparatory articles, Chukovsky issued his version of *Leaves of
Grass* in 1907, under the title *Poetry of the Future Democracy: Walt
Whitman*; a fourth edition, of 50,000 copies, was issued in 1919 by the
Petrograd Soviet of Workers and Red Army Deputies. A third edition, in
1918, had had a preface by Lunacharsky himself, presenting Whitman as
the prototype of 'the man with the open heart . . . the shape of the great, all
embracing man', the committed Communist. In Mayakovsky the new
Russia saw Whitman's heir and successor, amplified by an even stronger
voice and firmer pulse and by his inescapable living presence.

Between Whitman and Mayakovsky came the great wave of scientific,
technological and industrial advance, as well as international socialism.
Few doubted that this spelled progress: the twentieth century would
harvest what nineteenth-century progressives had sown. Whitman wel-
comed the railroads and 'the electric telegraphs of the earth'; he could
scarcely guess at the scale of the urbanisation and industrialisation that
was to come though he noted the acceleration that led into them. And

there came new sources of power and new stationary and mobile engines driven by them, particularly the automobile and the aeroplane; there came electric lighting in the home and the street, in theatre and factory – and men felt they had at last triumphed over a timetable imposed by nature; there came the ubiquitous photograph and the cinema, the cheap newspaper, the typewriter, the sewing machine and the radio, the development of synthetic dyes, fibres and plastics. Such achievements had their fame and their palpable utility. They also had their mystery. As the implications of technical advance became ever more inviting, physicists appeared to be removing its base from general comprehensibility. In their various ways scientists like Planck, Einstein and Rutherford were destroying the common-sense platform on which acceptance of Newton's universe had rested. Goethe and others had long ago doubted man's capacity for handling his new tools, but at least they had known how the tools worked and to what uses they might be put. Darwin's commonsensical explanation of man's origin, contradicting the magic of *Genesis*, had been a source of strength to those who wanted to belong to a world without supernatural agencies. But by 1900 Freud's investigation of the role of the unconscious was throwing doubt equally on the efficacy of reason and of faith. In practical matters mankind seemed to be rushing towards paradise, yet it appeared that man had scarcely embarked on knowing himself and the physical world was swimming out of his ken.

One telling response was that of Henry Adams. In 1900 the 62-year-old American historian and novelist, wise and worldy-wise, stood aghast before the huge dynamos on show in the Machine Hall at the Paris International Exposition, and knew that man the tool-user had entered a new realm, a world of 'forces totally new', of discoveries 'absolute, supersensual, occult', a 'supersensual world, in which he could measure nothing except by chance collisions of movements imperceptible to his senses'. Knowable natural philosophy had become 'physics stark mad in metaphysics'. The historian in Adams saw that here were forces that would rule mankind as once the force symbolised by the statue of the Virgin on the west front of Amiens Cathedral had ruled Europe, but more likely to produce division and disintegration than to unite in faith. He likened that moment of recognition to having 'his historical neck broken'. Helena Petrova Blavatsky was of the same generation as Adams. The tremendous success and spread and influence of Theosophy and Anthroposophy during the last decade of the nineteenth and the first two to three decades of the twentieth century represent a widely felt longing for a view of the universe and man's place in it that would outreach science and the hurrying years.

We tend to associate spiritualism with Symbolism and with Decadence, with the mental exhaustion felt by the dying century of progress. The new age of the twentieth century we associate with facts, with visible

achievements, and with implications of speed, energy and space on offer to those whose heads are not clouded by mysticism. Yet Symbolist ideals, detached from the ultra-aestheticism of *fin-de-siècle* Decadence, are potent within modernism, especially in those trends within modernism that lead into abstraction. Symbolism called for themes and a language separate from those of the everyday world – not merely for the use of symbols in place of direct description but for an art dependent on symbolical representation on account of its non-visual content. In doing so it suggested methods by means of which the next generation could confront the modern world. Most important, Mallarmé and other Symbolists forced attention on to the essential matter and process of each art form. This reinforced a tendency, influenced by historical, archaeological and anthropological research, to attempt to identify the primitive roots of human activities.

If poems, as Mallarmé instructed Degas, are made of words, then music is made of a sequence of sounds in time, drawing is marks on a sheet of paper, sculpture is the organising of solids and voids in space, and painting involves 'colours arranged on a flat surface', as the Symbolist painter Maurice Denis announced in 1890. From this to Schoenberg's 'twelve tones related only to each other' and its equivalent in the other arts is not a long step yet one demanding a heroism that many could imitate but few could muster. So much had to be jettisoned, so many hard-won skills, so many time-honoured, well-rewarded values. The sometimes Byzantine luxuriousness of much Symbolism was countered by extraordinary frugality: a response to Symbolism's call for purified means, perhaps, but driven by Romanticism's urge to find justification not in past authority but in the nature of things. It was stated clearly by Goethe: 'We want to sense laws . . . to get to know laws according to which nature in general, in the particular form of human nature, tends to produce and does produce what she can'. He had another word for these laws, and it echoes through modernist manifestos and expositions: 'necessity' – the outer necessity governed by physical laws and the inner necessity of the spirit. 'Everything arbitrary or illusory falls away', Goethe said of classical art; 'here is necessity, here is God!'[3] There were of course many ways in which modern artists (I use the term here for people productive in all the arts) could interpret such promptings. It is worth noting a corollary of this concept of laws – as opposed to recipe or time-honoured model, the 'convention that has masqueraded as law'[4] – as the basis for creative work. It placed the artist alongside the scientist and the engineer *and* the priest *and* the statesman as men professionally engaged in the present and the future, not representatives of a prolonged, once-glorious past. Slogans against the past were of course frequent: they suggest impatience with the recent past and with the abuse of traditions, and especially with the public's automatic adulation of both. But an assertion of relevance to the present and concern

with the future was now necessary for the artist as for those other professionals,[5] and with this assertion the apparent contradiction between the technological world and the world of the spirit is annulled. Even those who, like the Russian Constructivists, joined Marx's laws of production as determinants of social function to the laws of nature and human nature of which Goethe spoke, readily included in their programmes cosmic visions and expressed them through elements of esoteric mysticism.

Modern artists tended to see themselves, or present themselves, as carrying roles distinct or much changed from those inherited from Romanticism and earlier. The genius concept, particularly, had to be reduced to more human proportions. Thus the artist could see himself as a sort of priest and his art as a revelatory offering or even as ritual and temple combined. The Symbolists liked to see themselves as priests or magi; Yeats and Gordon Craig pursued a vision of the theatre as an ambiguously modern and ancient sacred precinct and of drama as symbolical ritual;[6] Wagner had promised a world redeemed by the power of his quasi-sacramental music dramas; similarly Isadora Duncan, amongst many others, offered her primordial dancing as a way of re-establishing religiosity in the modern world; Mallarmé sought to refine literature into 'a verbal art in which all science, all religion, all experience were to be contained'; the highbrow popularity of Henri Bergson's lectures and books can best be explained via Herbert Read's gratitude to him for offering 'a view of the universe that made up for loss of religious faith'. The artist could also see himself, not necessarily by way of alternative, as a kind of scientist making long and brave experiments for the future good of all. He could take comfort, as Valéry did, in the insistence of the great mathematician Poincaré on the essential unity of scientific and artistic creativity.

Priest, magus, has a primitive ring. Had not the role of the first artist been of this kind? Cave paintings had recently, and conveniently, come to light. Seen thus, the artist was at the centre of his tribe, even if the fallen post-tribal society of the modern world was as yet unable to recognise this position. Shelley had described poets as 'the unacknowledged legislators of the world', but that was not quite it because, as Goethe taught and science seemed to confirm, the laws were always there and had only to be expounded. Society, habitually distinguishing sharply between the useful advances of science and the entertaining or nostalgically reassuring presentations of the arts, had to be taught to see the arts as both basic and analogous to science. Manifestos and essays invoke scientific methods and aims, as well as concepts shared by the new physics and by spiritualism such as the fourth dimension and space-time, in order to cope with charges of obscurantism. You do not spurn the inventions of science, even if they are incomprehensible; why then spurn *Ulysses?* It has, wrote Eliot in a review of 1923, 'the importance of a scientific discovery'. Casting off the mantle of magus, the artist could similarly present himself as an applied

scientist: as a kind of builder or engineer, a constructor preparing models towards a better world but also demonstrating, *en passant*, the moral soundness and humanity of his methods and attitudes. No genius he, no frenzied poet beset by the Muses, but a worker close to other workers and close to reality in the materials he uses and in his diagnoses of his fellow man's needs.

The artist as self-relegating outsider, familiar to the modern press and other forms of fiction, is rare at any level of seriousness. Anarchism as a political programme certainly attracted artists, especially during the 1880s and 1890s, but could never square with work that has, in one sense or another, to be constructive. The Zurich Dadaists, literary men primarily, came close to enacting the roles both of the anarchist planting his bombs to liberate man from an oppressive social system, and of the scapegoat or victim, Hazlitt's 'limb torn off from society', suffering on behalf of a jeering populace, but they were more an idea than an event, not a movement but a moment, and after that moment they dispersed to pursue other, 'insider', tasks such as making art or poetry or politics. The artist wishing to remain on the periphery of society was more likely to disembody himself, to work (as Eliot put it) towards a 'continual extinction of personality', or offer himself as the 'vessel through which the *Rite* passed' (Stravinsky) and the 'finger of the hand of Necessity' (Middleton Murry).

It took a really confident artist like Matisse to say that he wanted his art to function like the intellectual's equivalent of a good sit-down in an armchair. Normally the images modern artists adopted emphasised their seriousness of purpose. They did not see it their duty to entertain the world. They derided the means whereby entertainment had been disguised as grave matter. The arts, they said, must get away from naturalism, from providing reassuring accounts of pleasurable situations and scenes. They must get away from narrative, the Victorians' favourite pabulum. Away from the harsh realism of Ibsen and Zola, even: not even real stories about the real world, but inner truths, about big issues. Away from the narcissism of the suave actor, of the self-revealing poet or novelist. Down with the self-indulgence of the psychological drama or novel, titillating the public with pseudo-profundities and keeping their attention away from pressing social problems. Down, above all, with the conventionalised eroticism of so much nineteenth-century artistic production. No nudes for ten years, ordered the Futurists. *Blast* blasted the 'raptures and roses of the erotic bookshelves'. Stop altogether that complaisant emphasis on the human weakness of humanity. Instead, depersonalise your figures: use masks, marionettes (the Symbolist Maeterlinck had already done so), types as against individualised characters (Maeterlinck, Strindberg), ritualised actions and an anti-naturalistic style that prevent audiences from identifying with the protagonists, as well as a disrupted or inconsequential structure that inhibits the suspension of disbelief (Jarry, Yeats).

In many of these developments the visual arts led the way. Perhaps it was easier for them to do so: the entertaining arts – the arts dependent for the realising of a work upon public presentation and all that that entails – are necessarily less mobile. A more certain reason is that many of the negatives had never, so to speak, been firm positives for painting or sculpture. Neither art form lends itself to convincing narrative, particularly not to the complex, polyphonic narratives pioneered by the eighteenth-century novel and emulated on stage. Pictures and sculptures can hint at psychological knots but neither tie nor untie them. The nineteenth century achieved miracles of naturalistic representation, yet nothing actually *is* less like a landscape than a length of oil-on-canvas by Constable or less like apples than another length by Courbet. There were some brilliant essays in tinted marble and glass eyes, but even given all the skills that sculptors could bring to inert matter to make it hint at softness and warmth, the sculptural product can only stand there, proving itself impregnable to life or death. Even a shoddy stage production would be more effective; the audience would be confronted by real people and actual actions. The development of music ran parallel in some respects to that of the visual arts. Music is never closely identified with narrative content and naturalistic manner but is received as a man-made, non-representational but expressive form of communication. Thus it could serve as analogy for art forms shedding their representational functions. Most striking is the economy achieved in both arts, the insistence upon 'primal needed work'. Not only the arbitrary and the illusory, but all sorts of ornaments and enrichments are dropped, including the virtuoso elements valued by the public as evidence of mastery. The bareness of much modern art and modern music, affronting many, was a dramatic move after the rich cultural diet of the preceding decades. One of Nietzsche's charges against Wagner was that no one could possibly manage the sustained attention demanded by the scale and the complexity of Wagner's operas. Stravinsky, who was to mock 'this comedy of Bayreuth, with its ridiculous formalities', greatly admired Schoenberg's *Pierrot Lunaire* (1912), a miniature opera in the form of a song-cycle for a singing-speaking voice and a chamber orchestra of five players with eight instruments between them. Webern's music at times achieved astonishing succinctness. Astringency and concentration also enabled music to minimise the restraining effect of the economics of performance. The other arts essayed similar condensations. Thus about 1890 Strindberg wrote three one-act plays as material for an experimental theatre he hoped to found in Copenhagen; one of them, *The Stronger*, is for two actors, only one of whom speaks. Practical limitations could thus encourage a paring away of means that served also to reveal the essential nature of each art form.

It is possible to show the gradual testing, challenging and devaluing of subject matter in the visual arts – from, say, Manet's 'Olympia' (1863) to

Malevich's 'Black Square' (c.1915), via Monet's series of 'Haystacks' (eighteen of them painted in the winter of 1890–1), but that of course is not the whole story. Abstract art too has content, and early abstract art often has content specific enough to be called subject matter. There was, clearly, a turning away from the imitating of visual appearances (which in any case had rarely been the dominant purpose or method of art), but it should be seen as a positive move into exploiting the optical, associational and symbolic power of non-representational forms and colours. In the same way, the much discussed flattening of pictorial space, the abandonment of the idea of the picture as a window opening on the world (again, not important to the history of painting), must be seen as a positive attempt to give the work of art a different kind of presence: an invitation not to dream, fantasise, escape, but to be aware, to confront and engage actively. That is why the move into modernism in general, and into abstract forms of art in particular, is so often accompanied by assertions of the *reality* of the work, its purposes and its means. Friends and enemies of modern art could not but be aware that, whatever else had happened, the new product demanded from them a new response: an intelligent, committed and collaborative response. Many, of course, were not willing or able to make it. The habit of reading a picture for its descriptive or anecdotal content, enforced by nineteenth-century art criticism, was too firmly established.

Yet it was precisely in the area of the new abstract art that a concern for communication can be found. Perhaps those artists most intent on discharging messages were also the most likely to concentrate their art into a symbolical vehicle, eradicating secondary functions. Such artists were not, at this stage, content with parable. Wishing to convey a not very specific presentiment about society Picasso painted the 'Family of Saltimbanques'; for similar purposes Malevich floated his rectangles and bars of colour in the measureless space of his white canvases, Mondrian erected his horizontal-vertical scaffolding and planes of colour, and Kandinsky sought an apparently more immediate and personal pictorial statement that might or might not (until about 1914) contain legible symbols but whose effect was primarily emotional. The abstract artist would claim that, in the case of the Picasso, the anecdotal interest offered by his vaguely poignant troupe of circus people screened the viewer from the painting's true content, and ten years after the picture was painted Rilke proved this right: 'But tell me, who *are* they, these acrobats, even a little / more fleeting than we ourselves . . .?' The others not only wished their statements to be more direct but invested a great part of their activity in preparing the grammar of their pictorial languages and establishing a theoretical basis for them. In Kandinsky's case this involved a remarkably thorough investigation of the sensory and psychological stimuli received from colours and forms as such. Seurat had sought scientific evidence to this end, dissatisfied with Delacroix's more purely intuitive and empirical

approaches to, in Delacroix's words, 'the musical parts of painting'. Delacroix had still relied on nature for the 'dictionary' of his art; Seurat imperiously adapted the offerings of that dictionary to give primacy to the abstract communication of his paintings; Kandinsky, encouraged by the aesthetic researches of Art Nouveau and Jugendstil, turned instead to the researches in perceptual psychology recently published by Theodor Lipps and others. In his writings Kandinsky provided an immediately influential apologia for an art employing imagery originating in man, not borrowed by man from his environment or from literature; such art would represent the inner life of man, the artist's linked directly to the beholder's. Malevich's and Mondrian's goals were less intimate. Their writings envisage a fusion of science, religion and art and a physically as well as spiritually reconstructed world which Malevich's paintings pointed to in the manner of signposts while Mondrian's symbolised, and to some degree represented in microcosmic form, the living harmony which should be its form and character. None of this art was intended to provide entertainment or ornament. It was didactic, paradigmatic, and in this sense it is the true heir of the history-painting tradition, the most honoured because the most elevated branch of Renaissance art.

Just like the eighteenth-century adherent to that tradition, so also the early twentieth-century pioneer of abstract painting faced a big decision: Florence or Venice, Poussin or Rubens, drawing or colour? To, say, Reynolds this meant determining the rival claims of intellect and emotion, and the modern artist's associations were no different. Colour and free form, or geometry. Nineteenth-century example supported either, but the former suggested spontaneity and personal authenticity, whereas the latter not only extended the long chain of classical design linking Seurat, David and Poussin back to the metopes of the Temple of Zeus at Olympia, but shared with Renaissance and ancient classicism a theoretical base that identified anthropometry with geometry and geometry with the universe. Plato, who warned us of the essential untruth of imitative art, had also spoken of the absolute beauty of geometrical forms, and it was upon precisely such forms, most perfectly fabricated and related to each other, that the visible aspects of modern technology depended. William Morris hated the machine because it deprived work and its product of human values, and many another nineteenth-century thinkers feared the increasing mechanisation of life. But the machine could also be seen as man's ultimate achievement of positive aesthetic value as well as a major determinant of the man-made environment. Just as western man in the seventeenth and eighteenth centuries took pride in his towns and cities, so now he could take pride in the coming, if not the actual, machine-formed world. Thus geometric art could not only draw strength from ancient theory and practice; it also echoed the reality of the present and offered samples of a future world in which human knowledge and human skill,

rendered globally efficacious by advancing technology, would have stilled conflict and eradicated ugliness.

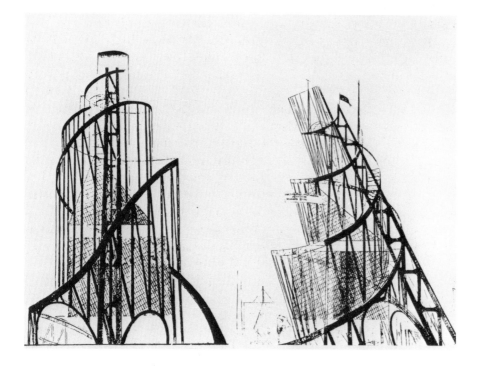

Vladimir Tatlin, *Elevations for Monument for the Third International*, Moscow, 1920

The dream survives, and we need not think it a foolish one. It survived the First World War though that brought evidence both of the destructive power of machinery and of its failure to make war shorter and cleaner (let alone unnecessary). A second new age opened with the apocalypse of 1915, the Russian Revolution of 1917 and the establishment of the German republic in 1918. In Russia and Germany, amid economic collapse and social discord, it seemed that the true 'morning of world-making' was about to dawn.[7] The war had certainly dented confidence in the machine and in international progress, and it forced artists to reconsider not just the artistic character of their work but also its social function, especially where political change brought or promised extensive social reconstruction. In Russia the new art of Malevich, Tatlin and their followers could claim to have pre-echoed such change and to be in unison with the needs and aspirations of the new state. In Germany too it looked for a while as though a socialist state was being formed, and artists and designers assumed that their work prepared and promoted this development. The geometrical 'first and final Renaissance' promised by Edward Gordon Craig in the first article of the first issue of his theatre magazine *The Mask* (March 1908) seemed imminent.[8] Craig's 'Evil prophesied long ago in Babel which has separated these three Arts and which leaves the world

without a Belief – dividing the Occident from the Orient, state from state and man from man', was answered by Tatlin's grandiloquent invention, the Monument to the Third International (1919). With its stereometric solids, hanging within a gigantic spiral skeleton directed at the Pole Star and turning in unison with the earth about its axis, with the moon about the earth and the earth about the sun, Tatlin's Tower was designed to serve as the command module of the space-ship Earth.[9] It remained a project, though an enormously influential one, and its optimistic fusion of technology with cosmic ambitions prepared for the marriage of Dutch *De Stijl* to Russian Constructivism and for Central European Elementarism, its offspring. Gabo developed the artistic implications of Constructivism, and took them further west, to France, Britain and America, but the Elementarism spawned by Van Doesburg and Lissitzky, embracing art but concerned first with 'the building of new forms of life', was the more potent growth, charged with mystical beliefs and implications. New Objectivity (not a style nor an art movement but a vague, broad, 'call to order') was to make any reference to them old-fashioned though we catch echoes of it at the Bauhaus until 1928, and later still in the case of individual artists.

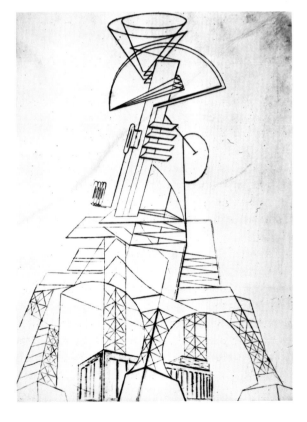

Naum Gabo
Project for a Radio Station,
1919–20
Pen and ink

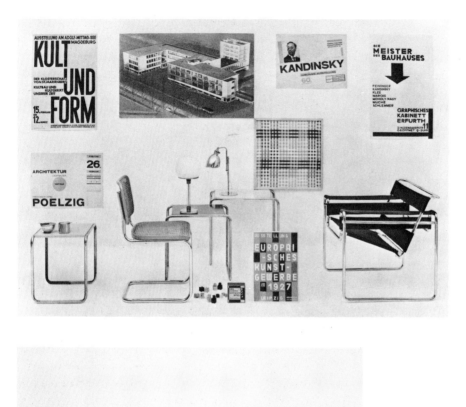

The Bauhaus
The approved image, as promoted by leading Bauhaus emigres to the United States and summarised in a Museum of Modern Art, New York, display (shown in an illustration from Alfred H. Barr's *Masters of Modern Art*, 1954). Nothing earlier than 1924; nothing later than 192

Bauhaus Building, Dessau, by Walter Gropius, 1925–6
Posters, George Dexel: **Kult u Form**. Unknown designer: **Meister des Bauhauses**. Other three posters by Herbert Baye 1926–7.
Table Cloth (framed), Anni Albers: woven cotton, *c.*1926
Chess Set, J. Hartwig: wood, 1924
Furniture (chromed tubular steel framing), Marcel Breuer: three end tables, 1926; side chair, 1928; armchair, 1925
Ash Trays, Marianne Brandt: chromed steel and brass ash trays, *c.*1924–6
Lamps, K. Jucker and W. Wagenfeld: glass and metal lamp, *c.*1924. Christian Dell: chromed metal lamp, 1926

El Lissitsky
The New Man, no. 10 from
Victory over the Sun
Lithograph, $20\frac{1}{8} \times 17 (51 \times 43)$
Tate Gallery

This activity represented socially progressives purposes. It did not aim at the kinds of success that still satisfied the academic artist and beyond which even Cubism and *Brücke* Expressionism did not aim. It was exemplary. Its fulfilment would come not through exhibition or acquisition but by extension and use. It aimed not at providing art for the salon or the boudoir or even the public museum but at architecture, at the total environment, at harmonising and energising the world. And it knew, or thought it knew, that its idiom of simple (often primary) colours and clear geometrical forms would offer no problems to the man in the street or the factory. Influenced by Suprematism, but intent also on effective communication, Kandinsky around 1920 abandoned his freely expressive forms and marks for geometrical shapes, without departing from the personal and particular content of his art. At Gropius's Bauhaus geometry ruled from 1922 on (when Kandinsky joined the staff, but not merely because of him) as a modern folk idiom that would o'erleap class barriers with its stylelessness and its combination of Platonic idealism with functional aptitude. Styleless, of course, it was not, nor truly functional, and idealism seems to fade on the conveyor belt. Mondrian's and Le Corbusier's right angle, 'the essential and sufficient implement of action', and Kandinsky's and Klee's circle, perfect and dynamic, man-made and cosmic, at once all and nothing, make up our present world in large measure, carrying with them many of the values that the pioneers of abstraction saw in them (free form and spontaneous action having been enlisted by Surrealism and Abstract Expressionism). Nevertheless, in spite also of its evident clarity and optimism, and in spite of its circumnavigating the sophisticated tastes and references that had made art divisive, this abstract art remains the prime butt of public opinion, perhaps precisely because of its association with the world, the as yet wholly inglorious world of industrial labour. Constructivist art survives, even thrives, but is rarely invited out of the studio, while latter-day mysticism, though it proselytises via the jet plane and the Rolls-Royce car, shuns the forms and rhythms of technology. The artists whose work prophesied a brilliant and dynamic world – in which, as Mondrian said, art would have no place, since 'beauty will then have ripened into palpable reality' – are misrepresented as ascetics and their followers as self-mortifying pedants.

The psychological background to early modern colour: Kandinsky, Delaunay and Mondrian

John Gage

> 'People today have a remarkable relationship with colour. Our time, which depends on the past more than any other for its forms, has produced a kind of painting in which colour is independent.'
>
> (Karl Scheffler, 'Notizen über die Farbe', *Dekorative Kunst*, IV, 1901, p.187.)

Scheffler's view of the centrality of colour in modern painting was reinforced by many critics and artists in France and Germany before the First World War; and if colour came to play a leading role in early abstraction, this was not so much because it had lost its traditional mystery, but rather that this mystery had been deepened and ramified by developments in colour-study during the second half of the nineteenth century to the point where it could become a central preoccupation of painters seeking new means of expression. The aims of abstraction were spiritual, but for the means of realising those aims painters were ready and able to use the very substantial body of colour-theory which had been published by 1900.

The classic studies of Goethe (*Theory of Colours*, 1810) and M.E. Chevreul (*The Principles of Harmony and Contrast of Colours*, 1839) had established the study of colour, from the point of view of the painter, firmly on a subjective basis, and the developing science of experimental psychology, and, later, of phenomenology, gave a good deal of attention to the perception of colour. Experimental psychologists frequently drew on their experience of painting: several, like David Katz, were themselves painters, and others, like Müller-Freienfels, were also historians of art. Their tastes were usually conservative, but this was not always so. Just before the First World War a painter from the Cleveland School of Art and a physiologist from the Western Reserve Medical School published a general study which examined not simply the physiological basis of Neo-Impressionism, which had been the first movement in painting to base its style and technique specifically on the data of colour-perception, but also the reaction against Neo-Impressionism in the work of the Fauves, who had found, like many other artists around 1906, that the pointillist technique produced a decidedly achromatic, greyed effect, and who sought to base a new colouristic style on the contrast of large areas of flat tint.[1] 1908, the year of Matisse's thoroughly phenomenological 'Notes of a Painter', in which

he described his painting procedure as starting from the immediate, naïve sensation of a colour-patch set down on the canvas, was also the year of E. Utitz's *Principles of the Aesthetic Theory of Colours* (*Grundzüge der ästhetischen Farbenlehre*), which claimed that the painter 'does not take his habitual colours [the colours habitually associated with objects, expected, and hence perceived in them] to his subject, but gives himself up naïvely to the immediate impression'. This view was quoted approvingly by David Katz in an early classic of phenomenology, *Die Erscheinungweise der Farben und Ihre Beeinflussung durch die Individuelle Erfahrung* (*The Modes of Appearance of Colours and their conditioning by Individual Experience*) of 1911.

The interests, and even the methods adopted by painters and psychologists, were very much in tune. A series of studies carried out in the Leipzig psychological laboratory of Wilhelm Wundt in the 1890s and in the early years of this century, was directed towards establishing colour-aesthetics on an empirical basis by means of controlled experiments with many subjects. In an early study, Jonas Cohn had already discovered that most of his subjects (who were all educated men) preferred combinations of highly saturated colours, and particularly saturated complementaries, and he noted that this preference had hitherto been regarded as peculiar to primitives and the uncultivated. In a later series of experiments, carried out in 1910–11, F. Stefanescu-Goanga came to the conclusion that the feelings produced in his subjects by colours were the direct effect of sensory perception, rather than the result of associations, which were secondary phenomena.[2] This work tended towards the view that colour-sensations themselves could be free of associative elements, could be more abstract.

It is not at all certain how far these studies were accessible to painters, in the way in which the earlier, simpler and more comprehensive manuals of Goethe, Chevreul and Ogden Rood (*Modern Chromatics*, 1879) had been, but what is clear is that, in the early development of abstraction, painters interested in colour were experimenting in very much the same way as the psychologists, that they used analogous experimental procedures and sometimes came to very similar conclusions. Painting had been established as an experimental activity in the 1880s by Seurat; after the death of Cézanne in 1907 it became more insistently so and, if we examine painterly practice and theory in the years around 1912 with a view to discovering its preoccupations and motivating forces, we may go far towards reconstructing the processes of trial and error which, more than ever, shaped the non-representational painting of that time.

* * *

'The first colours that made a strong impression on me were bright, juicy green, white, carmine red, black, and yellow ochre. These memories go back to the third year of my life. I saw these colours on various objects which are no longer as clear in my mind as the colours themselves.'

(W. Kandinsky, *Reminiscences* (1913), trans. Herbert.)

In this opening passage to his essay in autobiography, Kandinsky presents himself not simply as an instinctive, inveterate colourist, but also as an introspector who seems to be describing the experience of what Katz in 1911 had characterised as *film* colours: colours which are perceived as only loosely attached to objects. Recent commentators on Kandinsky's theory of colour, as set out in *On the Spiritual in Art* (1912), have emphasised its links with Theosophy, in particular with the writings of Rudolph Steiner, with which the painter had become very familiar in the years after 1908. It has been suggested that he became interested in modern psychology only after the war, at the Bauhaus, where the experimental method was very much part of his teaching. But this is to overlook the extent to which Theosophical writers were themselves indebted to recent discoveries in experimental psychology, and the colour formulations of Kandinsky's treatise suggest a far more precocious interest than that. One of his preoccupations at this time was the establishment of a 'grammar' of painting on a level with what he saw as the 'grammar' of music: again and again he quoted a remark of Goethe's that painting needed a thorough-bass: the eighteenth-century method of establishing a base-line in a score which predetermined the subsequent elaboration of the other parts – and this is a quotation which is not without its irony in the context of 1912, since at this time Kandinsky's friend and collaborator Arnold Schoenberg was asserting that the method was entirely outmoded (*Theory of Harmony*, 1911). Kandinsky had been concerned with the theory of colour at least since 1903, the year of the German translation of Signac's manifesto, *From Delacroix to Neo-Impressionism*, and it is very likely that he had already read Scheffler's article on colour (cited above), to which he referred in *On the Spiritual in Art*, where the treatment of mental disturbances by chromotherapy was one of the subjects under discussion. Some aspects of the dynamic of colour, which Kandinsky made the basis of his colour-system, have rightly been traced to a pamphlet on chromo-therapy by A. Osborne Eaves, *Die Kräfte der Farben* (*The Powers of Colours*) 1906, where red and blue were characterised as the most contrasting and the most therapeutically effective colours, and where Kandinsky made his characteristic diagrams of expansion and contraction in the margin of his own copy. But Kandinsky's system was based upon the primary polarity of yellow and blue (fig. 1), a polarity which goes back ultimately to Goethe's table of plus and minus, active and passive colour-sensations (*Theory of Colours*, §696), but which had been much amplified by Wundt in his

Principles of Physiological Psychology (1874; 5th edn 1902), into what he called the 'unique contrast of feeling [*Stimmung*] in colour': the lively (yellow) and the calm (blue). Wundt described a two-fold movement from yellow to blue: an unstable, labile progression through red, and a stable, balanced, restful progression through green, which colour, according to Kandinsky, also represented 'the passive principle'. In his discussion of synaesthesia (the simultaneous response of two or more senses to a single stimulus) Wundt introduced some musical-chromatic examples which are close to Kandinsky's: their scarlet trumpet is a very traditional equivalent, which goes back to the eighteenth century, but the light blue of the flute is probably peculiar to them. And like Wundt's pupil, Stefanescu-Goanga, Kandinsky felt that 'the theory of association is no longer satisfactory in the psychological sphere. Generally speaking, colour directly influences the soul.' But the detailed correspondences between the ideas of Kandinsky and those of Wundt and his school are only occasional, and rather unimportant; what is more interesting is the painter's method of proceeding in his enquiry, whose conclusions were, as he said, the result of

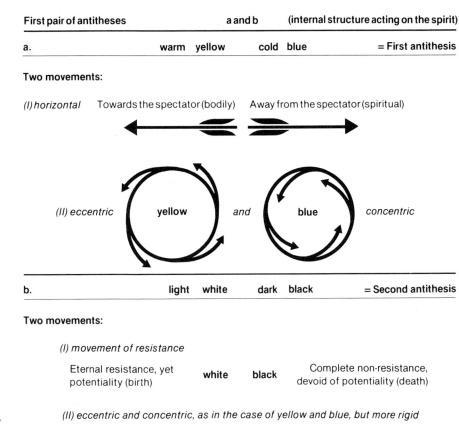

First pair of antitheses		a and b	(internal structure acting on the spirit)
a.	warm yellow	cold blue	= First antithesis

Two movements:

(I) horizontal Towards the spectator (bodily) Away from the spectator (spiritual)

(II) eccentric yellow *and* blue *concentric*

b.	light white	dark black	= Second antithesis

Two movements:

(I) movement of resistance

Eternal resistance, yet potentiality (birth)	white	black	Complete non-resistance, devoid of potentiality (death)

(II) eccentric and concentric, as in the case of yellow and blue, but more rigid

The primary polarity of yellow and blue

'empirical feeling', 'not based on any exact science', but which could be substantiated by 'proceeding experimentally in having colours act upon us'. Kandinsky, who had been trained in law and ethnology before he turned to painting, was no stranger to the experimental method. It was apparently not until after the publication of *On the Spiritual in Art* early in 1912, and under the influence of the American printer Edward Harms, that he subjected Goethe's *Theory of Colours* to experimental test, hoping (in vain) to substantiate Steiner's theosophical interpretation of that work; but that he should have felt that such experimentation would be appropriate at all is witness to a remarkably positivist element in his mind.[3]

After the war Kandinsky introduced the study of the medical and physiological, as well as the occult aspects of colour into his proposals for the curriculum of the Moscow Institute of Art Culture, and three years later, at the Bauhaus, he added psychology, stressing that all these studies should be carried out by means of exact measurements and experiments. His most notorious excursion into experimental psychology was the test on 1000 postcards, sent out to a sample of the Weimar community, who were asked to allot the three 'primary' colours, red, yellow and blue, to the three 'primary' shapes, the triangle, circle and square. The questionnaire produced an 'overwhelming majority' in favour of the yellow triangle, the red square and the blue circle. But, like its results, the psychological pre-suppositions of this survey had already been hinted at in *On the Spiritual in Art* in 1912.

* * *

'In these years [about 1912] whole treasuries of patience, analysis, research and learning were devoured in the studios of the young painters in Paris, and sheer intelligence welled up more intensely than ever before. The painters looked at everything: contemporary art, and art in every historical style, the expressive means of all peoples, the theories of all periods. Never before had so many young painters been seen in the museums, studying and comparing the techniques of the Old Masters. They looked at the artistic productions of savages, of primitive peoples, and the evidence of pre-historic art. At the same time they were much occupied with the latest theories about electro-chemistry, biology, experimental psychology and applied physics . . .'

(Blaise Cendrars, *Aujourd'hui*, 1931, pp.138f.)

The poet Cendrars was referring here to the Paris circle of artists which included Robert Delaunay, whom he had met at the end of 1912. Delaunay was still working on a series of paintings of 'Windows', which he had begun a year earlier, but at the end of 1912 he painted the first 'Disc' (plate 1), which was to mark an entirely new direction in his work, and which was effectively to form its basis until his death in 1941. The painter and his critics have seen the work of this period as the first non-representational painting in France, and it is worth examining the

painting of this seminal year in the light of the theory of art that Delaunay began to elaborate at this time, for the comparison will show how close he was also to developing an experimental method.

Delaunay called this style of painting *Simultané*, taking up the term applied by Chevreul to a particular kind of colour-contrast, which he had made the focus of his 1839 treatise, *De la loi du contraste simultané des couleurs*:

> In the case where the eye sees at the same time two contiguous colours, they will appear as dissimilar as possible, both in their optical composition and in the height of their tone. (§16)

Delaunay may have studied Chevreul as early as 1906, when his painting passed through a Neo-Impressionist phase. The large, square brush-strokes which characterise the work of this period were both a reaction against the greying effect which was being widely criticised as the result of Seurat's smaller dots, and, in the 'Landscape with a Disc' (1906; Paris, Musée Nationale d'Art Moderne), as an expressive means: the vibration created by the refusal of the large colour-patches to mix optically has a direct relation to the dynamic subject of the painting, the sun. This picture also makes some play with complementary after-images (red-green), but there is no reason to suppose that it represents any sustained study of Chevreul.

When, early (?) in 1912, Delaunay wrote to Kandinsky outlining his theories, he had shifted to a rather different approach:

> . . . the laws I discovered . . . are based on researches into the transparency of colour, that can be compared with musical tones. This has obliged me to discover the *movement of colours*.

The preoccupation with colour-dynamics is one which in France had been the particular concern of Charles Henry, who in his *Cercle Chromatique* (1888) had presented red as moving vertically upwards, blue horizontally from right to left, and yellow from left to right. Delaunay also shared it with Kandinsky, whose *On the Spiritual in Art* he had just received from the artist, but could not read. But that this movement could be achieved through the means of transparency was very much Delaunay's own conception and, like colour-movement itself, had very little to do with Chevreul. Chevreul had, however, introduced a discussion of stained-glass windows, and especially rose-windows, as a brilliant example of simultaneous contrast, and he attributed their beauty,

> 1 To their presenting a very simple design, the different, well-defined parts of which may be seen without confusion at a great distance.
> 2 To their offering a union of coloured parts distributed with a kind of symmetry, which are at the same time vividly contrasted, not only among themselves, but also with the opaque parts which circumscribe them. (§435).

It is very likely that Delaunay's interest in transparency was also stimulated by his study of stained glass, at Laon, where he worked in 1907, and again early in 1912, and in the Paris church of St Séverin, of which he made a series of paintings in 1909 and 1910. Perhaps, too, it was the experience of these windows which led him to the 'Window' series of 1909–12, where the technical problems of conveying transparency were addressed for the first time.[4] In the earliest of the series, 'La Ville No.2' (Paris, Musée Nat. d'Art Moderne) the upper part of the window has been treated in a pointillist technique, while the lower parts are handled in flat tones, so as to convey the varying qualities of reflected (iridescent) and transmitted light. Later, for example in the two pictures in the Guggenheim Museum in New York (plate 2), the whole surface has been treated in the chequerboard manner, and there is little doubt that Delaunay was concerned to render an all-over transparency by means of the phenomenon of *lustre*, which had been described by the theorist most used by the Neo-Impressionists, Ogden Rood:

> If the coloured lines or dots are quite distant from the eye, the mixture is of course perfect ... but before this distance is reached there is a stage in which the colours are blended, though somewhat imperfectly, so that the surface seems to flicker or glimmer – an effect that no doubt arises from a faint perception from time to time of its constituents. This communicates a soft and peculiar brilliancy to the surface, and gives it a certain appearance of transparency; we seem to see into it and below it. With bright complementary colours the maximum degree of lustre is obtained; when the colours are near each other in the chromatic circle, or dull or pale, the effect is not marked, but exists to the extent of making the surface appear somewhat transparent.

The palette of these pictures is indeed dull or pale, and it was not until the end of 1911, in 'Simultaneous Windows on the Town' (Hamburg, Kunsthalle, plate 3), that Delaunay began to work out his composition in strong simultaneous complementary or near-complementary contrasts of orange and green, yellow and purple, and to abandon the use of a dotted technique, which survives only in a few residual touches on the painted frame, in favour of angular planes of colour derived from a study of Picasso's work of 1910–11 and, more interestingly, from the late works of Cézanne. Now the colour-patches are bounded sometimes by hard edges, sometimes by soft gradations made by glazing or scumbling the colours over one another: transparency is achieved by the directest of painterly methods.

Delaunay continued to work on the 'Window' series throughout 1912, but in his statements of intention made later that year, the emphasis on transparency has gone. The *Essay on Light*, which was composed during the summer of 1912, attributed the movement of colours less to transparency than to the qualities of hue:

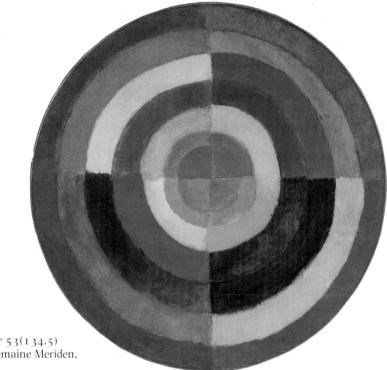

Plate 1
Robert Delaunay
Premier Disque, 1912
Oil on canvas, diameter 53(134.5)
Mr and Mrs Burton Tremaine Meriden,
Connecticut, U.S.A.

Plate 2
Robert Delaunay
Window on the City, No.3,
1911–12
Oil on canvas,
$44\frac{3}{4} \times 51\frac{1}{2}(114 \times 131)$
Solomon R. Guggenheim Museum
Photo: Robert E. Mates

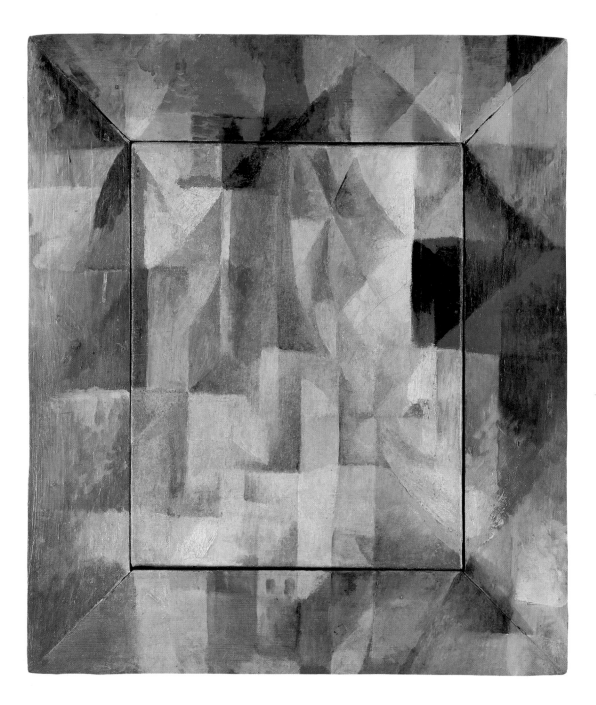

Plate 3
Robert Delaunay
Simultaneous Windows on the Town, 1911
Oil on canvas, $18\frac{1}{8} \times 15\frac{3}{4} (46 \times 40)$
Kunsthalle, Hamburg

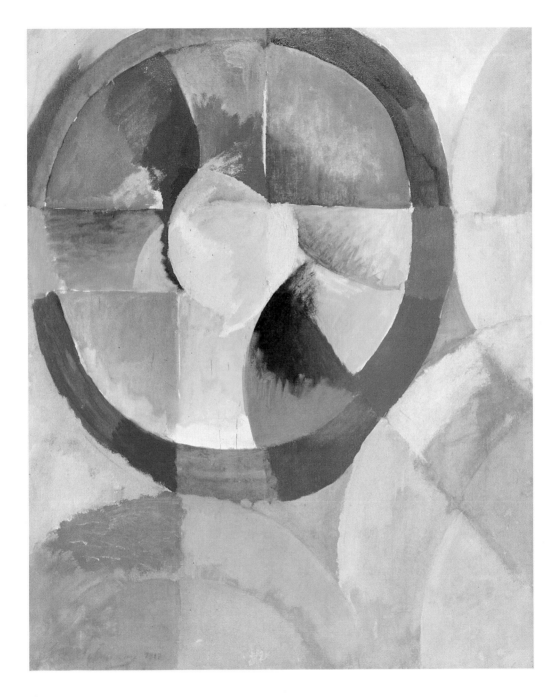

Plate 4
Robert Delaunay
Sun No.1, 1912–13
Oil on canvas, $39\frac{1}{2} \times 31\frac{7}{8}$ (100 × 81)
Stadtverwaltung Ludwigshafen am Rhein,
Wilhelm-Hack-Museum

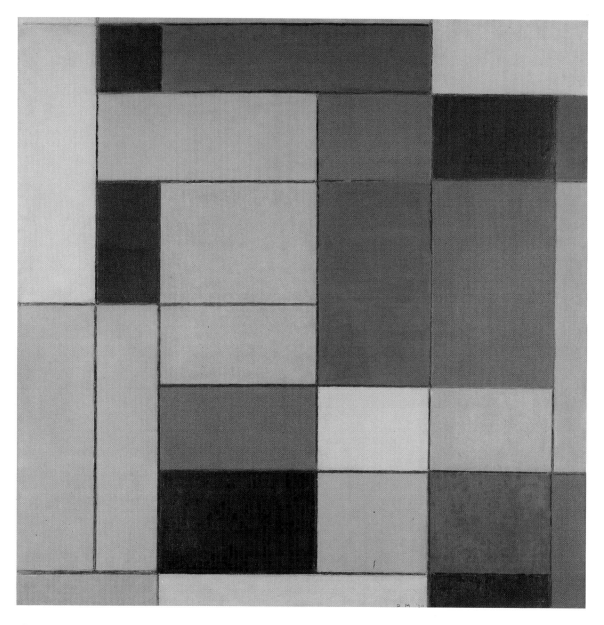

Plate 5
Piet Mondrian
Composition with Grey, Red,
Yellow and Blue, 1920
Oil on canvas, $39\frac{1}{4} \times 39\frac{1}{2} (99.7 \times 100.5)$
Tate Gallery, London

Plate 6
Juan Gris
Grapes and Wine, October, 1913
$36\frac{1}{4} \times 23\frac{5}{8} (92 \times 60)$
Museum of Modern Art, New York.
Bequest of Anna Erikson Levene
in memory of her husband
Dr Pheobus Aaron Theodor Levene

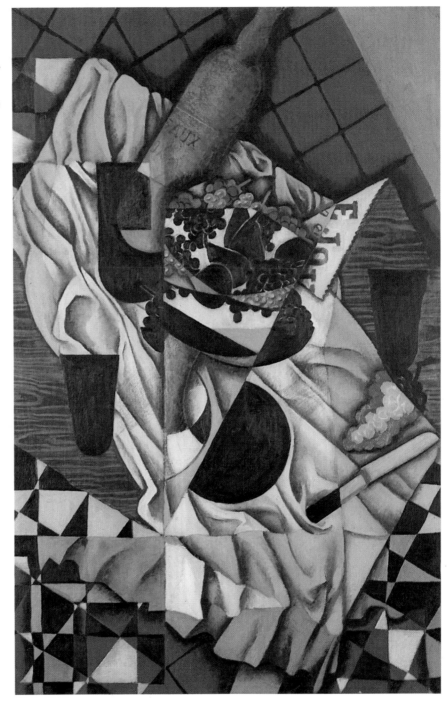

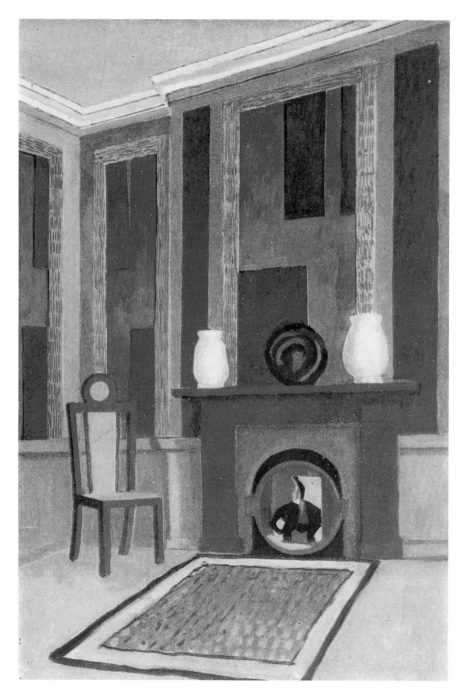

Plate 7
Omega Workshops Ltd
Interior for Madame Lalla Van
der Velde, 1916
Photo: *Colour*, April 1917

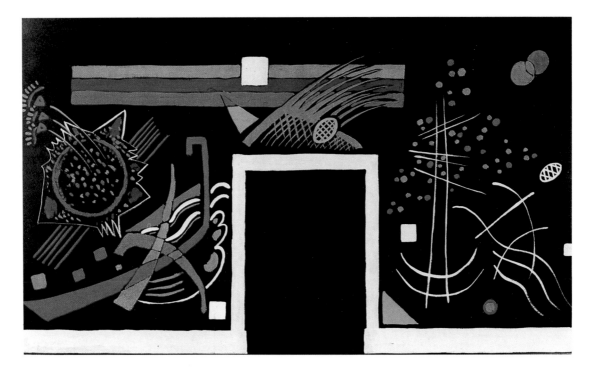

Plate 8
Wassily Kandinsky
Studies for murals for the
Juryfreie, Berlin, 1922

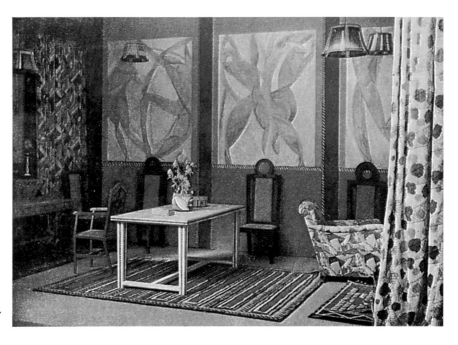

Plate 9
Omega Workshops Ltd
Post Impressionist Room
at the *Daily Mail Ideal
Home Exhibition*, 1913
Photo: *Illustrated London News*,
25 October 1913

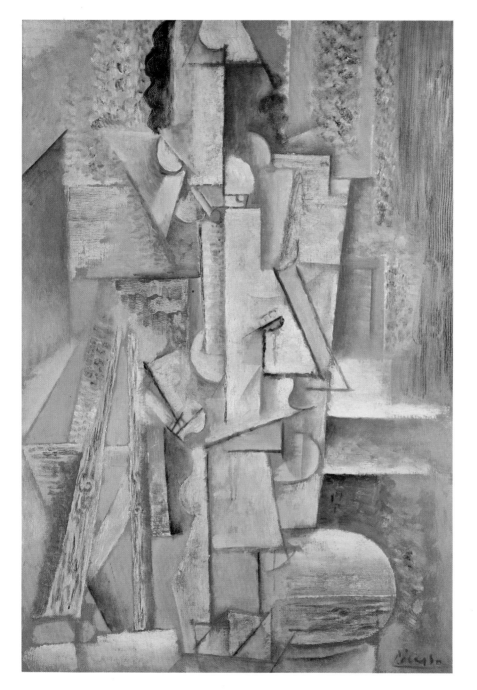

Plate 10
Pablo Picasso
The Model, 1912
Oil on canvas,
$45\frac{3}{4} \times 32 (116 \times 81)$
Private Collection

> Movement is given by the relationship of *unequal measures*, of contrasts of colours among themselves which constitute *Reality*. This reality has *depth* (we see as far as the stars), and thus becomes *rhythmic Simultaneity*.

That summer, Delaunay was staying outside Paris, and according to his wife, Sonia, he was much occupied with the clouds and the heavenly bodies by day and night: the material of his new repertory of 'disc' subjects in 1913.[5] The use of the term *simultaneity* suggests a renewed interest in Chevreul, and by August 1912 Delaunay was no longer speaking in terms of depth; he was now focusing solely on the complementary contrast of colours as a pictorial means. Of Seurat he wrote:

> *His creation remains the contrast of complementary colours* (optical mixture by means of dots , since it is nothing but a technique, does not have the same importance as contrast, THE MEANS OF CONSTRUCTION FOR PURE EXPRESSION).

The aspect of Chevreul's work which now absorbed him was painting in flat tints, whose characteristics, according to Chevreul, 'necessarily consist in the perfection of the outlines and colours. These outlines contribute to render the impression of colours stronger and more agreeable . . .' (§303). For Chevreul in 1839, such painting had only a decorative, accessory function, but the Delaunays did not feel the distinction, and Sonia had recently been experimenting with flat colours in appliqué textiles and in book-bindings decorated with collage.[6] This new experience culminated in Robert's 'Disc' (plate 1), an experiment of December 1912, designed to test the psycho-physiological effects of certain colour-combinations, and painted in bands of flat colour with hard contours. As he wrote in the following summer to Mlle de Bonin, the near-complementaries of blue and red at the centre of the circle produced a slow-moving contrast, and the dissonances towards the edges moved rather faster.[7]

The 'Disc' was not a picture, but a means of experimentation, however it gave Delaunay the experience necessary to create a number of pictures of 1912–13: the 'Circular Forms' with references to sun and moon, several of which, like the 'Sun No. 1' (Cologne, Wilhelm Hack; plate 4), are painted in largely flat tints, and have very pronounced and regular contours. It was perhaps this picture to which Delaunay referred in a letter of 2 June 1913 to the young German painter August Macke:

> My last picture is the 'Sun'; it shines more and more strongly the more I work on it; it is from this movement that from now on all my new Synchromies will be born. The 'Windows' saw the opening of them.

The place of Delaunay's 'Disc' of 1912 in his experimental approach to painting cannot be underestimated. The 'Circular Forms', like Kupka's

'Discs of Newton' of 1912, are still subject-pictures, and it is arguable that Delaunay, unlike his German critics, had no conception of a non-objective art before the First World War; but the 'Disc' and its antecedents show clearly that Delaunay conceived of the role of the painter, in relation to his expressive means, as akin to the role of the experimental psychologist.

* * *

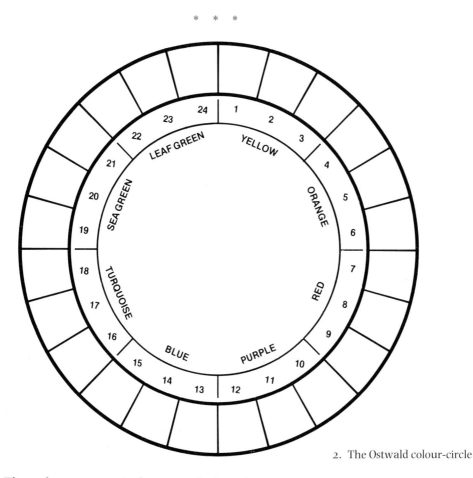

2. The Ostwald colour-circle

The colour interests of painters before the war had been nourished by rather traditional sources of theory: the texts to which they referred had, for the most part, been published in the 1870s, and some of the most important go back to the early years of the nineteenth century. But during the war a new body of colour-theory was published in Germany, and came to dominate the field of colour-studies for the next decade. It was the work of the veteran chemist Wilhelm Ostwald, who had occupied himself in his retirement with problems of colour-measurement. Ostwald felt that there could be no certainty in colour-studies until colour was quantified, from the psychological as well as from the physical point of view; he drew particularly on the work of G. T. Fechner (*Elemente der Psychophysik*,

1860), who had shown that stimuli relate to sensations not in a direct, but in a proportional way: a simple arithmetical progression in sensations must be based on a geometrical progression in the stimuli. Ostwald applied these findings to colour first of all by establishing a scale of greys between white and black, in which each perceptual step was made by increasing the proportion of black to white geometrically (i.e. by squaring the quantity of black). This grey-scale he then applied to scales of each of the hues on his colour-circle, which at first had 100 hue-divisions, but was then simplified to 24 (fig.2). These 24 hues were based on the system of four psychological primaries, red, yellow, blue and green, which Ostwald derived from Ewald Hering (*Lehre vom Lichtsinne*, 1878), who had divided colour-sensations into 'complementary' pairs: black and white, blue and yellow, green and red. Although green had traditionally been regarded as a mixed colour, Hering had claimed that, perceptually, it was autonomous, and it can be seen to play a large part in Ostwald's circle, which includes nine greens. Ostwald was aware of the novelty of this arrangement, and explained that 'the beginner' would probably have difficulty in distinguishing so many: 'this is due to the fact that this area of the colour-circle is very little known to us, since the colours hardly occur in nature'. During the preparation of a colour-atlas, to demonstrate the colour-solid based on these principles, Ostwald had noticed that individual sections of the solid, which showed complementary hues with equal degrees of value on the grey scale, were particularly pleasing, and he concluded that the principles of colour-harmony depended on the balance of values (the black and white content of each hue), and, among the hues round the colour circle, on the juxtaposition of those which are found at intervals of 3, 4, 6, 8, or 12. Harmony, he said, is order, and it was this order in colour which he felt he had finally established.

Ostwald's theory was first published in a short book, *Die Farbenfibel* (recently translated as *The Color Primer*,) in 1917, and was immediately taken up by the Dutch movement, De Stijl, founded in the same year by Theo van Doesburg, Piet Mondrian, Bart van der Leck and Vilmos Huszár, who published an article on Ostwald's system in the first volume of the group's magazine.[8] Huszár stressed that Ostwald, who, as a chemist, had given particular attention to the properties of available pigments, was far more useful to artists than earlier theorists had been, and that his system was the first to be based on geometry, a feature which would especially appeal to the members of the De Stijl group, who were establishing a geometrical aesthetic. He was, however, quick to warn of the subjectivity of colour-sensations, and to insist that Ostwald's circle of hues had no compelling aesthetic validity, and it is true that Ostwald's four primaries had little interest for the group, except perhaps for van Doesburg, who continued to make extensive use of green.[9] What was far more important to De Stijl was the concept of harmonising colours by balancing their white

and black content; and the first painter to show an interest in this aspect of Ostwald's ideas was Mondrian.

Mondrian had been painting in a brilliant, Fauve-like palette since about 1908, and about the same time a brief involvement with Neo-Impressionism led him to formulate a simple doctrine of pure colours laid side-by-side 'in a pointillist or diffuse manner'. But the impact of Cubism from 1911–12 directed his attention away from questions of colour, and it is only in the 1914 sketchbook that we find hints that he had come across Kandinsky's *On the Spiritual in Art*, and had been pondering the complementary relationship of red and green as female and male, external and internal colours.[10] Mondrian's characterisation of red and green as respectively external and internal might simply refer to their role in the modelling of flesh, but the context suggests that they were far more than this, and, although they are not Kandinsky's values for these colours, they are very close to those of the Theosophists, to whom Mondrian had been attached since 1909. In Annie Besant and C. W. Leadbeater's *Thought Forms* (1901) red, Mondrian's female, material colour, is characteristic of pride, avarice, anger and sensuality; and green, his male, spiritual value, of sympathy and adaptability.[11] By 1917, perhaps following the lead of Huszár,[12] Mondrian had adopted a basic palette of white, black and grey, plus three primaries, red, yellow and blue. He still regarded red as essentially an 'outward' colour, and, following Goethe, Kandinsky and the Dutch Theosophist H. Schoenmaekers, he claimed that yellow and blue were more 'inward', but that, for the moment, the three primaries together could not be dispensed with in painting.[13]

But, although, perhaps under the influence of Kandinsky, he now had no liking for green, Mondrian was also very much affected by his reading of Ostwald. In a footnote to an article dealing with colour in *De Stijl*, he wrote that black and white may be mixed with yellow, red and blue, and yet these would still remain primary colours,[14] and in his painting of the period he used planes of very desaturated primary colours, which may be clearly related to Ostwald's view that colour-harmony was to be achieved chiefly by regulating *value*. The earliest composition to make use of this principle seems to be 'Composition-1916' in the Guggenheim Museum in New York, but the idea was explored far more systematically in 1917 and 1918, for example, in 'Composition with Colour-Planes No.3' (The Hague, Gemeentemuseum), 'Composition: Colour-Planes with Grey Contours' (Zurich, Max Bill) and 'Composition with Grey, Red, Yellow and Blue of 1920' (London, Tate Gallery, plate 5); and well into the 1920s Mondrian was mixing a good deal of grey into his primary colours.[15] During that decade he moved away from this interest in desaturation and in grey, but the origins of his Neo-Plasticism during and after the war had been very much affected by Ostwald's promise that it was possible to quantify the psychology of colour, and thus to make it into a mathematical study.

Music and abstract painting: Kandinsky, Goethe and Schoenberg

Peter Vergo

'In recent times, the arts have never been closer to one another than in this latest period of spiritual transformation.

In all that we have discussed lie hidden the seeds of the struggle towards the non-naturalistic, the abstract, t o w a r d s i n n e r n a t u r e . . . Gradually, artists are beginning to occupy themselves, consciously or unconsciously, with examining their materials, weighing on a spiritual balance the inner worth of those elements out of which their art is best suited to create.

And from this effort, there arises of its own accord the natural consequence – the c o m p a r i s o n of one's own elements with those belonging to other arts. In this case, the richest lessons are to be learned from music. With few exceptions and deviations, music has, for several centuries, been the art which employs its resources, not in order to represent natural appearances, but as a means of expressing the inner life of the artist, and in order to create a unique life of musical tones.

An artist who sees that the imitation of natural appearances, however artistic, is not for him, the kind of creative artist who wants to express his own i n n e r w o r l d, sees with envy how naturally and easily such goals can be attained in music, the least material of the arts today. It is understandable if he turns towards it and tries to find the same means in his own art. Hence the current search for rhythm in painting, for mathematical, abstract construction, the value placed today upon the repetition of coloured tones, the way colours are set in motion . . .'

(Kandinsky, *On the Spiritual in Art*, 2nd edition [Munich] 1912.)

The conviction that the different arts were, or should be, coming closer together was not of course peculiar to the twentieth century.[1] Kandinsky's observations are, however, especially relevant to his own era in two important respects. First, the phenomena he describes, the comparison of different art forms, and the growing-together of the arts, are more marked during the early 1900s than at any previous period.[2] Painters, writers and composers began to show intense interest in other forms of art than their own, drawing inspiration from experiments their contemporaries were conducting in various fields. Moreover, many avant-garde artists refused, characteristically, to limit themselves solely to one medium. Composers, like Schoenberg, painted pictures; painters, like Kandinsky and Kokoschka, wrote plays and poems; playwrights made sculptures, like

Barlach. These cross-fertilizations lent added richness and complexity to the already hectic development of the modern movement in all the arts, in both Europe and America, during the first two decades of this century.

Secondly, Kandinsky's statement draws our attention to an aspect of this development which, though crucial, has often been overlooked: to the fact that these experiments were the product of a change not in style, but in beliefs. Nearly all the artists of the avant-garde were now convinced their aim should no longer be simply to 'record' or 'depict' events in the external world. On the contrary: the task of all the arts was to express the 'internal', whether that 'internal' was the artist's own innermost thoughts and feelings, or a mysterious reality which lay behind the mere outward appearance of things. Hence the 'external' differences between one medium and another became largely irrelevant now that the task of every art was 'internally' the same. On a slightly different level, most younger artists had, by the beginning of the century, come to scorn academic training, not just in the theory and practice of the arts but in the manipulation of a given medium, affecting to despise the acquisition of 'skill', in the conventional sense, altogether. 'Art', declared Schoenberg, 'comes not from ability, but from necessity.' The artist, unabashed by his lack of formal training, had only to choose what he considered the external form best suited to the inner content he felt himself impelled to communicate, no matter whether that 'external form' was a sonnet, a sonata or a statue. This disdain for conventional skills tended further to erode any clear-cut distinction between different art forms.

The 'internal' assumed new importance in another respect, too. What has been described as the 'unselfconscious depiction of the world, or of experience' gave way to a highly self-conscious concern not only with the artist's own psyche, his thoughts and feelings, but with the internal resources of art itself. All the arts, and philosophy as well, became, to borrow a striking phrase, 'concerned with their own innards'.[3] The disintegration of traditional forms led to a preoccupation with questions of organisation, with the structural principles that underlay each art, while the increasingly blurred distinction between the different arts encouraged artists to look beyond the traditional boundaries of their accustomed medium in the hope of finding new principles of organisation – the 'comparison of one's own elements with those belonging to other arts' that Kandinsky describes.

Nowhere is this phenomenon more marked than in the relationship between music and painting. Painters, and architects too, for that matter, had always been fascinated by music, from the Renaissance onwards. But not until the twentieth century do we encounter such determined efforts to apply musical principles to painting – not simply to find pictorial equivalents for musical elements such as rhythm or syncopation, but actually to translate musical *structures* – fugue, canon and so on – into

paint. These efforts were not peculiar to Kandinsky, nor to artists working in the German-speaking territories. The Lithuanian painter-composer M. Ciurlionis tried to create paintings based on musical forms (fig.1, 'Sonata of the Stars'); the Italian Futurist Luigi Russolo to 'depict' music (fig.2, 'Music'). Russolo also published a treatise called *L'arte dei rumori* and, starting in 1913, gave a series of 'noise concerts' involving bizarre instruments (*ronzatori, crepitatori, ululatori*).[4] Kupka believed he could 'find something between sight and hearing . . . produce a fugue in colours, as Bach has done in music.'[5] Duncan Grant made what he called an 'Abstract Kinetic Collage Painting with Sound' which was intended to unroll itself before the viewer's eyes while a slow movement from one of Bach's concertos was performed.[6] Delaunay wrote with disdain of the Cubists' disregard for colour, confessing that he himself hoped to find 'more flexible laws, based on the transparency of colour, which can be compared to musical tones. It is this which has caused me to seek the *movement of colours*.'[7] Willard Huntington Wright, the chronicler of Synchromism,

1. M. Ciurlionis
Sonata of the Stars, 1908
Tempera on paper,
$28\frac{7}{8} \times 24\frac{5}{8} (73.5 \times 62.5)$
Kaunus Museum, Lithuania

2. Luigi Russolo
Music, 1911
Oil on canvas,
$86 \times 55 (218.5 \times 140)$
Private Collection

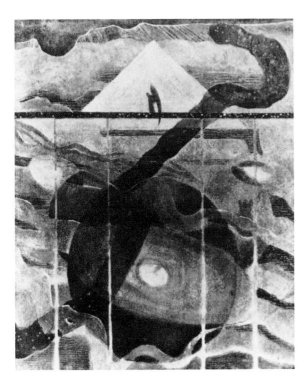

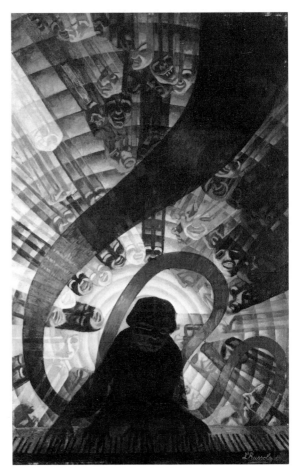

described the 'rationalisation' of the palette (in the works of Macdonald-Wright and Morgan Russell) 'so that one could strike a chord upon it as surely and as swiftly as on the keyboard of a piano.'[8] An interview with Picabia in the *New York Tribune* records that 'the comparison M. Picabia is fondest of making is that with absolute music.'[9] Even an artist as sober as Braque entitled one of the most abstract of his Cubist compositions 'Aria de Bach' (fig. 3).

This array of evidence is both bewildering and tantalising. Why, at precisely this period before the Great War, should painters have been so absorbed in music? What advantages was music seen to possess, by comparison with painting? Why the urge to emulate music, to apply musical principles to painting, to create musical paintings? Why, in particular, did music, and comparisons with music, play such a dominant role in the discussions which raged as to the nature and purpose of the 'new' art – in group manifestos, in artists' statements about their work, in the writings of historians and critics?

Consider, for example, the almanac *Der Blaue Reiter*, edited by Kandinsky and Franz Marc, and published in Munich in May 1912.[10] The almanac was intended as a kind of conspectus of the arts, a 'synthetic' publication aimed at forging a link between different art forms, as well as between 'primitive' and 'modern' art. Poets and musicians, painters and critics all contributed. Kandinsky, in addition to two long theoretical essays, published in the almanac a 'synthetic' stage composition entitled *Yellow Sound*, a weird, plotless affair which synthesised the effects of diction, stage movement, music and an extremely complex lighting score.[11] Another 'synthetic' work subjected to long description and analysis is the Russian composer Aleksandr Skryabin's *Prometheus – the Poem of Fire*, a quasi-symphonic piece which included a part for colour organ.[12] Kandinsky himself was very interested in Skryabin's work, especially the composer's attempts to establish a 'table' of equivalences between colours and musical tones: he refers to these experiments in *On the Spiritual in Art*,[13] as well as devoting considerable space to Skryabin in *Der Blaue Reiter*. In fact, Russian music is given unusually generous treatment in the almanac as a whole, including articles by the composer Thomas von Hartmann on 'Anarchy in Music' and by Kandinsky's friend Nikolai Kul'bin on 'Free Music', besides the essay by Leonid Sabaneev on *Prometheus* already mentioned.[14]

There can be little doubt that *Der Blaue Reiter* represented, in the minds of its editors, a step towards breaking down the barriers between all the arts. It is, therefore, all the more surprising just how much specifically musical material the almanac contains.[15] Was it just that, in the event, the other arts happened to have got short shrift? Or are we to infer some special relationship between painting and music? What are we supposed to make of the lengthy analyses, the frequent musical examples, the songs

3. Georges Braque
Aria de Bach, 1912–13
Collage and charcoal,
24 × 18 (61 × 45.7)
Mr and Mrs Paul Mellon,
Upperville, Virginia

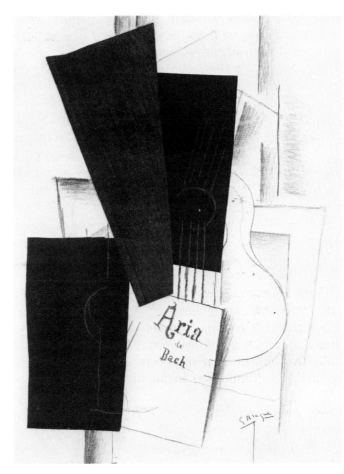

reproduced in the appendix? Why did Kandinsky preface Thomas von Hartmann's article 'Anarchy in Music' with a quotation from Goethe which ran 'Painting has long since lacked any knowledge of *Generalbass*, there is a lack of any established, recognised theory, such as exists in music'?[16] This detail, apparently unimportant, in fact crucial, becomes intriguing when we find the same passage cited no less than three times in *On the Spiritual in Art*. Kandinsky's interest in Goethe is well known and has been frequently discussed – especially in Goethe's *Theory of Colours*, which he apparently read in the version edited by Rudolf Steiner.[17] But the quotation about painting's lack of theory comes, not from the *Farbenlehre*, but from Goethe's *Conversations*.[18] And there are further echoes of Goethe in *On the Spiritual in Art*, quotations from the poet's other writings on art and aesthetics. In particular, Kandinsky's telling utterance regarding the 'envy' with which the painter views music, 'the least material of the arts today', at once recalls Goethe's observations concerning the superiority of music over the other arts, since it 'owes its worth . . . to the fact that it has no *material* which need be discounted.'[19]

By 'material' – *Stoff* – Goethe meant two quite different things. On the one hand, he is pointing to the fact that the musician, like the poet, but unlike the painter, sculptor or architect, does not need materials such as paint, stone or marble in order to express his ideas. This consideration, curious though it may seem to us, weighed heavily with writers wedded to an Idealist aesthetic. It was precisely because of the excessive dominance of material over idea that Schopenhauer assigned bottom place to architecture in his hierarchical system of the arts; whereas music reigned supreme, being the direct reflection of the Platonic Idea, unfettered by any 'material' whatever. Herein lay its superiority over all the other arts, even tragedy. 'To become like music', wrote Schopenhauer, 'is the aim of every art.'[20] But *Stoff* has a second meaning: it denotes subject-matter; and indeed, music does differ from every other art form, including poetry, in that it is not concerned with narrative or descriptive aims. Even in opera, oratorio or *Lieder*, the text or poem does little more than complement the music. In an important sense, our understanding of a particular aria or song does not really depend on knowing the text. Schoenberg, in his article 'The Relationship to the Text', makes a telling confession: that he had known a group of Schubert songs for years without having the faintest idea what was happening in the poems on which they were based. But when he read the poems, he found they in no way influenced his opinion of the musical statement: 'on the contrary, I had quite obviously grasped the content, the real content, perhaps even better than if I had clung to the surface of the actual verbal ideas.'[21] Even where we do know the words, our emotional response to opera or song has comparatively little to do with the verbal message. One of the most affecting moments in all Mozart comes when two rival sopranos sing nothing other than a string of musical tempo-markings: *adagio, allegro, allegrissimo.*[22] Nor, for that matter, is 'abstract' music – symphonies, sonatas, string quartets – incomprehensible because devoid of stories or words. Had Walt Disney never existed, had Beethoven himself not written bucolic peasants and piping shepherds into the score, his 'Pastoral' symphony – or rather, Beethoven's Symphony No.6 in F, Opus 68 – would still *mean* something. But what?

The question 'What does music mean?' has been addressed by many acute minds, with varying degrees of sucess.[23] To rehearse all the arguments here would lead far beyond the scope of this essay. It is, however, possible to pluck out from this web of discourse those strands which bear directly on the question of abstract painting.

First, it is important to understand that music can and does operate simultaneously on several different semantic levels. It may, contingently, include a verbal element, as in opera or song, which can be removed or ignored without rendering the music itself meaningless. Witness the fact that not only minor composers like Triebensee and Wendt, but even Mozart himself, were quite prepared to rearrange parts of *The Marriage of*

Figaro, *Don Giovanni* and *Die Entführung aus dem Serail* for wind band. The composer may also deliberately write to a specific, extra-musical programme, as in the tone poems of Richard Strauss; but again, this extra-musical element is merely contingent, and may be safely ignored without damage to the purely musical argument. For music, without reference to the external world, to images or actions, has its own intrinsic meanings, 'which are not to be confused with specific feelings or moods, and certainly not with pictorial impressions or stories.'[24]

Secondly, just as there is general agreement that music means *something*, so too there is a widespread consensus that this 'something', whatever it is, is certainly not trivial. Just the reverse: generations of writers, be they musicians, critics or philosophers, have suggested that, of all the arts, music expresses the deepest human emotions, exploring areas of 'our interior lives, our psychic landscapes and actions, where names elude us.'[25] Schopenhauer assigned the composer such an elevated position, not merely because of the emancipation of his art from representational or narrative aims, but because of his capacity to 'reveal the innermost essence of the world, pronouncing the most profound truths in a language his reason cannot understand, drawing, like a galvanised sleepwalker, conclusions as to things of which, waking, he has no conception.'[26] Téodor de Wyzéwa, writing in the *Revue Wagnérienne*, distinguished music from every other art form on account of its capacity to 'translate our feelings and emotions . . . Neither the novel, nor poetry, but only music can express this emotional substratum which exists, at times, beneath our ideas.'[27] Wagner himself, in his famous letter to Frédéric Villot published under the title 'Zukunftsmusik', wrote in overtly Schopenhauerian language about his intentions in composing *Tristan and Isolde*: 'I immersed myself only in the depths of the inner motions of the soul and, unhesitating, created from out of this most secret kernel of the world its outward form . . . Life and death, the whole significance and existence of the external world are here dependent only on inner movements . . . The entire action comes to light only at the innermost prompting of the soul, and appears in the form in which it is inwardly conceived by the imagination.'[28]

It is easy to see why Wagner's theories exercised such a hold on the imagination of painters, from the mid-nineteenth century onwards.[29] For painters, too, faced with the example of music, were beginning to question the 'significance and existence of the external world', the importance of narrative and didactic concerns in painting. As early as the 1850s, Gilbert Hamerton, who was to witness the Impressionist revolution at first hand, wrote about the 'contempt' younger painters were showing for traditional subjects, believing that painting should offer 'nothing but its own merchandise. And the especial merchandise of painting they hold to be the visible melodies and harmonies, a kind of visible music, meaning as much and narrating as much as the music which is heard in the ears, and

nothing whatever more.'[30] Why shouldn't the 'abstract' elements of painting, colour and form, be just as expressive, just as meaningful as the tones of music? Couldn't painting, like music, convey its own, intrinsic meaning, as distinct from narrative or subject? Baudelaire thought it could. In the chapter 'De la couleur' from his *Salon de 1846*, he wrote: 'The way to tell whether a picture is melodious is to look at it from such a distance as to be able to distinguish neither the subject nor the lines. If it is melodious, then it already has a sense, it has already taken its place within the repertory of memory.'[31] Delacroix, despite his observations regarding what he considered the limitations of music compared with painting, wrote of that 'impression which results from a certain arrangement of colours, of light, shade, etc. . . . what one might call the music of the painting.'[32] He was also apparently prepared to associate particular colours with particular semantic values, without regard for the represented object. 'Everybody knows', he declared, 'that yellow, orange and red induce and represent ideas of joy and riches.' This observation struck Kandinsky so forcibly that he placed it at the head of the sixth chapter of his treatise, *On the Spiritual in Art*, the chapter entitled, significantly, 'The Language of Forms and Colours'. Kandinsky also follows this quotation (and thus completes the equation) with his own, gratuitous conclusion: 'These two quotations' (Shakespeare's 'Man hath music in himself' also stands at the head of the chapter) 'demonstrate the profound affinity between the arts in general, and between music and painting in particular.'[33]

The nineteenth-century statements quoted above – Hamerton, Baudelaire, Delacroix – were not, of course, calls for a non-representational art and should not be read as such. But when, in the early twentieth century, artists began seriously to consider the possibility of a kind of painting freed, not merely from narrative aims, but also from the task of representing the visible world, they re-animated many of the ideas and arguments first advanced half a century (and, in some cases, a whole century) earlier.

Looking back on the rise of abstraction from our own vantage point of half a century later, we may well find it difficult to understand why the development of an entirely non-representational school of painting took so long. What, after all, was the inherent difficulty about painting abstract pictures? None: you took brushes, colours, canvas or board, and there you were – more or less. All except the 'how'. And in the 'how', to quote Hofmannsthal, 'therein lies all the difference.'[34] We forget how hard it was for artists working in the years immediately before the Great War to visualise what an entirely abstract picture would look like. If we try to peer into the minds of painters like Kandinsky, Malevich or Mondrian, we soon realise they were haunted, each in his own way, by the resonances set up by objects, and by the echoes of those resonances which remained in the mind long after conventional figuration had, on the face of it, disap-

peared.[35] There was, moreover, as Wright observed, no obvious precedent for purely abstract form, 'any more than there was a precedent for the construction of painting solely by means of colour and line. This was not due to an absence of desire in the artist for an abstract language of form, but to a natural diffidence on his part to break once and for all with centuries of tradition . . . to cast aside the accepted *raison d'être* of the visual arts.'[36] Nor did abstract painters, working for the most part in isolation, have any point of reference with which to compare their experiments. Kandinsky in later years recalled that he was able to come only very gradually to abstraction, not because he was unsure of his goal, but because 'at that time I was all alone in the world'[37].

There were other problems, too: questions, the answers to which were far from obvious. What was the compositional basis of the new art to be? Was there not a very real danger that, in throwing out the bath-water of representation, one was also throwing out the baby – the baby being, in this case, structural logic, composition, coherence, comprehensibility? And even if the artist could satisfy his own doubts, what of his already sceptical audience? (The battle for abstraction was fought, let it be said, as much across theoretical as across practical terrain.) How could he prove that his abstract and apparently formless compositions were in fact just as logical, just as carefully structured as the masterpieces of the past? Abandoning narrative was bad enough. Painting's traditional claim to seriousness had rested partly on the fact that it dealt in ideas and ideals. To dispense with narrative was already sufficient to undermine that claim. But if painting without narrative was in danger of forfeiting its claim to seriousness, how much greater was the danger for painting without objects? And what of communication? If the function of art, or one of its functions, was to serve as a dialogue between artist and audience, how could one be sure that, without objects, conversation was still possible? Whatever Delacroix and others might have thought, were colours and forms really expressive in themselves, *inherently* expressive? And if so, expressive of what?

There were of course potential answers to at least some of these questions. Kandinsky himself could see that abandoning objects in paintings meant placing far more weight on structure, that whatever would replace the missing object was to be found in the realms of 'composition' and 'construction'[38] – although, as he ruefully admitted, 'what seemed so easy in theory just would not come in practice.'[39] There already existed paintings in which the depiction of objects played so muted a part one might easily be forgiven for overlooking their presence. When Kandinsky, aged thirty, first saw one of Monet's 'Haystacks', he was unable, by his own account, to recognise the object, which thus 'became discredited as an indispensable element of a painting.'[40]

The applied arts, too, could offer countless instances of 'abstract' design:

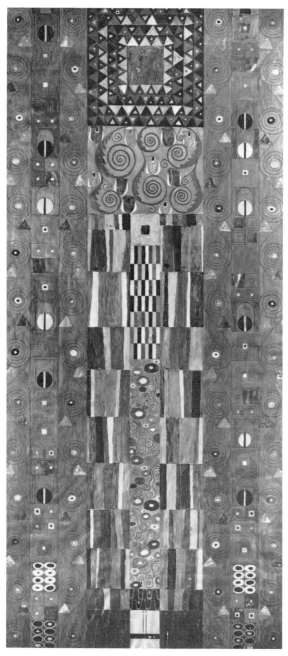

4. Gustav Klimt
Decorative design for the
narrow wall of the Dining
Room of the Palais Stoclet,
Brussels, 1905–9
Mixed media on paper,
$77\frac{7}{8} \times 35\frac{3}{4}$ (197.7 × 91)
Österreichisches Museum für
angewandte Kunst, Vienna

soft furnishings, end-papers, mural decorations, ceramics.[41] (fig.4) Kan-
dinsky, having spent as long as he did in Munich, was well acquainted with
Jugendstil theories of design. He even knew some of the leading designers
personally. Gabriele Münter recalled that Kandinsky 'knew Obrist well and
appreciated his ideas. At one time, we were often invited by Obrist and his
family and we thus had occasion to see several of his abstract designs and

sculptures.'[42] Obrist, Adolf Hoelzel, whose designs for ornament were published as early as 1905,[43] and August Endell, designer of the facade of the famous Elvira Studio in Munich (fig. 5) were among those who contributed significantly to the debate carried on among the representatives of *Jugendstil* as to the abstract, expressive potential of line and form. Endell, in particular, foreshadows Kandinsky in many of his reflections on the future of art, especially his famous prediction of the birth of a new kind of art using 'forms which mean nothing and represent or recall nothing, and yet which rouse our souls as deeply, as powerfully as only the tones of music have ever been able to do.'[44]

But Kandinsky, though unsure in which direction the way ahead for abstract art lay, was certain in his own mind that it did not lead toward the realm of ornament. He even refers, in *On the Spiritual*, to the 'danger' of ornament, which he describes as an 'alogical confusion . . . like that of a kaleidoscope.'[45] Ornament, for Kandinsky, was a kind of hieroglyphic language whose original force and significance had been lost to sight. What is more, he certainly did not want his own work lumped together with that of designers. One can see why. For one thing, ornament seemed inadequate as a vehicle for the communication of profound spiritual messages, in Kandinsky's eyes the highest function of art. For another,

5. August Endell
Facade of the Elvira Studio,
Munich, 1897
Destroyed

the age-old, hierarchical distinction between 'fine' and 'applied' art was still very much alive, even in the first decade of the twentieth century. Hostile criticism is often more telling, at least in retrospect, than mindless adulation; and the critic who, in 1910, wrote about Kandinsky's 'Composition 2' that he would have fewer objections if it said underneath 'colour sketch for a modern carpet', but that Kandinsky and his friends were 'too good to allow themselves to be put on the same level as designers'[46] was more perceptive than we perhaps realise.

No, ornament could not really serve as a model for abstract painters to emulate. But music could – or so it seemed. Music was 'abstract', yet at the same time expressive of profound spiritual truths. Precisely *what* it expressed was impossible to translate into concepts; yet it was not vague, but precise ('too precise', wrote Mendelssohn, 'for verbal expression').[47] Nor was the 'expressivity' of music purely a matter of convention or agreement. Music, like the other arts, had its rules, its outward forms, the product of centuries of development and refinement. But beyond these rules lay deeper, immutable laws, rooted in the very nature of musical sound – laws closely related to those unchanging principles of mathematics and proportion for which the ancients had evinced such reverence. Even Schopenhauer, who placed music highest of the arts for metaphysical rather than physical reasons, was impressed by the 'kind of certitude' music derives 'from the fact that its forms can be referred back to quite definite laws, expressible in mathematical terms, from which it can never depart without altogether ceasing to be music'.[48] He also quotes Leibniz's famous definition of music as 'exercitium arithmeticae occultum nescientis se numerare animi' – a secret exercise in arithmetic performed by a mind oblivious to the fact that it is counting.[49]

6. Part of the harmonic series from Leonard Bernstein, *The Unanswered Question*, Harvard University Press, 1976, p.18, fig.20

It was precisely this systematic aspect of music which occasioned the 'envy' painters felt for their sister art. For there was no doubt that, as Goethe had observed, painting lagged far behind music in this respect. Goethe was not the only writer to comment on the fact that, notwithstanding all the treatises on painting, all the debates about *disegno* and *colore*, the preceding centuries had not really come up with any fundamental reappraisal of the material resources of painting. Moses Mendelssohn wrote that artists had 'scarcely begun' to formulate a harmony of colours: 'the only things people knew about colour harmony were as a result of mere experience.'[50] More than a century later, artists who could see no

purpose in the 'imitation of natural appearances, however artistic', were still bewailing the fact that music appeared to rest on a 'basic science or system' which painting lacked. As late as 1919, Denman Ross wrote: 'Considering the Art of Music . . . it seems that the musician has a great advantage over the painter in having a fixed scale of tones, and definite rules for using it.'[51] And yet, how tempting it was to believe, given the resources of science, that it might be quite possible to show that colour, for example, was not only just as expressive but just as systematic as the tones of music. Baudelaire, as so often prophetic of the future, aired this question in his *Salon de 1859* when he wrote: 'The art of the colourist relates in certain respects to mathematics and to music.'[52] Painters became, as never before, avid readers of the latest handbooks of physics, the latest treatises on colour theory and the psychology of perception. Just as the writings of Chevreul, Rood and Helmholtz had been virtually required reading for the French Impressionists and Neo-Impressionists, German artists, as late as the first decade of the twentieth century, turned back to Goethe's *Farbenlehre* and Schopenhauer's *Ueber das Sehen und die Farben*.[53] Brücke's *Physiology of Colours*, to which were appended colour diagrams and other systems of colour notation,[54] was an object of some interest to artists such as Marc and Macke. Macke returned again and again to the subjects of both colour and music, writing to his fiancée on one occasion about the 'undreamed-of power one would possess, if only one could organise colours into a system, like notes'.[55] Marc, in endless experiments, sought to translate the musical concept of dissonance into colour, describing his attempts at length in his letters to Macke.[56] Kandinsky was obsessed with Goethe's prophecy of the need for a 'thorough-bass' of painting, equating 'thorough-bass' sometimes with a 'grammar' of colour, sometimes with what he termed a 'Theory of Harmony' for painting, a theory he believed he himself might one day write.

But having seized on this analogy between colour and musical tones, artists found it was not, in practice, quite so easy to sustain. One might argue that optics, too, revealed on examination certain indisputable data, such as the seven prismatic colours; one might even try to link these seven colours with the seven notes of the diatonic scale. But, as already mentioned, no agreement could be found as to which colours corresponded to which notes;[57] and though optimists like Kandinsky might believe that a study of the respective wavelengths of colours and musical tones could lead to the desired result,[58] not much progress was made in this direction. It was even more difficult to get round the fact that, in most respects, colour was not similar to music but strikingly different. Colours had no overtones, no 'upper partials', and therefore could not, in isolation, suggest a colour 'key' or tonal centre. Indeed, musical harmony had no true equivalent in colour, however gaily critics might talk of the 'harmony of a picture'. In music, notes sounded together are heard simultaneously, although

perceived as distinct. Colours, on the other hand, whether arranged vertically, horizontally or whichever way you please, are always perceived sequentially; their juxtaposition on the canvas might possibly be considered the equivalent of a tune, of a melodic, but scarcely of a harmonic progression. Nor can mixing colours correspond to a chord in music, since the ingredient elements of a mixed colour can no longer be perceived as distinct; rather, an entirely new colour is created. If mixed colours 'correspond' to anything in music (which is doubtful), they might perhaps be compared to *one* tone sounded simultaneously by several different instruments; in fact 'orchestral colour' is a concept familiar to musicians and critics alike. Musicians are, however, just as given to loose talk about analogies with visual art as their colleagues in painting are with regard to music.

There was also a further problem – not so much a practical difficulty as a philosophical one. Artists wedded, or even only engaged, to abstraction were clear on one point: that their art was the antithesis of nineteenth-century materialism – and hence, by extension, of positivism in science. The ban on science was by no means total: revolutionary discoveries, the kind that turned traditional science on its head, were hailed as evidence that not just art but civilisation as a whole was approaching a decisive turning point (as indeed it was, if one thinks of European civilisation and the battlefields of Verdun and the Somme).[59] But the artists of the avant-garde rejected, almost with one voice, the positivistic science of the preceding century; and in so doing they created for themselves, in some cases at least, almost insuperable problems. In order to counter the accusation that painting without representation would be random, illogical, it was necessary to show that colour was just as logical, just as coherent as the system of musical tones. But on what was music's claim to coherence based? On the fact that its structures, its forms, its ways of organising its material (sound) could be 'referred back' to physical laws. And how were these laws to be discovered? Through the science of acoustics, the analysis of physical phenomena. But it is noticeable that, as soon as artists embark on a similarly 'scientific' analysis of the physical resources of painting, they begin to betray an extreme, even embarrassing nervousness.

Kandinsky himself is a case in point. He devotes considerable space to an examination of colour in his treatise *On the Spiritual in Art*; three of the central chapters are entitled, successively, 'Effect of Colour', 'The Language of Forms and Colours', and 'Theory'. But his account of colour is curious in the extreme. One might think Kandinsky's purpose was to demonstrate the self-sufficiency of colour, that colour is perfectly capable of existing 'in its own right'; and in places this seems to be the case. But in other places Kandinsky happily associates colours either with the sound of certain instruments or even with specific objects. (Yellow, for example, is compared not only with the sound of a trumpet but with a canary and a

yellow Bavarian post box.) He then confuses us further by adding that these observations 'are of course only relative'.[60] He also shifts constantly between giving a fairly straightforward account of the physical properties of colours (their possible uses, combinations, juxtapositions, etc.) and discussing their metaphorical or allusive properties. (In this respect, Kandinsky's discussion of colour closely resembles parts of Goethe's *Farbenlehre* [theory of colours] such as the section called 'Sinnlich-sittliche Wirkung der Farbe' [sensory-moral effect of colour] which, as its title suggests, lends itself to precisely the same kind of ambiguity.) But in the end it is clearly the allusive, associative properties of colour that interest him most. Indeed, he seems in places positively to shy away from giving any 'scientific' account of colour at all. Clearly, Kandinsky's commitment to the 'spiritual' in art, to the irrational and inspirational element in creation, debars him from making any very great concessions to the methods of scientific enquiry, regarded, almost by definition, as antithetical to art. It is not even enough to have rejected the spectrum, from which more 'rational' colour theories take their starting point, in favour of the irrational, anti-Newtonian system which starts from the 'polar opposites' blue and yellow, the system on which Goethe's *Farbenlehre* is also based. Just in case there should be any lingering doubt that what Kandinsky is proposing in any way resembles traditional, 'scientific' theory, at the very moment at which he produces his own (decidedly peculiar) colour diagrams and starts discussing colours in detail, he adds the following, otherwise incomprehensible footnote: 'All these assertions are the result of empirical-spiritual experience, and are not based on any positive scientific system.'[61]

It is surprising that Kandinsky does not extract more mileage from the term *Generalbass* which, as we have seen, he picks up from Goethe's *Conversations*. The term is sometimes misunderstood, especially by English-speaking readers, but it has a quite precise musical significance. *Generalbass* denotes what musicians call 'thorough-bass' or 'figured bass', a method used mainly in seventeenth-century and eighteenth-century music to simplify notation, a kind of 'shorthand' according to which the keyboard player would reconstruct the continuo part, according to definite rules, and in conformity with a relatively elaborate convention which left him, none the less, considerable freedom of choice in matters such as registration, the spacing of the accompanying chords, ornamentation, and even melody. Kandinsky writes about the need for a *Generalbass der Malerei* (a thorough-bass of painting), which, in itself, means nothing; but his intention is perfectly clear. *Generalbass* stands as a metaphor for the systematic character of music, that 'certitude' which painters found so enviable.

Generalbass was, of course, a set of rules as well; and Kandinsky, as we have seen, gives such emphasis to the spontaneous or inspirational

element in artistic creation that the whole notion of 'rules for art' can be handled only with kid gloves. None the less, a fruitful line of argument might have gone as follows. One could well point to the similarly systematic basis on which, for example, both the 'theory' of colours and the 'method' of figured bass are constructed, while preserving intact the spontaneity of the creative act by stressing the similarities between the role of the performer faced with the task of freely interpreting a Baroque continuo part and that of the painter under the 'sway of inspiration' – or however else it might be described. Rather surprisingly, Kandinsky does not attempt this tack at all. Instead he turns, not to conventional musical theory, but to the much more difficult 'new' music of Schoenberg and his pupils in search of support for his own ideas about the future development of art.

Kandinsky and Schoenberg met in Bavaria in the summer of 1911; an exchange of letters between them dates back to the beginning of that year.[62] It seems Kandinsky first became aware of Schoenberg's music at a concert given in Munich; this concert, which included the composer's first two string quartets, is described in a letter dated 14 January 1911 from Marc to his friend August Macke in Bonn.[63] Marc, on his own admission, had been struck at once by the 'similarity' between Schoenberg's music and Kandinsky's paintings. ('I kept thinking of Kandinsky's great Composition . . . and of [his] "leaping blobs" [of colour].')[64] However, Kandinsky himself, though doubtless impressed by the aural effect of Schoenberg's innovations, was clearly much more interested in the programme note, which contained extracts from the composer's writings, than in the music itself.[65] Apparently these extracts were printed in the programme without any reference to the source from which they were taken, which caused Kandinsky to write to Schoenberg, whom at this date he did not know at all, asking where he could get hold of the original text, and for further clarification.[66] Schoenberg wrote back to the effect that the programme note was part of a chapter from his as yet unpublished *Harmonielehre* (*Theory of Harmony*).[67] This chapter had, however, already been published separately, under the title 'On Parallel Octaves and Fifths', in the Berlin periodical *Die Musik*.[68] Kandinsky obtained an offprint of this article, which fired his imagination to such an extent that, without even waiting for the composer's permission, he translated the whole thing into Russian, adding important footnotes of his own, and caused it to be included in the catalogue of an international exhibition, *Salon 2*, organised by his friend Vladimir Izdebsky and held in Odessa that same season (winter–spring 1911).[69]

On an elementary level, it is not difficult to understand why Schoenberg's article should have been of such interest for Kandinsky. One is struck immediately by the manifest affinities of thought, stylistic similarities, common preoccupations. The whole subject of Schoenberg's argu-

ment, which consists of a refutation of the academic 'ban' on writing parallel octaves and fifths, closely resembles Kandinsky's attacks on the illogicality of what was or was not considered academically 'respectable' in painting. And, if one looks at Kandinsky's other writings of this period, not only *On the Spiritual* but also his essays, and compares them with Schoenberg's *Theory of Harmony*, one finds both painter and composer voicing the same disquiet regarding the danger in trying to derive precepts for art from the analysis even of the greatest works of the past – precepts which might all too easily be taken for 'eternal' laws. Such 'laws' both artists regarded as a potential obstacle to the 'dynamic', forward-moving progress of art.

But what really captured Kandinsky's interest were the most specifically technical parts of Schoenberg's argument: the passages in which the composer sought to justify his use of unresolved dissonances. Here it is important to understand the precise meaning of 'unresolved'. For there was nothing new about dissonances as such: dissonant intervals such as the minor seventh or major second had always played an important part in Western music. They are to be found in the music of the Renaissance; they are present, usually in the form of suspensions, in Venetian music of the sixteenth and seventeenth centuries, in the compositions of the Gabrielis and Monteverdi, in the music of Bach and Handel. Moreover, with the dawn of the Romantic era dissonances proliferated. Where would Chopin and Berlioz, Beethoven and Weber be without dissonance? But these were 'resolvable dissonances'; they occurred within a tonal context. The listener perceives such dissonances in relation to an already established sense of key; the ear demands that the dissonance be resolved, as it is, for example, when the dominant seventh chord resolves itself on to the tonic, the 'dissonant' seventh note descending one semi-tone to become the major third within the tonic triad (fig.7). Even when, as so often in Romantic

Key of C

7. Typical resolution of a dominant seventh chord from Imogen Holst, *An ABC of Music*, Oxford University Press, 1963, p.90. The seventh (F) appears as a passing note

music, the 'resolution' of a dissonance turns out to be another dissonance, this further dissonance still requires to be resolved, is still perceived in relation to its ultimate destination, however distant that destination may

be. It is in precisely this way Romantic music makes such emotional
demands on us, arousing certain expectations, only to deny them while
creating, at the same time, further, often more urgent expectations.

But Schoenberg's music did not work like this at all. In his works of
1910–11, dissonances occurred outside any tonal framework, standing
by themselves, ambiguous, inscrutable. They evoked in the listener no
expectation that they would be resolved, only, in those unaccustomed to
Schoenberg's innovations, a profound sense of disquiet, since they failed to
provide the least suggestion of any key. It was this effect Marc tried to
describe in his letter to Macke about the January 1911 concert, a letter
which evidently depends for its technical vocabulary on the same
programme note that had caught Kandinsky's eye:

> Can you imagine a kind of music in which tonality (that is, adherence to
> any key) has completely disappeared? . . . Schoenberg starts from the
> principle that the concepts consonance and dissonance simply do
> not exist. A so-called dissonance is merely a further-removed conso-
> nance . . .[70]

But although Schoenberg's compositions were not like any music ever
written before, they were, none the less, the final, logical phase in a period
of transformation music had undergone over a span of more than half a
century – in fact, ever since Wagner wrote *Tristan and Isolde*. Wagner had
given music, and opera in particular, a new impetus; but in doing so, he
had stretched tonality almost to the limit. Music of the 'classical' period
depends heavily on the notion of a 'home' key, a key in which a symphony
or sonata begins and, with a bit of luck, ends. A movement written in
sonata form, for example, might be compared to a journey through a
landscape, by way of certain fixed points or landmarks whose relative
positions are easily determined, after which we end up, despite deviations
and detours, at the point from which we started. With *Tristan and Isolde*, we
cannot even be sure from what point we started. In what key does the
prelude to the opera begin? Various keys are suggested; in some cases, even
'suggested' is too definite a word: 'hinted at' might be a better description.
(fig.8) Dissonance succeeds dissonance, each demanding resolution, each
unresolved because followed by yet another dissonance, itself demanding
resolution. Some writers have even considered *Tristan and Isolde*, all five
hours of it, to be nothing other than a single, enormous, unresolved
dissonance. The vast landscape becomes, as we traverse it, bewilderingly
unfamiliar; the landmarks by which we might have navigated are dis-
torted by mists, tonally ambiguous. And the further we progress, the less
idea we have of the character of the terrain we still have to cross.

As it happens, some of Wagner's later operas are less tonally ambiguous
than *Tristan and Isolde*; but the effect of the composer's startling chroma-
ticism, and of *Tristan* in particular, is undeniable. It led to what might be

8. Wagner, *Tristan and Isolde*, beginning of Prelude from Leonard Bernstein, *The Unanswered Question*, Harvard University Press, 1976, p.230

called an 'ambiguity boom' in late nineteenth-century music – a boom which continued well into the first decades of the twentieth century. The shimmering uncertainties of *L'Après-midi d'un Faune* are more evanescent than anything in Wagner, the mists which hang over the gloomy kingdom of Allemonde even more impenetrable than those spanned by the rainbow bridge leading to Valhalla. Schoenberg, too, took Maeterlinck's *Pelléas et Mélisande* as the subject of a musical composition, though his 'symphonic poem' is closer in style to the tone poems of Richard Strauss than to Debussy's opera. But Schoenberg, despite the Wagnerian chromaticism of his own early music, was able to see the logical consequence of the tonal ambiguity which characterised not only his music but that of many of his contemporaries. If increasing chromaticism, the proliferation of unresolved dissonances had brought about a situation in which, for page after page of the score, it was impossible to be certain in what key a piece of music was written, why not cut the Gordian knot? Why not simply abandon tonality, since it had clearly become an old-fashioned straitjacket, a meaningless constraint? Why not allow dissonances simply to

stand by themselves, not suggesting a sense of key, not asking to be resolved, but simply as autonomous, expressive elements, existing in their own right?

Certainly, it was possible to advance strong arguments in support of this seemingly radical move. For one thing, as Schoenberg insisted, it was a question not of revolution but of evolution, simply the next logical step. Looking back on the development of atonal music, he recalled with studied astonishment the 'superficiality' of the critics 'who neglected to ask to what extent the "eternal" laws of musical aesthetics had been obeyed, contravened, or simply modified to suit a change in circumstances . . . Hence the accusations of anarchy and revolution, whereas it was surely a question of evolution, a step in the development of music no more far-reaching than any previously accommodated.'[71] For another, the emancipation of the dissonance from any tonal function was not mere 'wilfulness'. On the contrary, even the furthest dissonances, just like the tonally more 'explicit' consonances, were themselves generated by the harmonic series; such dissonances, wrote Schoenberg, 'differ from consonances only in degree; they are nothing more than further-removed consonances, the analysis of which presents the ear with greater difficulty, because they are more distant, but which, once analysis has brought them nearer, have the same possibility of becoming consonances as the more immediate overtones.'[72]

Kandinsky could scarcely fail to be struck by the effect produced by Schoenberg's use of dissonance in works such as his second string quartet or *Das Buch der hängenden Gärten*. He even tried to equate the composer's methods with his own goals in painting, especially in respect to his use of colour. He commented ruefully that 'the young French painters (Rouault, Braque, Fauconnier, Picasso, etc.)' had 'already grasped the Schoenbergian principle', whereas he himself was still dissatisfied with his own efforts, confiding to Marc that his attempts to 'resolve' colours in one great harmony 'had been a *faute de mieux* in his works, something he still had to overcome.'[73] But more important than any practical consequences he might draw from Schoenberg's music was the nature of the justification the composer had advanced for his 'unresolved' dissonances, the use of which had taken him beyond the threshold of tonality. For Kandinsky, despite his somewhat shaky grasp of musical theory, was perceptive enough to realise the implications of what Schoenberg was saying. Schoenberg was not 'preaching' atonality, any more than Kandinsky, then or later, wished to advocate abandoning all forms of representational art. But he *was* able to show that tonality, despite having previously been regarded, at least in modern Western civilisation, as the indispensable basis of musical creation, was not essential but contingent and that the same laws which had always governed musical creation still applied, whether one retained a sense of key or not.

Kandinsky was not slow to seize on the value of the analogy between the new music and the new painting. In the past, writers had tried to compare the representational element in painting with the verbal aspect of music: the 'words' of a song, some text or libretto. But was it conceivable that the parallel had been incorrectly drawn, that the more telling analogy was not between representation and text, but between representation and tonality? If this were so, could one use Schoenberg's arguments as a model after which one might fashion a similar justification for abandoning representation? Could one show that representation, previously considered the indispensable basis of Western painting, was likewise only contingent? Was the rejection of representation implicit in the development of Western art during the preceding few decades, in movements such as Impressionism, Post-Impressionism, Cubism? Was it possible that abstract painters did not need to discover new 'laws' for painting, that the old laws which had always governed artistic creation still held, and were not infringed by discarding subject-matter? The answer to all these questions, at least at first sight, appeared to be a perfectly plausible 'yes'.

Kandinsky himself was too close to the heart of the problem and too excited by Schoenberg's 'discoveries' to be able to see matters in perspective. What he did not perceive (and it would have been surprising, at this date, if he had) was that Schoenberg in his bid for freedom had encountered difficulties in his own art and theory very similar to those confronting Kandinsky himself. Just as for the painter the crucial question remained 'What is to replace the object?', so too for Schoenberg the crucial question, though he never formulated it in this way, was 'What is to replace a sense of key?'. As long as one retained some vestige of tonality, some vestige of representation, both painter and composer could still counter the charge of arbitrariness, since both representation and tonality, as well as being a convention enabling the viewer or listener to comprehend the import of certain intended effects, also provided a set of relations, structural principles according to which the relative significance and status of forms, whether musical or visual, could be gauged. But abandon representation, abandon tonality, and all this was lost. Without tonality, what was sweetly consonant, and what jarringly discordant? Much of German Expressionist painting depended for its effect upon the 'expressive' distortion of nature; but discard representation altogether, and one is no longer able to speak of 'distortion' at all. How, in an atonal composition, can one recognise with any certainty the various 'tunes' (assuming, that is, that tunes still exist), since the very notion of a 'tune' is inextricably bound up with a sense of key? How, in an abstract painting, can one determine the logic of spatial relations, since along with representation, space itself has, if not vanished, then at least become manifestly ambiguous?

Schoenberg, for his part, seems to have been acutely aware of these

problems. In his *Harmonielehre* and other writings of the same period, he sets out with apparent confidence to show that his own development of free atonality was no more than a logical extension of the possibilities of musical expression, a step which could be accommodated within, and justified in terms of, already existing laws. But reading between the lines, it is clear he was deeply worried lest, in discarding tonality, something perhaps fundamental to his art had been abandoned. The chromaticism of the post-Wagner era had indeed opened up new possibilities, what Bernstein calls the 'delights of ambiguity'.[74] But ambiguity, Bernstein rightly insists, has not only its 'delights' but also its 'dangers', the greatest danger being a lack of clarity. If a musical phrase or sentence has not just one intrinsic meaning, but innumerable meanings, then 'meaning' itself is thrown in doubt. Schoenberg knew only too well that the even greater ambiguities of his own atonal music demanded new principles of containment, analogous to the constraints imposed by tonality, if meaning was to be preserved. But, as with Kandinsky and the problem of 'construction' in art, he had at this date no idea what these principles of containment were to be.[75] The composer, no less than the painter, evinced a profound distrust for the whole notion of 'rules for art'. In his *Harmonielehre*, he wrote: 'The positive gain of a work of art is dependent upon other conditions than those expressed by rules; neither can it be reached by way of rules.'[76] But discarding 'rules' is one thing; being unable to define, or even describe the 'laws' which governed his 'choice of this or that dissonance' is quite another; and Schoenberg is thrown back on threadbare phrases such as 'divine intervention' in order to be able to give *any* account of his creative progress.[77] Only in the 1920s, with the invention of the method of 'twelve equal notes related only to each other', was he able to point to the structural principles which underlay the new music. Even then, his difficulties were not entirely over. The twelve-tone method, though it might indeed solve such problems as order and coherence, left little room for inspiration, the irrational within an increasingly rigid system. As for the 'laws' he had felt instinctively must determine his seemingly 'arbitrary' choice of unresolved dissonances, laws which, he had prophesied in the *Harmonielehre*, would soon reveal themselves – these fundamental principles of selection remained obstinately obscure; and, as Rudolph Reti pointed out, Schoenberg 'never spoke of this matter again', save in a negative context.[78]

For both Kandinsky and Schoenberg, moreover, this theoretical dilemma had its counterpart in a kind of creative frustration. Kandinsky, though able to formulate a perfectly adequate justification for abandoning representation in painting, was quite unable, before 1914, to paint a wholly non-representational picture. He himself wrote that, for a long time, he did not *want* to abandon objects altogether, because of the 'spiritual overtones' which cling to them; instead, he 'dissolved' objects to a

greater or lesser extent, 'so that they might not all be recognised at once'.[79] What this means in practice is that recognisable motifs, once established, are subjected to an increasingly elaborate process of formal abstraction, so that in the end they are 'legible' only with difficulty; but *purely* abstract forms appear in his paintings of this period only in conjunction with other more overtly representational elements.

Schoenberg's dilemma, and its consequences, are even more marked. His abandonment of tonality around 1909 posed extremely serious structural difficulties, difficulties the composer was unable to solve for more than a decade. The marvellous array of vocal and operatic works created between 1909 and 1920 – *Erwartung, Pierrot Lunaire, Die Glückliche Hand, Die Jakobsleiter* – should not blind us to the fact that, during these years, Schoenberg was virtually unable to write compositions of any length *unless* based on a text or libretto – in other words, some extra-musical structuring element. In fact, between the 'Five Orchestral Pieces', Op.16 (1908) and the 'Five Piano Pieces', Op.23 (1923), the only 'absolute' works are the short piano pieces, Op.11 and Op.19. Only later, after the adoption of the twelve-tone system, does any extended 'abstract' argument, independent of any tonal or textual framework, again become possible.

It was perhaps rather naïve of Kandinsky to seize on the Schoenbergian 'principle' of dissonance and seek to apply it to painting; but in other ways, he was more astute, perhaps, than he himself realised. In his theoretical writings, and especially in *Der Blaue Reiter*, he drew attention again and again to the converging paths of the different arts in modern times, and of music and painting in particular, pointing to the 'new music' of Schoenberg and his pupils as an example of the freedom from convention that painting was only beginning to seek. What he did not comprehend was that the kind of music to which he felt the new painting was so intimately related had itself encountered, for the moment, insuperable problems of organisation.

Mathematics in early abstract art

Lucy Adelman and Michael Compton

Although painting and mathematics are two very different disciplines, that have often been considered totally opposed, there have been many connections between them. In Western Europe the most fundamental, as well as the most sophisticated and fruitful, was the invention of single viewpoint perspective in the fifteenth century. Itself based on Euclidean theorems, it was in turn to contribute to the development of projective geometry from the early seventeenth century. The importance of perspective in art was not so much that it was a means of creating an illusion but that it was a rigorous model of three-dimensional space constructed on a two-dimensional surface. At the same time it was a system of proportion in that objects diminished precisely in proportion to their distance. As a practice it favoured the depiction of rectilinear or familiar forms, since it was by the deformation and diminution of these that the third dimension, that of depth, was indicated. Deformation of irregular or unpredictable forms could not be distinguished so easily by the eye and so, in landscape, distance was often indicated by other means.

Regular forms in two and three dimensions and regular proportions had been studied in the ancient civilisations and endowed with special properties of beauty, universality and even holiness. The invention of perspective, in turn was associated with a notion of cosmic harmony that went beyond any mere correctness of representation. However, by the mid-nineteenth century, although art students were taught perspective and were given exercises in drawing regular solids and figures in proportion, these special properties had been more or less reduced to banalities.

Between the seventeenth and the twentieth centuries, moreover, mathematics developed rapidly, producing many concepts and methods that were not, or could not, be applied directly to painting, such as the calculus. Indeed, in the world of art, as in everyday life, 'geometry' continued to mean triangles, squares, cubes and cones – the illustrations of elementary geometry text books rather than the essential logical derivation of theorems from axioms which these figures are designed to make comprehensible. Much abstract and some figurative art in the twentieth century has been and is commonly described as geometric in the same sense but in the early part of the century there was a new meeting of art and mathematics that proved fruitful to the former. Although what can

most easily be discerned in the relevant paintings of the period is rather *naif* in mathematical terms: lines and arcs, squares and triangles, the contact took place on a number of different levels which we will divide here for convenience although they can often be shown to operate together in the work of a single artist or even perhaps in a single picture. Firstly there was a widespread interest in non-Euclidean and/or n-dimensional geometries, and in the philosophical implications of these which were generally taken to be anti-materialist. Secondly, the period marked the overthrow of perspective and the substitution for it of various less systematic devices. Thirdly, artists made use of numerical proportions and grids, which, like the geometric figures, were associated with the idea of reducing art to its own specific elements. Fourthly, elements appear in painting that are drawn from mathematical text books: numbers and algebraic notations. Finally, simple geometric figures were associated with the machine and its products and so with 'progress' or modernity.

All of these, except perhaps the last, are to some degree present in Cubism and so we will begin the story there. By 1909 Apollinaire was writing about Braque: (he) '. . . visibly proceeds from a geometric *a priori* to which the entire field of his vision is submitted and he attempts to translate the whole thing by combinations of a few absolute forms'.[1]

However, Braque himself said much later: 'When in 1909 fragmented objects appeared in my canvases . . . I had already adopted the concept of tactile or manual space.'[2] This remark sounds like an echo of the famous lines of Gleizes and Metzinger in their enormously influential *du Cubisme* of 1912:

> . . . the cubist painters, who indefatigably study pictorial form and the space which it engenders.
> This space we have negligently confused with pure visual space or with Euclidean space.
> If we wished to tie the painter's space to a particular geometry, we should have to refer it to the non-Euclidean scientists; we should have to study, at some length, certain of Riemann's Theorems.
> As for visual space, we know that it results from the harmony of the sensations of convergence and accommodation of the eye.
> For the picture, a plane surface, the accommodation is negative . . . To establish a pictorial space, we must have recourse to tactile and motor sensation . . .[3]

Dr Linda Henderson has shown that these remarks derive from the writing of the mathematician and philosopher Henri Poincaré.[4] Poincaré had asserted that man constructs a three-dimensional concept of the world by adding to the two-dimensional image on the retina of the eye the results of experiencing the agreement between the sense of convergence of the eyes and the sense of altering the lens of the eye, 'accommodation'. He argues that, while this experience of space can be matched to the Euclidean three

dimensions, this is a matter only of convenience. Our experience of objects in space is made up of the senses of touch, of the tension of muscles and the resultant knowledge of positions of the parts of the body in space. These could be considered as so many separate dimensions or grouped, again by the experience of their agreement, into a fourth dimension.[5]

We think there are qualities of Cubism which can be related fairly to this concept. The parts of the objects represented in a Cubist painting are not grouped visually as they might be projected on the retina at any moment, or any sequence of moments, but built up out of separate sensations. There is no empty space between the objects and they appear to be assembled, out of partial sensations, on the surface of the picture. Elements are derived from different approaches to the body or the other objects that are represented and are not coloured, perhaps since touch has not colour.

However, as Linda Henderson demonstrates abundantly, the term 'fourth dimension' was in great currency in the late nineteenth and early twentieth century. One of its meanings was purely geometric, a simple extrapolation of Euclid. Briefly, since a one-dimensional line can be moved at 90° to form a plane square and a square moved at 90° to form a cube, by extension it should be possible to imagine moving a cube in another dimension at 90° to these to form what was sometimes called a 'hypercube'. Poincaré challenged (as others had done) anyone to represent such an object on a two-dimensional surface. There appears to be no single

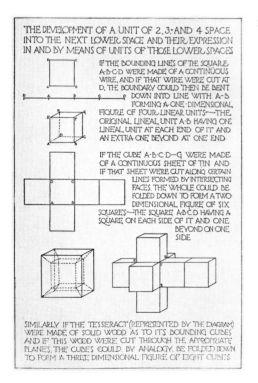

1. C. Bragdon
Tesseract or **Hypercube** from
A Primer of Higher Space,
New York, 1913, pl. 3

1a. Plate from R. G. Kirby *The Fundamentals of Mechanical Drawing*, 1930, p. 37 (first edition 1918)

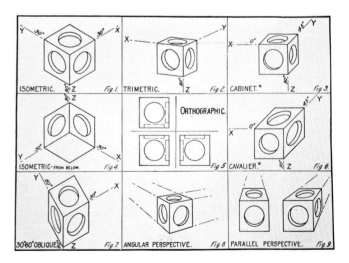

picture which exploits such notions systematically. On the one hand no person can perceive and so try to represent a four-dimensional object directly (in this sense) and, on the other, as Gleizes and Metzinger themselves wrote: 'Geometry is a science; painting is an art. The Geometer measures, the painter savors. The absolute of one is necessarily the relative of the other: if logic is alarmed at this idea so much the worse! Will it ever prevent a wine from being different in the retort of the chemist or in the glass of a drinker?'[6]

All the same, artists did draw some devices from the attempts of amateur and professional mathematicians to illustrate four-dimensional solids in a two-dimensional space, that is on paper. One of these was perhaps the use of axonometric or other similar perspectives. In these the third dimension is measured arbitrarily at, say, 45° to the first two, which are on the picture plane and so 'undeformed'. The scale on this dimension will be the same as, or some reduction of, the first two. Lines of the object represented which are parallel and which lie along the axis of the third dimension will be parallel in the representation (fig. 1 and 1a).

Many details can be found in Cubist paintings that approximate to this kind of projection (fig. 2). They may appear on the same canvas with other types of conventional projection not specifically associated with four-dimensional geometry, of which the most familiar is that which is used in mechanical drawing – orthogonal projection (that is, at right angles to the plane) on two or three planes normally at 90° to one another (fig. 3). In addition, in mechanical drawings there are often sections and details which may be projected on planes at other angles where it may be

Pablo Picasso
Seated Nude, (detail)
1909–10
$36\frac{1}{4} \times 28\frac{3}{4}$ (92×73)
Tate Gallery, London

Right
Plate from John E. Jagger,
Mechanical Drawing, 1910,
p.195

Far right
Juan Gris
Drawing, c.1913–14
Pencil, size unknown
Sections of parts of the table can easily be seen. The composition has been built up by the use of a 60°–30° set square

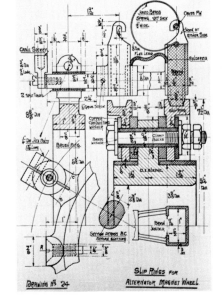

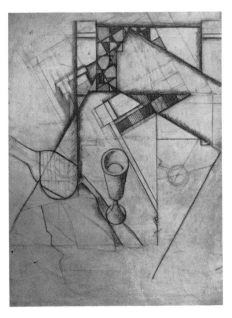

necessary to make clear an awkward shape or relationship. Again details of paintings by Picasso and Braque (fig. 4a) are sometimes constructed on the basis of orthogonal projections of this type, elements taken from two or more projections or sections are generally combined so as to overlap; redundant information, such as a symmetrical profile or the whole of a circle is discarded.

The reduction of the body of a bottle is reminiscent of the late nineteenth-century writer Charles Blanc[7] who described the cylinder as particularly harmonious because it combined the circle with the rectangle. The artist who made most systematic use of such devices was again Juan Gris (fig. 4).

4a. Pablo Picasso
Table, Glasses, Cups, Mandolin, (detail) 1911
$24\frac{1}{2} \times 19\frac{1}{2}$ (62.2×49.5)
Lady Hulten

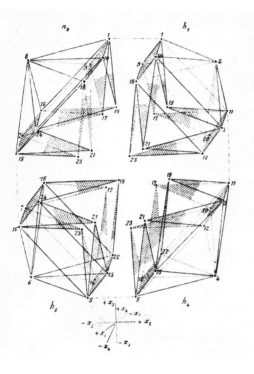

5. E. Jouffret
Sixteen Fundamental Octagons of the Ikosahedroid from *Traité Elémentaire de Géometrie à Quatre Dimensions*, Paris, 1903, fig.41

Dr Henderson has related the shimmering, faceted effect of Cubist paintings to the projections of the same logical type, but of complex figures, drawn by E. Jouffret, author of a treatise on four-dimensional geometry, in order to represent four-dimensional solids (fig. 5). Her argument is convincing, especially in respect of the use of a kind of shading to relate lines which form angles in the same plane, which, to the Cubists, must have recalled the colour passage used by Cézanne for a roughly similar purpose. However, it must be pointed out that Jouffret's presentation of a number of different projections of the same object is only a means to represent a fourth dimension geometrically, just as mechanical drawings represent three-dimensional objects, it is not analogous to the kind of

exploration of objects by means of sensory-motor experience discussed by Poincaré as a means of constructing four or more dimensions. In fact the Cubists did not attempt to project separate viewpoints systematically in order to give complete information about objects in space. The subjective experience of the artist and the problem of presenting it on the canvas remained the dominant inheritance of their art both from Impressionism and from Romanticism. Equally it accorded with their view of the artist's prophetic role in society. In other words, four-dimensional geometry, however often invoked at the time, was not taken seriously by the Cubists as a geometry to be used in constructing pictures in the way that Alberti in the fifteenth century, had taken two- and three-dimensional geometry. On the contrary, it seems to have meant to the Cubists rather a freedom from strict conventions and from a consensus of what was to be deemed objective. It was also an emblem of the artist's special insight into a higher world often a spiritual world.

The reference to the mathematician Riemann by Gleizes and Metzinger, that is to his postulate of a non-Euclidean geometry, was also not pursued as it might have been, for example simply by painting on curved surfaces. Nevertheless one painting at least by Metzinger does suggest an attempt at

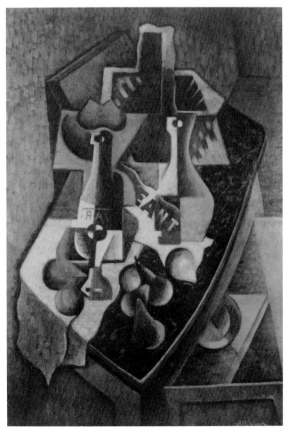

6. Jean Metzinger
Still Life with Pears, 1912–17
$45\frac{3}{4} \times 32 (116 \times 81)$
Winston-Malbin Collection

'curved' space, 'Still Life with Pears 1912–17' (fig. 6). Although no doubt drawn free-hand, the curved sides of what must be considered a rectangular table may be imagined as having been produced by projecting them first on a curved surface and then on a flat one as the geometry of Riemann and other 'non-Euclidean' geometrics had been pictured by the mathematician Beltrami. (Riemann had proposed that parallel lines would meet at two points as an axiom.)

It seems that the possibility of a number of geometries proposed by Lobachevsky, Bolyai, Reimann and Gauss was another allegory, for the Cubists, of the possibility of individual freedom. For these geometries were true, not by virtue of the mind of God, of direct intuition, of nature or of any other 'necessity', but simply by virtue of the lack of internal contradiction. If Euclid, whose axioms and theorems, in spite of some reservations, had survived so long and had been represented as truer than any sensory experience, could be shown by these 'non-Euclidean' geometers simply to have produced one geometry among an infinity that might be deduced from different sets of axioms, then perhaps, an artist's personal 'geometry' had equal value. It is not possible to show unequivocally that non-Euclidean geometry did play this role for the major Cubists, but at least it seems clear that their art was in part an attempt to create alternative constructions of sensations of space to the long established 'Euclidean' space of perspective.

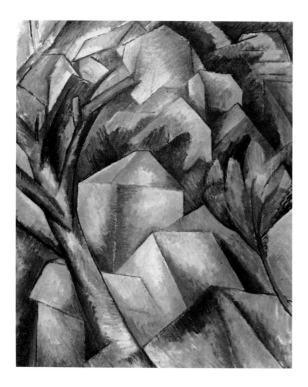

7. Georges Braque
Maisons à l'Estaque, 1908
$28\frac{3}{4} \times 23\frac{1}{2} (73 \times 59.5)$
Rupf Stiftung, Kunstmuseum, Berne

8. M. de Zayas
 Vollard, from *Soireés de Paris*,
 July–August, 1914

That geometry was the chosen field for this experiment is confirmed not only by the contemporary references to geometry in general and to the n-dimensional geometry (that is geometry based on an arbitrary or indefinite number of dimensions) cited by Dr Henderson, but by the fact that Cubist works of 1909–10 comprise many simple 'geometric' objects more or less conventionally represented (fig. 7). Soon after, in 1910–11, Cubist pictures were made up largely of intersecting straight lines and arcs, the very stuff of schoolboy geometry as practised by means of ruler and compass. The lines are not outlines or in any direct way descriptive, they appear to be willed by the artist and so consort with the frequently expressed view that geometry does not exist in the world but only in the mind or as a practice.

Numbers or algebraic expressions occur also in the art of the period (fig. 8). These algebraic expressions, such as the one illustrated by Marius de Zayas, for example do not seem to have any specific meaning, even though they include the roots of negative numbers, then recently given a new graphic meaning. I think they must be simply regarded as non-specific symbols of a very different type of 'language' to that used by artists, one that was eminently non-descriptive.

One further mathematical concept that was certainly familiar to

9. David Bomberg
Study for 'In the Hold',
1913–14
Drawing $21\frac{7}{8} \times 26(55.5 \times 66$
Tate Gallery, London

Cubists, although not deployed consistently, was that of proportion. It was well known that the Greeks had employed canons of proportion in their sculpture and the writings of Renaissance artists such as Alberti, Leonardo and Dürer and others were available. In the nineteenth century, Egyptian carvings and paintings were shown to have been based on systems of proportion expressed as grids. Some of them were illustrated in Charles Blanc's universally read *Grammaire des Arts du Dessin* already referred to. Artists were also familiar with the use of grids to square-up drawings in order to enlarge a design to fit the canvas size. Parts of a squaring up grid can be seen in Seuret's unfinished 'La Cirque' of 1890, exhibited in 1905.

In a painting by Matisse, 'La Jeune Femme à l'Ombrelle' of 1905, such a grid is left visible, deliberately or not, so as to form part of the image. Some of Sickert's Venice paintings of *c.* 1901 have the same feature but he wrote at the time that he wanted to paint it out.[8] In 1913–14 he was advocating its use as a means of regulating the composition. His followers Gore and Gilman in 1913 allowed it to appear as a feature of certain paintings. At the end of 1913 or early 1914, Bomberg made a much more dramatic use of the convention of squaring up in 'Ju-Jitsu' and 'In the Hold' (figs. 9 and 10). The height and the width of the canvas are each divided in two, in two again and yet again so that it becomes an oblong chequer board of eight sections each way. The diagonals are drawn in a way that was tradition-

10. David Bomberg
In the Hold, 1913–14
78 × 101 (198 × 256.5)
Tate Gallery, London

ally used to check the accuracy of the squaring and to supply extra lines. Then Bomberg superimposes this whole diagram on a group of figures which have already been reduced to rectilinear shapes and then simply interchanged the colours at each intersection. This apparently *naif*, rule-of-thumb device produces a picture of great energy and vitality. It closely resembles passages of several pictures painted by Juan Gris in the south of France between October 1913 and February 1914 but seems to have been worked out, or at least conceived, in England (pl. 6, p. 33) almost simultaneously. Before leaving Bomberg, it is interesting to see that he produced more or less simultaneously, a curvilinear and a rectilinear abstraction, both loosely geometric. The same is true of Kupka and can be traced back to a polarity of Art Nouveau as Werner Hoffman has pointed out[9] (fig. 11). This tradition can be considered as forming an art-derived alternative or, rather, supplementary prehistory to the 'rule and compass' geometry-derived aspect of Cubism and later abstract art. Gleizes and Metzinger, like Charles Blanc, argued that a painting should have both curves and straight lines while Mondrian demonstrated it in his drawings and paintings of 1912–13.

Returning now to Cubism and to Gris, we have already said that Gris was the artist who most directly employed the devices of mechanical drawing. He was certainly the most mathematically minded of the leading

The Oval
Method

The Rectan-
gular
Method

11. Walter Crane, from *Line and Form*, 1900, p.11

Cubists and a mere glance at his pictures and drawings of 1912–13 is sufficient to reveal that they are built up largely of loose grids and angles. William Camfield has written an article demonstrating (with an admitted degree of uncertainty) that Gris used the Golden Section in constructing the partial grid that dominates certain of his compositions.[10] The Golden Section is the division of a line AB by a point C such that the proportion of AC to AB is the same as that of CB to AC. That is, in numbers, 1:1.618 = .618:1. This ratio can be constructed with compass and set square; the rectangle whose sides are in the same proportion can be constructed with the same tools.

An artist can then make a triangular set square by cutting the diagonal of a Golden Section rectangle and this in turn will produce rectangles of the same proportion wherever the diagonal intersects lines at right angles. This is of course a familiar Euclidean concept. Moreover, constructing the rectangle geometrically, the artist will have drawn a right triangle with the proportions 2:1. In addition any artist interested in such things would have had the two commercially produced set-square triangles 45°, 45°, 90°, (1:1) and 30°, 60°, 90°, (1:√3) that any schoolboy or craftsman had. The easiest right triangle to make is the one with the proportions 3:4:5.

2. Juan Gris
The Watch (Sherry Bottle).
1912
$25\frac{5}{8} \times 36\frac{1}{4} (65 \times 92)$
Thompson Collection

Such a picture as Juan Gris' 'The Watch (Sherry Bottle)' 1912 (fig. 12) can be shown to have been at least partly constructed by using such triangles. A vertical line EF is drawn so that EBCF is a square whose sides equal the height of the canvas. A similar square drawn from the left is less conspicuous AGHD. A Golden Section set square is used to draw the diagonal AI and, where this cuts EF at J, a horizontal line is drawn to K. The resulting rectangle EBKJ is bisected by the line LM which is the shelf on which the bowl stands. This line is continued to cut AI at N where a perpendicular is drawn NO. This must also produce two Golden Section triangles AON and EOP. A symmetrical Golden Section triangle produces the decorated edge MQ. Another right-angled triangle with sides in the proportion 1:2 seems to have been used to draw the line MR and the group of lines at right angles to it such as RS. A third triangle introduces a new rotational shift UTC. This has sides in the proportion $1:\sqrt{2}$. There are several lines parallel to or at right angles to this so that further triangles in the same proportion are generated. One of these is the triangle IVW. In a similar way the parallels x and y may have been drawn with the same set square as AI. Many lines are hidden or distorted by Gris in the process of painting no doubt because he wanted his picture to feel right and not to appear to be a mechanical exercise.

It may well be objected that it is difficult to be certain that the triangles and rectangles described are those intended by the artist. Perhaps Gris simply drew lines that pleased him. Moreover the proportions of triangles (rectangles) that I have suggested Gris might have used are quite similar.

Between or close to them are several others based on the familiar Fibonacci series (1:2:3:5:8 etc.), and on the main musical intervals (1:2:3:4 etc.) and roots of integers) $\sqrt{2}$ $\sqrt{3}$ $\sqrt{4}$ etc). All the same the analysis by angles does seem to reveal a process by which he may have built up the composition. Moreover the same angles appear again and again in paintings and drawings between 1911 and 1916. The measurement of dimensions is less sure because of the irregularity and thickness of lines.

13. Plate from D. A. Low and A. W. Bevis, *A Manual of Machine Drawing and Design*, 1902, p.6 This illustrates the way of making parallels at an angle to a base line

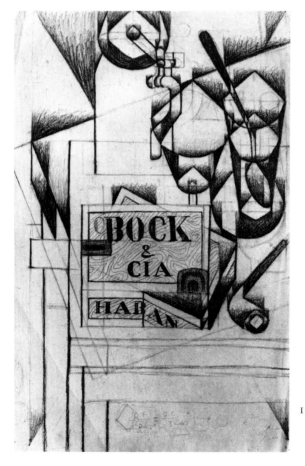

14. Juan Gris, drawing from photograph in the Kahnweiler Archive, 5896 Gallery Louise Leiris, Paris

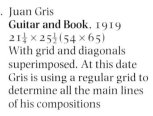

. Juan Gris
Guitar and Book, 1919
$21\frac{1}{4} \times 25\frac{1}{2}$ (54×65)
With grid and diagonals
superimposed. At this date
Gris is using a regular grid to
determine all the main lines
of his compositions

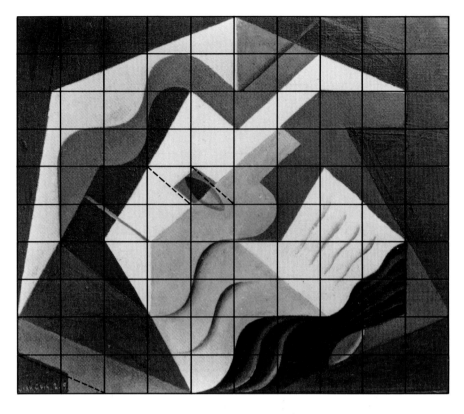

In some of his other pictures, at least the first steps in dividing up the picture surface seem very clear. In 'Le Banjo' at the Museum of Modern Art in New York, for example, the picture is first bisected vertically and horizontally. The rising angles at the bottom, to the right seem to have been drawn with a Golden Section set square; those to the left with a 30° set square. Such parallel lines are most easily drawn using a T-square and set squares of various sorts (fig. 13). It is likely that he used one to make the intersecting lines of the chess boards in pl. 6 which are placed at 30° to one another. This picture is dominated by the concept of rotating grids in relation to one another, a feature which recurs in Gris' art during the period 1914–16.

Another proportion that seems to have interested Gris is the ratio between the area of a circle and the area of square inscribed. In many paintings circular objects like buttons are drawn as a half circle with, beneath, a half inscribed square. A drawing in the Kahnweiler archive (No.5896) sketches the relationship and gives the ratio 1:1.570 or $\frac{\pi}{2}$ (fig. 14).

Studying the pictures and drawings our impression is that Gris built up his main lines by simple divisions and by set squares in a sequence determined by his own judgement and then extemporised the detail. He

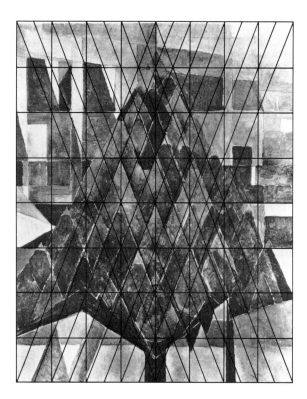

does not seem to have used regular grids, articulating the whole surface. Certainly they do not appear in the drawings about this date (fig. 15).

On the other hand some pictures by other artists appeared in the teens which did make use of regular grids, not as an independent feature of the imagery as Bomberg had done, but as a means of organising the objects within the canvas. A series of works by Van Doesburg apparently painted at the beginning of 1916,[11] were based on grids of 4, 8 or 16 subdivisions vertically and horizontally, together with diagonals. The simplest case is that of his 'Triangular Composition' (fig. 16 and 16a). Later, Van Doesburg was to simplify his method still further confining his divisions almost entirely to those suggested by an underlying grid of 4 or 8 sections (fig. 17). Although he did not (as far as we know) describe this elementary technique in his copious published writings, its meaning for him may be deduced from the fact that one picture which seems to combine at least two different systems for each axis is entitled 'Composition in Dissonances' (1918).

Although Van Doesburg and Mondrian disagreed explicitly on other matters their divergence on the use of grids does not seem to have been one of them. Mondrian did paint a few pictures in which he selected the main lines from those of a regular 8 × 8 grid with diagonals which are left revealed (illustrated on p. 151). These are mainly diamond shaped and in

16. *Above left*
Theo Van Doesburg
Triangular Composition,
1916
26 × 22 (66 × 55.8)
Portland Art Museum,
Gift of Mr Jan de Graaf
Grid with diagonals
superimposed

16a. *Above right*
F. Andri
Poster for *26th Secession*,
Vienna, 1906
$37\frac{3}{8} \times 24\frac{3}{4}$ (95 × 63)
This may be the motif from
which Van Doesburg drew
for 'Triangular Composition'.
It is easy to see that in spite
of its grid traces, Van
Doesburg's painting
illustrates the artist's
irregularity in comparison
with the designer's regularity.
Van Doesburg wrote about
this matter in *De Stijl* 11
no.4, 1919, pp.42–4

the first two of these the composition is marked solely by thickening some of the lines. However, a drawing for 'Composition Picture I' (1921) reveals him pencilling-in a freehand grid which divides the short side into sixteen (fig. 18). He seems to have used the same intervals to make a grid of twenty-five parts in the vertical dimension but then avoided almost every line of it in his composition. Numerous later drawings by Mondrian show that he adjusted his lines by trial and error without any *a priori* determinants except the fundamental one that they are at right angles to one another. In Mondrian's case the right angle had hardly any mathematical meaning. He regarded vertical and horizontal as symbolic opposites rather than as complementary dimensions and his traditional works remind one rather of the tradition referred to above as exemplified by Crane (fig. 11 and footnote 9), than of mathematical co-ordinates. Although his pictures look 'geometric' in fact they seem rather to be a reduction of the concept of painting itself to terms that are consistent with it and are binary or triadic like so many linguistic devices: vertical and horizontal (the parallels to the sides of the picture); red, yellow and blue (the artist's not the scientist's primaries); black, grey and white, later black and white (the artist's chiaroscuro).

Below left
Theo Van Doesburg
Composition, 1919
$36\frac{1}{4} \times 28 (92 \times 71)$
The grid underlying it superimposed
Note that Van Doesburg is careful to avoid all but one of the more obvious horizontal divisions, the $\frac{1}{2}$, $\frac{1}{4}$ and $\frac{1}{8}$ choosing the $\frac{1}{16}$s

Below right
Piet Mondrian
Drawing for Painting I, 1921
$22 \times 24\frac{1}{2} (55.8 \times 61.5)$

19. Giacomo Balla
Iridescent Interpenetration
$39\frac{1}{8} \times 23 (99.3 \times 58.5)$
Winston Malbin Collection

Before leaving these grids we should point out the similarity of those of Van Doesburg to some used by Hans and Sophie Arp (illustrated on p. 103). In each case lines are selected from a regular grid to form a number of rectangles of varying proportions. Loose grid constructions were also used by Delaunay, Marc, Itten, Klee, Kandinsky and many others. On the other hand, Balla in his 'Irridescent Penetrations' used every element of his complex geometric schemata (fig. 19) so that one is uncertain whether they are to be regarded as art or decoration. When a pattern is so complete the situation is similar to that in information theory: when a signal is perfectly predictable no information is communicated. On the other hand the effect of the colour and of the eye's response to it is dramatic and certainly not 'geometric'. The visual inspiration for some of the art of this date may well have derived more from the traditional texts, on the decorative arts in which some of these artists worked, with their traditional

'Euclidean' patterns, than from texts on higher mathematics (in which some of them were interested). Standard texts and manuals on the decorative arts, which were traditionally non-representational, stress the systematic inflection of a limited number of simple geometric forms as the basis of all good design, and it was natural that they should appeal to artists seeking a logical and clear style of art. Eugene Grasset, for example, had said that abstract ornament 'is only based on the geometric combination of a small number of simple elements',[12] and Von Bezold had said that 'all ornaments . . . owe their origin to the same simple elements' and that in uniform designs 'the combinations of equivalent elements are quite limited in number and embrace only the simplest patterns . . . Bands of equal width, triangles, quadrangles and hexagons of equal size are the only geometrical figures of which such patterns can exist.'[13] But generally an all-important difference separates the new styles of art from the traditional decorative arts. Although similar forms appear in both fine and decorative art, a work of fine art was not considered complete in the traditional sense unless this geometry was modified or elaborated until it was at least partly personalised. It was left to the abstract artists of the 1950s and 1960s to make paintings and sculpture in which the geometry and logic were so clear that they totally determined the work and could be unmistakably discerned by the viewer.

Van Doesburg too was interested in the fourth dimension. His earliest formulation was:

> 'However as Man, as the appearance of the utmost internality of spirit does not possess any point in the front, at the side or the back, no fixed point at all towards which he could define a dimension. This explains why, in expressing the spiritual, in making spirit an artefact he will be forced into a moto-stereometric form of expression. This moto-stereometric form of expression represents the appearance of a four-dimensional world in a world of three dimensions.'[14]

It is interesting to relate this idea to Charles Blanc's view, that it was painting's two-dimensional quality that made it appropriate to the expression of the spirit, while three-dimensional representation, sculpture, was appropriate to the expression of the body.[15]

Later, Van Doesburg argued that colour could render visible a fourth dimension. Except in this legitimate, but non-mathematical, sense it does not seem to have affected his painting although the diagonally inter-penetrating spaces of the architecture of his De Stijl associates were certainly affected by his space-time notions (illustrated again by the hypercube) derived apparently from Hinton.[16] However a 'space-time' drawing of a human figure in his book *Principles of Neo-plastic Art* is simply a Cubist pastiche.

In 1915, at an exhibition in Petrograd entitled *Last Futurist Exhibition of Pictures 0.10*, Malevich exhibited thirty-nine paintings which comprised

simple combinations of two-dimensional geometric forms, including his famous 'Black Square' (illustrated on p. 147). While the black square, the cross and the elements of a few other early suprematist works were fixed like icons in the centre of the canvas, in general Malevich's simple geometric elements were placed on diagonal axes so as to appear to be moving beyond the limits of the canvas (illustrated on p. 149). The first version of his Suprematist manifesto, written about the time the pictures were being painted, suggests principally that he wanted to achieve the dynamism of the Italian Futurists but to relate it solely to the specific means of the artist, that is colour masses, and not to the appearance of objects in the outside world. His 'geometry' then may be seen as a means of eliminating naturalism so that painting could talk its own 'language'.[17]

However, Suprematist 'geometry', like that of Cubism, was associated yet again with the theories of a four-dimensional world. Five of the thirty-nine works that Malevich exhibited at 0.10 have subtitles in which the term 'fourth dimension' appears: for example, 'Lady-Colour masses of the fourth and second dimension' and 'Painterly realism of a football player – Colour masses of the fourth dimension'. Malevich's conception of the fourth dimension is not clearly articulated in his numerous writings and does not seem to have had a logical mathematical basis. It seems rather to have been influenced by the teaching of his countryman P. D. Uspensky, a mystical philosopher-cum-mathematician whose theories were in turn indebted to those of Hinton an English writer, one of the most systematic writers on the geometry of four dimensions with mystical overtones. Just as certain Cubist pictures do, some of Malevich's resemble illustrations from text books of the fourth dimension. For example, Hinton 'tesseract' seems to provide the skeleton for a backdrop for the production of the opera *Victory over the Sun*.[18]

As a means of demonstrating the perception of a higher dimension, Uspensky gives an example (similar to that of Hinton and of Claude Bragdon, an American theosophical theorist of the fourth dimension) of a two-dimensional being perceiving a three-dimensional figure. If a cube were to pass through a plane at various angles, it would be perceived as various changing two-dimensional shapes. In Bragdon's 'Man the Square'[19] there are indeed illustrations of the shapes that result from a cube passing through a plane at various angles and moments (fig. 20) that resemble some of Malevich's Suprematist works (illustrated on p. 149). However, the resemblance might well be a coincidence.

In fact, those pictures that suggest movement are simply those in which the elements are tilted. Movement through the plane in the sense required by Bragdon cannot have been his intention both because the paint quality of the picture is emphasised and because elements are superimposed. That is, if he saw and was interested in these diagrams, he did not take them in the sense intended by Bragdon. He wrote at the time[20]: 'In naming some of

20. Plate from C. Bragdon,
A Primer of Higher Space, 1913

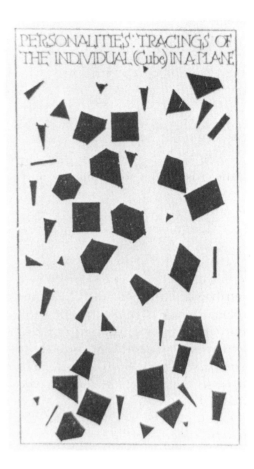

these paintings I do not wish to point out what form to seek in them but, I wish to indicate that real forms were approached in many cases as the ground for formless painterly masses from which a painterly picture was created, quite unrelated to nature.' It is interesting that here the word 'formless' must mean geometric – a very exceptional usage.

In a recent article, Rainer Crone,[21] whilst devaluing the relationship of Malevich's thinking to that of Uspensky, relates it to the numerological and linguistic theories of his poet friend Khlebnikov and to the ideas of Einstein and Minkowsky as popularised by a contemporary, A. Vasilyev. He suggests, with some plausibility, that the title of a lithograph (fig. 21) 'Simultaneous Death of a man in an Aeroplane and on the Railroad' refers to Einstein's theory that what is simultaneous to two viewers travelling at the same speed and in the same direction is not simultaneous to viewers travelling at different speeds or in different directions. If this is indeed the case, then Malevich is once again demonstrating either that such a theory can not be presented in a work of pictorial art of that he had not understood

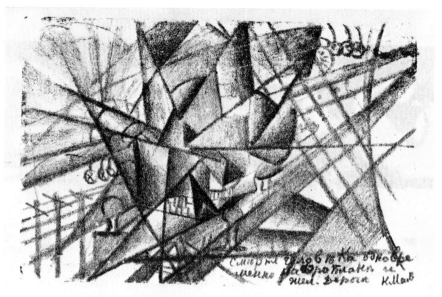

21. Kazimir Malevich
Simultaneous Death of a Man in an Aeroplane and on the Railroad from A. Kruchenykh *Explodity*, 1913

the theory, because the effect of the relative velocities concerned would have been so small as to be imperceptible and, moreover, from the point of view of the witness of both (the artist or the person looking at the lithograph) no contradiction of simultaneity arises. Malevich's nearly contemporary reference to the movement of objects existing objectively for everyone seems in any case to deny relativity.

But for Uspensky, the fourth dimension was loaded with mysticism and idealism. His view of the fourth dimension agrees remarkably well with that of one of its first proponents, Henry More who, in his 'Enchiridion Metaphysicon' 1667 had proposed it as the realm that the Platonic ideal could occupy.[22]

Uspensky's four-dimensional world was a metaphor for a perfect realm in which the 'enigmas of the world' are solved. Realisation of a four-dimensional, *true* reality was the answer to all of life's evils. The three-dimensional world was presented as merely a product of man's limited 'psychic apparatus'; if he could find his 'cosmic consciousness' man could perceive this true, four-dimensional reality. He 'will sense a precipice, an abyss everywhere . . . and experience indeed an incredible horror, fear and sadness, until his fear and sadness shall transform themselves into the joy of sensing a new reality.'[23]

In the same way that of Malevich is expressed as a mystical, idealistic realm, identified with a spiritual as well as a physical state. And in this context the simple forms of suprematism signify in a general way a higher state of consciousness towards which man must aspire; a state in which he is united not with the earth but with the entire cosmos. Malevich's geometry is then an allegory of man's striving to become psychically one

with the universe, to become, in the artist's words, 'a mist in the whirlwind of the entire cosmic vortex'.[24]

But he wrote: 'Space is a receptacle without dimension into which reason deposits its creation.' Then later, in 1919, Malevich wrote that the principle of economy (that is, of concepts) should govern art and is the fifth dimension.[25] This seems to be a clear reference to the views of Mach and Avenarius, philosophers of science in the nineteenth century. They had been particularly important in forming the ideas of Lunacharsky who was the commissar who gave an opportunity to Malevich and other 'abstract' artists in the period immediately after the political revolution of October 1917. It seems as if 'economy' in Mach's sense, which is in terms of perception what Occam's razor is in terms of ontology (that is that entities should not be multiplied unnecessarily), may have meant to Malevich simple shapes. However in his introduction to a volume of thirty-four Suprematist drawings[26] Malevich assigns the white square to pure movement, the black to economy and the red to revolution. So it must be said that he was always ready to attach new meanings to existing works.

In fact Malevich's writings seem to be contradictory in respect of the sense in which his painting could be said to have meaning at all. On the one hand he said that 'colour and *faktura* are ends in themselves they are the essence of painting, but this essence has always been destroyed by the subject',[27] and 'all art has freed its face from foreign elements'[28] implying that it did not have meaning or reference outside itself. But he also said 'colour is a means of creating form and structure is not composition for composition's sake; it is something different – a language composed of special words. It is something with the help of which one can talk about the universe or about the state of our inner animation, something one cannot express by means of words, sound.'[29] It must be deduced that the words of this language were the same simple colours, shapes and lines and the grammar, the arrangement of them on the picture surface but in order to 'talk' they must have had in some sense a subject. A similarly ambiguous position was taken by Khlebnikoff in relation to sounds. The implication was that such elements had a pan-human primordial meaning.

If Malevich and Mondrian had for virtually religious reasons stripped painting to basic 'geometry', some of their younger contemporaries and immediate followers exploited that geometry for different purposes, allotting it a social rather than a spiritual significance, no doubt this was largely the result of the war and revolution that had wracked Europe and Russia. In the West, Dadaism had proclaimed the death of traditional art, associating it with the values that had resulted in the horrors of world war. But the obverse of Dada, nihilism, was the ambition to project a more perfect future, to place hope in man's power to create a new and orderly world. Artists across Europe and Russia felt it was their task to help forge a new world which was to be marked by a unity and order utterly opposed to

the fragmentation and chaos into which civilisation had fallen. The configurations which had been endowed with spiritual power could be redeployed to represent human aspirations to an ordered society. Socially conscious artists formulated a parallel between the condition of civilisation and of art. In the *Realistic Manifesto* (1920) the Russians Gabo and Pevsner declared that 'The distracted world of the Cubists, broken in shreds by their logical anarchy cannot satisfy us who have already accomplished the revolution or who are already building up anew.'[30] In France, Ozenfant and Jeanneret call Cubism 'that troubled art of a troubled epoch'.[31]

As it had been for the Cubists, geometry was to be an expression of a man-made rather than a natural order. But these artists rejected the ambiguity of 'logical anarchy' of the older artists in favour of an ordered and rational art expressive of a dawning era in civilisation. Geometry was exploited as the expression of man's power to impose order on the world, to use his intellect to dominate and control nature, rather than to submit to or to repudiate her.

This did not mean however, that the interest in non-Euclidean geometries ceased immediately. Lissitsky, who worked under Malevich for three years, named an essay 'A and Pangeometry'. A stands for 'Art' and Pangeometry refers to Lobachevsky's book of that name in which he challenged Euclid. Lissitsky was a little more specific, writing that the Euclidean conception of fixed space was destroyed by Lobachevsky, Gauss and Riemann, three of the creators of axiomatic geometries. However, when he said, echoing Malevich, that 'Suprematism had advanced the tip of the visual pyramid into infinity. It has broken through the blue lampshade of the firmament',[32] he seems to have misunderstood the perspective of the fifteenth century which had located the point at which parallel lines converge precisely at infinity, no matter what the distance between the eye and the picture plane. His own habit, which this remark is obviously intended to support, was to use axonometric projections in which parallel sides do not converge and which, when drawn as open structures, appear to project or to recede indifferently or alternatively. Lobachevsky had proposed as an axiom that an infinity of lines could be drawn through a point parallel to a line which they would not meet even 'at infinity' and this, of course, was beyond Lissitsky's powers to represent directly on a sheet of paper as he recognised in the same essay.

This text finally makes it clear that the value of the notion of axiomatic geometry (as established by Lobachevsky, Gauss, Bolyai, Rieman, etc.) was precisely that it contested the claim to unique truth put forward for Euclid's geometry. Although Lissitsky himself used the traditional forms, right angles, triangles and circles, it is evident that he regarded them, like variations in tone, colour, texture, composition, rotation, etc., as part of a set of devices specific to working on a two-dimensional surface. He combined them with more sophisticated curves, ellipses, parabolas and

hyperbolas which, although two dimensional, may symbolise the various types of space, Riemanian, Lobachevskian and Euclidean. Other artists looked to history as a witness to the power of traditional geometry to forge order into the world. In France, the founders of Purism reached as far back as Plato to affirm the superiority and eternal validity of the geometric forms which are made by man rather than by nature. In the journal *L'Elan*, for example, Ozenfant published part of Plato's 'Philebus' in which Socrates elucidates the distinction between forms which are attractive because of their sensual beauty and those which are beautiful and eternal because they are created by the mind. Le Corbusier based both paintings and architecture on subtle grids 'tracées regulateurs' (fig. 22). The Polish artist Cobro and the Hungarian Beothy made sculptures by the strict application of proportional systems derived from the Golden Section and Fibonacci series. The painters Severini and Matila Ghyka wrote treatises on the subject.

. Le Corbusier
Design of Facade with 'tracés regulateurs' from *l'Esprit Nouveau* 5, 1921, p.572

It was believed that the effect of great art had always been due to its underlying geometry and that the naturalistic figures and objects which have obscured that geometry were merely superfluous elements, concealing the inherent order of the work and thus detracting from its true impact. The Belgian artist Georges Vantongerloo said that much of his abstract work actually derived from the geometric analysis of Old Master paintings, in which he penetrated beneath superficial appearances to reach the underlying geometric structure. Similar analysis was undertaken by Hoelzel and was a required part of Johannes Itten's Basic Course at the Bauhaus in Weimaer. Religious sentiment is evoked in the beholder not by the dead Christ or by the weeping Virgin, but by the specific angle created by their adjacent bodies. It was the man-made, abstract structure of a composition, rather than the naturalistic representation, that was significant and this in turn was held to have been the universal language of art.

Thus traditional geometry was thought to transcend specific reference to become a means of universal expression, surpassing local linguistic and cultural barriers, a universally accessible art to express the characteristics of the new age. The first De Stijl manifesto, written in 1918, made the link

between universality and a new era in civilisation explicit: 'There is a consciousness which belongs to the old days and another which belongs to today. The old one is aligned with the individual. The new one is aligned with the universal.'[33] The new era was to be marked by collaboration rather than individualism, by clarity rather than ambiguity, and by order rather than chaos. And these qualities are all embodied in simple geometry.

A photographic self-portrait by El Lissitzky (fig. 23) demonstrates that by 1924 at the latest the identification of artist with geometer had become almost complete. Lissitzsky's head faces the observer. A piece of graph paper is superimposed over the composition and over this his right hand covers that side of his face, a juxtaposition which emphasises the cerebral nature of the new art. Between his fourth and fifth fingers, Lissitzsky holds an open compass with which he has traced a circle on the graph paper. Next to the paper is a configuration of simple, flat, geometric forms. The side of the picture with the tools and images of mathematics is bathed in light, the traditional symbol of rational thought. The right side is dark and somewhat mysterious; even the graph paper, the only sign of mathematics on this side, fades into an indistinguishable blur. Lissitzsky thus represents the symbolic dark and light sides of human nature. He identifies mathematics with the rational, conscious side and, as this is a self-portrait, with the tools of the artist. Lissitzsky's substitution of the compass and grid for the traditional paint brush and canvas is an allegory of the substitution of the precise, impersonal construction of form in the new art for the nuanced, personal brush-stroke of all earlier art. Unlike Gleizes and Metzinger the new artist measures in order to ensure complete objectivity and to avoid any evidence of his individual personality. Indeed the art of the new, universal era is anonymous.

Perhaps the most extreme example of the anonymity of geometric forms is Moholy-Nagy's 'telephone paintings' of 1922. The artist described the creation of these simple geometric configurations thus: '. . . I had the factory's colour chart before me and I sketched my paintings on graph paper. At the other end of the telephone the factory supervisor had the same kind of paper divided into squares. He took down the dictated shape in the correct position.'[34] The geometric forms of the new art, then, impersonal, precise and extremely simple, can be produced by anyone. Furthermore, because they are discrete, the structures of the picture are additive rather than organic, and these forms can be produced and reproduced *ad infinitum*. Accordingly, the elements of the artistic vocabulary became analogous to the mass-produced objects of the machine age. The era in which abstract painting was born was also that of the tremendous proliferation of the modern machine, which was exalted by some artists as the embodiment of all that was good about the new age. Mass-production forfeits the uniqueness so valued in the old, individualis-

El Lissitsky
Self Portrait: The Constructor.
photomontage, 1924

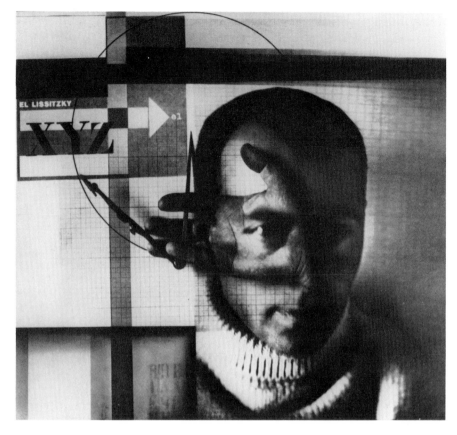

tic way of life for the unity and order that makes the new. And as such the forms of the machine-made object became identified with the forms appropriate to the new art. Theo van Doesburg said 'The new possibilities of the machine have created an aesthetic expressive of our time . . .'[34] And the Dutch architect J. J. P. Oud enumerated several products of modern production and said that they '. . . possess within themselves, as the purest expression of their time, the elements of a new language of aesthetic form and can be considered as the point of departure for a new art, through their restrained form, lack of ornament and plain colours, the comparative perfection of their materials and the purity of their proportions – largely due to their new, mechanical methods of production'.[35] Servrancx based paintings on simplified machine shapes. Thus the forms of simple, traditional geometry, which by a happy coincidence happened to be the forms of contemporary machine-produced objects, were taken to by the forms *inevitable* to machine-production. And as such they reinforced the belief in geometry as the means by which man imposes order on his environment. However there is something academic about all this art which is contemporary with the neo-classicism of the older Cubists. Mathematics had become again a symbol of order rather than freedom.

The abstract interior

Jane Beckett

It is as difficult to paint a room as to make a painting. It is not enough to set a red, a yellow, a blue, a grey, etc. next to each other. That would be merely decoration . . . It is all in the how:

(Piet Mondrian. *Natural Reality and Abstract Reality*. Scene VII: Z's studio. *De Stijl*, 1920.)

An important aspect of the development of abstract art in the first two decades of the twentieth century was the realisation of the abstract implications of the applied arts; pursuit of the 'decorative' and the 'ornamental' contributed to the growth of a language of pure form. The complex and intricate currents within this development emerged from the nineteenth-century debate on the nature and appropriateness of decoration, which led both to conventionalised forms of abstraction from nature, and also to arguments for the rejection of all ornament. The most extreme position was taken by Adolf Loos in his essay *Ornament und Verbrechen* (Ornament and Crime) of 1908.

A second, concomitant debate on the issues raised by handcraft and machine production developed into the 'design for industry' aesthetic. The foundation of the *Wiener Werkstätte* in 1903, under the inspiration of the aesthetic ideas of the English Arts and Crafts Movement, particularly C. R. Ashbee's Guild of Handicraft, was closely followed in 1904 by the Dutch *Vereniging-voor-Ambachts-en-Nijverheidskunst*, while the *Deutsche Werkbund*, founded in 1907,[1] and the English Design and Industries Association, founded as late as May 1915, reflect the move from a handcraft to an industrial aesthetic. The DIA's concern for 'appropriateness, technical perfection and honest workmanship' linked with the desire to create a public demand for what is 'best and soundest in design',[2] exemplifies the aims of these associations and indicates the social and economic factors that contributed to the design debate. Moreover the concern of these associations with the means of education of artists and designers, again reflects one of the major issues of nineteenth-century discussion, which culminated in the foundation of The Free State Art Studios and *Vkhutemas* after the revolution of 1917 in Russia, and the of *Das Bauhaus* in Weimar.

On the other hand, the 'abstract interior', the main theme of this essay, developed from an alliance between the applied arts, painting and architecture, rather than from the social and economic considerations in the development of design for industry. In the third volume of *Das Englische Haus* (published by Wasmuth in 1905), Herman Muthesius formulated the

Charles R. Mackintosh and
Margaret Macdonald
Music Room,
House for an Art Lover
(Haus eines Kunstfreundes).
Drawing from Meister der
Innen Kunst portfolio
C. R. Mackintosh, *Haus eines
Kunstfreundes*, Darmstadt,
1902
Glasgow School of Art

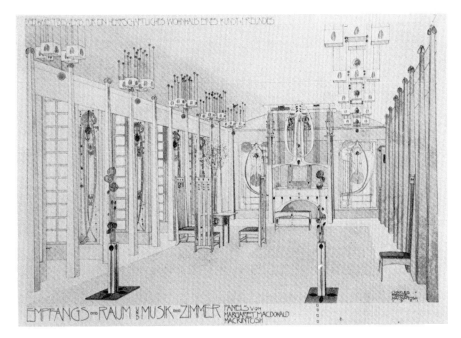

Charles R. Mackintosh
Ground floor plan,
House for an Art Lover, 1901

idea of the interior as 'a whole, the essence of which lies in fact, in its
totality, in its quality as space. In conceiving the interior as a work of art,
therefore, the artist must first think of it as space, that is, as the overall form
and interrelationship of space enclosing surfaces.'[3] This concept owes a
great deal to the 'Aesthetic Interior' of the 1860s and to Whistler's
provision of a *mise-en-scène* for his paintings. Muthesius pinpoints the

origins of the idea in The Red House, Bexley, designed by Philip Webb and William Morris, and it was principally in the Victorian notion of the artist's house in which walls, furniture, objects and paintings conform to the same aesthetic that the concept originates.[4] Muthesius' comment that 'the new arts and crafts had sprung from painting: Rossetti's school was its foster mother; its adherents aesthetes in general, not architects'[5] reflects the character of the movement.

By the end of the nineteenth century, collaboration between architect and artist or artist *as* designer was established and focused specifically on the theme of the artist's or art-lover's house. The house that C. F. A. Voysey built for J. W. Forster at Bedford Park, Josef Hoffmann's studio houses in Vienna (1901–2) and cultural communities, such as the Darmstadt *Kunstlerkolonie*, (1899–1901), became models for development. The concept was embodied in the competition, held in 1900 by *Zeitschrift für Innendekoration*, for a 'House for An Art-Lover'. In particular, M. H. Baillie Scott and Charles Rennie Mackintosh designed interiors in which works of art and environment were spatially co-aesthetic. Both schemes gave particular prominence to the Music Room, clearly the room in which the fusion of the arts was exemplified. When Mackintosh designed a music room for the Viennese art patron Fritz Wärndorfer, he used white walls, sparingly articulated with modulated colour to achieve an exposition of the architectural spaces. The furnishings were white. White also predominated in Mackintosh's Mains Street flat, praised by Muthesius, and he introduced a 'White Room' into Miss Cranston's Ingram Street Tea Rooms in Glasgow, at the same date (1900–1).

Peter Vergo has demonstrated the profound effect that Mackintosh's interiors had in Vienna, particularly on the design of the *XIVth Sezession* exhibition in 1902.[6] This was devoted to the presentation of a single work: Max Klinger's polychrome sculpture of Beethoven. The temporary exhibition building was designed by Josef Hoffmann. Klinger's sculpture was axially sited, surrounded by murals (of which only those by Klimt survive), and oil paintings. The rectilinear stucco reliefs by Hoffmann orchestrate the interior space, but, unlike the friezes of Klimt, reject the curvilinear elements of Mackintosh's style.

Many of the same themes are linked in Hoffmann's house in Brussels for Adolphe and Suzanne Stoclet (1906–11).[7] Both exterior and interior were conceived as a totality and depend upon a formal vocabulary of elementary and geometric forms. Hoffmann took great care with the precise siting of the Stoclet's collection of Oriental and European works of art. Like Mackintosh's 'House for An Art-Lover', it has a music room, here sunken and marble-clad, and also a white room. The uniqueness of the commission was fully exploited in the careful design of wallpapers, carpets, furniture, silver-ware, indeed, in all the decorative effects. Klimt's mosaic frieze in the dining room partially disrupts the geometric vocabulary of the

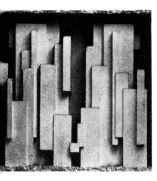

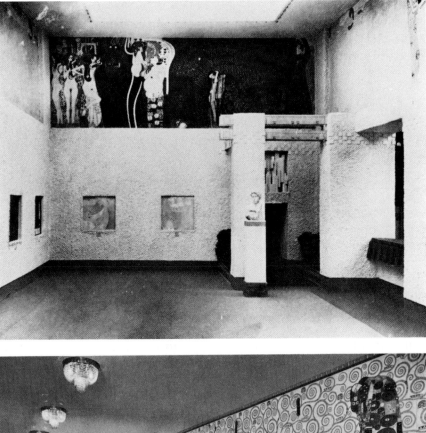

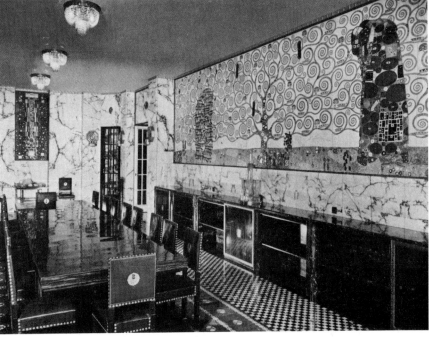

furniture, by drawing upon Byzantine, Japanese and even Mycenaean ornament. The friezes on the two long walls of the room depict the Tree of Life and are divided into seven identical sections with the exception of two

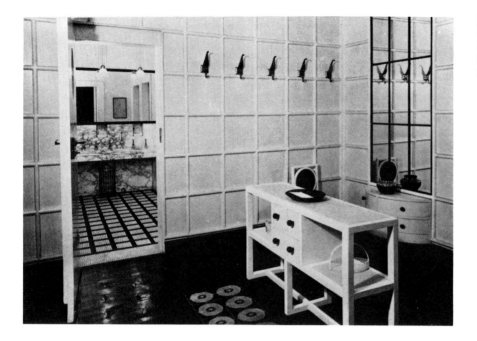

Josef Hoffmann and
Gustav Klimt
Dining Room, Stoclet House,
Brussels
Photograph: Ritter

panels 'Expectation' and 'Fulfilment'. The two friezes are punctuated by a narrow, abstract panel on the entrance wall of the room.

These buildings, and above all their interiors, were illustrated and discussed in journals that were disseminated throughout Europe. Among them were *The Studio* founded in London in 1893, followed by *L'Art Décoratif* in Paris in 1893, *Kunst und Dekoration* and *Dekorative Kunst*, both in Germany in 1897. In 1888 the Arts and Crafts Exhibition Society had been founded in London and in 1891 the *Salon de Champs de Mars* in Paris exhibited applied art on an equal footing with sculpture and painting. *Les Vingt*, founded in Brussels ten years earlier, changed its name to *La Libre Esthétique*, specifically so that craft, sculpture and painting could be exhibited together, while in the summer of 1897 the international exhibition in the Glaspalast, Munich, included crafts which ranged from rugs, embroidered wall-hangings and stained-glass windows to ceramics and bookbindings.

Thus there was a rapidly growing body of literature on the concept of a room as an aesthetic unity, on the formal qualities of ornament and of painting and on the nature of decorative art. It included theories of colour, of the psychological importance of line and the assertion that spiritual values could be expressed through formal devices.

Maurice Denis's claim that 'above everything else a painting should be an ornament. The choice of subjects for scenes means nothing. It is through coloured surfaces, through the value of tones, through the harmony of lines, that I attempt to reach the mind and arouse the emotions'[8]

draws on the legacy of monumental art in France as well as on symbolist and synthetist art theory. In 1891 Albert Aurier had discussed the decorative qualities of Gauguin's painting[9] bringing out their debt to Egyptian and Greek art. The polemical end of the article: 'You have among you a decorator of genius: walls! walls! give him walls,' had partially been fulfilled in the murals and panels at Marie Henri's inn at Le Pouldu in 1889. The same year Oscar Wilde discussed the qualities of decorative art as 'the one visible art, that creates in us mood and temperament. Mere colour unspoiled by meaning and unallied with definite form can speak to the soul in a thousand different ways. The harmony that resides in the delicate proportion of lines and masses becomes mirrored in the mind . . . By its deliberate rejection of Nature as the ideal of beauty, as well as of the imitative method of the ordinary painter, decorative art not merely prepares the soul for the reception of true imaginative work, but develops in it that sense of form which is the basis of creative no less than of critical achievement.'[10]

It has been suggested that much of the theory in Kandinsky's *On the Spiritual in Art* (December 1911) was 'consciously founded on assumptions arising out of the decorative arts'.[11] Kandinsky's involvement with the decorative arts and with the implications of the 'total interior' lasted many years. In 1905 he had exhibited at the *Salon d'Automne* in Paris a '*Projet décoratif*' (catalogue no.822) and at the same salon a year later he exhibited woodcuts, four handbags, a sewing set and a tobacco pouch made in collaboration with Gabriele Münter. It appears that Münter made up many of Kandinsky's designs, which included wall-hangings in appliqué embroidery and even dresses. In a letter to Münter (17.8.04) it is clear that Kandinsky had begun to think in terms of the total environment of a room. He wrote: 'Pictures, decorative paintings, embroideries, whole rooms are suddenly in my head again.'[12] The distinction between 'pictures' and 'decorative paintings' is a revealing one. In *On the Spiritual* he acknowledges that works of applied art can elicit 'nerve vibrations', yet distinguishes these as of a lower order than those that works of art can inspire. Ornament however did provide a model in which form and colour were free of association with nature and were not handled in 'a purely external manner'. However, he sees the danger in this model as that of 'degenerating into purely external ornamentalism: pure patterning'. He suggests that, in patterning, the significance and meaning of the original forms can be lost, until 'we can no longer decipher their inner value'.

From 1900 Kandinsky had designed furniture, and, in 1909 at Murnau, he decorated his own furniture and stairs. In this work he was apparently stimulated by Bavarian glass and folk painting as well as by his recollections of the decorated interiors of houses in the Vologda region of Russia.[13] In primitive and folk arts Kandinsky saw a concern, parallel to his own, with 'the expression of inner and essential feelings'. He remained

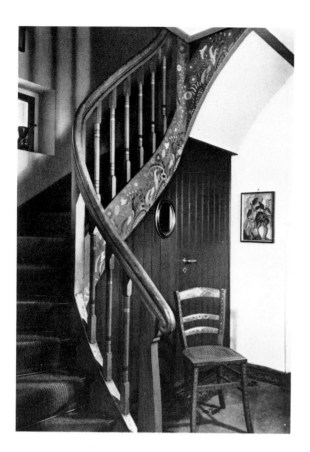

Wassily Kandinsky and
Gabriele Munter
Interior, House at Murnau,
c.1909

interested in the concept of the total work of art, as he recalled to Will
Grohman in 1924: 'To work with space, i.e. architecture, is an old dream
of mine.'[14] The four panels he painted in 1914 for New York and the
banqueting room for the *Juryfreie* Exhibition Committee in Berlin in 1922
were his first commissions for interiors (colour plate 8).

The ultimate aim of Kandinsky's aesthetic, as discussed in *On the
Spiritual*, was the synaesthetic union of all the arts into one 'monumental
art'. In this he continued the nineteenth-century tradition from Herder to
Wagner, whose concern with the *gesamtkunstwerk*, the total work of art,
remained a powerful model. In 'Der Gelbe Klang' (Yellow Sound) published
in *Der Blaue Reiter* Almanac (1912) Kandinsky explored the fusion of
music, movement and sound. A great deal of Kandinsky's argument in *On
the Spiritual* depends upon musical analogies with the formal and expres-
sive devices of painting. The difficulties arising from such analogies and
their historiography have been discussed by Ernst Gombrich.[15] The work
of artists in cabaret is pertinent to that discussion, since artists in different
media were working together, employing melody, rhythm, words, colour,
light, form and articulated movement, in some cases within a common
aesthetic.

Lisa Appiganesi has shown that cabaret grew out of the French *café concert* in 1881, when Rodolphe Salis opened *Le Chat Noir* in Montmartre.[16] The walls were decorated with work by Adolphe Willette and the posters and sheet music were designed by Steinlen. From this date cabaret spread through Montmartre and then to Germany, Switzerland, Austria, Russia and England. Initially artists performed only subsidiary roles, providing illustrations to reviews and using the walls of the cabaret as an unofficial salon on which to hang their work. At the *Kabarett Fledermaus* in Vienna, however, Josef Hoffmann designed a setting for the cabaret. It opened in October 1907 'to serve the cause of true entertainment culture by means of organised, unified synthesis of all relevant artistic and hygienic elements'.[17] The 'artistic elements', the tile decorations by the *Wiener Werkstätte*, were emblems of the satirical content of the cabaret.

Josef Hoffmann and Weiner Werkstätte Kabarett Fledermaus, Vienna, 1907

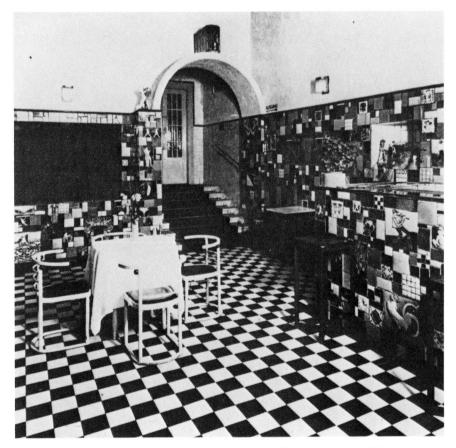

By May 1912, when Madame Frieda Strindberg, widow of the Swedish playwright, opened her Cabaret Theatre Club, the Cave of the Golden Calf, in London, she commissioned decorations to be carried out 'entirely and exclusively by leading young British artists'. Unfortunately nothing of the

completed decorations survives and it is only possible to reconstruct a fragmented view of how far the decorative interior fulfilled her ambition to have a 'place given up to gaiety . . . surroundings which after the reality of daily life reveal the reality of the unreal'.[18] Sir Osbert Sitwell's later recollection of 'gesticulating figures dancing and talking, while the rhythm of primitive forms throbbed through the wide room'[19] suggests some of the atmosphere created by Charles Ginner, Spencer Gore, Wyndham Lewis and Jacob Epstein, the artists commissioned by Madame Strindberg. The richly coloured animal forms in the sketches for murals by Ginner and Gore (Tate Gallery) can be related thematically to Epstein's work, which Violet Hunt recalled as 'white wooden pillars like caryatids . . . all had scarlet details, the heads of hawks, cats and camels'.[20] While Epstein remembered that they were worked directly in 'plaster, making an elaborate decoration, which I later painted in brilliant colours'.

Wyndham Lewis's work at the Cabaret Theatre Club is more difficult to determine. He later recalled 'abstract hieroglyphs round the stage' and a note from Madame Strindberg (Department of Rare Books, Cornell University) records payment for two paintings, two screens and the arrangement and decoration of the walls. Surviving brochures, a programme and a poster from the cabaret, all reproduced drawings of abstracted dancers by Lewis. In a review of the Allied Artists' Association summer exhibition at the Albert Hall in 1912, Roger Fry writes of a painting, entitled in the catalogue 'Creation' (present whereabouts unknown) as a 'design for "Kermesse", originally intended for the Cave of the Golden Calf, the new Cabaret Theatre.'[21] The title, 'Kermesse', derives from the name of the annual fairs of the Low Countries famous for noisy merrymaking and so a suitable subject for the club. Lewis certainly lent Madame Strindberg a painting entitled 'Kermesse'. While doubt must remain over the precise identification of this large canvas, Lewis reproduced in his magazine *Blast* (No.2 1915 p.75) a drawing of four figures laughing and dancing riotously and entitled 'Design for a programme cover – *Kermesse*'. This drawing survives in a private collection and can be stylistically linked with three small watercolours of dancers (British Council Coll. and Philips Coll. Montreal). The watercolours and the poster designed by Lewis for the Cabaret (Department of Rare Books, Cornell) are all constructed from facetted, fragmented forms of interlocking planes, marked by parallel lines of hatching. They may be sketches for the complete painting 'Creation/*Kermesse*' which was to set the tone of the cabaret. Augustus John congratulating Lewis on the painting, wrote of 'beating of drums and blowing of horns and thumping of feet'.[22] In his review of the exhibition Fry comments that the 'rhythm of these elementary geometric forms . . . (is) based upon the rhythm of the human figure' and goes on to speak of its 'definitely evocative dionysian mood'. Nijinsky's choreography (subsequently described as expressing 'strong

P. Wyndham Lewis
Design for a mural, Cave of
the Golden Calf, Cabaret
Theatre Club, London, 1912
Private Collection

Spencer Gore
Design for a mural, 1912
Oil on paper,
11 × 24 (28 × 61)
Private Collection, London

Spencer Gore
Design for a mural, 1912
Oil on paper,
12 × 23¾ (30.5 × 60.5)
Tate Gallery, London

primitive things in a jerky angular fashion'[23]) seen in London with the Imperial Russian Ballet in June 1911 and sketched by Lewis, might well have provided the theme for a 'dionysian mood'. Yet it must also be remembered that American ragtime dances such as the 'Bunny Hug' and the 'Turkey Trot', as well as the Tango, arrived in London during 1912. The syncopated rhythm and formalised steps of these dances were just as likely to interest Lewis. He later wrote to Ezra Pound in 1916 that 'Kermesse', which he was then repainting, 'is in its primitive state . . . even for a wall painting it is too uncouth'.[24] There is little to suggest that there had been a guiding overall conception for the interior of the Cave of the Golden Calf, but the combination of the brilliant red, yellow and blue of Ginner and Gore's mural schemes, with Epstein's animals and Lewis's wildly dancing figures must have confronted the visitor with a total aesthetic of primitive savagery, or, as Lewis later commented, 'provided a kick or two for the young man about town'.[25]

During the spring and summer of 1916 there was a similar interaction between radical cabaret and painters concerned with abstraction at the *Cabaret Voltaire* in Zurich. Several young artists, among them Marcel Janco, Hans Arp, Otto and Adya Van Rees, answered Hugo Ball's advertisement 'to bring along suggestions and contributions of all kinds to the Hollandische Meierei café at Spiegelgasse 1'. There, on 5 February 1916 the café opened, the walls hung with paintings and 'futuristic posters', and soon 'Janco's sumptuous archangels were hanging with the other beautiful objects'.[26] The Cabaret Voltaire, however, was less of a *mise-en-scène* than Madame Strindberg's Cabaret Theatre Club although it is clear from contemporary descriptions and memoirs that it featured simultaneous performances of music and poetry in costume.

The collaboration of Hans Arp, following his arrival in Zurich in the summer of 1915, with the Dutch painters Otto and Adrienne (Adya) Van Rees[27] was instrumental in his move to abstraction. They worked first together on some murals for the Pestalozzi Girls' School in Zurich and subsequently exhibited together in the winter of 1915 at the 'Galerie Tanner' in an exhibition entitled *Moderne Wandteppiche, Stickerein, Malerein, Zeichnungen*[28] (Modern tapestries, embroideries, paintings, drawings). Of the eighteen works Arp exhibited (ten in ink, five in charcoal and three in textiles) all were simply entitled 'Gestaltung' (Composition). The wall hangings and silk embroidery were worked by Adya Van Rees. One of the hangings is based on an earlier drawing entitled 'Crucifixion', but the figurative elements of the original drawing have been abstracted and the forms hardened and tilted at a diagonal. The drawing was also used as the basis for a large oil painting and Arp apparently made no distinction between the pure and the applied arts. In his preface to the Galerie Tanner catalogue he stresses the rejection of traditional painting and figuration. 'These works', he wrote 'are put together from lines, planes, forms and

colours. They try to approach the unfathomable and eternal values above mankind. They are a reaction against egotistical human concerns. They show hatred for the shamelessness of human existence, a hatred of paintings as such'.

Hans Arp, worked by
Adya van Rees
Abstract Composition, 1915
Embroidery,
$29\frac{1}{2} \times 35\frac{1}{2}$ (75 × 90.2)
Collection, F. Arp, Paris

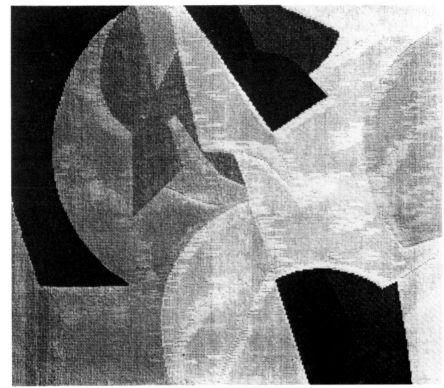

The silk hanging, worked by Adya Van Rees (F. Arp Coll., Paris) exemplifies this catalogue statement, as well as the importance of his relationship with the Van Reeses. Entirely abstract, the embroidery is constructed from geometric forms, principally positive and negative segmental forms. In Paris (from 1906), the Van Reeses had been friendly with a wide artistic circle that included Guillaume Apollinaire and Blaise Cendrars. After 1909, Adya Van Rees concentrated primarily on textile designs, both embroideries and woven woollen wall hangings, evolving an abstracted vocabulary, frequently interchangeable with figurative elements. Although little of her early work survives she exhibited wall hangings at the Moderne Kunstkring in Rotterdam in 1912, and at the Erster Herbst Salon in Berlin in 1913, some of which were after designs by Otto Freundlich. A surviving photograph of one lost hanging, suggests an awareness of Nabi wall hangings in its division of the plane into flat, interlocking colour zones. Between 1912 and 1915 there is a concentration on interlocking linear elements in her work, characteristic of the work of a group of Dutch

artists working in Paris.[29] The same forms recur in her embroidery and wall hangings, and by 1914, the figurative elements in these have been almost totally suppressed. The materiality of the surface is emphasised by the differing directions of the silk stitches. Another hanging, in wool, 'Le Trans Sibérien' (present whereabouts unknown) suggests a poetic content to her work, for it may have been inspired by the poem of that name by Blaise Cendrars, for which Sonia Delaunay had already produced an illustrated text.

Similar compositional elements and subject matter, in a wide range of works in differing media, are apparent in the work of Otto Van Rees. The vocabulary used by the Van Reeses and by Arp at this time was characterised by Hugo Ball as 'plane geometry . . . a love of the circle and of the cube, of sharply intersecting lines'.[30]

While the Van Reeses did not develop the abstract implications of their work any further, Arp pursued the implications of geometric abstraction in the following year in Zurich, notably in collaboration with Sophie Tauber, whom he had met at the Galerie Tanner exhibition. Sophie Tauber had studied textile design at St Gall, Munich and Hamburg and during the summer of 1916, gave a course in design and needlework at the Zurich Kunst Gewerbeschule. Apparently at the time they met, she was making small embroideries based on abstract formulations, one of which was

Below left
Hans Arp and Sophie Taeuber
Collage, 1915

Below right
Sophie Taeuber Arp
Embroidery from collage, 1915

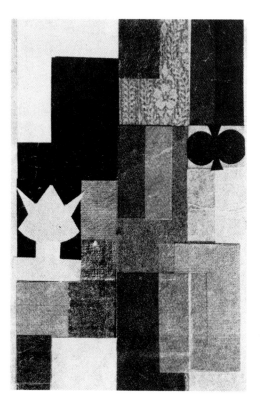

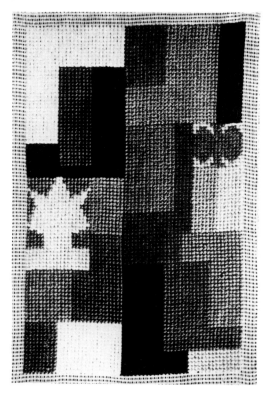

Sophie Taeuber Arp
Horizontal Vertical, 1916
Wool embroidery

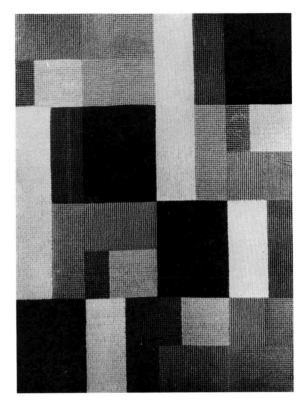

reproduced in Tzara's *Dada No. 1* (1918). Surviving watercolours and crayon sketches from this period seem to be based on a geometric grid structure, which may be related to the method of working out designs for embroidery. As Arp later acknowledged,[31] her 'extreme simplifications, her exclusive use of rectangular planes placed horizontally and vertically in her pictures' exercised a decisive influence on his work. Between 1916 and 1917 they frequently collaborated, with Tauber working designs by Arp as embroideries or, as in 'Duo Collage', producing together a work of strict geometric regularity based on mathematical subdivisions. A group of small collages exhibited by Arp in July 1916 all have a similar structure, in the symmetrical construction of the main elements around a central axis. One work incorporates a label, perhaps an ironic reference to his collaborator, it reads 'Extra fine pointed polished steel cast tapestry'. In her embroidery entitled 'Composition horizontal vertical' of 1916, Tauber employs a rectangular unit, multiplied by four, then equally placed in an horizontal and vertical direction. This structure is displaced by subdividing the unit and by repeating the multiple of four for each unit of the subdivision. In this way the frontality of the image is disrupted.

Arp's intention to develop a language based on elementary forms found a model in Tauber's embroidery. Moreover her experience as a Laban

dancer may have provided yet another precedent. Hans Richter later recalled that the dances of the pupils of Rudolph von Laban, and his contribution to choreography, finally involved the whole Laban school in the Dada movement. 'Its students danced in the ballet *Die Kaufleute* (The Merchants). In front of abstract backdrops ("cucumber plantations") by Arp and myself; dancers wearing Janco's abstract masks fluttered like butterflies of Ensor, drilled and directed according to the choreography written by Kathe Wülff and Sophie Tauber in Laban's system of notation.'[32] Laban's system (published only in 1926) was evolved after detailed study of the description of movement, and of Chinese and Egyptian scripts. He used vertical, horizontal and diagonal notations to describe the movements of the body. Left and right sides are ordered in relation to a central 'spine' and movements indicated in columns beside the spine. In this way the system provides a structure for the description of rhythm, sequential movement, response to tonal variation etc. Familiarity with both categories, dance and embroidery notation, does not necessarily provide a firm foundation for the exploration of geometric structures in painting, but must have been a powerful model for Arp.[33]

Roger Fry's comments on Lewis's 'Kermesse' have already been quoted but he was a protagonist in his own right in the continuing debate on the relationship of painting to decoration and also to that between the exponents of handcraft and machine design. His formulation of an aesthetic of pure design, common to both 'pure' and applied arts, was combined in the Omega Workshop project with an urge to provide artists with a means of livelihood that would give them freedom to paint and also with the ambition of providing reasonably priced items of common use for the public.

Fry's theory of the dissociation of form from content, first discussed in the 'Essay on Aesthetics' in the *New Quarterly* (No.6 Vol.II 1909) is well-known. It was elaborated in many places including his introduction to the French section of the catalogue of the *Second Post-Impressionist Exhibition* in 1912 in which he discussed the work of Braque and Picasso as 'undoubtedly . . . the attempt to give up all resemblance to natural form and to create a purely abstract language of form – a visual music'. In the same catalogue, in his introduction to the English section of the exhibition, Clive Bell set out his closely related theory of significant form. Immediately following the exhibition Fry was able, as a result of a legacy, to take premises at 33 Fitzroy Square, and there opened in July 1913 the Omega Workshops Ltd. He noted later in an undated brochure for the Workshops that 'The artists who have associated themselves to found the Omega Workshops Ltd are by nature predisposed to the study of pure design.'

The Workshop was a loose union of artists, Continental and English, who worked in the studio workrooms on the first floor for 7/6d per day or thirty shillings a week.[34] Fry's emergent social ideals, linked with the

Salon d'Automne, Paris, 1912
Living Room, Maison Cubiste
Photograph: *Art de France* 1,
1962

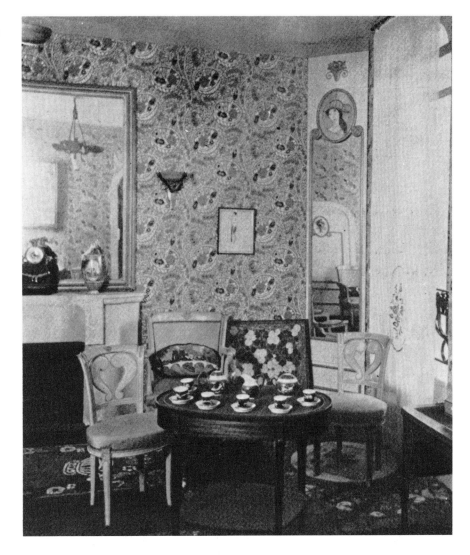

concept of a loose community of artists, were no doubt stimulated by the experience of working in collaboration with Duncan Grant, Frederick Etchells and others on the murals for the Borough Polytechnic dining room during the summer of 1911. Equally, his friendship with the poet Charles Vildrac, whom he met in the same year, may have further promoted this interest.

Vildrac with Georges Duhamel, Albert Gleizes and Henri-Martin Barzun had founded a community of writers and artists at the Abbaye de Creteil in the autumn of 1906.[35] Although only a short-lived experiment, it was dedicated to the problem of the creation of a new art suited to the life of a new age. Barzun founded a review, *Poème et Drame*, in 1912, dedicated to the concept of interaction between the arts. Furthermore, as a member of

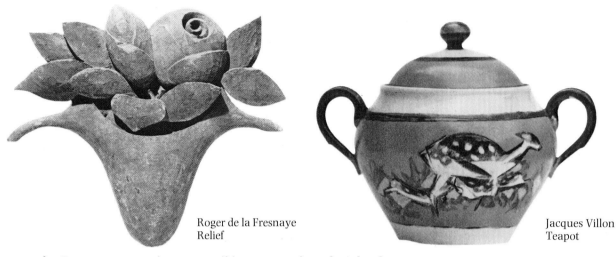

Roger de la Fresnaye
Relief

Jacques Villon
Teapot

the Puteaux group, he may well have contributed to the discussions surrounding the 'Maison Cubiste', exhibited at the 1912 *Salon d'Automne*.[36] This scheme combined a façade by Raymond Duchamp Villon with an interior decorative scheme co-ordinated by André Mare. It contained a vestibule and a large living-room with furniture by Mare, wall-paper by J. L. Grampert, a door panel relief by Roger de la Fresnaye, a tea service in orange and violet china (now in the Musée d'Art Moderne, Paris) by Jacques Villon and other decorative objects. On the walls hung paintings by Marie Laurençin, Fernand Léger, Albert Gleizes and Marcel Duchamp. How far it was intended to incorporate any of the concepts of cubism is not clear. The decorative scheme, based on floral motifs, bowls of fruit and flowers, recalls much Nabi decoration and is quite different in style from the paintings that hung on the walls, despite 'weekly meetings to harmonise the ideas'.

The direction of Fry's thinking in the formation of the Omega Workshops emerges in an article he published in May 1912, entitled 'The artist in the Great State'.[37] In the article he diagnosed the problem for art, which he described as 'the spiritual life', in a plutocratic state, as the alienation between artist as 'creator of purely ideal and abstract works' and the patron who fails to comprehend these works and so buys the 'dead beauty of the past'. He related the problem to the design of everyday objects which he sees in the railway waiting room in which he writes. He described these as 'eczematous eruption of pattern on the surface of modern manufacture'. The artist, as designer, has become crushed under the pressure of modern manufacture so that he cannot produce expressive designs but only dead patterns. Fry, echoing Morris, suggested that in the Great State 'Guilds might regain something of the political influence that gave us the Gothic Cathedral of the Middle Ages', and proposed the temporary suppression of the 'pure artist' to relieve the extravagant social status accorded to works of art. He suggested that the artist would then 'naturally turn to one of the

applied arts as a means of livelihood, and we should then get the artist coming out of the *bottega*, as he did in fifteenth-century Florence'.

The consistency of these ideas and the practice of the Omega Workshops is striking. It is manifested in Fry's insistence, at all times, on the use of the Omega symbol instead of a signature to preserve the anonymity of the designer and in his insistence on the importance of the direct expressive qualities of handcrafted products which he found in the 'spontaneous freshness of primitive or peasant work'. The Omega Workshops' prospectus underlines this attitude by stating that 'the artists refuse to spoil the expressive quality of their work by sandpapering it down to a shop finish', in the belief that the public has at last seen through the humbug of the machine-made imitation of works of art'. The handpainted ties, cushions, cloaks and boxes of the Omega Workshops embody this principle and continue the traditions of Morris and Ashbee.[38] Fry also identified the qualities of expressive design in the revival of Victorian cross-stitch embroidery in chair seats and fire screens.[39] However he did employ limited machine production for the Omega Workshops in the manufacture of linens and in making up furniture.

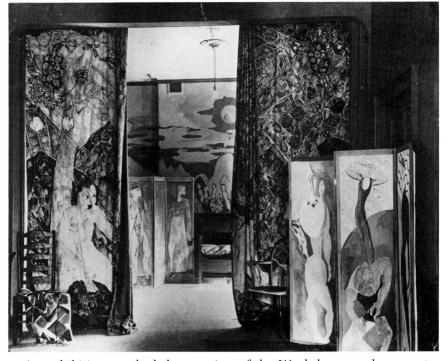

Press photograph of Omega Workshops Ltd, 33 Fitzroy Square
Photograph: *Daily News and Leader*, 7 August 1913

An exhibition marked the opening of the Workshops, and a reporter from the *Daily News* and *Leader* (7 August 1913) described the Workshops as 'busy experimenting in revolutionary furniture, evolving walls that are inspiring and instructive, chairs that are witty, hangings that are humorous, and curtains that sing gaily in wild transports of colour'.

Photographs which accompanied this account indicate the variety of objects made at the Omega: screens by Duncan Grant and Wyndham Lewis, furniture, small boxes and candlesticks. There was also a mural which the reporter described as 'a wonderful landscape in aesthetic tones, pale purple skies and a shining moon and blue mountains'. Painted curtains were also part of the decorative scheme.

During 1913 the Workshops expanded and by the end of the year a showroom nursery and bedroom were opened. Work on these had been briefly interrupted by the abrupt withdrawal of Wyndham Lewis, Frederick Etchells, Cuthbert Hamilton and Edward Wadsworth following the rumpus over a commission for a 'Post-Impressionist Room' at the *Ideal Home Exhibition* held in October 1913 (colour plate 9).[40] The commission was carried out by those artists remaining at the Omega Workshops, although a carpet designed by Etchells was included. The room contained furnishings and three murals on the theme of the dance (surely related to Lewis's painting for the Cave of the Golden Calf). The Post-Impressionist Room, described in the catalogue as 'by the Omega Workshops Ltd', whose work 'lies in the application of pictorial designs to the decoration of walls and designing various hangings', can be seen as the summation of the intentions of the work produced at the Omega in 1913. Two processes of work emerge. One involved the borrowing of form and subject of contemporary paintings and applying them in abstracted form to the surfaces of objects. Vanessa Bell's painting, 'Summer Camp' of 1913 (a pastoral theme of seated figures in a landscape), is transferred although schematised to a three-panel screen (now in the Victoria and Albert Museum). Similarly a section of Fry's 'Still Life' (private collection) of 1912, was the basis of the fabric subsequently entitled 'Amenophis', while Grant's painting, 'Lily Pond' of 1912, appeared on a variety of screens and table tops. The other process involved the production of designs in the Omega workrooms that were subsequently collected into portfolios and used as 'working designs' by the Omega assistants for the decoration of different objects. The implication of this was that the artist was free to produce a design for its own sake independent of function. Thus no distinction was apparently made between the decorative qualities of the fine and the applied arts, and formal qualities could be pursued for their own sake. In some cases at least the experience of working at the Omega was a major factor in the development of abstraction. The carpet designed by Etchells included in the Post-Impressionist Room at the *Ideal Home Exhibition*, shows the remarkable change in his work from a free application of colour to the acceptance of an inherent geometric structure. Clearly the processes involved in making an embroidered rug predispose the designer to the use of a geometric structure but Etchells playfully sets off the gridded structure against the form of an abstracted figure, using the same module for figure and ground, but turning the figure through 45°.

Frederick Etchells
Rug, 1913
Hand knotted wool on canvas,
58 × 36(147.5 × 91.5)
Chelsea School of Art

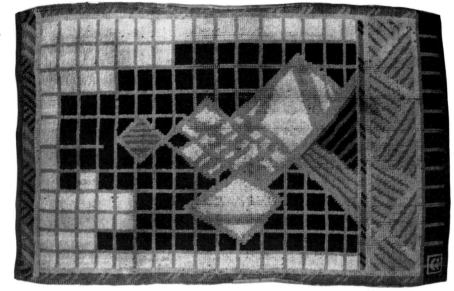

During 1914, working with collage seems to have become an important part of the process of design at the Workshops. Numerous designs principally for rugs and trays, are characterised by the use of geometric forms frequently subdivided into rectangular segments. Several abstract collages by Vanessa Bell date from the winter 1913–14 in which such rectangular forms articulate randomly related planes. This zonal conception of the pictorial surface was undoubtedly influenced by Byzantine mosaics, which she had seen in Constantinople in the spring of 1911 with Bell and Fry. In a letter of June 1911, she wrote 'I am trying to paint as if mosaicing, not by painting in spots but considering the picture as patches, each of which has to be filled in by the definite space of colour, as one has to do with mosaic or wool work, not allowing myself to brush the patches into one another'.[41] This denial of the illusionistic role of colour and assertion of the planar structure is seen also in Grant's contemporary 'Scroll' (Tate Gallery, London) which is related both to Bach's fugual structure and to Chinese scroll painting. In his 'Essay on Aesthetics' (*New Quarterly* 1909) Fry described the length of Chinese scroll painting as 'so great that we cannot take in the whole picture at once', yet in the process of rolling and unrolling it, 'we have received a very keen impression of pictorial unity'. He refers to the importance of the unity of successive events in literature, music and in painting.

The completely abstract forms of Grant and Bell's contemporary paintings and collages do not appear in the contemporary decorative schemes of the Workshops: the antechamber for Henry Harris in Bedford Square; the Omega Lounge at the *Allied Artists Association Exhibition*; the decorations for Sir Ian and Lady Hamilton at Hyde Park Gardens or the

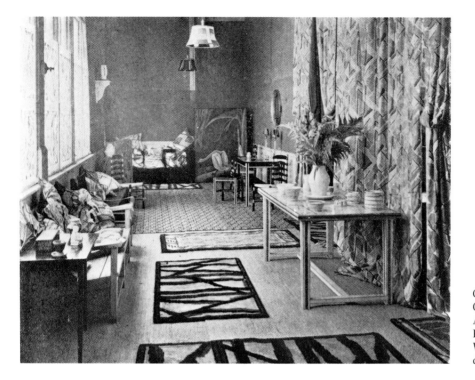

Omega Workshops Ltd
Omega Lounge, Allied Artists
Association, July 1914
Photograph: Omega
Workshops Ltd, artists' and
decorators' brochure

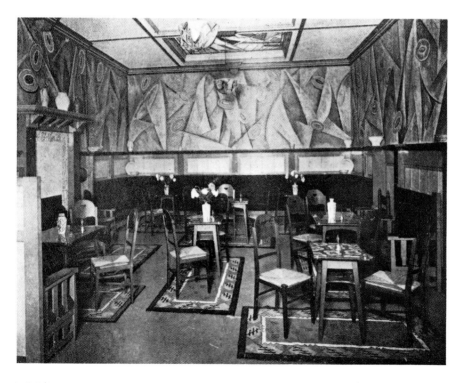

Omega Workshops Ltd
Cadena Cafe, Westbourne Grove
Photograph: Omega
Workshops Ltd, artists' and
decorators' brochure

Omega Workshops Ltd
Entrance Hall for Sir Ian and
Lady Hamilton
Photograph: Omega
Workshops Ltd, artists' and
decorators' brochure

Cadena Café decorations, Westbourne Grove, all of 1914. There is, never-theless, a pictorial unity, a totality of conception in these interiors. Nina Hamnett's recollection that 'at the Omega Workshops we spoke and thought only of modern French art, Derain, Picasso, Matisse and others', and the frequent references in the popular press to Cubist, Futurist and Post-Impressionist furniture and interiors denote the range of sources and styles.

It is not clear from surviving accounts, newspaper articles and photo-graphs, whether the intention of the Rebel Art Centre in Great Ormond Street to decorate the interior with 'a series of large murals and friezes' (Rebel Art Centre Prospectus, private collection) was ever carried out nor whether there was a coherent decorative scheme. Surviving newspaper photographs suggest that only one mural by Wyndham Lewis was started and that the other walls were hung with canvases by various members of the Centre. On the whole the decoration relied upon stark contrasts. The main space, a large room on the first floor had walls 'painted lemon yellow . . . doors of lawless scarlet' and 'decorous carpets of dreamy blue'. A divan base was covered with red, white and blue striped material from Liberty's. Two contemporary photographs (*Daily News* and *Leader*) indicate that the curtains at the Centre were remarkably similar to those hung at the Omega Workshops. They were hand painted by Laurence Atkinson, and described by the reporter of the *Daily News* and *Leader* as 'containing points of purple

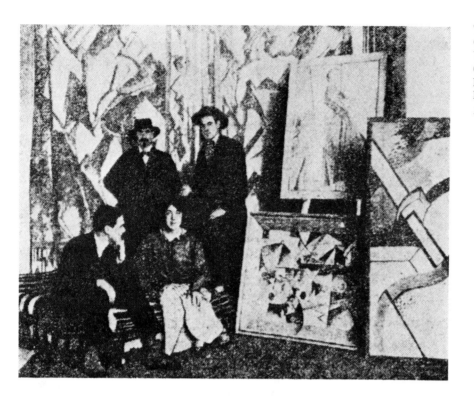

The Rebel Art Centre, Great Ormond Street, London
Wadsworth, Nevinson (standing), Hamilton(?) and Kate Lechmere
Photograph: *Evening Standard*, 30 March 1914

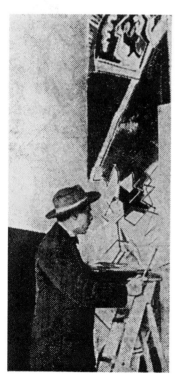

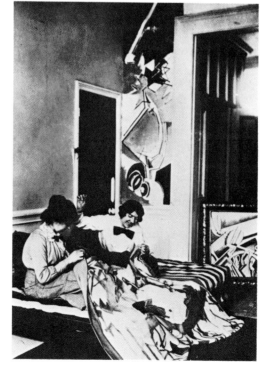

Far left
Lewis painting a mural
Photograph: *Daily Mirror*, 30 March 1914

Left
Kate Lechmere and friend sewing curtains
Private Collection

and cubes of green and yellow, intermingled with slashes of deep rose red, which formed themselves as one gazed at them, into fantastic human figures'. The Rebel Art Centre clearly intended to compete with the Omega Workshops, for the prospectus proposed 'lectures, the staging of short plays or *ombres chinois*', as well as 'tuition and instruction in the various forms of the Applied Arts such as the painting of screens, lampshades (and) scarves'. Some of these products were exhibited at the Rebel Art Centre Stand at the *Allied Artists' Association Exhibition* in June 1914, but none are now identifiable.

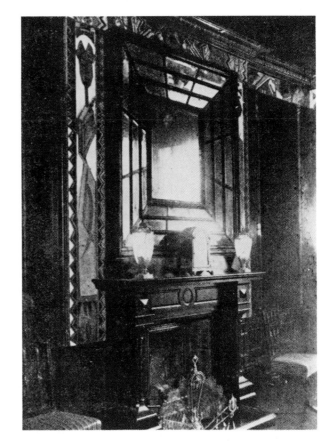

P. Wyndham Lewis
Dining Room for Lady
Drogheda, Wilton Crescent,
London
Photograph: *Illustrated
London News*, 1914

More startlingly innovative was the interior designed by Wyndham Lewis for Lady Drogheda at her home at Wilton Crescent.[42] It was opened in February 1914 simultaneously with an exhibition of his drawings at Wilton Crescent. In contrast to the nineteenth-century all-white interior, Lewis had all four walls and ceiling painted black. Above the doorway was a large painting, 'The Dancing Ladies', in which the forms have advanced to a radical degree of abstraction. The walls are articulated by an abstract frieze, placed just beneath the eighteenth-century cornice (which Lewis painted gold) and by strips of bevelled glass in the corners of the room,

which reflected the 'rioting mass of colours, each vying with one another for brilliance, quite irrespective of form, meaning or design – colour for colour's sake so to speak' (*Vanity Fair*). Probably most dramatic of all, was the fireplace wall where, over the fireplace, Lewis placed a mirror sub-divided by black beading into a perspectival structure with vertiginous effect. Flanking it, like two totemic guardians, were abstracted figures in long thin panels extending below the level of the mantelpiece. The glass must have reflected not only the occupants of the room and its furnishings but sections of the frieze and black walls so that the space of the room was totally fragmented.

Lewis's concern with a language of painting derived from 'the rigid lines of houses, a plague of cheap ornamentation, noisy street locomotion' and the 'rigid reflection of steel and stone',[43] is reflected in the angular, geometric forms of his paintings of 1914, now unfortunately mostly lost.

One of the major distinctions between the conception of the interior at the Omega Workshops and in Lewis's work, therefore, turned on the rejection or acceptance of a machine aesthetic. In *Blast* No.1 (published in July 1914) Lewis praised the 'plague of cheap ornamentation' so lamented by Fry. He suggested that 'the surfaces of cheap and manufactured goods, woods, steels, glass etc., already appreciated for themselves and their possibilities realised, have finished the days of fine paint . . . Even if painting remains intact it will be more supple and extended, containing all the elements of discord and "ugliness" consequent on the attack against traditional harmony' (*Blast* No.1 p.142).

T. E. Hulme made a similar distinction in a series of articles on 'Modern Art'[44] in which he distinguished a 'rather fumbling search for an appropriate means of expression' among English painters which has lead to a reassessment of Byzantine, Archaic and African art principally for their geometric structure. From this search he argued that a rationale for contemporary abstraction had developed. The work of Fry and his associates, 'English Post-Impressionism', which had been described by Clive Bell as a return to first principles, was seen by Hulme as a new disguise for nineteenth-century aestheticism and 'as some emporium which will provide the wives of young and advanced dons with suitable house decoration'. Hulme argued that a new sensibility was 'finding for itself a direct and modern means of expression', accepting 'the beauty of banal forms like teapot handles, knuckledusters, saws etc . . . and the use of shapes taken from machinery'.

After the completion of Lewis's Drogheda dining room, the Omega Workshops decorated three rooms for Sir Ian and Lady Hamilton at 1 Hyde Park Gardens. Here the Omega first explored ideas discussed three years later by Fry in an article entitled 'The artist as decorator'. Fry suggests that the artist may be able to 'transform a room completely, giving it a new feeling of space, or dignity or richness. In fact, he can underline as it

were, the actual proportional beauty of the architecture or counteract its architectural defectiveness.'[45] The Hamilton rooms appear to have been conceived as interrelated but there is a sense in which the decorative conception works against the architectural structure. One of the rooms was painted black with a frieze, while the form of the entrance stair was interrupted by the linear mosaic around it. Fry, in collaboration with Nina Hamnett in 1916, attempted a similar disruption of the wall surface in an interior for Madame Lalla Van der Velde (colour plate 7). Simple rectangular forms in discordant colour created a rhythm, running counter to the wall surface. However, more lyrical decorative schemes generally prevailed among the Bloomsbury painters. The continuous decorative treatment of the wall surfaces at Charleston (1916–60) testifies to their enduring love of a painterly ornamental surface.

The effect of exotic props and the precise placing of objects to create a particular mood in an interior ensemble has always been part of the paraphernalia of studio decoration. The American architect, Frank Lloyd Wright, acknowledged that the rearrangement of objects in a room could transform the interior and used his own studio as an experimental space. In 1904 Charles White recorded 'the studio is torn up again by the annual repairs and alterations. Twice a year Mr W. rearranges and changes different rooms. He says he has gotten more education in experimenting in his own premises, than in any other way.[46]

In Dresden, in 1905, the artists of *Die Brücke* carved furniture and painted murals in the shop they rented as a studio, stimulated by primitive and oriental art. Their interest had been stimulated by the exhibition in the city of Gauguin's paintings which led them to study the rich ethnographic collections of the Dresden Museum, notably the roof beams from Palau, New Guinea. These beams, decorated with schematised figures in brilliant colours, provided an irresistible model to the artists. Max Pechstein not only visited Palau in 1914, but subsequently decorated his Berlin flat with a frieze derived directly from the beams. Moreover Ernst Heckel and Ernst Ludwig Kirchner decorated their studios in direct imitation of the same source.

During 1910, Kirchner spent several months in the Dresden Central Art Library investigating a range of material from Benin and Egyptian art to wall-paintings from Ajanta, India.[47] Existing photographs and contemporary accounts indicate that, following his move to Berlin in the autumn of 1911, references to these sources began to appear in his studio decorations and as schematic abstracted forms in his paintings. The creation of his studio environment went hand in hand with his pictorial development. Oriental umbrellas, Buddhist prints, a tablecloth made of decorative African patterns and abstracted figures, a carved figure and a large vase are combined in the studio with erotic wall paintings and decorative palmettes. The chrome yellow, red and black colour scheme

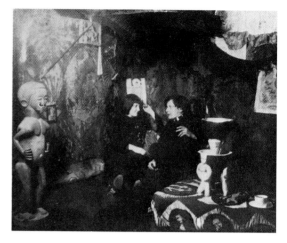

Above left and right
Ernst L. Kirchner
Studio in Berlin, *c.*1910
Photograph: Source
unknown

was again derived from the Palau beams. In 'Franzi in a Chair' (Thyssen Collection) the girl, Franzi, is seated in a chair which Kirchner had carved in the winter of 1908–9. Clearly dependent on Cameroon wooden sculpture, it is anthropomorphic in form, carved from limewood and painted pink and blue. Similarly, draperies after African and New Guinea ornamental designs appear in several paintings after 1910, for example, 'Milli Asleep' (Kunsthalle, Bremen). The 'Seated Woman in an interior' (Galerie Grosshenning, Düsseldorf), indicates the remarkable degree to which Kirchner synthesised the decorative treatment of wall surfaces in his studio with the decorative treatment of the picture plane. However, *Die Brücke* artists did not develop this tradition into full abstraction and in their subsequent interior schemes they continued to draw on the forms of primitive art.

It was not only German artists who explored decorative schemes in their own studios. Following his marriage in 1912 the Dutch artist, Bart Van der Leck, decorated his small house in Soesterberg with white walls and employed primary colours in rugs, curtains and upholstery to articulate the space. Later, in April 1919, Piet Mondrian moved back to Paris from Holland and settled eventually, in 1921, in a studio in the Rue du Départ.[48] During this period, 1919–21, he wrote and published in *De Stijl* a series of articles in trialogue form, entitled 'Abstract and Natural Reality'.[49] In the trialogue, a naturalistic painter and an abstract-real painter walk from the country to the city, and arrive with Y, an art lover, in the studio of the abstract painter Z. Y comments: 'Your studio doesn't really surprise me. Everything here breathes your ideas. Other studios are not like this,' to which Z replies that 'it is difficult for an artist to strive towards a new conception of the beautiful, while he continues to make his house, or studio, a kind of museum of old art . . . This studio expresses to some extent the idea of Neoplasticism. In a certain way it shows the equivalence of relations achieved exclusively by the elements of colour and line (*Destijl*,

Piet Mondrian
Studio, 26 Rue du Depart Paris
Photographs c.1926

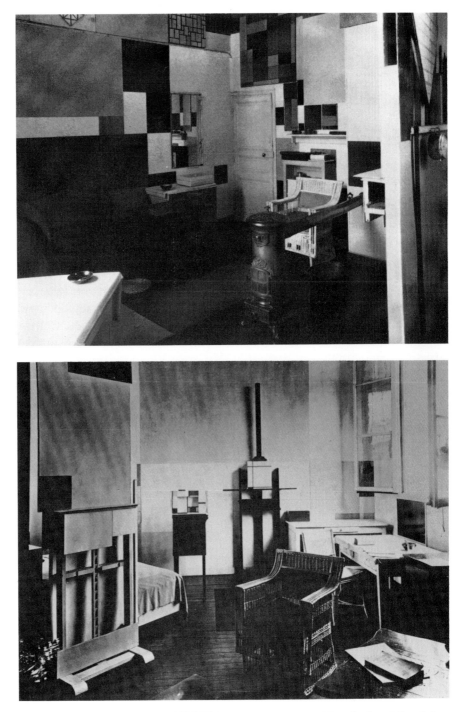

III. 6, March, 1920 pp.54/6).' This account was written before Mondrian began to transform his studio in the Rue du Départ. The transformation was recorded by various visitors, one of whom, a reporter for the Dutch

newspaper *De Telegraph* (11 September 1926) commented that the wall had been treated in a painterly way. 'I asked Mondrian about his ideas on the relationship between the two: "With me there is no absolute opposition as with Léger, who discriminates between easel painting as condensed innerness and the superficially pleasing decorative wall. As my painting is an abstract surrogate of the whole, so the abstract-plastic wall is part of the profound content implicit in the whole room. Instead of being superficially decorative the entire wall gives the impression of the objective, universal spiritual condition that comes to the fore in the most severe style form."'[50]

By this time, Mondrian was therefore not concerned with decoration in its limited sense but with an aesthetic that proposed not merely the transformation of the environment but of life as well. In the interview, Mondrian articulates ideas formulated ten years earlier in Holland among his colleagues in *De Stijl*. In the first issue of the review *De Stijl*, of October 1917, Mondrian had argued that life was becoming more abstract and that 'in pictorial not decorative painting, naturalistic expression and naturalistic means become more inward, are intensified into the abstract.' From 1916 the artists of *De Stijl*, Piet Mondrian, Bart Van der Leck, Vilmos Huszar and the architects, Jan Wils and J. J. P. Oud worked towards the development of an elementary means of expression proper to each art, free of association with the representation of nature. By 1918 they had arrived at the vocabulary of Neoplasticism: horizontal and vertical lines, primary and non-primary colours.

Jaffé has argued that the central thesis of the *De Stijl* programme was the realisation of a universal law and a universal spirit. 'In its striving after abstraction, after the liberation of the arts from all accidentals, *De Stijl* constantly aims at the visible expression of the universal principle which its members consider the rendering of exact equilibriated relationships.'[51] Coincidentally they saw, like the Puteaux Group, like the Abbaye de Creteil experiment and like the Omega Workshops, in the creation of a style the realisation of the consciousness of the times. Between 1916 and 1921 this style emerged in the collaboration between the *De Stijl* architects and painters.

The question remains, nevertheless, whether an aesthetic rooted in the assumption that painting could be a metaphor for a spiritual conception, could become a collective aesthetic for the fusion of art and architecture. For the editor of the review, Theo Van Doesburg, it undoubtedly did, although it was not until 1924 that he finally formulated this aesthetic in 'Towards a Plastic Architecture'. The early *De Stijl* aesthetic argued by various writers, depended upon some common models, such as Cubism and Futurism, but also on some disparate ones, such as the elimination of representation in painting, not really a problem in architectural terms. However the concentration on elementary forms, common to both architects and painters, did provide a shared vocabulary.

After Van der Leck had decorated his studio in Soesterberg, he continued as he later recalled, his 'quest for creating unity in the interior and painting, in generalising form and colour'.[52] Commissioned in 1914 to design a stained glass window for the hall and stair in the headquarters of the Müller and Co. Shipping Line in the Hague, he was subsequently appointed colour adviser to the firm. In this capacity he was called upon to work, in a rather uneasy alliance, with H. P. Berlage, architect to the firm. Van der Leck also designed a variety of objects for the Müllers, including portfolio and file covers, posters, advertising material, and he provided colour schemes for the interiors of several houses for the Müller family.

Much of this interior work relies upon an emblematic conception of abstraction, rooted in his interest in monumental art and in his early training in a stained glass atelier. In his designs for the Müller and Co. window, Van der Leck draws on this early training. There are fifteen panels in the window, each containing a scene from the mining activities of the company. The figures are set against a clear background, spatially comparable to the white ground he used in his painting. The lead strips between the glass emphasise the hieratic quality of a figure style, strongly influenced by Egyptian painting.

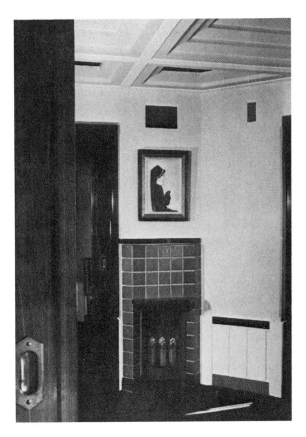

Hendrik P. Berlage and
Bart van der Leck
Interior, St Hubertus Hunting
Lodge, Honderloo, 1916

Van der Leck's work in collaboration with Berlage between 1914 and 1916 at Holland House in London, at 'De Schipborg', the farm designed for the Müller's eldest son at Zuid Laren, and at St Hubertus hunting lodge, Honderloo, was largely restricted to tile decoration. For Holland House, his ceiling mosaics and tiles, contain emblems of merchants and ships, while at Zuid Laren the tile frieze was made up of emblematic horses, cows and pigs. A similar emblematic conception is apparent in a contemporary large painting, 'The Storm' (Rijksmuseum Kröller Müller, Otterloo) completed in March 1916.

Bart van der Leck
Carpet design, $8\frac{7}{8} \times 6\frac{3}{4}$ (22.5 ×
Rijksmuseum Kröller Müller

Van der Leck's ambition to create monumental art was restricted by the constraints of the space made available to him. For Mrs Kröller Müller's house, Huize ten Vijver, he only advised on colour schemes for walls, doors, furniture, carpets and upholstery. Apparently he was using the strong colour accents that he had introduced into his own house in 1912, for Mrs Kröller Müller writes that the 'poster red is too shrill . . . the unbroken red too intense' (letter dated 16 January 1916. Rijksmuseum Kröller Müller, Otterloo). There is also an interesting exchange of forms between his paintings and his applied art. Two designs that appear on a small carpet (Rijksmuseum Kröller Müller, Otterloo) also appear in two paintings, 'Composition 1918 no.4' (Rijksmuseum Kröller Müller, Otterloo) and 'Composition 1918 no.5' (Hannema-De Steurs Fundatie, Heino). Apparently Van der Leck, like Arp, Macke and the Van Reeses made no distinction between pure and applied arts.

Van der Leck's conception that colour should be used 'not merely as a

flat plane . . . but as the plastic expression of space' was restricted at Berlage's insistence to a limited application of colour to furniture and small wall areas in St Hubertus Lodge. Nevertheless the colour structure makes a tentative articulation of the interior and, in the application of colour to the walls, Van der Leck is attempting to free the planes of the wall surface.

His two articles in *De Stijl* on the relationship of painting to building, define that relationship as a continuity of space which is conveyed 'expressively on a flat plane – the flat plane is retained and space created [by colour] as an extension of that plane' (*De Stijl* I.4, Jan. 1918 pp. 37–8). In his article 'The place of Modern Painting in Architecture' (*De Stijl* I.1, Nov. 1917 pp.6–7) he contrasts painting and architecture in terms of open/closed, space/colour, neutral plastic/constructive equilibrium. The idea of painting as a destructive force was held also by Van Doesburg. 'Modern structure begins' he wrote in a letter to the painter Peter Alma in 1918, 'when architectural structure is opened up.' In the same way Mondrian opposes the equilibriated relationship in painting to 'closed form (as in architecture)'.[53]

The embryonic conception of the *De Stijl* interior is apparent in the small seaside villa at Katwijk am Zee, that Oud converted in 1916. The decoration of the interior, principally in tiles, was carried out by the family of the painter Kammerlingh Onnes while Van Doesburg designed a mosaic and stained glass windows. The design of the interiors is strongly rooted in an Arts and Crafts aesthetic with characteristic emphasis given to the main circulation space and stairs. However the next collaboration between the same artists at De Vonk, Noordwijkerhout transcends this model. The house was a combination of rest home and school for Leyden girls with the

J. J. P. Oud and
Theo Van Doesburg
Exterior, 'De Vonk'
Noordwijkerhout, 1918
Photograph: Jane Beckett

J.J.P. Oud and
Theo Van Doesburg
'De Vonk', Noordwijkerhout,
1918, Entrance Hall interior
and first floor landing
Photograph: Jane Beckett

apartment of the founder on the first floor. The work of the two painters
Onnes and Van Doesburg is fully integrated with that of the architect, Oud,
and reinforces the architectural expression of the formal functions of the
building. On the exterior Van Doesburg designed a rich geometric abstract
work, skilfully using the main brick structure as the module unit, then
playing with the proportions and relationships of one unit to another. The
main theme is presented over the entrance door, with subsidiary mosaics
over the two side windows, each a mirror image of the other. Van Doesburg
designed tiles for the main entrance floor and the upper landing as well as
the whole interior colour scheme. Onnes' stained glass window on the
main stair serves as a device to link the two floors. Although the emphasis
given to the central axis of the entrance again recalls the Arts and Crafts
aesthetic, the relationship of Oud's cubic stair to the decorative schemes
proclaims a new concept of form. Commenting on this work in *De Stijl*
(II.2, Nov. 1918 pp.10–12) Van Doesburg declared that 'the conscious-
ness of the new plasticism implies co-operation of all the plastic arts
in order to attain a pure monumental style on the basis of balanced
relationships'. Like Van der Leck, he argues that each artist must restrict
himself to his own field (a view he was later to modify) and in this way
he will be able to liberate the plastic means at his disposal and so allow
the concept of 'applied arts to disappear'. Architecture and painting
will produce an harmonious combination precisely because they have
opposing characteristics. He sees architecture as rooted in construction
and function while he sees painting (exemplified at De Vonk in floor tiles
and colour scheme) as creating space through the destruction of the
neutral architectural planes. Van Doesburg includes a criticism of the
building in his account: 'stained glass windows too dark, the light one of
the chief factors in the art of monumental space, cancels out much of the
effect'.

The use of light in the creation of a monumental art recurs in several interior schemes that included stained glass designs by Van Doesburg and by Vilmos Huszar. Both artists used a module unit to build up a rectilinear structure in the design. In Van Doesburg's window for the de Lange House, Alkmaar, designed with Jan Wils in 1917–18, he employed primary colours for the first time, and, as at Noordwijkerhout, not only reversed forms from one window to another, but used discords in the repeat. Similarly his contemporary paintings employ a rectilinear module as a constructional unit, and colour to interrupt and destroy the structure, as in the 1918 'Composition in dissonances' (Arp Hagenbach Coll., Basel).

But it was in Huszar's interior schemes for the Bruynzeel family (1919–20) and Van Doesburg's colour schemes for Oud's housing at Spangen, Rotterdam (1919), that they first challenged the solid rectangularity of the wall. In these interiors, the colour planes float on their neutral ground, visually disrupting the planar structure of the wall surface. In Huszar's collaboration with Jan Wils in the Atelier Bursenbrugge in the Hague (1919–20) and in his collaboration with Gerrit Rietveld for an interior to be exhibited in Berlin (1922) this conception is pushed further, so that the distinction between one wall and the next is broken down by the application of the rectangular colour

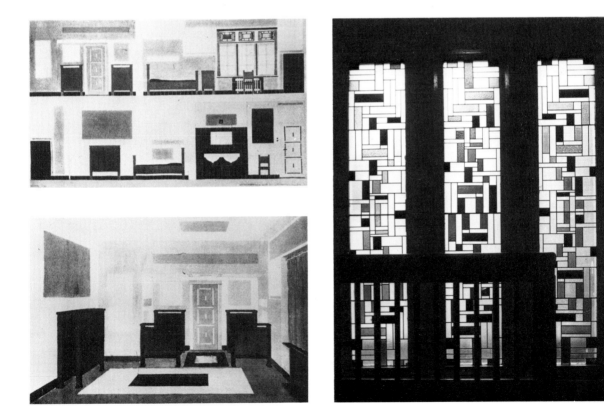

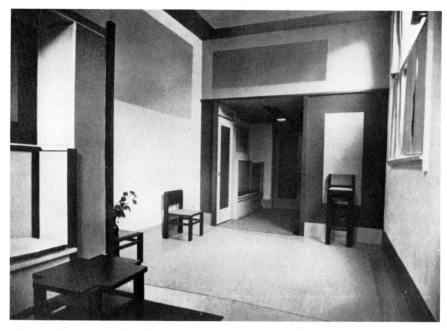

Jan Wils and Vilmos Huszar
Interior Atelier Bursenbrugge,
The Hague
Photograph: De Stijl V.1,
January 1922

planes. It remained only for Van Doesburg with Cor Van Eesteren to completely destroy the distinction between the planar surface of the wall and the applied colour, in 1924, 'to suppress painting as a separate, illusory expression of harmony' and 'to construct in the new realism of space time' (*De Stijl* VI.6–7, 1924 p.82).

Gleizes and Metzinger had argued against decorative considerations. 'The decorative work of art' they wrote in *Du Cubisme* (Paris 1912), 'exists only by virtue of its destination; it is animated only by relations existing between it and determined objects.' In distinction they saw the work of art as 'essentially independent, necessarily complete'. Yet the corollary to the transference of this conception to the whole space, to the interior, is the rejection of the work of art as an independent entity. This process is encapsulated in the change in Piet Mondrian's conception of his work between 1917 and 1919. In February 1917 he wrote in reply to a letter from Van Doesburg: 'You must remember that my things are still intended to be paintings . . . not part of a building' whereas by 1919 in an article in *De Stijl* he wrote: 'the abstract real picture will disappear as soon as we can transform its plastic beauty to the space around us, through the organisation of the room into colour areas'. He argued that a room should not be an empty space, but a divided space 'hence a space already partially filled, limited by the six surfaces which are also divided and which balance each other in their relations of position, dimension and colour' (*De Stijl* II.6, April 1920 p.55). He saw in the unification of chromoplasticism with architecture the total rejection of the conception of decoration: 'It is not a "decoration". It is an entirely new painting . . .'

Abstract art – a language?

Stephen Bann

> This thing that hath a code and not a core,
> Hath set acquaintance where might be affections,
> And nothing now
> > Disturbeth his reflections.
>
> Ezra Pound, 'An Object' (1912)

One of the recurrent questions which arises in relation to the development of abstract art is precisely its status, or lack of status, as a language. It has become customary, both in histories and exhibitions of modern art, to draw attention to abstraction as a *reductive process*. Identifiable references to the external world are progressively (and irreversibly) eliminated in a series of related works which may extend over a long period of time. The various sets of works by Mondrian, referring to motifs like the tree, are an obvious case in point. But this representation of abstraction as process inevitably raises some problems. Is the series only comprehensible as such, in its complete development from recognisable image to abstract structure? Does the 'abstract' work only have meaning as a 'trace' of the figurative image which has been progressively eliminated? Such questions also raise the more fundamental problem of the 'language' of abstraction. On what terms, if at all, we are impelled to ask, does the 'abstract' work communicate? Is the 'abstract' artist perhaps the victim of a solipsistic illusion if he continues to believe that his work holds meaning for the rest of the world?

I intend to discuss this question with reference not only to the 'origins of abstraction', but also to the continuing phenomenon of abstraction in the art of the twentieth century. After more than half a century of development from the heroic period of the modern movement, it becomes increasingly difficult to regard abstraction merely as a temporary aberration. And yet there is no general agreement about the type of communication which abstract art, in its classic or more recent manifestations, is thought to involve. Propaganda continues to be turned out in favour of a return to 'figurative art'. Where it merely asserts the superiority of the figurative, with no attempt to understand the origins of abstraction, it can be dismissed as mere rhetoric. But where it attacks the very basis of abstract art – its capacity to communicate – it should obviously be taken seriously.

A good point of departure for this enquiry, therefore, would be the substantial arguments advanced by two theorists of undoubted seriousness against the validity of abstract art. For the anthropologist Claude Lévi-

Strauss, an initial and unquestioned assumption is that art must be a language, an organised system of signs. According to this criterion, he argues, abstract art is merely a pseudo-language, incapable of achieving signification. This is because the 'sign system is created by a single individual, and he is liable to change his system fairly frequently'.[1] Language is, as Lévi-Strauss further claims, 'a group phenomenon and therefore a stable phenomenon'. Presumably we would not have a meaningful abstract art, in his terms, unless we had agreement on a basic vocabulary. Each artist would then be articulating, and giving characteristic expression to, this vocabulary of plastic form.

But this utopian situation would not satisfy Lévi-Strauss. The reason is comprised in the similar arguments by E. H. Gombrich, who has returned on a number of occasions to the question of communication in abstract art. For Gombrich, as with Lévi-Strauss, the 'reality' of the work of art is 'of a semantic nature' (i.e. it is composed of meaningful signs). Gombrich therefore salvages two of our leading modernist (but not abstract) artists by pointing to a universal principle at work in their paintings: 'something happens to the motif, the nude or the still-life, as it is transposed into shapes and colours, transfigured or distorted, and this event, as Picasso or Klee never cease to realise, is part of the complex structure we call a painting'.[2] In effect, the principle which Gombrich invokes is that which the linguist refers to as 'double articulation'. Just as ordinary spoken language consists both of sounds (the phonetic level) and meanings (the semantic level), so the painting is held to exist on two separate, though intricately interwoven, levels: that of the plastic vocabulary ('shapes and colours') and that of the represented (nude or still-life). It is only with this model in mind that we are able to sustain, in Gombrich's terms, the notion of artistic communication.

Of course the objection to abstract art which Gombrich is here vindicating implies not that the abstract work is incapable of communicating – but, on the contrary, that it communicates too much. Its meanings are not, as Lévi-Strauss put it, 'stable', and we can read into it what we like. Gombrich demonstrates the point by wickedly devising an 'Abstract' by 'Trebla Dranseb' – which turns out to be a detail, in negative, from a nineteenth-century salon picture.[3] He suggests that this counterfeited abstract is neither better nor worse than *bona fide* abstract painting. While he concedes that a case can be made out for the purely expressive effect of such a work, or indeed any configuration of colours and lines, he deplores the irrationalism that seems to follow from abandoning the strictly linguistic model of communication.

In the argument which follows, I shall take for granted the main assumptions of both Gombrich and Lévi-Strauss: that language is a 'group phenomenon', and that artistic communication implies a double level of articulation. It goes without saying that I shall not be defending 'Trebla

Dranseb' according to these criteria, any more than I shall be interpreting the post-war 'tachism' which was probably in the sights of Lévi-Strauss. But I shall certainly claim that a substantial part of the modern movement can be defended in these terms. Indeed, to go further, I would suggest that to dismiss the extent to which such artists as Tatlin and Malevich, Van Doesburg, Kandinsky and Klee, were concerned with this problem, is to obscure their real contribution. It is no accident that modern art 'came of age' at the same time as the structural linguistics of Saussure which has laid the foundations of the modern study of language.[4] In the discussion, I shall attempt to demonstrate a similar concern with 'foundations' in the development of modernist art, one which can be directly identified with the problematic of 'abstraction'.

To emphasise how far I am from wishing to dismiss the criteria erected by Lévi-Strauss and Gombrich, I shall continue by using two related examples from their writings which cast further light upon the linguistic status of abstract art. In his essay on 'Expression and Communication', Gombrich discusses the case of a painting by Kandinsky entitled 'At Rest'. He notes that Kandinsky employed 'unstructured colours and geometrical shapes in the belief that these were inherently charged with emotive power'.[5] But he will not concede that Kandinsky has arrived at a truly public vocabulary, a genuine system of double articulation. 'I certainly doubt that even the most sensitive beholder would feel "at rest" in front of this picture.' However Gombrich then proceeds to make a further point which substantially modifies his earlier criticism. Kandinsky was not working in a vacuum, he reminds us: to be precise, he was working in 1928 (the year of the production of 'At Rest') among his fellow artists of the Bauhaus. In particular, he was working in close contact with Paul Klee, who had himself 'experimented with the suggestion of movement in ships' in 1927. As Gombrich argues: 'Kandinsky's work, painted a year later, gains in intelligibility when placed side by side with Klee's. Suddenly the massive rectangular forms acquire indeed the dimensions of heaviness and calm, they are the "pong" to Klee's "ping".'[6]

It is important to be aware how much is granted, and how much withheld, by this concession. Gombrich explicitly rejects Kandinsky's own theory of the 'inherent' meanings of colour and shape (this will be investigated further at a later stage in the essay: for the moment it is worth stating the implication that such a theory, if correct, would presumably oblige all non-figurative artists to employ Kandinsky's 'vocabulary'). The 'intelligibility' which he postulates is not to be found in the work 'At Rest' considered in isolation, but in the *relation* between a certain picture by Kandinsky and another by Klee. Such a relation is dependent on the historical fact that the two artists worked together at the same institution. But we may well ask how essential this historical connection is held to be, and what relevance it might have to the public appreciation of the two

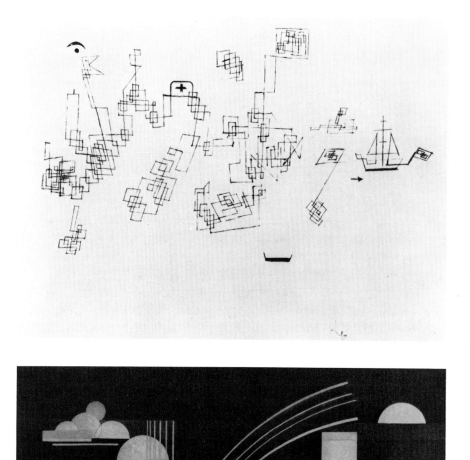

Paul Klee
Bustling Harbour
Pen and ink
Kunstmuseum Bern,
Paul Klee Foundation

Wassily Kandinsky
At Rest, 1928
The Solomon R. Guggenheim
Museum, New York

works. Is Gombrich saying that the juxtaposition of the two works is a *sine qua non* of our understanding them? If so, then the fact that they are in different collections would presumably bar them from achieving intelligibility, except in the privileged location of his own essay. Obviously

this inference would be absurd. What Gombrich's remark implies is surely the much more general and acceptable proposition that a work of art has meaning only in relation to other works (to a 'tradition' of representation); and that this rule applies as much to 'abstract' works as it does to every other form of art. In other words, he is restating a position to which his own writings, in a multitude of different fields of art history, have already given cogency and substance.

One further elucidation is necessary if we are to go beyond Gombrich's example. In equating the relation of the two works to the relation of 'ping' and 'pong', he is making direct use of the categories of the psychologist C. E. Osgood, who posited the notion of a 'semantic space' which we construct through the proliferation of binary terms (warm/cold, light/heavy, bright/dark, etc., etc.).[7] In striking the contrast between the two works, Gombrich implies a systematic relation of difference: the Klee would be, perhaps, cold/light/bright, etc. and the Kandinsky warm/heavy/dark, etc. Yet this model, based as it is upon the binary principle, hardly takes us very far in elucidating the overall 'intelligibility' of abstract art. For this purpose, we need not merely a principle for finding local relationships between individual works, or sets of works, but a comprehensive system for the analysis of art as discourse. To borrow the linguist's terminology, we need not simply a principle of 'synchronic' comparison, which will establish a relationship between individual works considered outside historical sequence, but a 'diachronic' principle which traces the morphology, or logic of the evolution of forms, in time.

For this purpose, Lévi-Strauss's 'Overture' to *The Raw and the Cooked* turns out to have an obvious relevance. Lévi-Strauss suggests that throughout the extreme diversity of Western musical history, a recurrent 'cycle' can be observed. Composers fall into 'distinct categories according to the nature of the information of which they make themselves the carriers'.[8] These categories, however, are not exclusive to music as such. They can be equated directly with the analysis of the different cognitive functions of language as they have been defined by the linguist Roman Jakobson. Hence, where Jakobson postulates the *meta-linguistic*, the *referential* and the *poetic* functions of discourse, Lévi-Strauss puts forward the analogous hypothesis of composers of the *code*, the *message* and the *myth*. In his terms, Bach (for example) is a musician of the code, a 'meta-linguistic' composer in the sense that his work 'makes explicit and comments upon the rules of musical discourse': the 'Art of Fugue' would presumably be a clear instance of this disposition. Beethoven, on the other hand, is a musician of the message, concerned with the referential function of discourse: his work is expressive, sometimes even in the programmatic terms of the 'Pastoral' symphony. Finally Wagner is taken as an example of the musician of the myth, the 'poetic' composer who encodes his messages 'from the basis of elements which are already present' in the discourse: one

supposes that Lévi-Strauss would choose the Wagnerian use of the *leitmotiv* as his prime example. Perhaps these three composers, thrown into unexpected conjunction, are too far-flung to lend much conviction to Lévi-Strauss's notion of a cyclical development from code to message and myth. But it is important to bear in mind that he also gives examples from the modern period, in which the 'cycle' appears to function in a much more contracted form. The inverted cycle of myth/message/code seems to him to apply both to the sequence Debussy, Ravel, Stravinsky, and to the musicians of the Vienna School, Berg, Schönberg and Webern.

It is not a necessary step in my argument that Lévi-Strauss's hypothesis about the evolution of musical forms should be accepted as having categorical value. For one thing, they are closely associated, in the 'Overture', with arguments against the validity of abstract art, which run counter to the drift of this article. But Lévi-Strauss's use of Jakobson at least draws attention to a crucial proposition: that we can use the formal models of discourse devised by the linguist to analyse the underlying structures of an artistic 'language'. Clearly art historians make considerable use of concepts like the 'Classical' or the 'Mannerist', which are intended to designate different types of artistic discourse. But these concepts are so loosely applied that their cognitive value is almost negligible. Consideration of the terms which Lévi-Strauss borrows from Jakobson will show us how their application penetrates to some extent the clutter of existing terminology.

A further word is necessary, however, on the precise usage of the three categories of code, message and myth, and their basis in Jakobson's analysis. In the first place, Jakobson is concerned with additional functions of discourse other than the meta-linguistic, the referential and the poetic. It is simply that Lévi-Strauss selects this particular triad as a tool for investigating characteristic types of artistic discourse. In the second place, Jakobson does not present the various functions as mutually exclusive. Different functions co-exist in the same message, but 'the verbal structure of a message depends before all else on the predominant function'.[9] In the slogan 'I like Ike', for example, the directly referential function is subordinated to the poetic: the phrase 'I support Eisenhower for President' has an identical referential meaning, but it does not foreground the phonetic structure. In the investigations which follow, I shall not be assuming the existence, in theory or in practice, of a 'code' of plastic expression, but simply drawing attention to certain artists' need to foreground the 'meta-linguistic' function. Equally, I shall treat the 'message' stage not simply as the norm of referential discourse, but as the deliberate harnessing of artistic discourse to a programme, whether of social or of philosophical application. It will be obvious that, where Lévi-Strauss seeks the predominant function in a composer's entire *oeuvre*, I am postulating a succession of different 'predominant functions' in the course of an

individual career like that of Tatlin or Van Doesburg. But I should also mention that my concept of 'mythic' or 'poetic' discourse poses an issue which will not necessarily be apparent in the previous examples. I take as signs of mythic discourse not simply the foregrounding of the plastic elements themselves (by analogy with 'I like Ike'), but also the implicit reference to, and distance from the earlier stages of code and message. 'I like Ike' is registered, we might say, not only as a 'poetic' statement, but also as a departure from the extended form of the same message which it both presumes and repudiates. The example of Van Doesburg, from the early days of *De Stijl* to the manifesto of Concrete Art, will demonstrate this point most clearly.

Yet there is a further, more particular reason for citing Lévi-Strauss's musical examples at the outset of this discussion of abstract art. In selecting the Vienna School of composers for his example, he draws attention to a stage in the development of music which, in so far as it was concerned with the repudiation of traditional tonality and the invention of a new 'law' of musical expression, affords a direct parallel with the development of abstraction. Such a comparison remains simply on the level of a suggestive parallel if we do no more than note the historical connections between individual members of each movement (for example, between Schönberg and Kandinsky). But it acquires a much greater potential explanatory power if we discuss both examples in the light of linguistic categories such as Jakobson's functions of discourse.

Before I proceed to consider the 'origins' of abstraction from this basis, I should emphasise that this is a modest contribution to a debate which has as yet hardly been launched. When Marcelin Pleynet aspires to trace in modern painting 'something like what happened in music with Schön-berg, Berg and Webern',[10] he is defining a project which, even in France, has hardly left the ground. By comparison, the analysis of modern music has reached a considerable level of sophistication. The highly subtle investigation of modern music as discourse which characterises (say) Adorno's works on *Mahler* and *The Philosophy of Modern Music* has no parallel (though Adorno almost certainly envisaged one) in the domain of the visual arts.[11] This is partly because the whole phenomenon of abstraction, even granted that we accept the parallel with atonality, is considerably more diverse: rather than one school of closely associated colleagues, we must reckon with – at the very least – three different foci of activity. But it is also because of a certain distortion brought about by the very multiplication of specialist studies on the subject. Modern art, one might say, is acquiring a history. The kind of synthetic overview of the movement towards abstraction which made Charles Biederman's *Art as the Evolution of Visual Knowledge* (1948) so catalytic a force in post-war Britain, can only with difficulty be recovered. It would be senseless to stigmatise the historical research that is teaching us so much about the

precise circumstances of the years in which abstraction originated. But it is only reasonable to point out the need for a new equilibrium between history and theory. Even the best art historical studies, by the very nature of the discipline, tend to lay too much stress upon the value of continuity; indeed the general history of 'movements' in modern art seems to presuppose not merely the continuous superseding of one 'movement' by another, but also the 'progressive' nature of this process – as if Cubism were, in some sense, an 'advance' on Fauvism.[12] The role of theory by contrast, is to introduce discontinuities: it ruptures what narrative convention presents as the seamless robe of history, and explores historical practice through the oblique intrusion of a conceptual scheme. That this conceptual scheme was not available to the historical actor is scarcely relevant. It is enough that it should derive its operations from the domain of general applicability which is the science of language.

<p style="text-align:center">* * *</p>

My enquiry into the origins of abstraction therefore takes the form of a question which the foregoing discussion will have rendered comprehensible. Where do we find, in the field and period open to debate, the artist of the code? It goes without saying that Lévi-Strauss's cycle of code/message/myth is inconceivable without the crucial *meta-linguistic* stage, in which the artist 'comments upon and makes explicit the rules' of his discourse. If we are to interpret abstract art as having a morphology of this kind, we must pay special attention to the attempts to return to the foundations of plastic expression, to elaborate a new and binding code. And once this aspiration is expressed in these terms, it becomes clear that in Russian modernist art, with Tatlin and Malevich, such an aspiration is indeed to the fore. Tatlin, to begin with, expresses in the manifesto 'The Work ahead of us' (1920) all the salient points of a movement towards a new code. Initially he presents the *anomie* of artistic production in pre-modernist Russia: 'The foundation on which our work in plastic art – our craft – rested was not homogeneous, and every connection between painting, sculpture and architecture had been lost: the result was individualism...'[13] This crisis of expression, identified precisely as a lack of 'foundation' and descent into 'individualism', has resulted in the re-formulation of artistic aims, with a consequent generalisation of artistic means: 'The investigation of material, volume and construction made it possible for us in 1918, to begin to combine materials like iron and glass, the materials of modern Classicism, comparable in their severity with the marble of antiquity.' Tatlin takes care to sign this manifesto, not as an individual creator, but in company with three others who were at that stage helping him in the re-erection of his 'Monument to the Third International'. Evidently the text was intended to serve as a retrospective reference to the elaboration of the new codes, which had now left its

'laboratory' stage and was offered for general use in the new, post-revolutionary society.

Let us be more precise about this manifesto and the issues which it raises. Tatlin points to a founding moment in the recent past, the year 1914 'when "materials, volume and construction" were accepted as our foundation'. How are we to assess this claim, in relation to the 'code' stage? First of all, it is worth pointing out that the programme of 'materials, volume and construction' expresses, however crudely, a project which is strictly meta-linguistic in character. If language is (as Saussure expressed it) 'the domain of articulations', then Tatlin's reference suggests an articulation of visual art which substitutes new, but analogous terms for the proper terms of linguistics. Saussure defined language in terms of its sound element (the *signifier*) and its thought element (the *signified*) relating to one another as two sides of a sheet of paper: 'Linguistics then works in the borderland where the elements of sound and thought combine; their combination produces a form, not a substance.'[14] Tatlin reduces plastic expression to the terms of *material* and *volume*, and calls the combination whereby the material and non-material become form a process of *construction*. Secondly, however, we must bear in mind that to pick up this significant reference is to do no more than register the transformation which Tatlin's actual practice has brought about. The 'counter-reliefs' to which he makes reference in the manifesto would themselves allow us to trace the theoretical direction of his work (even though it is their photographic image which must, for the most part, content us). Tatlin's visit to Picasso's study in 1913 enabled him to take stock of Cubism at its furthest point of development: the assemblage of materials which mimed the pictorial organisation of the Cubist still life but did so through the use of fragments and 'found' elements which took on a new, metaphorical meaning in the work. Tatlin kept the assemblage, but jettisoned both mime

Below left
Pablo Picasso
Still Life, 1914
Relief,
$10 \times 18 \times 3\frac{5}{8}$
$(25.5 \times 46 \times 9.3)$
Tate Gallery, London

Below right
Vladimir Tatlin
Counter-relief, 1914

and metaphor. What is more, he used the radical principle of 'materials, volume and construction' to override all supposed consistencies of genre: his work was to proceed from three-dimensional relief, to hanging construction and eventually to the total supersession of the art work as such, unprotected by its generic safeguards.

Tatlin's affiliation and break with Picasso, his concern with new 'foundations' and his meta-linguistic programme, all qualify him to be considered an artist of the code. According to the same criteria, Gabo – quite apart from the respective value of his work – was not an artist of the code. His relation to Picasso was with an earlier phase in that artist's development, possibly with that series of female nudes following 'Les Demoiselles d'Avignon' which found their way to Russia and seem to be echoed in the planar emphasis of his 'Constructed Head' (1916). Nor did Gabo attempt at any stage the reductive formulation of Tatlin's 'counter-relief' – although he undoubtedly benefited from the demonstration of his colleague's rigour. In the case of Malevich, however, there is a very different argument to be sustained. It is not my concern to dispute between

Naum Gabo
Head No.2, 1916
$69 \times 52\frac{3}{4}(175.2 \times 134)$
Tate Gallery, London

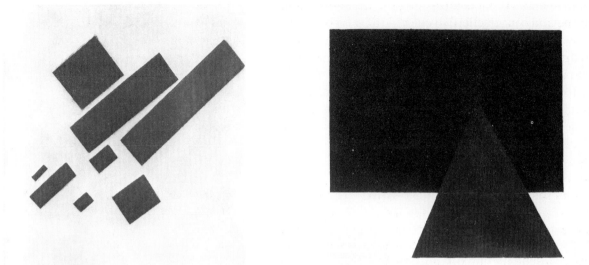

Above left
Kazimir Malevich
Suprematist Painting,
Eight Red Rectangles, 1915
Oil on canvas,
$22\frac{5}{8} \times 19\frac{1}{8} (57.5 \times 48.5)$
Stedelijk Museum, Amsterdam

Above right
Kazimir Malevich
Suprematist Painting,
Black Rectangle, Blue
Triangle, 1915
Oil on canvas,
$22\frac{1}{2} \times 26\frac{1}{4} (57 \times 66.5)$
Stedelijk Museum, Amsterdam

Tatlin and Malevich the claim to the leadership of the Russian avant-garde which both artists evidently made. What is more relevant is the fact that Malevich also undertook a deconstruction of the work of art as a preliminary to reconstruction. His work can be regarded, like that of Tatlin, as a meta-linguistic project, an attempt to codify the values of plastic art. But the 'code' which he succeeds in demonstrating is quite different from that of Tatlin. Indeed, if an artist of the code is necessarily concerned with writing the future history of art, then Malevich's prediction takes a wholly different direction to that of Tatlin.

In part, this difference can be identified in these artists' respective attitudes to illusion, and to the material means for creating illusion. Troels Andersen records how in two paintings dating from 1914, Malevich incorporated a wooden spoon as a collage element: at a later date, however, he removed the spoon and 'simply painted it on the canvas'.[15] As opposed to Tatlin, who programmatically rejected such illusory effects, Malevich retained the indefinite 'floating' spatial effect even when he dismissed all vestiges of figuration. What then did Malevich imply when he asserted in his manifesto 'To the New Limit': 'We are the first to come to the new limit of creation . . .'?[16] What, for Malevich, functioned as a 'limit' if it was no longer to be the literal identity of the constructor's material? The answer can be found partly in another manifesto, 'Non-Objective Creation and Suprematism', dated 1919. As Malevich asserts, with reference to his earlier writings on Cubism, Futurism and Suprematism from 1915 and 1916: 'The plane, forming a square, was the source of Suprematism, new colour realism, as non-objective creation.'[17] In other words, prior to being concerned with squares, or The Square, Suprematism is concerned with

the plane. And the plane can only exist in a *differential* relationship: it is defined, as plane, against the 'space' of the picture. Malevich's achievement as an artist of the code is to postulate, as a 'limit', the instance where the 'plane' becomes homogeneous with the surface and therefore negates itself. Hubert Damisch writes succinctly of 'the "infinite" white plane of Malevich, a prelude to the historical production of a new structure, a structure that this time is truly *dialectical*, unlike representational structure which was founded upon the "annihilation" of the support and not upon its negation'.[18] His comments define with exactitude Malevich's status as painter of the code.

We therefore arrive at a clear antithesis between the 'codifications' of Tatlin and Malevich. El Lissitsky, Malevich's pupil, graphically represents the Suprematist square as the 'zero' in the mathematical series. The art of the past is seen as following a regressive series (infinity … 6, 5, 4, 3, 2, 1, 0), while the art of the future will begin 'on the other side of the picture'[19] (0, 1, 2, 3, 4, 5, 6). The vertiginous optimism of this formulation helps us to understand, perhaps, why Malevich's problematic of surface and space is hardly developed in the ensuing period, apart from the work of the exceptional Blok group in Poland.[20] It could be argued that only in the past ten years, with post-minimal painting in America and such groups as Supports/Surfaces in France, have its implications begun to be drawn. On the other hand, Tatlin's principle of material construction, though inimical to the autonomy of the work of art, exerts an immediate and massive influence on the course of Russian artistic development. In a sense, Tatlin remains an artist of the code only so long as to consolidate the rupture with the past: he then reveals himself as an artist of the 'message', Jakobson's referential category. Even in the 1920 manifesto, which glances retrospectively at the meta-linguistic stage, he concludes by describing the result of his work as: 'models which stimulate us to inventions in our work of creating a new world'. Tatlin therefore represents, for our period even more than for his own, an art of mythical self-immolation. The transcendence of genres results in the negation not of the pictorial 'support', but of the very concept of an art work. Hence Rodchenko can write in 1920, with complete fidelity to Tatlin's practice: 'Down with art, which only camouflages humanity's impotence./The collective art of the present is constructive life.'[21]

Tatlin's example therefore suggests an accelerated progression through Lévi-Strauss's three categories. From the 'code' he passes to the 'message'. But he does not remain at the stage of the artistic 'model', in the utopia of function. Or rather his work is caught up, in spite of himself, in the mythical discourse of revolution. Tatlin's tower, borne through the streets of Leningrad in 1926 to celebrate the festival of the First of May, is no longer (in material or meaning) the tower erected at the Party Congress in 1920.[22] It is a scaled-down, squared-up version, as appropriate to the

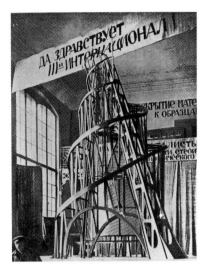

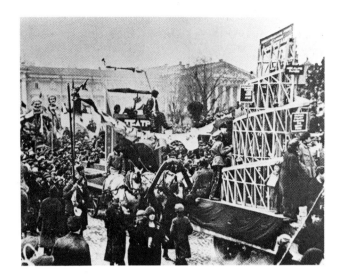

Above left
New Left Books emblem
reproduced original size

Above centre
Vladimir Tatlin
Model for Monument for the
Third International

Above right
The streets of Leningrad

mythic purpose as the miniaturised emblem of the same work which appears on the embossed covers of New Left Books. To put the point in another way, it is hardly surprising – indeed it is highly appropriate – that Tatlin's reputation has prospered so remarkably in the West when virtually no examples of his work have been seen, or are known to continue in existence. For Tatlin's impact today lies not within the terms of art as a language: it is maintained to the extent that his art, and his career as an artist, have been assimilated to the myth of 'revolutionary art'. That he has achieved immortality at such a price can only appear ironic.

If Russian art, with Tatlin and Malevich, supplies the most vivid examples of the 'coding' of abstract art in the modern period, there is hardly less interest in the emergence of the De Stijl movement and in the careers of its two leading artists, Piet Mondrian and Theo Van Doesburg. More clearly than in any other case, the paintings of Mondrian – after his transition to abstraction – form a single, homogeneous 'set'. Hence Max Bill can speak of 'almost two hundred pictures, whose structure resides in the fundamental principle of a rhythmic horizontal-vertical division of the picture space'.[23] Hence Anthony Hill can proceed from an inventory of this entire set to the hypothesis that topological symmetry is the consistent principle at work in Mondrian's structures.[24] But where does this leave the linguistic analogy? We can say immediately that Mondrian is exceptionally careful not to allow confusion on the level of the 'message'. While admitting the possible extension of Neo-plasticism into architectural form, he himself resolutely refuses to present the painting as a 'model' in Tatlin's terms. He thus illustrates what Adorno perceptively called the 'loneliness of constructivist painting and twelve-tone music': a loneliness which arises from the dialectical possibilities inherent in the very notion of abstraction:

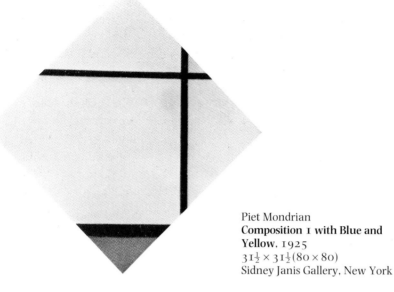

Piet Mondrian
Composition 1 with Blue and Yellow, 1925
$31\frac{1}{2} \times 31\frac{1}{2}(80 \times 80)$
Sidney Janis Gallery, New York

Illusion vanishes from the work of art as soon as the work begins to define itself in the battle against the ornament; in the process the position of the work of art in general gradually becomes untenable. Everything having no function in the work of art – and therefore everything transcending the law of mere existence – is withdrawn. The function of the work of art lies precisely in its transcendence beyond mere existence. Thus the height of justice becomes the height of injustice: the consummately functional work of art becomes consummately functionless. Since the work, after all, cannot be reality, the elimination of all illusory features accentuates all the more glaringly the illusory character of its existence.[25]

This inescapable dialectic becomes the identifying mark of Mondrian's painting. And it clearly has implications for the hypothesis of an artistic 'code' in his work. Bill is of course correct in identifying the 'horizontal-vertical' element as a consistent motif. On various occasions, Mondrian seems to wish to naturalise the opposition by equating it with, for example, the female and male principles, just as he identifies the 'transcendence' of the work of art with the realm of reality postulated by the Theosophists. But this theoretical effort always seems to result in a kind of 'mismatch', between principle and practice. Indeed such a failure is actually one of the signs of Mondrian's exceptional percipience. The crucial feature of his painting is after all the rigour with which it calls into question the very notion of 'code' or 'vocabulary' by its dialectical insistence. If Malevich established a dialectic of surface and support, Mondrian used his much more lengthy career to dialecticise the relations of colour and non-colour, matter and emptiness. As Max Bill suggests, his principle of 'dynamic

[138]

equilibrium' as expressed in a lozenge-shaped canvas like 'Composition 1/1925' even goes so far as to imply a relationship between space within the canvas and its infinite prolongation into the space beyond the frame.[26] What counts for Mondrian is precisely the multiplicity and interaction of *relations* – as in his statement: 'I declare that the relation is the principal thing.'[27]

Mondrian therefore resolutely avoids the sin with which Neo-Plasticism is vulgarly taxed: he avoids the fetishisation of the square. Indeed his calling into question of the terms of representation seems to echo the principle which Saussure declared as sovereign in linguistics: 'in language there are only differences. Even more important: a difference generally implies positive terms between which the difference is set up; but in language there are only differences *without positive terms*.'[28] By contrast, Mondrian's colleague Theo Van Doesburg runs the risk, and encounters the obstacles, of a didactic and propagandist approach to the furtherance of abstraction. As early as the editorial introduction of *De Stijl* (I.1, Oct. 1917), he declares himself as an artist of the 'message', calling for a new art which is 'based on a pure relationship between the spirit of the age and the means of expression'.[29] Both the title of the movement – *The Style* – and his proselytising role are derived from an evolutionary view of art, which is held to have reached the stage of generalised, 'monumental' expression, transcending its local and individual antecedents. The geometric vocabulary of Neo-Plasticism was thus the bearer of a Utopian message. But it had not yet passed through a stage of public theoretical codification. In the early 1920s, Van Doesburg responded to his sense that such a codification was essential in a number of ways. He quarrelled furiously with Lissitsky over the dating of Malevich's 'square', which he tried to nudge forward a number of years in order to secure *De Stijl*'s priority.[30] On a more substantive level, he promulgated the notion of 'Elementarism' which was to answer the artist's need for 'conscious control of his elemental means of expression'.[31] Curiously enough, the point of departure for this theory or 'systematic making of rules' was the exact converse of Tatlin's 1920 statement. Where Tatlin had deplored the loss of 'every connection between painting, sculpture and architecture' and sought for an undifferentiated, genre-transcending expression, Van Doesburg recalled the moment in 1916 when he had claimed as a prerequisite for the New Art 'separation of the different realms of formation'. 'Indefiniteness of means' seemed to him a mere 'remnant of the Baroque', and the 'Elementarist' manifesto was to demonstrate the separate 'figure-basses' of painting, sculpture and architecture.

It is worth pointing out the difficulties implicit in this formulation, which appear on one level to have been the most coherent attempt at positing a 'code' for abstract art. Tatlin, as we recall, established the meta-linguistic basis of 'material, volume and construction'. But he deliberately avoided

Van Doesburg
Elementaren Gestaltung from the cover of G, 1923

the problem of *syntax*. According to what principle were the 'units' of material (and materials) to be assembled? The answer can only be that they were assembled, selected and shaped according to Tatlin's intuition. Van Doesburg may seem at first sight to have overcome this deficiency. Construction, in his case, is not the literal juxtaposition of materials: it contrasts with 'composition', or the simple 'assembling' of elements, and posits instead the impulse towards 'synopsis, concentration'. Moreover, it would seem (again at first sight) to be firmly sited in the syntactic 'figure-basses' of the respective arts. But this impression dissipates if we look more closely at the intersection between theory and practice in the work of Van Doesburg. All of his theoretical drive in the 'Elementarist' period is towards 'division' and definition according to the abstract constants of geometrical form: towards clear expression of the 'unit' of construction. Yet this unit – graphically expressed in the illustrations to the manifesto – does not in fact function syntactically in his paintings. Van Doesburg's Neo-Plastic paintings effectively exhibit the same problematic of positive/negative, surface/space etc. that we have noted in the case of Mondrian. His meta-linguistic theory not only fails to take this into account: it actually obfuscates the question by giving spurious identity to the purely ideal construct of the 'elemental' means.

Yet Van Doesburg is wholly vindicated by an abrupt reversal in theory and practice that distinguished the last years of his life. In his manifesto of 'Concrete Art', published in April 1930, he asserts the 'universal' nature of an art that receives 'nothing from nature's given forms', and defines the problem of pictorial syntax in the following, shrewdly reductive terms: 'The picture must be entirely constructed from purely plastic elements, that is, planes and colours. A pictorial element has no other meaning than "itself" and thus the picture has no other meaning than "itself".'[32] If this

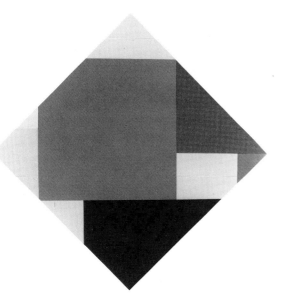

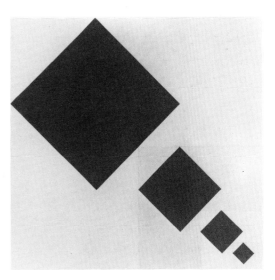

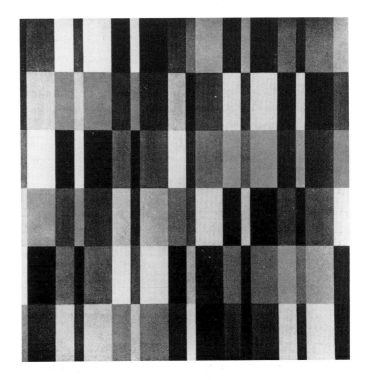

Above left
Theo Van Doesburg
Counter-Composition V, 1924
Oil on canvas,
39 × 39 (100 × 100)
Stedelijk Museum, Amsterdam

Above right
Theo Van Doesburg
Arithmetic Composition, 1930
Oil on canvas,
40 × 40 (101 × 101)
Mr F. Witzinger

Right
Richard P. Lohse
**Six horizontal bands of six
formally similar colour
groups**, 1950–1

statement had been accompanied by no transformation in practice, it would have been open to the same change as the earlier formulation. But in effect, Van Doesburg's 'Arithmetic Composition' (1930) signals the change in practice. 'Construction' here becomes a question, not of the generation from an ideal 'figure-bass', but of the regular progression of a form across the plane surface. In postulating the utopia of an art of 'purely

plastic elements', Van Doesburg throws forward a challenge which is only picked up in the post-war period, notably by the Swiss concrete artist, Richard Paul Lohse.[33] But he also liquidates to all intents and purposes the other utopia of an art of the message. For the pictorial element to mean no more than itself, it must slough off the architectural and social bearings of the 'model' stage. To put it another way, Van Doesburg's manifesto of 1930 signals the coming of an abstract art of the 'myth'; an art which foregrounds the plastic elements, accepting both the demise and the legacy of the heroic phase.[34]

<div align="center">* * *</div>

Up to this point, I have considered the contribution to abstract art of two Russian artists, Tatlin and Malevich, and two Dutch artists, Mondrian and Van Doesburg. I have not tried to show that abstraction forms a coherent language in the sense in which Kandinsky would have so argued. But this is hardly the point. Even an enthusiast of Kandinsky like Hugo Ball was content to answer his question of whether 'Kandinsky's paintings also have an objective psychological meaning' with the disclaimer 'Hardly'.[35] Nor have I attempted to prove that the theories of the artists under discussion present, either singly or in conjunction, a coherent justification for the 'language' of abstraction. What I have suggested, however, is that the criteria of linguistic status advanced by Gombrich and Lévi-Strauss, the public character of the sign and the principle of double articulation, are constantly reappearing, thinly disguised, in the theory and practice of such artists. I am not suggesting that this fact proves that abstract art was, indeed, a language. But I am certain that we can only imperfectly understand these artists if we neglect their concern with the 'code', their aspiration to the 'message' and their submission to the 'myth'. In other words, to pursue the question of a language in this context is not simply to trace an analogy, however imperfect, with the theoretical development and self-awareness of Saussurean linguistics. Nor is it merely to assert that abstract art, like every form of artistic expression, belongs within a tradition of representation. It is to direct a series of crucial questions at the morphology of modern art, questions which bring out the hidden and fascinating complexities of an apparently simple concept like 'abstraction'.

Yet there is a further issue which can hardly be dismissed at this stage. The notion of abstract art and that of the art of the 'code' are not of course synonymous. It could be argued plausibly that Cubism initiates the 'meta-linguistic' concerns of the artists under discussion, and that abstraction is simply a contingent sign of these concerns. Equally, it could be argued that Cubism is primarily the sign of a crisis in the perspectival system which had dominated Western painting from the Renaissance up to the time of Cézanne. By this token, the 'meta-linguistic' impulse would not necessarily be confined to abstract expression, since artists might react to the crisis of

perspective with other formal means. With this in mind, it seems worthwhile to consider the cases in art which most closely approximate to Lévi-Strauss's model: from Schönberg as composer of the message to Webern as composer of the code. We might class as an artist of the message Kandinsky, about whom Hugo Ball perceptively stated in the text already quoted: 'Cubism operates with grammar, Kandinsky with flexible inner necessity. His art aims at liberation and it embraces the age.' Equally we might take as the artist of the code, in an idiom as pure as that of Webern, Kandinsky's younger colleague Paul Klee. It is a striking characteristic of Klee that he does not adopt, except with his own modifications, the geometric constants of abstract art. Does this mean that he works with no meta-linguistic basis, that he merely supplies a personal poetry to the formal language of his predecessors? Surely not. As Anthony Hill has reminded us, the 'atoms' of form 'are simply *points*, and not the "squares, circles, ellipses and triangles"' associated with abstract art.[36] It is Klee's formulation of the 'code' through an 'atomism of the point' that demonstrates his divergence from Kandinsky, who continues to work with hypostatised geometrical figures – 'squares, circles, ellipses and triangles'. And in this respect, as Hubert Damisch explains at length, Klee deconstructs the perspectival space of the Renaissance, constructed as it is upon presumption of the unique vanishing point. 'In vain', writes Alberti in his *Della Pittura*, 'one draws the bow where there is no *point* at which to aim the arrow'.[37] For Klee, evidently, this more profound problematic

Paul Klee
Equals Infinity, 1932
Museum of Modern Art,
New York

supersedes and renders meaningless the supposed antithesis between abstraction and figuration.

What this implies, presumably, is that 'abstract art' cannot ultimately be regarded as a special case, defended by its partisans and apologists, proscribed by its antagonists. The issue is not abstraction or figuration, but a comprehensive review of the strategies of representation within which the appearance of abstract art forms, at a certain historical stage, the illusion of an exception. Arguably this can only be done if we examine the abstraction and 'construction' of the modern movement against the 'legitimate construction' of the Renaissance, that other high point of modernism. But to do so would also be to disengage another historical series, the history of figuration.[38] The place of the body in the history of painting, and the place of painting itself among other signifying systems, are connected themes that have barely begun to be investigated.

This invocation of the wider context against which abstraction must be measured leads me to make a further reservation about the status of this essay, and indeed of any contribution to the question of abstract art as a language. My strategy has been to deflect, rather than respond directly to the type of critique made by Gombrich and Lévi-Strauss. I would reject as utterly implausible the specific equations of form, colour and meaning propagated by Kandinsky. But I would equally question the broad condemnations of Gombrich and Lévi-Strauss, based as they appear to be on an understandably jaundiced reaction to the 'tachiste' or lyrical abstract art of the post-war period. The intermediate position seems to be an acceptance of the importance of morphology in abstraction. If we follow the pioneers of the Modern Movement through their very diverse careers, we find the same types of constraint operating upon the development of their artistic discourse. Analysis in terms of the code, the message and the myth could not claim to exhaust the significance of such work. But it perhaps helps to show that the development of abstract art was much more than a perverse and random process. And in so doing, it gives us new ways of assessing the importance of contemporary abstraction, which is only comprehensible (I would submit) with reference to a morphology of this type.

It may appear at this stage that my investigation has been nothing more than a plea for the acceptance of abstract art as a self-referential discourse. I have been concerned to show not so much that the abstract work has meaning, as that it simulates the structure of meaningful discourse and borrows its functions in a parasitic fashion. Of the different responses which could be made to this point, there is one which must be lightly sketched in – even though its full development would imply quite a different approach. Supposing that we accept the 'meta-linguistic' concerns of the early abstract artists, then what status do they have in other than artistic terms? Jackobson gives two instances of characteristic uses of

the meta-linguistic function: that of the sender of a message who is impelled to verify if the channel of communication is still open ('are you receiving me?'), and that of the child who is learning his mother tongue.[39] How can we explain, in cultural or philosophical terms, the constraints which led these artists to model their discourse upon this function? Obviously we need to look beyond the historical and circumstantial aspects of the early twentieth century. The First World War and the Russian Revolution exercise a massive and irreversible effect upon the artistic discourse of Modernism. But Cubism precedes the war, and the example of Cézanne precedes Cubism. Perhaps we could reflect, finally, on the brief poem by Pound which I quoted at the outset:

> This thing that hath a code and not a core . . .

Pound's meditation on his art takes the form of epistemology. The 'Object' of the title is the poem itself, in its new-found distance. But the implied reference is to the philosophical debate on the relation of subject and object which had preoccupied German philosophy from the time of Kant onwards, and infiltrated itself into the sphere of English aesthetics with Ruskin, Arnold and Pater. The implications of the subject/object relationship for representation, and in particular for the traditional theory of *mimesis*, were indeed far from absent in the debates which accompany the genesis and development of abstract art. The Russian critic Nikolai Taraboukine went so far as to sketch out a history of recent painting in which the various schools were differentiated primarily in terms of their implicit allegiance to different philosophical positions: the Impressionists as 'empiricists and solipsists in descent from Hume', the Cubists as followers of Kant in their radical revision of the subject/object dichotomy and the 'Res-ists' of post-revolutionary Russian art as 'Intuitionists of the type of Bergson'.[40] However confusing Taraboukine's categories may appear, they testify to an essential point about the rise and development of abstraction. The concern to find a new 'code' did not create the crisis of representation. On the contrary, it was a response to such a crisis, which was already well under way in literature and portended a new epistemological configuration: a new way of prefiguring the map of knowledge and the subject's relation to the external world. Abstract art, which achieves the break with *mimesis* in a particularly salient and polemical way, has for that reason become an obvious whipping boy, and indeed is still – from various quarters – under attack. To defend abstract art is, however, not to defend a genre or a movement. It is to accept responsibility for scrutinising the relationship of art to knowledge in the modern world.

The ratification of abstract art

Charles Harrison

'On their voyage of discovery to Australia, a group of Captain Cook's sailors captured a young kangaroo and brought the strange creature back on board their ship. No one knew what it was, so some men were sent ashore to ask the natives. When the sailors returned they told their mates, 'It's a Kangaroo'. Many years later it was discovered that when the aboriginals said 'Kangaroo', they were not in fact naming the animal, but replying to their questioners, 'What did you say?'

(The *Observer* magazine, 25 November 1973; quoted by Ian Hacking in *Why does Language matter to Philosophy?* Cambridge University Press, 1975.)

It must be clear that abstract art involves a reduction of some sort in the range of correspondences which a spectator can make between a given representation or artefact and the world. Much, or almost all, that conventionally served to establish the possibility of such correspondences was abandoned in non-representational painting. It has been suggested (e.g. by Gombrich) that a body of attendant theory developed to 'compensate' for the reduction of representational content, and it is indeed a commonplace statement that abstract art has more theory than representational art. This statement is false, however. What is true is that abstract art and some attendant discourse are not driven apart in practice by realistic considerations or by those descriptive limits of language which are in fact the logical margins of pictures.

It might be held by some that the history of art is a narrative which includes and connects certain things which are seen as having 'stood the test of time', where the property of having 'stood the test of time' is seen as a confirmation of the status of some thing as a work of art. How has it come about that according to this view the paintings of e.g. Malevich, Mondrian and Kandinsky appear to have stood the test of time, when they so manifestly failed to satisfy the criteria according to which the art of painting had itself antecedently been valued?

In the absence of defensible theory it could only be because transcendental consumership obliterates or obscures any significant differences between the realism[1] of representational art and the idealism of abstract art; i.e. connoisseurship, being entirely promiscuous, will enable *anything* to stand the test of time (save that by which transcendental consumership would itself be negated, to the extent that the meaning of standing the test of time was radically changed). It might otherwise be thought that assent

Kazimir Malevich
Black Square, after 1920
Oil on canvas,

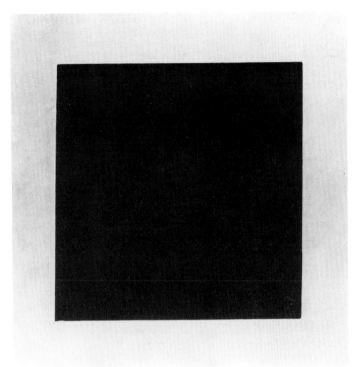

could not readily have been given to any ambitious claim for abstract art without some strong theoretical support for that claim. To say that something is non-representational is after all to say that in order to stand for anything it has to have an external explication of some sort.

What we are saying[2] is that the history of the ratification of abstract art is not so much explained as confused by the fact that theoretical (or pseudo-theoretical) justifications *were* proposed to compensate for the absence of or to supersede representation in the artefacts of the artists concerned. The essence of the confusion is this: unless blinded by the habits of connoisseurship, one might expect that critical attention would have been focused not upon the artefacts of abstract art, which could, after all, be thought to stand or fall along with their supporting justifications, but upon the justification themselves; yet historically this was not the case. Documents such as *Uber das Geistige in der Kunst* do not seem to have been treated at the time of their publication as if they were speculative and discursive, open to analysis and criticism. And in a sense they are not. They are generally assertive and dogmatic with little internal discursive detail. They seem nevertheless to have been accepted as if they *were* successful arguments in favour of those artefacts they purport to justify. This takes some explaining, given the patent logical and historical absurdity of much of what is asserted in these writings.

The rhythm of relation of colour and size makes the absolute appear in the relativity of time and space – Mondrian 1919

A chair, bed, and table are not matters of utility but rather, the forms taken by plastic sensations, so the generally held view that all objects of daily use result from practical considerations is based upon false premises. – Malevich 1927

The hidden construction may be composed of seemingly fortuitous shapes, without apparent connection. But the outer absence of such a connection is proof of its inner presence. Outward loosening points toward an internal merging. This holds good for drawing and painting alike. – Kandinsky 1912

If steadily gazed at in any geometrical form, yellow has a disturbing influence; it pricks, upsets people, and reveals its true character, which is brash and importunate. – Kandinsky 1912

etc. etc.

We might ask: What kind of history can there be, what kind of practice, such that passages like these are left unridiculed as component parts of classic texts? Yet what passed and still passes as comment upon these texts has been more like exposition, or textual analysis, than criticism. They are treated as literature, as reified lumps of enlightenment, objects of mere documentary and historical interest, rather than as instances of arguments possibly open to a purposeful refutation or confirmation indexed to some possibly non-participatory teleology. Those who saw themselves as participants in whatever debates there might have been did not include among their number anyone equipped to make a purposeful examination of the logic of the justifications; or if there were any so equipped they were sufficiently mystified by the projected picture of artistic practice as to see it as somehow immune to the operations of rational intelligence. This is to say that, despite the propagandising of a rapprochement between art and science by such as Lissitsky, Rodchenko and Van Doesburg, the discursive context of art practice was already, in the early twentieth century, highly insulated from those practices in which men actually did put questions to nature and did conduct logical enquiries in the search for substantive content and detail in the utterances of others.

What has thus happened is that the artists' writings, along with their works, have been seen to or have been allowed to stand the test of time and thus to have been validated as aspects of art practice continuous and consistent with the works themselves. But to stand the test of time is not the same as to stand up to scrutiny.

On February 19, 1914, at a public lecture, I rejected reason. – Malevich[3]

It is because our painting is still at an elementary stage that we are so little able to be moved by wholly autonomous colour and form

composition. The nerve vibrations are there (as we feel when confronted by applied art), but they get no further than the nerves because the corresponding vibrations of the spirit which they call forth are weak. When we remember, however, that spiritual experience is quickening, that positive science, the firmest basis of human thought, is tottering, that dissolution of matter is imminent, we have reason to hope that the hour of pure composition is not far away. – Kandinsky 1912

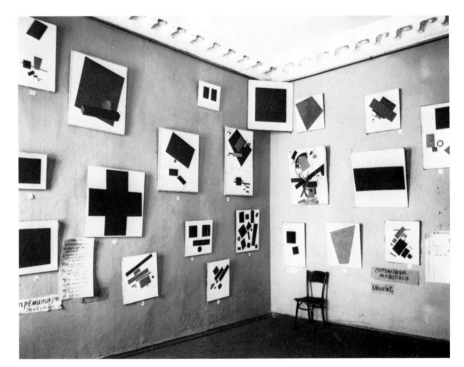

10. The Last Futurist Exhibition the Dobychina Gallery, etrograd, December, 1915

The bathetic irrationalism or sheer unintelligibility of the artists' pronouncements has been no bar or hindrance to their documentary significcation. Nor should it be. People often do not know quite what they are doing. But irrational or unintelligible blather is not to be confused with speculation. Blather helps to generate objects (both critical and first-order 'artistic') and in that respect it is immutable and incorrigible, whereas speculation faces the prospect at least of *a priori* refusal or refutation. Blather is a feeble means of production, however, unless the grounds of its incorrigibility have a material force. What we are offered here is pictures and documents which are proposed as similarly immutable, similarly immune to refutation, but where the relation of the one to the other is proposed as a means of justifying correspondence to reality. By now, it seems, they have entered history together. The writings are seen as incorrigible in the sense that the 'authentic text' of a Shakespeare play

becomes incorrigible; as for the paintings, they are accorded the status of religious relics (however scruffy the pigges bones may turn out, in fact, to be).

We might speculate as to what could have happened if determined attempts *had* been made to subject those texts to some scrutiny of their situational logic. Such speculation is ultimately idle however. In considering the ideological implications and ramifications of early abstract art we are confronted, whether we like it or not, with the consequences of the gradual and virtually uninterrupted expansion, over the past sixty years or so, of an area of ligitimation; with the end results, as it were, of a game of Chinese whispers. The consequences of this expansion are to be experienced not as objective properties or valuations of a set of objects plus a body of discursive but historical text, but rather as determining features of our intellectual environment. The 'history' of abstract art, that is to say, is to be sought in the locale of those conversations of which it is currently the subject.

We return to the question of how it has come to have such a history. If correspondence to the real world is, finally, the arbiter of cognitive significance, then it seems clear that those aspects of ideological production which will not stand up to criticism in respect of their correspondence must have some other means of becoming internalised by people if they are to have any kind of life in culture. This entails an heuristic[4] of some kind; there must, in other words, be some means by which people learn or are induced to believe in the value of that production.

Can we be sure that this is the case with abstract art? The status of abstract art as somehow 'non-representational' has always been open to doubt. We don't mean by this to suggest that a given abstract painting will represent in the sense that it will be a picture of x where x plays a significant role in a causal chain leading to the production of that picture; rather we can say that the painting might 'resemble' something and *ex post facto* that might be significant (to someone); or (and this may reduce to the same or its near neighbour) that it might 'represent' in the sense that it might be formed and articulated in such a way as to be 'read' as representing; or it might be thought of as 'text', albeit according to a now somewhat discredited model. The conclusion seems to be as follows: either (a) the full-dress text analogy will stand up, which surely it will not (even with the assistance of the quasi-aesthetic pseudo-systems of semiotics) in so far as that analogy is the product either of a trivial sense of 'text' or of some kind of illicit formalism (a confuting of two different senses of 'read'), or (b) what we are left with is some species of merely adventitious correspondence, a reflection of something no doubt in so far as any production can be seen as determined at some level, but epistemologically blind nonetheless. 'I can see x as y,' is not, as it stands, a statement of much interest.[5]

Piet Mondrian
**Composition: Bright Colour
Planes with Gray Lines**, 1919
Oil, $33\frac{1}{8} \times 33\frac{1}{8}$ (84.2 × 84.2)
Kröller Müller Museum, Otterlo

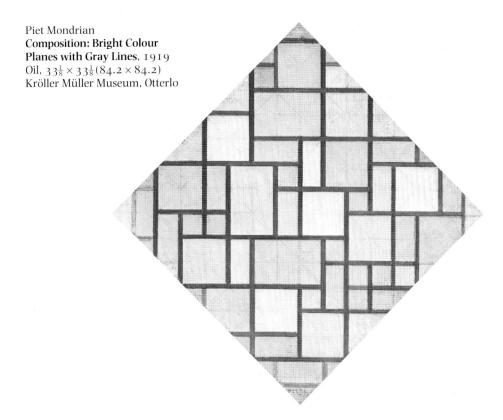

It does thus seem that abstract art and its discourse is without some definite arbiter of cognitive significance which is even marginally within the realm of some defensible realism. The production and its justificatory support, that is to say, is not treated – cannot be treated – as open to possible refutation. It follows that abstract art and its means of delivery or justification are merely dogmatic, formal and authoritarian ideology.

> A true, absolute order in human society could only be achieved if mankind were willing to base this order on lasting values. Obviously, then, the artistic factor would have to be accepted in every respect as the decisive one. – Malevich 1927

Or, if you're not in tune with the universe as we are, then you're not so much at fault as dead. It is by means of a dogmatic heuristic that abstract art secures itself. It must have heuristic rather than history as fundamental. We would say that the historicity of abstract art is *soi-disant*, reducible to a formality or set of protocols.

An observation to support this view is that interest in and articulation of abstract art has generally been well behaved – a form of affirmative consumership. To subject abstract art to ridicule, on the other hand, and thus to proffer robust evidence of the *ad hoc* nature of the concepts involved, would be to put beyond the Pale, as one might be who took a sardonic atti-

tude towards the objective mind-independent reality of the experimental sciences. Of course, the truth value of seeing physics as parody is not the same as the truth value of seeing abstract art as parody, or as absurdly adventitious. Socially and psychologically, however, the two positions might seem identically unsightly. That this is so, we would suggest, is due to the fact that epistemologically weak ideology may characteristically be powerful agency. That is to say, the dominance of an heuristic implies a powerful material basis from which that heuristic is generated. (Twentieth-century history provides some palpable illustrations.)

This is tantamount to saying that there are some social concepts which are not susceptible to the kind of *ad hoc* refutation that others are; i.e. that we are not just talking about interests, we are asserting some ontological independence for that which determines those interests. We are not, in other words, suggesting the existence of a conspiracy by means of which abstract art was established as other than adventitious; we are rather saying that the claim that abstract art has an objective history (a history independent of the minds of its consumers and its subjects) reflects the involvement of bourgeois ideology with heuristic; and that the success of the claim reflects the power of agency which invests powerful heuristic. People can be fooled (or can be made to make fools of themselves).

One of the uses of an heuristic to an epistemologically weak ideology – as we would say the ideology of abstract art must be, for the reasons given above – is that it defeats or mimics history. In the manner of heroin it mimics all the molecules that metabolically history would create. It 'excites but does not inform'.

Is it then merely adventitious that we are talking about abstract art at all? Can we claim that abstract art is at least vivid in some way in relation to the issue of correspondence to reality? Or, to put the question another way, does the relation of heuristic against history somehow reflect the relatively powerful referentiality of representational art in relation to non-representational art? i.e. is representational art somehow more powerfully tied to history than it is under-written by an heuristic? In looking at abstract art are we looking at something which is symptomatically vivid as an illustration of some kind of defeat of history by heuristic?

The relation 'picture of' is powerful. The logical unpacking of that relation *vis-à-vis* a representational work is more materially powerful than it is in the case of abstract art. The former involves or implies at least the marginal existence of causal chains between the world and that which is represented. The unpacking of abstract art cannot avoid the matter of agency in dealing with that causal chain. Abstract art involves logically powerful reference to its own agency, and this reference is given a separate logical status and existence from reference to the non-agental causality. Or, to put it another way, the sense of the force of subjective 'insight' is divorced from examination of the relation to the world.

Under Suprematism I understand the Supremacy of pure feeling [*sic*] in creative art. To the Suprematist the visual phenomena of the objective world are, in themselves, meaningless; the significant thing is feeling, as such, quite apart from the environment in which it is called forth. – Malevich 1927

All means are sacred which are called for by internal necessity. All means are sinful which are not drawn from inner necessity.
– Kandinsky 1912

Precisely by its existence non-figurative art shows that 'art' continues always on its true road. It shows that 'art' is not the expression of the appearance of reality such as we see it, nor of the life which we live, but that it is the expression of true reality and true life . . . indefinable but realizable in plastics. – Mondrian 1937

It might be argued that this assertion of a 'true' (subjective) reality, independent of or in contradistinction to 'the appearance of reality as we see it' or of 'the life which we live', is the essence of the early abstract art theorists' sense of Kant's Copernican revolution: the recognition of the part played by subjectivity; i.e. that objective knowledge presupposes knowing subjects. But Kant was in a position properly to organise the relationship between reality and subjectivity, and not to have to make absurd ellisions, conflations, psychologisms and pseudo-phenomenologies around that relationship. His philosophy is at least capable of standing for a realism of some sort. The transcendental argument of Kant, in so far as it presupposes that knowing subjects have a practice in the world, is not a solipsistic argument; neither is it an argument for agental solipsism; it cannot be used to defend the megalomaniac ambitions of agency ignoring the world in its search for the 'spiritual', for 'unity' and for the 'universal'.

There is an old and a new consciousness of time.
The old is connected with the individual.
The new is connected with the universal.
The struggle of the individual against the universal is revealing itself in the world war as well as in the art of the present day.
The war is destroying the old world and its contents: individual domination in every state. – Manifesto 1 of De Stijl 1918

Art is a universal and real expression of creative energy, which can be used to organise the progress of mankind; it is the tool of universal progress. – Statement by the International Faction of Constructivists 1922

How do we offer evidence to support our view that the historical property of abstract art is actually illusory, that abstract art is historicistic, its concept of progress merely self-validating? Presumably by showing that its operations are dogmatic, formal and authoritarian and not actually progressive, except in so far as the concept of progress is itself formal. Evidence

for this would be provided if one could demonstrate that the thematically historical explications of abstract art are merely formal or historicist. The search for such a demonstration seems like a project of some urgency.

We should make it clear at this point that we are assuming the ultimate *absorbtion* of all abstract art theory into a formalistic dogmatism. We are not asserting that all theoretical writing in support of abstract art is internally dogmatic. Most of it is. Some of it, perhaps, is not. The historical circumstances in which abstract art was produced in Russia might be thought to provide some evidence to counter our assertions regarding abstract art in general. It does seem, for instance, that the debates conducted at the Vkhutemas (as represented even in such self-justificatory and anti-Productivist accounts as Gabo's) were debates on historically substantial issues and that they were invested by a productive sense of doubt as to the validity of an idealist position. There is a significant sense in which the actual historical content of these debates was and remains opaque to scrutiny from liberal cultural interests – a sense which is consistent with the virtual exile of Kandinsky and with his self-transformation into a successful pan-European modern artist. (Given this opacity in the area of historical debate – a barrier to one means of consumption – it is not surprising that we should be presented, however unintentionally, with the resurrection of e.g. Rodchenko as the technical precursor of subsequent styles in modern Western art, a kind of Abstract Expressionist before there could be Abstract Expressionism, as if there were meaning and virtue in the anticipation in Russia in 1920 of the technical concerns of American art in 1950.)

Wassily Kandinsky
Composition, 1916
Watercolour,
$8\frac{3}{4} \times 13\frac{1}{4}$ (22.4 × 33.7)
Kunstmuseum Bern,
Hermann and Margrit Rupf
Stiftung

But the subsequent history of Russia cannot be used either to validate the (analytically anti-materialist) assertion that the artists had the revolution first and somehow authentically, or to turn e.g. the Productivists into the heroes of a leftish art history. The fact that abstract art is not approved and has not been approved in Russia since Stalin's aesthetic big moment is neither here nor there. The pseudo-theoretical rantings of a set of monstrous philistines (Stalinist baddies) do not turn the liberal idealist defenders and producers of the objects of these rantings (Constructivist goodies) into the practitioners of a revolutionary (*in fine* non-idealist) art, or for that matter, into representatives of much more than a social axiology permitting the growth and proliferation of a formalist heuristic. That the tekne of abstract art, and the aesthetic of this art, could be adapted to 'Productivism' (in certain instances) is not a matter of great historical or cognitive depth. The *aesthetics* of a 'revolutionary' are matters of entirely *formal* necessity. They get a practical twist when someone wants to use products with a 'powerful' aesthetic purport to mark or signify some sort of difference or change. But arguing about symbols of this kind is a weak relative of a sort of 'logical' relativism.

In paraphrasing Tatlin to the effect that he and his fellow artists 'emphasised on the last day of 1920' that 'the Revolution of 1917 had been anticipated by a revolution in pictorial methods that could be dated as early as 1914', the author of *The Tradition of Constructivism* is compounding an error.[6] Tatlin was in no position to emphasise any such thing, for it could not be true.

Abstract art discourse keeps the subject alive as a sort of shrivelled Gallilean Simplicio. No discourse is objective if it has to be seen as 'held in the heads' of privileged individuals whose practice is distinct from others' by virtue of some exotic mental operations. Knowledge can be conceived as sets of sentences organised in various ways, but this entails the possibility of some kind of transformation through reorganisation. The discourse of abstract art is 'objective' only in a pietistic sense: its history can be written, but only by members of its congregation. For others its 'sentences' must be seen as only radically translatable; their sense, that is to say, is not so much transformed as abolished by paraphrase or reorganisation. Objective discourse implies real historical investigation. The soi-disant history of abstract art cannot include or imply such investigation, lest its heuristic, its formality, fly apart at the seams.

Such errors as the one quoted above are the fabric of the situational logic of abstract art. We are reinforced in our belief that it is high time (unless it is too late) to initiate some investigation of the discourses of abstract art as extreme historical vagaries. If someone does begin, the tools will not all come from one place.

Cubism and the possibility of abstract art

Christopher Green

Many of the paintings made by Picasso and Braque in 1911 and 1912 defy simple interpretation. To the uninitiated, even still, they can seem abstract and indeed they were an important stimulus to much genuinely abstract painting. Yet, their abstractness is merely a disguise, however elaborate, designed to be slowly but surely penetrated and often behind them lie simple beginnings where their subject was utterly clear. 'The Model' (plate 10) is such a painting. Without its title even an eye well educated in the quirks of Picasso's figure-styles at this time would find little to encourage the idea of a model but, set searching by the title, those pink surfaces, those suggestions of a head, an eye, the bend of an elbow assemble the fragments of such an idea. And it is possible to know for certain what kind of simple figurative beginning the painting had, because close relatives, whose relationship cannot be doubted, survive in ink drawings made by Picasso the same summer as the painting, in 1912 (fig.1). From what might be called a witty variation on the pin-man Picasso has arrived at an architecture of planes which defies interpretation but which retains just enough of its figurative beginnings always to tempt interpretation.

If by abstract painting in its purest sense we mean painting which starts and finishes with no reference to subject-matter, how does such a painting as Picasso's 'The Model' relate to it? The starting-point here is undeniably in the composition's subject-matter; it is a schematic representation of a figure. Yet, this is not a representation arrived at in direct response to any particular figure posed for the artist; it is a simple, though highly original, symbol for a figure which has been invented by the artist. Its originality distinguishes it from the typical pin-man symbol but it relates to the figure in much the same way. Writers on Cubism have tended to distinguish be-tween an 'analytic' and a 'synthetic' approach to the subject in the making of Cubist pictures.[1] By analysis, they have meant the breaking down of a subject into its component aspects, usually as the direct result of obser-vation; by synthesis, they have meant the building up of new, invented configurations which can stand for a subject without any dependence on observation. 'The Model' was synthetic from the beginning and therefore, though it started with a transparent statement of its subject, it did not depend on the appearance of such a subject even at the outset. Braque's mode of working in 1911–12 was rather different from Picasso's, involv-ing entirely non-representational elements from early on in the process, but he too arrived at images whose apparent abstractness is subverted by

1. Pablo Picasso
Guitarist with Sheet of Music,
1912
Pen and ink, $5\frac{1}{8} \times 3\frac{3}{8} (13 \times 8.5)$

hints conjuring the presence of a subject, and whose starting-point is in synthesis, not analysis.

From its earliest years in the art of Picasso and Braque through into the 1920s, Cubism was founded on a deep hostility to art as the counterfeit of nature and a deep faith in the ability of painters to invent their own pictorial structures independent of nature. As early as 1908 the poet, Guillaume Apollinaire, already the intimate of Picasso and Braque, had written of flame as 'the symbol of painting', because of its capacity to transform 'into itself whatever it touches', and had written of artists who 'esteem their purity in the face of natural forces'.[2] Yet, this essentially Symbolist view of the gap between art and nature did not imply the necessary rejection of the subject altogether. While Picasso and Braque were making compositions like 'The Model', they were reading with great enthusiasm, guided by their poet friends, the late writing of Stéphane Mallarmé. It was just such a balance as Mallarmé had achieved between the pure manipulation of words for their rhythmic and musical qualities

and the evocation of an elusive yet insistent idea of subject-matter, that Picasso and Braque aimed at in their manipulations of line, tone and plane. Commentators close to them at the time (Kahnweiler, Raynal, Reverdy) later always stressed the relationship between Cubism and the poetry of Mallarmé, and one is struck by the strong Mallarméan flavour of comments made by Picasso at the end of his life on the paintings of 1912. 'At the time,' he told William Rubin, 'everyone talked about how much reality there was in Cubism. But they didn't understand. It's not a reality you can take in your hand. It's more like a perfume – in front of you, behind you, to the sides. The scent is everywhere, but you don't quite know where it comes from.'[3]

The desire for a tension of this kind between apparent abstractness and suggested representation naturally meant that Picasso's and Braque's hostility to the imitation of nature would not lead to abstract art, and indeed the synthetic way they worked greatly reduced the temptation of the abstract. For, as we have seen, they were never dependent even at the outset on the appearance of their subjects; their art was, in fact, assured of its purity however clearly it began in representation. It was fundamentally and in every way anti-naturalistic. Perhaps more important, for artists who tended to progress by the practice rather than the theory of making paintings, the decision to set representation and its opposite in direct conflict on the canvas opened up infinite possibilities for future change, as the subsequent, astonishingly varied and unpredictable history of Cubism was to demonstrate. From 1908 Apollinaire dedicated much creative energy to the celebration of man's ability to create, to transform the world as does the flame. Picasso's and Braque's Cubism carried on his celebration of the artist as inventor, and it did not require total abstraction to make plain either its purity or its inventiveness.

Yet, for a while Apollinaire, if not these two painters, *was* tempted by the possibility of a kind of purity in painting altogether free of representation and, with him, so too was a small group of artists in Paris, all of whom knew him and all but one of whom learned a great deal from Cubist paintings like 'The Model'. In February 1912 Apollinaire published a prophetic essay called 'Du sujet dans la peinture moderne', where he wrote of the coming of an art without subject-matter, summing up thus: 'The young painters of the extremist schools wish therefore to make pure painting. Here is a completely new plastic art. It is only at its beginning and it is not yet as abstract as it would like to be.'[4] By the autumn of 1912 there were certainly three artists in Paris who had come close to what Apollinaire called 'pure painting'; they were Robert Delaunay, Marcel Duchamp and the Czech artist František Kupka and, in a lecture given at the avant-garde Salon de la Section d'Or and in slightly later writings, the poet identified a whole group who were moving in this direction, attaching the name Orphists or Orphic Cubists to them. He named Picasso as one,

perhaps because the Spaniard had done so much to make such a development possible, and otherwise Delaunay, Duchamp, Fernand Léger and Francis Picabia. Kupka was not included but a recollection by one of Apollinaire's audience at the Section d'Or lecture maintains that the poet's remarks about Orphism were made actually in front of paintings by Kupka. This new art was defined as: 'The art of painting new structures with elements which have not been borrowed from the visual sphere, but have been created entirely by the artist himself'[5] and Kupka perhaps more than any of those named had produced work which fitted this definition, as we shall see.

Picasso aside, all these 'Orphists', and Kupka too, certainly did pursue the possibility of art without representation during the period 1912–14 but, except for Kupka, their pursuit was surprisingly brief and they rarely achieved a purity in their painting comparable with that achieved outside Paris by such as Mondrian or Malevich. French Cubism in the form it had reached by 1912 was one major stimulus behind the development of both Mondrian's and Malevich's mature abstract styles, so the question remains: why did it not produce a lasting move towards abstraction in Paris? The Orphists were not a closely knit group with interlocking ideas about art and this is not, therefore, a question best answered by considering them together. It is better to take each attempt to make 'pure paintings' separately before hazarding generalisations and before confronting these generalisations with the particular and extraordinary case of Kupka, the artist who was left out, and who was indeed so much the exception.

The youngest of the artists named as Orphists by Apollinaire was Marcel Duchamp; in 1912 he was twenty-five years old. He, least of all of them, could have been called a pure painter at the time, and his was the briefest, least committed pursuit of purity.[6] It was a pursuit which paralleled and at a few points touched that of Picabia who, from the autumn of 1911 at the latest, was a close and constant friend.

Duchamp's elder brothers were the painter Jacques Villon and the sculptor Raymond Duchamp-Villon and during 1911 and 1912 these two were the centre of much activity at Villon's studio in the Parisian suburb of Puteaux. Here on Sundays there met critics, poets and artists determined to see Cubism through to new conclusions. Delaunay, Léger, Picabia, Gleizes, Metzinger, Apollinaire, they were all to be seen there from time to time and the talk ranged from the philosophy of Henri Bergson to the possibility of a fourth dimension. Duchamp was undeniably stimulated by what he heard in his brother's studio, but his lack of years and the fact that he lived out on a limb at Neuilly seems to have cast him to some extent in the role of an observer looking in from the side-lines. He was, however, a remarkably acute observer of Cubism, an observer capable of his own, original conclusions.

Duchamp's first conclusions about Cubism were destructive. Picasso and Braque may have built their paintings up synthetically from simple representational beginnings, at least after 1911 (an essentially constructive process), but what Duchamp saw in their painting was an invitation literally to destroy the visible world. His most graphic reply to this invitation was the small painting of 1911, 'Yvonne and Magdeleine Torn Up' (fig.2), where the title straightforwardly tells us what has happened to his two sisters in the making of the composition (or perhaps decomposition is better). From the interviews which he later gave with such expansive grace, it is clear that the involvement with movement which so occupied Duchamp in 1911 was motivated as much by the desire to dislocate the human-figure as by any other aim. As he told James Johnson Sweeney *à propos* his two depictions of a 'Nude Descending a Staircase', his interest 'was closer to the Cubists' interest in decomposing forms than to the futurists' interest in suggesting movement'.[7]

2. Marcel Duchamp
Yvonne and Magdeleine Torn Up, 1911
Oil on canvas,
$23\frac{5}{8} \times 28\frac{3}{4} (60 \times 73)$
Philadelphia Museum of Art
The Louise and Walter
Arensberg Collection

It was as the direct outcome of these attempts at 'decomposition' that he came as close as he did to 'pure painting' in 1912. 'Like most of the new painters,' wrote Apollinaire in the autumn of 1912, 'Marcel Duchamp has abandoned the cult of appearances.'[8] He had in mind a clutch of drawings, one of which is 'Virgin No.2' (fig.3), and three paintings, 'King and Queen Surrounded by Speedy Nudes', 'The Passage from the Virgin to the Bride'

Above left
Marcel Duchamp
Virgin, No.2, 1912
Watercolour and pencil,
$15\frac{3}{4} \times 10\frac{1}{8}$ (40 × 25.7)
Philadelphia Museum of Art
The Louise and Walter
Arensberg Collection

Above right
Marcel Duchamp
**The Passage from the Virgin
to the Bride**, 1912
Oil on canvas,
$23\frac{3}{8} \times 21\frac{1}{4}$ (59.4 × 54)
The Museum of Modern Art,
New York

(fig.4) and 'The Bride', all done by Duchamp between the spring and autumn of 1912. 'The cult of appearances' indeed had little to do with these works, and Duchamp himself maintained that they were the product of his compulsive need to 'reduce' the human-figure to the barest elements of painting – 'a dot, a line'. Yet, even Apollinaire was aware of the fact that behind images as abstruse as 'The Passage' and 'The Bride' lay the 'imprints', the 'traces' of 'beings'.[9] Duchamp never thought of these paintings as wholly abstract; they retained a tension between the abstract and the real not unlike the Cubism of Picasso and Braque. The element of representation contained, however, was of a different and personal kind, a kind that made inevitable Duchamp's final rejection not merely of 'pure painting' but of painting itself.

His use of titles betrays the nature of the difference. Apollinaire wrote of the title setting conceptual limits for the painting, scotching literary associations.[10] In fact, Duchamp's titles liberate these paintings from conceptual limitations, allowing the mind to take up the hints of bodily content, male and especially female, and let the imagination ride free in pursuit of the flux of mechanical, organic and sexual associations released. 'King and Queen Surrounded by Speedy Nudes', 'The Passage from the Virgin to the Bride' and 'The Bride' were the product as much of a fertile literary imagination as of an inventive pictorial imagination. Duchamp was another avid reader of Mallarmé but already by 1912 he had taken up

rather different enthusiasms, notably the work of Raymond Roussel and Jules Laforgue, enthusiasms which went with a feeling for words and for the fantastic interaction of human and mechanistic imagery not easily reconciled to 'pure painting'. The essentially literary way in which his imagination confronted the world by the autumn of 1912 comes across in a short piece written after a night-time drive from the Jura to Paris in the company of Apollinaire, Picabia and Picabia's wife, Gabrielle Buffet. For Duchamp, Picabia's speeding car is a child with five hearts and the road lit by the headlamps is a comet with its tail going before, an appendage to the child, absorbing and destroying the road.[11]

Besides literature, Duchamp was already diverting his mind along routes opened up by mathematics and science, and certainly in the last of the 'pure' paintings, 'The Bride', he attempted to embody the idea of the fourth dimension, presenting his mechanical organisms in a palpable if ambiguous space, as if they were the shadows, in a three-dimensional world, of beings and processes only fully perceptible in a further dimension.[12] The drawings and paintings of 1912 were an attempt to communicate both his literary and his quasi-scientific ideas by direct visual means. It was an attempt that was bound to fail, a fact demonstrated by the need for verbal explanation before a four-dimensional interpretation of 'The Bride' is possible; and by the end of 1912 Duchamp knew this for himself. He was already involved in the planning of his 'Large Glass', a work which was to make the verbal and the visual entirely interdependent, and within a few months he had 'chosen' his first 'ready-made', the notorious bicycle-wheel. His half-hearted dabbling in pictorial purity had been replaced by contempt, for nothing could reject such activities with more succinct finality than the ready-made – something which represents nothing other than itself (and is therefore 'pure') but which simultaneously could not be less pure or less pictorial.

'Picabia', said Duchamp to an interviewer, 'was above all an "Abstractionist", a word he had invented . . . He thought about nothing else.'[13] Picabia, Duchamp's friend among the Orphists, was very different. He was nearly a decade older; he had already accepted and rejected success as a painter (loosely speaking an Impressionist painter); he was extrovert rather than introvert and led an expansive life, dipping as easily into the world of the avant-garde (of Apollinaire and Jacques Villon) as into the world of bourgeois Paris. And he came close to a workable 'pure' style which could have lasted.[14]

Picabia did not, however, achieve such purity during 1912; paradoxically he needed the example of Duchamp's experiments of that year before he could make his own move. Early in 1913 he arrived in New York to help amplify the impact of Cubist and Orphist painting at the famous Armory Show. In March (part of the process of amplification no doubt) an exhibition of his watercolours opened at Alfred Steiglitz's Photo-Secession

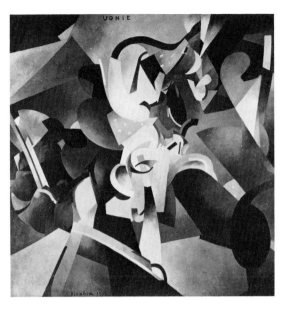

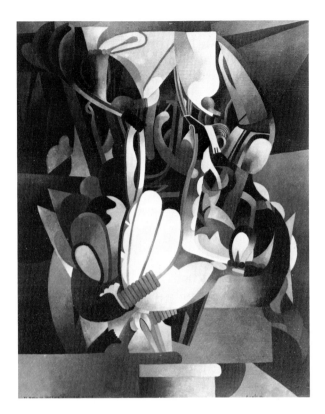

Above left
Francis Picabia
Udnie, 1913
Musée National d'Art Moderne
Centre National d'Art et de
Culture Georges Pompidou,
Paris

Above right
Francis Picabia
**I See Again in Memory My
Dear Udnie**, 1914
Oil on canvas,
$98\frac{1}{2} \times 78\frac{1}{4}$ (250 × 199)
The Museum of Modern Art,
New York
Hillman Periodicals Fund

Gallery; they had been done in his New York hotel-room. These were his first attempts as an 'abstractionist', and they led to a pair of enormous oil-paintings puzzlingly titled 'Udnie (Young American Girl: Dance)' (fig. 5) and 'Edtaonisl (Ecclesiastic)', which he completed on his return to Paris. From this ambitious launching, came a whole series of 'pure' works painted before the outbreak of war (August 1914), works like 'I See Again in Memory my dear Udnie' (fig.6), whose confidence outfaces even the mocking scepticism of Duchamp.

Picabia's paintings of 1913 and 1914 may have been triggered by Duchamp's 'Bride' and her companions, but behind them lay a thoroughly personal approach to content and pictorial expression, an approach whose rudiments he had established even before 1910. Picabia worked out a complete theory of expression in painting; it is rather blurred by comparison with, say, Kandinsky's or Mondrian's, but it was the key to the confidence and the length of his pursuit of 'pure painting'. Fortunately, we have access to it still by way of the many statements he made in his exhaustive search for publicity at the time.

Through his wife Gabrielle Buffet, who had been trained as a musician, he was aware of Symbolist musical theory and, developing the analogy with music, maintained that painting could communicate emotion by

correspondence. He was almost certainly one of the first in Paris positively to respond to Kandinsky's *On the Spiritual in Art*, and by the time of his New York watercolours was speaking of the emotions to be communicated as the product of the soul' not of mere vision.[15] He neither defined what he meant by the 'soul' nor specified the possible correspondences between emotions and particular forms or colours. One of his strengths was to leave possibilities open by defining no limits. All he insisted on was that the artist should work spontaneously, improvising like the jazz musicians he heard in New York; while he identified as the source of the emotions expressed in his own paintings (at least of 1913) the sheer vitality and variety of his experience of the city, and his memories of the voyage across the Atlantic.[16] The bustle of lower Manhattan, the languid luxury of New York at its most fashionable, these combined with the recollected sexual attractions of a professional dancer on-board ship and her effect on a sombre clerical spectator provided Picabia with the stimulus for his first 'pure' paintings. It was a kind of content which, at the time, he was firmly convinced *could* be expressed by non-representational form and colour. For him, in clear contrast with Duchamp, pictorial means could be found to correspond to his expressive ends.

Yet, the fact is that after only two years he turned away from the promise of a limitless future in 'abstractionist' painting as well, and the reasons for his decision to reject his achievements of 1913–14 were as personal as the expressive approach that made them possible in the first place. Duchamp always stressed two of Picabia's characteristics: one was his compulsive need for change, the other was his love of contradiction. Picabia carried on both his life and his art with a Nietzschian hatred of the conventional and the static. 'Udnie' and 'Edtaonisl' were not the product of a *fixed* faith in the communicative power of form and colour. Had Picabia established such a faith he would have been forced to commit himself to the further evolution of his style of 1913–14. At the same time, there was no single metaphysical truth to be uncovered behind these paintings, as Mondrian and Kandinsky believed there was behind theirs, for Picabia was unable to accept any single truth other than his own effervescently changeable individuality. 'Udnie', 'Edtaonisl' and the paintings that were their immediate sequel expressed no more than the thrill of passing experiences – highly subjective experiences. Picabia's theory of expression in abstract painting was certainly workable – the means *were* adequate for his expressive ends, but behind the painting and the theory lay a personality too mercurial, in a sense too vital for either to have satisfied their creator for long.

Both Duchamp and Picabia had experimented with Impressionism – Duchamp briefly, Picabia at length. They were well aware that their 'pure painting' denied the accepted Impressionist emphasis on the immediacy of day-to-day visual experience; Duchamp because of his poetic and con-

ceptual intentions, Picabia because of his focus on the psychological and the expression of emotion . For Delaunay and Léger, who for a while (up to about 1913) were friends too, 'pure painting', far from rejecting the immediacy of visual experience, actually drew its strength from its capacity to communicate the essential, the living qualities of such experience. They too began by 'doing' Impressionism, before going on to explore Signac's Divisionism,[17] but in many senses their pursuit of abstract painting took its starting-point from where Monet and Signac had apparently left off. They continued that peculiarly French concern, at one and the same time with painting as a 'pure' activity and with life acutely encountered at first hand.

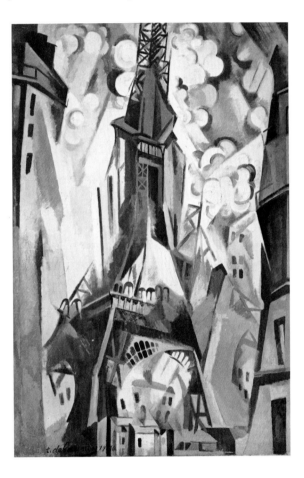

7. Robert Delaunay
Eiffel Tower, 1910
Oil on canvas,
$76\frac{3}{4} \times 50\frac{3}{4}$ (195 × 129)
Kunstmuseum, Basle
The Emanuel Hoffmann-
Foundation

In one sense, however, Delaunay's response to Cubism was like Duchamp's: it was destructive.[18] His dramatic 'Eiffel Tower' paintings of 1910–11 (fig.7) declared what he was to call an 'epoch of destruction', and certainly he used the licence to dislocate structures, given him by Picasso, totally to shatter the structure of the tower. But, where Duchamp's 'Yvonne and Magdeleine Torn Up' (fig.2) is the record of a

mental process of dismemberment. Delaunay's 'Eiffel Towers' are presented as the record of a visual experience – an experience of moving around the tower and, most prophetically, of seeing that great iron skeleton cut through by the shafts of sunlight. 'Light', Delaunay wrote later, 'deforms everything, breaks everything',[19] and it does so here in preparation for the complete take over of his art.

The elegant silhouette of the tower, seen from a distance, is still visible as the axis of the earliest of a series of paintings that Delaunay produced in a burst of intense creative energy during the summer of 1912, the 'Window' paintings (fig.8), but it remains as a mere vestige in compositions whose real subject is light – as a reminder of what has vanished in the face of so dazzling a challenge. In a famous letter written to Kandinsky just before he started on the 'Window' series, Delaunay wrote of his 'search for pure painting'; he himself, at the time and afterwards, was convinced of the fundamental purity of these compositions and of the 'Circular Forms' series that followed in 1913 (fig.9). 'No copying from nature,' he remarked of the 'Windows' in 1924 – 'the "surnaturalism" of Guillaume Apollinaire if you like – more than that, the first abstract painting in colour.'[20] Yet, however purely Delaunay concerned himself with the relations between coloured areas of oil-paint on the surface of his canvases, the fact remains that his art was still concerned with the sensation of light as it is experienced in nature. The connection between his painting and nature was left unbroken.

This is transparently clear in a text published to go with the 'Windows' in January 1913 and called simply 'Light'. It begins thus: 'Light in Nature creates movement in colours. The movement is provided by the relationships of uneven measures, of colour constrasts among themselves and constitutes Reality.' 'The Eye', he continues, 'is our highest sense, the one that communicates most closely with our brain, our consciousness, the idea of the vital movement of the world, and its movement is simultaneity.'[21] Using glancing, poetic phrases to hint at his meaning rather than to explain it, Delaunay communicates unambiguously the fact that light is the key to our experience of the world, and that his painting is a celebration of its creative power. It is well known that his most important source beyond Signac was Chevreul's guide to colour, *De la loi du contraste simultané des couleurs*, and that he manipulated his colour planes with a precise knowledge of how a clear blue will make an adjoining yellow appear more orange or how a darker blue will make the same yellow appear more green.[22] He wanted his painting to make us more sharply aware of the way colours simultaneously relate and therefore of the way light works in nature. He wanted to isolate the fundamental components of optical experience (prismatic colours), put them together in vigorous new arrangements and make us see for ourselves, therefore, the very essence of all such experience – as he puts it, of 'reality' itself. That his exploration of

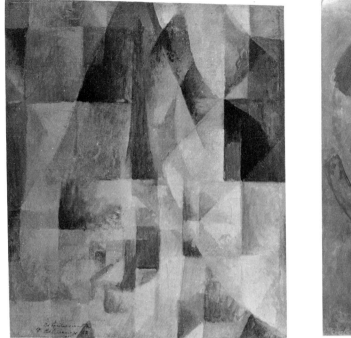

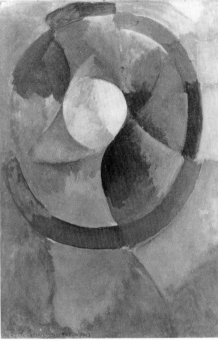

Above left
Robert Delaunay
**Simultaneous Windows
(2nd Motif, 1st Part)**, 1912
Oil on canvas,
$21\frac{5}{8} \times 18\frac{1}{4} (55 \times 46.5)$
The Solomon R. Guggenheim
Museum, New York
Photo: Robert E. Mates

Above right
Robert Delaunay
Circular Forms, Sun No.2,
1912–13
Oil on canvas,
$39\frac{1}{2} \times 26\frac{3}{4} (100.5 \times 68)$
Musée National d'Art Moderne
Centre National d'Art et de
Culture Georges Pompidou,
Paris

colour never broke with his experience of nature is further conveyed by the fact that his 'Circular Forms' of 1913 were attempts to capture the quality of specific kinds of light *in* nature – the light of the sun and of the moon – and that their ultimate sanction lay in Delaunay's direct observation of these phenomena.

Predictably, it was Delaunay's continuing involvement as a painter in the immediacy of day-to-day experience that led him away from an uncompromising pursuit of 'pure painting'. His 'Eiffel Tower' paintings had shown an early taste for the imagery of modern life and by the turn of 1912–13 this kind of imagery was beginning to find its way back into his art. One of the latest 'Windows' includes easily recognisable representations of the tower and the 'Great Wheel' (the latter then still to be seen on the Champ de Mars)[23] and early in 1913 this was succeeded by two paintings which explicitly took rugby players as their central subject and surrounded them with images of modern Paris, the two 'Cardiff Teams'. Alongside the 'Circular Forms' Delaunay produced through 1913 a whole series of works invaded thus by images of progress, in one sense demonstrating the breadth of his creative imagination but in another seriously compromising his campaign for pictorial purity.

His justification for this apparently contradictory development was simple; just as for him the 'idea of the vital movement of the world' could be found in the direct experience of simultaneous colour contrasts, so too, he

[167]

believed, could it be found in the complex but equally direct experience of modern life in action. Indeed, he believed that the two kinds of experience, each in their own way underlining the dynamism of all experience, could be fused pictorially in unified compositions of a symphonic grandeur.

In a general sense, his way of looking at the world was Bergsonian, and, of course, one of the main reasons for the appeal of Bergson's philosophy to French painters at this time, including Delaunay, was the fact that he too based his understanding of reality on what he considered the essential character of vital experience. Movement was certainly central to the Bergsonian idea of reality, since he held that our sense of 'duration' (i.e. movement through time) was central to our experience of life and certainly dynamism, as we have seen, was within the reach of Delaunay's Orphic painting. But the Bergsonian belief in the simultaneity of all experience in terms of space and time, in the importance to the present of phenomena remembered by us from other places and other times, this could not be communicated in so abstract a way. By 1912 spatial and temporal simultaneity were important themes in both the painting of the Italian Futurists and the poetry of such French writers as Jules Romains; at the turn of 1912–13 Apollinaire and Blaise Cendrars (a poet who was also close to Delaunay) took up comparable concerns.[24] Common to all these poets and painters was the conviction that the speed of modern transport (the train, the car, the transatlantic liner) and of modern communication (telegraph, wireless) had made the simultaneity of experience altogether more palpable – that in modern life man was confronted with the elasticity of space and time more directly than ever before. It was to convey the dynamism of experience on this more complex level that Delaunay introduced into his paintings the imagery of modern life. The two versions of 'The Cardiff Team' are at once mobile in colour and 'simultanist' in the way that disparate items from Delaunay's experience of Paris are brought together without regard for the unity of space and time. Only by the intrusion of easily recognisable (impure) images could he have conveyed the simultaneity which, for him, was as essential to his experience of life – especially modern urban life – as dynamism.

Looking back, Delaunay saw the pure side of his development from the 'Eiffel Tower' paintings to the 'Windows' as a progression towards 'construction', from an art dedicated to the demolition of the subject to an art where the subject has been demolished and pure colour construction is possible. Léger followed a parallel course into 'pure painting'; he too, like both Duchamp and Delaunay, started by pugnaciously confronting the subject head on, and ended, like Delaunay (not Duchamp) in 'construction', of a sort. But his progress into 'pure painting' came later and the results were rather different.[25]

When Apollinaire included him as an Orphist in the autumn of 1912, Léger was deep in his brief but hard-hitting destructive phase. That

10. *Above left*
Fernand Léger
Woman in Blue, 1912
Oil on canvas,
76⅜ × 51⅛ (194 × 130)
Kunstmuseum, Basle
Gift of Dr Raoul La Roche,
1952

11. *Above right*
Fernand Léger
Nude Model in the Studio,
1912–13
Oil on burlap,
50⅜ × 37⅝ (128 × 95.5)
The Solomon R. Guggenheim
Museum, New York
Photo: Robert E. Mates

autumn he showed his 'Woman in Blue' (fig.10), a large painting, conceived in part as a challenge to Cézanne's most substantial portraits, where the fragmented remnants of a seated female are cut through and everywhere jostled by sharp-edged, abstract planes of blue. Léger's destructive phase was, however, short, and the next step he took towards 'pure painting', 'The Nude Model in a Studio' (fig.11) of early 1913 was almost entirely constructive in spirit. Here the subject is not so much broken apart by the invasion of alien abstract shapes as transformed altogether into configurations only loosely related to its natural appearance. Léger has seen his nude in terms of long, elliptically curving forms which originated not in his observation of the nude but in his observation of smoke rising from the roofs outside his studio window. His subject has been translated into elements abstracted from another very different subject, and the result is hardly recognisable as a figure at all. In Apollinaire's words: 'The subject no longer counts.'

Just after he finished this painting, Léger delivered a lecture which was then published in a little periodical called *Montjoie!* It clarifies his position regarding 'pure painting'. Here he argued that 'the realistic value of a work' did not lie in its resemblance to a subject, but in its own properties

as a painting, 'pictorial contrasts,' he said 'used in their purest sense (complementaries) of colours and line, of form are from now on the armature of modern paintings.'[26] His intentions were certainly as 'pure' as Delaunay's had been at the turn of 1912–13, but there was one major difference: where Delaunay's contrasts were colour alone and were used in the service of light, Léger's were linear, formal and chromatic, used in the service of 'plastic' effect.

The *Montjoie!* lecture had its most direct sequel in a series of roughly painted yet definitive canvases begun in the middle of 1913 and carried on into 1914. Léger gave them the unassuming title: 'Contrasting Forms' (fig. 12). Elsewhere I have shown that these paintings probably originated in landscape compositions developed during 1911 and 1912,[27] and one might be tempted to align the process of abstraction behind them with that which led from city-scape (the Eiffel Tower seen at a distance) to Delaunay's 'Windows'. It is, however, profoundly different, for Léger does not isolate and purify any particular aspect of his landscape subject as Delaunay isolated the quality of light, instead he transforms his initial subject completely as he had 'The Nude Model' by imposing upon it elements alien to it: black and white, colours straight from the tube, and the cylinders and cones of solid geometry. The basic configurations of landscape compositions serve here merely as a pretext for the development of formal and colour contrasts which are apparently their own *raison d'être*.[28]

12. Fernand Léger
Contrasting Forms, 1914
Oil on canvas,
$31\frac{3}{4} \times 25\frac{5}{8}$ (80.7 × 65.2)
Kunstsammlung Nordrhein-
Westfalen, Düsseldorf

Yet, as I have suggested, Léger, like Delaunay a one-time Impressionist, never lost his desire to communicate the immediacy of visual experience in life. Even the most 'pure' of his 'Contrasting Forms' retain an unbroken link with the world outside painting. The link is not to be found, as it is in the art of Delaunay, by discovering the origins of his compositions in particular subjects (in this case landscape), because during 1913 and 1914 Léger never directly referred in his paintings to his real subject, to the visual experiences whose force he hoped to equal pictorially. He tells us what that subject was in words not paint, in another lecture, this one given in 1914: it was the energy of modern life, but experienced more brutally and directly than by Delaunay. Léger believed that dissonant contrast was the single common characteristic to be found in his experience of everything from a locomotive speeding through the countryside to an aero-engine on display at one of the aviation exhibitions and he believed that by reducing the elements of his art to the simplest terms – black and white, primary and secondary colours, straight and curved lines, geometric volumes and flat planes – and by setting these in conflict he could create an equivalent for such experiences. This was why he could say of his theory of pictorial contrasts in 1914 that it was 'not an abstraction', but rather was based on 'natural effects that can be seen daily'.[29]

In the end, Léger's continuing commitment to modern experience led him, with the coming of war, inevitably away from 'pure painting' and back to the explicit statement of his subject-matter. But even before this happened, his particular approach to the relationship between art and life allowed him to compromise the purity of the 'Contrasting Forms' by producing alongside them paintings which make no secret of a subject – easily deciphered figure-paintings, landscapes and still-lives. These had the advantage of conveying with great economy how his response even to the traditional subjects of fine art had been transformed by his need to find dissonant contrast everywhere – how he could find visual violence in the calmest, most static of things. And, since Léger always realised that these subjects were only ever pretexts, as in the case of Picasso's and Braque's Cubism in 1912, there is an important sense in which his art remained pure whether or not he let us decipher such subjects. The presence of a figure or a fruit-bowl could never mute the direct impact of his conflicting lines, forms and colours.

Thus far, it should have become clear that each of the four French painters named by Apollinaire as Orphists pursued 'pure painting' in very different ways. They emerge as sharply distinct individuals. Yet, it should also be clear that they emerge as two contrasting pairs – Duchamp and Picabia, Delaunay and Léger – which represent two sides of French modernism early in the century, two separate kinds of response to the possibility of abstract art. Duchamp believed that art was for the stimulation of the mind, not the senses. Picabia allowed himself to be moved by what he

saw, but insisted that what met his eyes was not enough – he called his abstractions of 1914 'psychological studies'. These were artists who approached abstraction from a fundamentally Symbolist stance, setting the mind against the senses, the inner against the outer. Both might have sustained a thoroughgoing abstract style had it not been for their scepticism and their passion for the individual and the changing. Delaunay and Léger never set the mind against the senses and never forgot their Impressionist beginnings. In the case of these two, it was their continuing commitment to the visible world and specifically to its most up-to-date manifestations that kept them from a sustained and uncompromising abstraction.

František Kupka stands apart, because he *did* produce a thoroughgoing abstract art, one that was firmly enough founded on durable enough convictions to be sustained through a long career which was not to end until 1957. The case of Kupka is so strongly in contrast to the cases of Duchamp, Picabia, Delaunay and Léger, that it throws them into the sharpest possible relief, underlining all they possessed and all they lacked that kept them from a deep and long plunge into abstraction. Throughout the period 1910–14 Kupka lived in Puteaux as the neighbour of Duchamp's brothers Jacques Villon and Raymond Duchamp-Villon. He was constantly friendly with these two and they, and those who came to their gatherings, certainly knew how he painted and how he thought. But there is much evidence that Kupka did not see himself as one of the Puteaux group, refused to connect his work in any way with Cubism and kept himself apart. He never forgot that, though he had settled in Paris many years before (in 1896), he was a stranger in a foreign city.[30]

This does not mean that there was nothing about his art or his ideas that related to those developed from within Cubism (or on its fringes) by French painters. Superficially, his move into 'pure painting' parallels (though slightly in advance) that of Delaunay, and certain similarities can be found between his ideas on painting and those of Delaunay, Léger and Picabia, if rarely of Duchamp. Between 1909 and 1911 Kupka occupied himself with issues which do not seem to set him apart from the French: the sequential depiction of movement, coloured pigment as an equivalent of light and the promotion of flatness in painting.[31] His interest in the sequential depiction of movement faded but he remained concerned with movement as such and this concern combined with the two others took him to his first undeniably abstract paintings, probably as early as 1911. 'Nocturne' (fig. 13) is one of these. It holds attention by the shimmering rhythm of its blue slabs of pigment alone and the fact that they have been literally hung like a curtain across an earlier landscape idea (something known from a surviving drawing) dramatises the *anti*-naturalist quality of the little canvas. Another such essay in abstraction is 'The Disks of Newton, Study for Fugue in Two Colours' (fig. 14), one of a more extensive series produced

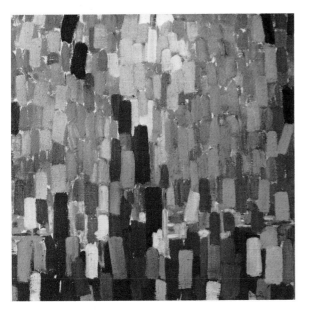

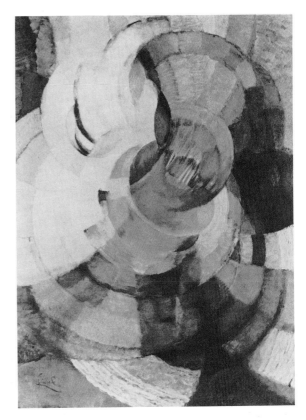

3. *Above left*
František Kupka
Nocturne, 1911
Oil on canvas,
26 × 26 (66 × 66)
Museum des 20.
Jahrhunderts, Vienna

4. *Above right*
František Kupka
**The Disks of Newton, Study
for Fugue in Two Colours**,
1912
Oil on canvas,
39½ × 29 (77.5 × 73.6)
Philadelphia Museum of Art
The Louise and Walter
Arensberg Collection

in 1911–12. Here contrasting coloured bands rotate with explosive centrifugal force, creating very much their own kind of visual excitement without any discernible relationship with a specific subject.

Partly out of 'The Disks of Newton' series came in 1912 two enormous paintings, 'Amorpha, Fugue in Two Colours' (fig. 15) and 'Amorpha, Warm Chromatics', which were both shown at the Salon d'Automne that year, an astonishingly uncompromising justification of Apollinaire's ideas about 'pure painting'. Partly out of the paintings and drawings like 'Nocturne' came in 1912–13 the equally enormous 'Vertical Planes III' (fig. 16), which was shown at the Salon des Indépendants of 1913. Behind the 'Amorpha' paintings lay an elaborate process of transformation which involved more than one subject – most importantly studies of Kupka's step-daughter Andrée playing with a ball, where the circuiting movements of the multi-coloured ball were his starting-point, and observations of the movements of the planets in space as tracked by astronomers. But such disparate origins were no longer to be more than guessed at in the paintings.

The ideas behind these unprecedented works did not reach even the restricted audience that existed for Delaunay's and Léger's statements of 1912–14 because Kupka was not able to publish them. They were

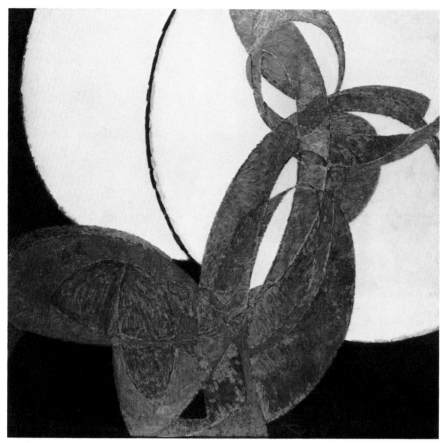

15. František Kupka
Amorpha Fugue in Two Colours
Oil on canvas,
$83\frac{3}{8} \times 86\frac{5}{8}$ (211 × 220)
Národní Galerie, Prague

available only in manuscript form, in the notes and early drafts for his book *Tvoření v umění Výtvarném* (*Creation in the Plastic Arts*), which did not appear until 1924 and then only in Czech.[32] The earliest of these manuscripts (they are written in French) dates from 1910–11 and, already here, all the fundamental concepts that lie behind the 'Amorpha' and 'Vertical Plane' paintings are to be found fully formed. Repeatedly in these earlier notes he rejects the representation of nature, arguing that the painting must not be merely a fragment of nature but something created with new forms. Indeed, he comes uncannily close to Apollinaire's later definition of Orphism as 'the art of painting new structures' with elements 'created entirely by the artist himself' and, when he insists that it is the *way* one paints not *what* one paints that counts, he anticipates a major point in Léger's lecture of 1914 too. Then again, when he turns to colour it is clear that he was familiar with the whole range of theory that engaged Delaunay, from Chevreul to Signac, and, like Delaunay, he stresses the dynamic quality of colour as light. Behind the abstract works of 1911 onwards lies a study of the technical means of painting (colour and line above all) far more extensive than those made by Duchamp, Picabia or

16. František Kupka
Vertical Planes III, 1912–13
Oil on canvas,
78¾ × 46½ (200 × 118)
Národní Galerie, Prague

Léger, and at least comparable with Delaunay's. His notes of 1910–11 are packed with statements about the pictorial possibilities of curved and straight lines, vertical planes and colour 'taches', and his interest in such 'pure' questions went back beyond his French phase to the teachings of his earliest master in Czechoslovakia, Alois Studnička. It was from this highly refined approach to the non-representational possibilities of painting that he evolved his particular interpretation of the analogy between painting and music, in several significant cases letting musical analogies take the place of subjects in his titles, 'Amorpha, Fugue in Two Colours' being, of course, the most notable.

All this might seem to align Kupka with the French Orphists, and it is an alignment strengthened by the obvious relationship between the

'Amorpha' paintings and Delaunay's 'Circular Forms', but Kupka's work drew its conviction and force from notions of content which are altogether alien. The manuscripts of the 1910–14 period make it clear that he believed absolutely in the capacity of abstract colour and form to embody an 'Idea' beneath the surface of appearances, to carry universal significance. He did not reject nature but he maintained that the artist must 'penetrate' beneath the optical experiences it provides in order to find the deepest of meanings. He was a searching observer of all that caught his attention, from the movement of light to the formation of plants and rocks, and he kept up a vigorous enthusiasm for the images revealed by the microscope and by the astronomer's telescope. But what he searched for in all such phenomena were the clues to underlying chromatic and formal rhythms which he could identify as the manifestations of universal rhythms. Where Delaunay's attempt to find the essence of what he saw in the prismatic structure of light carried only a gentle hint of a deeper metaphysical significance, Kupka's attempt at penetration began and ended with his belief in the possibility of exposing such inner meaning.

Ultimately his was an expressive theory of painting, but it was an expressive theory rooted in convictions far deeper than Picabia's. So strong was Kupka's faith in the capacity of colour and form to convey meaning beyond their merely formal properties that he could even maintain that the colours on a painter's palette, the result of accidents rather than decisions, were expressive. Further, both his faith in the communicative power of pictorial means and his desire to penetrate beneath appearances, led him to stress subjective invention and visionary imagination at the expense of nature in the process of painting, something which again is already clear in the earlier of the notes for his book, those of 1910–11. A deep understanding of natural form and light might lie behind his work, but Kupka believed that no artist should begin a painting with the study of a particular naturalist 'motif'. He believed that the artist should use as his springboard either pure technical exercises with lines and colours or 'subjective "motifs"' – images, as it were, seen in the 'mind's eye'. The 'Amorpha' paintings admittedly began in the naturalist 'motif' of Andrée and her ball, but much more significantly they are the combined result of technical exercises (including the 'pure' 'Disks of Newton') and 'subjective' inventions. The 'Vertical Planes' paintings are the result almost exclusively of technical exercises, one of which was 'Nocturne'. While the other series of the period, so far unmentioned, the 'irregular form' paintings ('Creation', 'Cosmic Spring', etc.) are the result almost exclusively of 'subjective' invention. Just as a specific naturalist 'motif' lies at a distance behind the 'Amorpha' paintings, even the 'Vertical Planes' and the 'irregular form' paintings carry associations, on the one hand of light reflected in water, on the other of rock formations and photographs of the surface of the moon. But, if, as I suggested at the beginning, abstract

painting at its purest starts and finishes with no attempt to represent subject-matter from nature, Kupka often reached a high degree of purity in his abstraction before 1914, and did so as a direct result of his determination to discover metaphysical truth.

It was at the deepest level this concern with the metaphysical that kept him apart from his contemporaries in Paris, and it was most of all their lack of such a concern that kept Picabia, Duchamp, Léger and Delaunay from a sustained and thoroughgoing abstraction. None of Apollinaire's Orphists could bring themselves to believe that painting could express more than subjective thought or feeling or sensory experience; none of them could believe in the communication of a single, universal 'Idea'. They lacked a deep metaphysical foundation in the theory and practice of their art; Kupka, largely through self-education, developed and nurtured just such a foundation of metaphysical thinking, and he was able to do so because he never forgot his origins so far from Paris. While a boy in Czechoslovakia, he had taken to spiritualism and discovered in himself a gift as a medium, which he continued to exercise at Puteaux until his death. While a student in Vienna during the early 1890s, he had read far into philosophy and taken a serious look at Theosophy; between 1910 and 1914 his writings often still reveal a familiarity with Idealist thought and a continuing desire to quote from the leading Theosophical writers, Madame Blavatsky and Rudolf Steiner. In the final analysis, Kupka's thinking, developed at first outside Paris, aligned him far more with the great mystical abstractionists – Kandinsky, Mondrian and Malevich – than with the Orphists, and it led him to an abstract style at least as comprehensive and as 'pure' as theirs, earlier than any of them. It was perhaps because his was so foreign an art that its impact in Paris alongside the impact of Duchamp, Picabia, Delaunay and Léger was so muted, so out of proportion with its originality and the breadth of its possible implications. The Parisian avant-garde was a hostile environment either for metaphysics or for abstract art to grow up in.

The spread of information leading to the rise of abstract art in Europe

Susan Compton

The emergence of abstraction in painting in a number of European countries at about the same time argues that it arose on the basis of similar reactions to shared stimuli. It seems likely that these stimuli were diffused across the western world through exhibitions, collectors, publications, word of mouth and the travel of artists themselves. Indeed, the spread of information was much more general than might be supposed. There seems to have been so much appetite for the 'latest trend' that news was carried widely and quickly. Conversely, information today regarded as crucial sometimes remained comparatively unknown and uninfluential. It is these aspects of the rise of abstraction in Europe which will be considered here.

Towards the end of the nineteenth century reports of new approaches to art were carried throughout Europe by the international exchange of new art journals, profusely illustrated by plates that had been made possible by the invention of better and cheaper photo-reproductive techniques. For example, in 1879 *La Vie Moderne* was founded in Paris, followed in 1891 by *La Revue Blanche*; in 1893, *Studio* was founded in London, in 1895, *Pan* in Berlin and in 1896, *Jugend* in Munich. A new situation developed in art in which a Scottish artist might be better known in Vienna or Munich than in London. Indeed, the dissemination of printed information soon led to a desire for the interchange of art objects themselves and a growing number of independent exhibiting groups were formed in order to show avant-garde work unacceptable to academic institutions.

When the Russian, Wassily Kandinsky, arrived to study painting in Munich in 1896, an astonishingly wide range of contemporary art could be seen in exhibitions organised by the Secession. There were pictures by the Swiss artist Hodler, the German, Böcklin, the English artists Burne-Jones, Brangwyn and even Turner, the French, Monet. German reviewers were already using expressions such as 'the magic of colours', 'modern lyric in colours' and the word 'sound' (*klang*) which Kandinsky used later in his writings.[1] As well as exhibitions and writing, new methods of teaching were instrumental in furthering new approaches to art. A number of Russian artists were drawn to Anton Ažbé's studio in Munich, to the sympathetic teacher who had attracted Kandinsky. Among Ažbé's pupils who were pioneers of abstract painting were Alexei von Jawlensky

and the Burliuk brothers, David and Vladimir. All were inspired by his insistence on the importance of using pure colours to model forms in space and the encouragement he gave students to develop as individuals. This was in contrast to the more rigid academic teaching depending on 'rules' which was typical of academic schools of the time. One of Ažbé's pupils (the Russian Matislav Dobuzhinsky) wrote in his memoirs that Ažbé's 'geometrical heads already anticipated cubism'.[2] No doubt he was referring to Ažbé's system of teaching his students to reduce human anatomy to geometry, for example, the head to a sphere.[3] This suggests a relationship to the kind of teaching which another early abstractionist, František Kupka, received in Czechoslavakia and then in Vienna at about the same time.[4] Such teaching was closely related to the contemporary concerns of the modern movement, Jugendstil or Art Nouveau.

A recent study of the relationship of Jugendstil to Kandinsky's development towards abstraction has provided a fascinating picture of Munich at the turn of the century.[5] From that time countless printed references to the coming of abstract art can be found. That these statements were made usually about applied arts is of secondary importance, for in Europe in the late nineteenth century, distinctions between 'fine' and 'decorative' arts were broken down and examples of applied arts were to be seen in many avant-garde exhibitions. As early as 1897 the January number of *Die Kunst für Alle* announced that the committee for the next international art exhibition 'recognises the fact that a part of the arts and crafts movement has begun to pioneer new paths'.[6] A statement by August Endell 'that every aware person is conscious not only of standing at the beginning of a new style period', but at the same time 'at the beginning of a totally new art, an art with forms that mean nothing and represent nothing and remind one of nothing, yet that will be able to move our souls so deeply, so strongly, as before only music has been able to do with tones' is only one among many which prefigure non-objective art.[7]

Although it is a fact that the language for, as well as the expectation of abstraction in art were already widespread in central Europe by the end of the last century, it has no doubt been overlooked because of a modern tendency to separate the study of decorative and fine art. This in turn has thrown too great an emphasis on fears expressed by Kandinsky himself as late as 1912. In *On the Spiritual in Art* (*Über das Geistige in der Kunst*) Kandinsky wrote: 'If we were to begin today to destroy completely the bond that ties us to nature, to steer off with force towards freedom and to content ourselves exclusively with the combination of pure colour and independent form we would create works that would look like a geometric ornament, which grossly stated, would be like a tie, a carpet.'[8]

Thus it is all the more remarkable that before 1912 Kandinsky was able himself already largely to fulfil the hopes expressed before the turn of the century by designers such as Endell: 'All our striving is to this end: to give

the fantasy free reign, to aim clearly at the goal and at the same time to set aside all dogmas – the goal is free forms, without any tradition, forms that rise up out of the soul of the individual and thus are his forms, his creatures' (1897).[9] It is even more interesting to compare early essays in free form by such a little-known artist as Katharine Schäffner with Kandinsky's own.[10] It immediately becomes clear that Kandinsky embraced the central ideas of the mainstream avant-garde and pushed them further. The same is true of other pioneers of abstraction, in Holland of Mondrian and in Russia of Larionov, and, at a slightly later date, of Malevich.

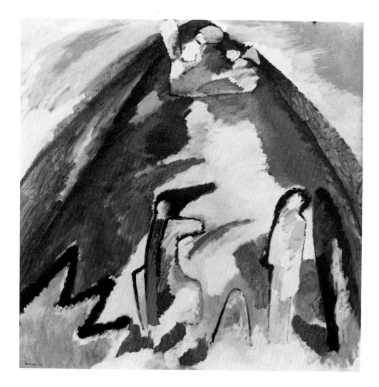

Wassily Kandinsky
Mountain, 1909
Oil on canvas,
43 × 43 (109 × 109)
Städtische Galerie,
Lenbachhaus, Munich

 This mainstream was situated in Paris where the idea of an 'avant-garde' already had a long history. Kandinsky arrived there in May 1906, not long after the first modern movement of the new century had made its appearance. Boldly painted, brightly coloured canvases had earned their painters the journalist's description *Fauves* (wild beasts) at the previous *Salon d'Automne*. There Matisse's controversial Fauve picture, 'Luxe, Calme et Volupté' had prompted a warning from the Nabi painter, Maurice Denis, who had written in the review *L'Ermitage*: 'He will not be discouraged by this first experiment; it should, indeed, help him avoid the dangers of abstraction.'[11] Kandinsky may not have seen Matisse's sequel, the painting 'Bonheur de Vivre', for it was shown at the *Salon des Indépendants* in March 1906 and purchased by the collectors Gertrude and

Henri Matisse
Bonheur de Vivre, 1905–6
Oil on canvas,
68½ × 93¾ (174 × 238)
Barnes Foundation, Merion,
Pennsylvania
Photograph copyright 1980
by The Barnes Foundation

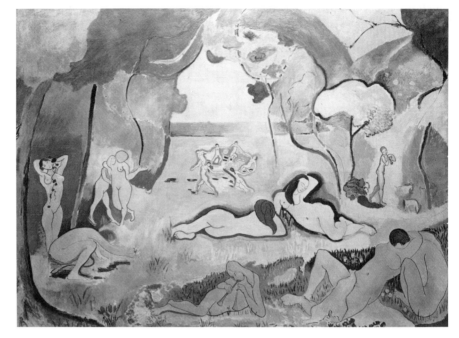

Leo Stein before Kandinsky arrived in Paris. Among many Fauve paintings which reveal a new freedom in colour, this one is unique, a portent of abstraction in its new stylisation and free rhythm of line and colour. It is tempting to compare Kandinsky's 'Mountain' (sometimes called 'Blue Mountain') of 1909 with Matisse's 'Bonheur de Vivre', for the relationship seems close enough to warrant the supposition that Matisse's approach contributed to the transformation which took place in Kandinsky's painting in 1908–9 after his return to Munich. Certainly Matisse's paintings were written about in terms which must have interested all artists searching for new forms. The young poet-critic, Guillaume Apollinaire, addressed Matisse in a revealing essay published in *La Phalange* in December 1907; 'People have often criticised you for this sketchiness, my dear Matisse, without stopping to think that you have thereby accomplished one of the most difficult of tasks; you have endowed your paintings with a plastic existence without having recourse to objects except to stimulate sensations.

'The eloquence of your work arises primarily from the combinations of colour and lines. That is what constitutes the art of the painter – and not the simple reproduction of objects, as certain superficial minds persist in believing.'[12]

Undoubtedly the use of brilliant colour that the Fauves had developed from the Impressionists and Post-Impressionists, acted as a catalyst for many avant-garde artists in 1906–7. However, alone, even with the promptings of Apollinaire, these innovations would not have lead to

abstract art. For example, although there is a superficial resemblance between Derain's 'Estaque' landscapes and the paitings which Mondrian made in Holland in 1907–8, especially his 'Woods at Oele', the colour scale which Mondrian chose is quite different to that of the Fauves. In an autobiographical essay, Mondrian remembered: 'The first thing to change

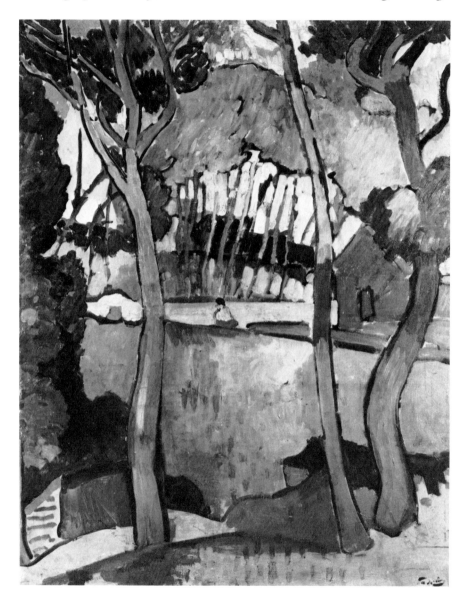

André Derain
Three Trees, L'Estaque, 1906
Oil on canvas,
$39\frac{1}{2} \times 31\frac{1}{2}$ (100.3 × 80)
Art Gallery of Ontario, Toron
Gift of Sam and Ayala Zacks,
1970

in my painting was the colour, I forsook natural colour for pure colour. I had come to feel that the colours of nature cannot be represented on canvas. Instinctively I felt that painting had to find a new way to express the beauty of nature.'[13] There is no doubt that Mondrian's position

changed following his familiarity with lectures given by the Theosophist, Rudolph Steiner, and published in Holland in 1908.

In lectures, often attended by artists in these years, Steiner outlined the means for expressing spirituality as well as a generalised spiritual content. His teaching must have reinforced the predisposition of any artist who was preoccupied by colour symbolism or the means by which painting might express what he felt to be a spiritual truth. Steiner's frequent travels on lecture tours during which he visited Amsterdam, Paris, London and Berlin as well as the Scandinavian countries, were as important in spreading these ideas as the travels of artists themselves. As well as Mondrian, Kupka and Van Doesburg were affected by Theosophy. Although the relationship of Kandinsky to Steiner is a matter for disagreement among scholars, at the least Kandinsky attended his lectures given in Berlin in 1908.[14] Nonetheless, theosophical ideas seem to have played a much smaller part in Kandinsky's artistic development than in Mondrian's.

In spite of his personal isolation in comparison with most other early abstractionists, for Piet Mondrian the means of a stylistic change were provided by the example of French paintings which he saw in exhibitions in Amsterdam. First the painting of Cézanne and then that of Picasso revealed new formal possibilities to him, and, after seeing Cubist paintings, he moved in 1912 to a studio in Paris. There Mondrian began work on a unique adaptation of Cubist ideas which lead him on a personal path to abstraction.

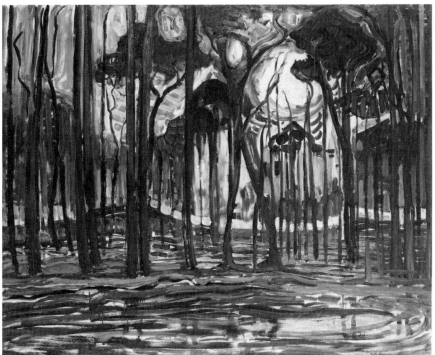

Piet Mondrian
Woods near Oele, 1908
Oil on canvas,
$50\frac{3}{8} \times 62\frac{1}{4}$ (128 × 158)
Haags Gemeentemuseum,
The Hague

African mask bought
by Derain from Vlaminck
Wood, whitened with clay,
$18 \times 11\frac{3}{4}(45.7 \times 29.8)$
Estate of Madame Derain

Other pioneers of abstract art encountered new art in Paris at an earlier stage. The Russian artists Mikhail Larionov and Nataliya Goncharova were taken to Paris in 1906 by Sergei Diaghilev for the *Salon d'Automne*, which included a large contingent of paintings from Russia. It was also the occasion of a huge retrospective of Gauguin's work, paintings, pottery, graphics and his primitive sculptures. This exhibition coincided with the period of maximum interest of the Parisian avant-garde in primitive art, of which one of the earliest collectors was the Fauve artist, Maurice Vlaminck. The effect that the discovery of African art had on Vlaminck and on his friend Derain is vividly described in his autobiographical writings.[15] What is interesting about the account is that apparently, before finding some negro sculptures by chance in a café, Vlaminck with Derain had already combed the anthropological collections in Paris museums, searching for primitive art. There they had succeeded in finding nothing which moved them as much as the statues and masks which they were soon able to buy from sailors and travellers.

The enthusiasm of their friends, Matisse and Picasso, for these and other forms of non-western art, in turn transformed their work, as can be seen in Picasso's well-known picture, 'Les Demoiselles d'Avignon'. In this canvas Picasso set aside the single-viewpoint perspective, which had been the hallmark of European art for five centuries. Today 'Les Demoiselles d'Avignon' appears an important landmark because it embodied the dual interest, African art and the work of Cézanne, which together lead Picasso to his early Cubist style. However, at the time, it appears that its direct

influence reached only a handful of friends. The picture stood in his studio after he had turned it to the wall sometime during 1907, because he was unable to finish it to his satisfaction.[16] Its wider implications reached artists through the many related studies which were brought by collectors, especially the Moscow merchant, Sergei Shchukin.

Thus although there was a marked change of style in Larionov's paintings following his direct contract with the Parisian avant-garde in 1906, the full impact of non-western art and the change in direction it was causing among Parisian artists was continually reinforced in Moscow by Shchukin's new acquisitions. Shchukin also commissioned panels from Matisse who visited Russia in the autumn of 1911. Larionov, amongst others, was present at a reception given for Matisse on this occasion. In Russian press interviews Matisse apparently praised traditional Russian art, icons and even folk art. He said of icons: 'This is primitive art. This is authentic popular art. Here is the primary source of all artistic endeavour. The modern artist should derive inspiration from these primitives.'[17]

Already in Russia, as elsewhere in western Europe, there was widespread recognition by avant-garde painters of the artistic values of objects formerly regarded as of purely anthropological, historical or sentimental interest. Primitive, prehistoric, naïve art and even drawings by children became of paramount importance to painters to provide new ways of creating art. They represented traditions free of the naturalistic con-

View of S. Shchukin's Dining Room, Moscow 1912, showing part of his collection

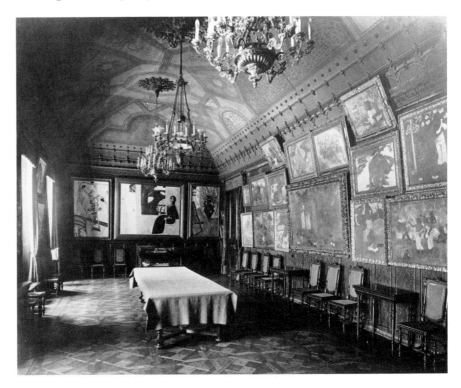

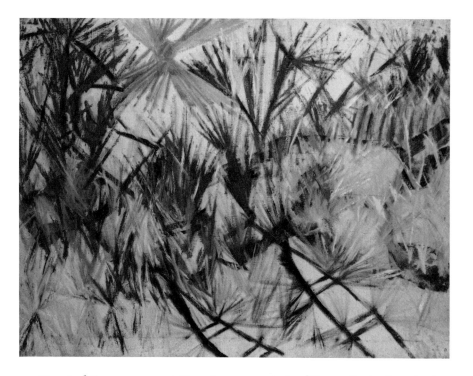

Mikhail Larionov
Rayist landscape, 1912
Oil on canvas,
$28 \times 37\frac{1}{4} (71 \times 94.5)$
Russian Museum, Leningrad

ventions of European post-Renaissance art, traditions that often had a religious, or, in Western terms, non-rational basis.

A combination of Cubism and primitive art was instrumental in bringing about the rise of abstraction in painting in Russia. For Larionov and Goncharova at least, a less thorough understanding of French Cubism proved more fruitful than the wholehearted adoption of that style which took place at the time in Czechoslovakia. Prague was a city rich in exhibitions of advanced Cubist painting and an indigenous school of Cubist work was soon established there, without leading to fully abstract painting, except, later on, in the case of Emil Filla. The dependence of Czechoslovakian avant-garde artists on French Cubism was perhaps too complete to allow for further development. In contrast, in Moscow, the idiosyncratic tastes of Shchukin and the accidents of examples of Western work shown in exhibitions, provided confusion between emergent Cubism and Primitivism. So in February 1912, when Cubism in Paris had evolved far beyond any direct dependence on 'primitive' arts, Goncharova stood up at a public discussion at a Moscow exhibition and said: 'Cubism is a positive phenomenon but it is not altogether a new one. The Scythian stone images, the painted wooden dolls sold at fairs are those same Cubist works.'[18] Such a remark is comprehensible only by reference to the kind of pictures by Picasso to be seen there that were predominantly neo-primitive in source.[19] In the absence of recent works, Goncharova and other Russian artists correctly saw primitivism as a vital ingredient in

Mikhail Larionov
Lithograph in A. Kruchenyk
V. Khlebnikov, *World backwa*
(*Mirskontsa*) Moscow, 1912

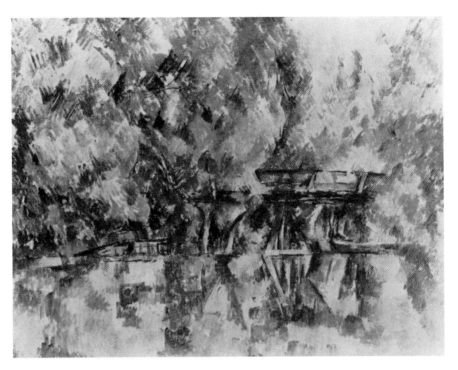

Paul Cézanne
Bridge over the Pool,
1888–90
Oil on canvas,
$25\frac{1}{4} \times 31\frac{1}{8}$ (64 × 79)
Pushkin Museum, Moscow
Formerly in the collection of
I. Morozov

Cubism which might give them a key to forming their own modern Russian art style. For a few months in 1912, Goncharova and Malevich made almost literal copies of the sources she had referred to.

Such an approach also contributed to the development of a largely abstract style by Larionov, which he called 'Rayism'. He used it for illustrations in Russian Futurist books as well as in exhibited pictures in 1912–13. However, in order to create what he intended as a national modern art form, Larionov took a different path to primitive art. Starting at the beginning by copying the marks made by the earliest prehistoric cave painters, Larionov went on to develop a linear style which was a mixture of ideas from many sources. Indeed, Rayism might be seen as an amalgam of avant-garde ideas from Europe; Larionov's drawings are closely related to some that Kokoschka and Kandinsky had made as cover designs for the Berlin periodical *Der Sturm*. Furthermore his early 'Rayist landscapes' of 1912-13 can be seen as an eccentric reading of Cézanne's 'Bridge over the Pool', now in the Pushkin Museum, Moscow and then owned by a Moscow collector. But there is also no doubt that a further stimulus in the development of Larionov's highly abstract style came indirectly from Italian Futurism. Larionov's biographer, Ilya Zdanevich, wrote in 1913 that a closer knowledge of Cubism and Futurism (presumably provided by exhibitions and photographs) had caused Larionov to become interested in the idea of style as such, suggesting that a more detached view of current trends allowed him more freedom to develop a personal style.[20]

[187]

As it happened, the large exhibition of Italian Futurist paintings which toured major cities in Europe during 1912 did not travel as far as Russia, so that knowledge of Futurist paintings there was derived from photographs reproduced in the catalogue and from other printed sources. Black and white photographs give a rather different picture from the original and much knowledge of the European avant-garde in Russia depended either on illustrations or on photographs brought back from Paris and Italy by artists studying abroad. In this respect an important role was played by Alexandra Exter, who lived in Italy and France for part of every year during the critical period of development of modern art. In his memoirs, a Futurist poet, Benedikt Livshits, records the excitement with which artists pounced on the latest photographs which she brought back with her.[21]

Such 'second-hand' information was backed-up by an astonishingly wide range of exhibitions organised by the avant-garde. A few months before the Munich exhibiting society founded by Kandinsky (*Der Blaue Reiter*) displayed a wide range of European graphic art in Germany, the Moscow 'Knave of Diamonds' put on an exhibition in which examples of work by artists from Paris, Munich and Berlin hung beside their own.[22] Thus pictures by Kirchner, Pechstein and Heckel were hung with those of Kandinsky, Marc and Macke, while Delaunay, Léger and Picasso joined the Burliuk brothers and Alexandra Exter. It is not surprising that in Russia the name 'Futurism' was simply a convenient label with which to 'tag' the avant-garde in much the same way as 'Expressionism' signified all that was progressive in Germany and 'Cubism' for a year or two in France. In Russia the name 'Futurism', originally borrowed by critics who saw a superficial resemblance to the Italian movement of that name, was given a new significance, utopian as much as iconoclastic. The movement and its artists Larionov, and, slightly later, Rozanova and Malevich developed quickly towards abstraction, unlike most of the Italian Futurists.

Nevertheless there is no doubt that Italian Futurism and the spectacular demonstrations which it generated played a role in the liberation of many artists in other countries who felt a need to work in a new way but lacked the daring. This was true even in Paris itself. In letters to a friend written in 1910 (after the *Foundation Manifesto of Italian Futurist Painting* had been published) František Kupka wrote: 'Even here, for years I had been a hungry soul, a soldier in the large army of great and small artists, until at the last – but better late than never – I have gained consciousness and now I stand hale and hearty before myself. The moment has come for me to write, draw and paint my credo.'[23] From 1909–10 he had painted a series of paintings and studies of a woman picking flowers which show the figure in successive stages of movement which antedated similar paintings by Italian Futurists. With his new-found courage he developed studies of a girl playing with a ball into a fully abstract painting 'Amorpha, Fugue in Two Colours' which caused a sensation at the *Salon d'Automne* in 1912.

Strangely, there was more popular discussion of the painting than it received in serious reviews. It was featured in a Gaumont newsreel, released throughout Europe but it is difficult to assess the influence of this first example of near geometric abstraction.

Equally problematic, though of much less importance, were the early manifestations of near abstraction painted in gouache by the Lithuanian, Mikalojus Ciurlionis. He was an artist/composer whose pictorial compositions were exhibited in Paris in 1910 with little apparent effect, probably because they were seen as symbolist. Ciurlionis also exhibited in St Petersburg, where he lived for the last two years of his life (from 1909–11). His work was illustrated and discussed in the widely read Petersburg journal, *Apollon*[24] but again there seems little evidence of direct influence even on such Petersburg artists as Nikolai Kul'bin and Mikhail Matyushin who shared similar interests in the relationship of music and art. It may be possible to trace later interest in Ciurlionis's preoccupations, which included Eastern philosophy and the possibility of applying the principles of music to art, to later followers of Matyushin. They included the Ender family of painters, who investigated abstract forms suggested to them by nature in a free, informal abstract style in the late 'teens and early 1920s.

The conjunction of the 'spiritual' with 'music and art' was exemplified at its highest in the writing of Kandinsky, where his ideas can seem to run ahead of his manner of painting. Both his writings and paintings were well known not only in Munich but in Paris and Russia. Kandinsky organised his own exhibitions and he was able to include sixteen canvases by Claude Monet in the seventh exhibition, *Phalanx*, in Munich (1902–4).[25] This was a remarkable exhibit considering Kandinsky's acknowledged debt to Monet: later he recalled that 'unconsciously the object was discredited as an inevitable element of a painting' when he had failed to recognise the subject of one of Monet's 'Haystacks' series in an early exhibition in Moscow.[26] In 1904 and 1905 Kandinsky exhibited with Jawlensky in Paris among the newly founded *Groupe d'Art des Tendences Nouvelles*. Kandinsky's woodcuts were illustrated in the magazine of the group and a large proportion of his *oeuvre* was featured in the 1907 exhibition organised by *Les Tendences Nouvelles* at Angers. Two years later the periodical published a portfolio of six wood-engravings by Kandinsky under the title *Xylographies* together with an essay on his art.[27] Also in 1909, the Russian avant-garde enthusiast, Vladimir Izdebsky, organised the first of two ambitious international Salons in Odessa. Kandinsky contributed to both, though the second was the more significant for the spread of his ideas and knowledge of his work among the Russian avant-garde. The catalogue of this Second Salon of 1910–11 was decorated with a woodcut by Kandinsky and contained an article by him[28] and the exhibition included more of his paintings than of those by any other artist. He showed many of his 'Improvisations' as well as his first three

'Compositions' there. As has already been mentioned above, Kandinsky participated in the Moscow 'Knave of Diamonds' exhibitions in 1910–11 and January 1912 and, in his absence, the Russian version of *On the Spiritual in Art* was read for him in St Petersburg in December 1911.[29]

Although it is not known precisely which artists participated in the 'All-Russian Convention of Artists' in December 1911 when Kul'bin read aloud Kandinsky's lecture, the simultaneous publication of the fuller *Über das Geistige in der Kunst* in Munich made Kandinsky's latest ideas available to a much wider artistic public. The book was an extensively revised form of the lecture and was, of course, illustrated with Kandinsky's abstract vignettes. It was soon followed by the publication in Munich in May 1912, of an almanac, *Der Blaue Reiter* (*The Blue Rider*) which contained essays by himself and his friends, mostly German and Russian. Clearly Kandinsky can be seen as instrumental in the forwarding of the ideals and practice of abstraction in art in Russia and Germany.

However it would be wrong to ignore the links which can be established between Kandinsky and Paris. Early in 1912, Robert Delaunay had seen a copy of *On the Spiritual in Art* and wrote to Kandinsky in Munich of his sadness at his inability to read the text. He added: 'There is still a great deal for the artist to do in this little-explored domain of colour construction . . . The search for pure painting is currently a problem for us. I don't know any painters in Paris who are really searching for this ideal world . . . I hope to find still greater flexibility in the laws I have discovered. They are based on the transparency of colour which can be compared to musical notes.[30]

Although Delaunay's 'laws' were not published as such, his ideas seemed attractive enough to Kandinsky's friends in Munich for them to visit Paris in 1912 especially to see him. Paul Klee went to Delaunay's studio with an introduction from Kandinsky in the spring and, later in the year, August Macke and Franz Marc followed. These German artists evidently found Delaunay's approach to colour combined with structure particularly helpful. No doubt they found it an alternative both to Kandinsky's intensely personal, free use of colour and to the structurally exciting, but colouristically subdued, Cubist paintings of Picasso. Such pictures were among the sixteen by Picasso (of all periods) hanging in the enormous *Sonderbund* exhibition that was open all summer at Cologne. Macke was on the 'Working Committee' for this important comprehensive, international exhibition, although Marc withdrew his pictures from it in protest against the way the entries were selected.

Following their visit to Paris, the immediate influence of Delaunay's painting on these Munich artists was made more widely available with the publication of his ideas. Klee translated an article by Delaunay which was published in the Berlin periodical *Der Sturm*. In the same issue, No. 3 of 1912, Apollinaire's article, 'Realité, peinture pure', included a characteristically utopian statement of intention by Delaunay: 'We are attaining a

purely expressive art, one that excludes all the styles of the past (archaic, geometric) and is becoming a plastic art with only one purpose: to inspire human nature towards beauty.'[31]A slightly shorter version of this article about Delaunay's ideas was published in *Les Soirées de Paris*, also in December 1912. The following month, coinciding with an exhibition of his paintings at the gallery Der Sturm, Delaunay published an album of eleven plates, prefaced by Apollinaire's poem, 'Les Fenêtres'.

These links between Delaunay and Germany, which were so strong in 1912 and early 1913, were extended to Russia later that year. A certain Professor Smirnov gave an illustrated lecture on 'Simultaneity' in poetry and painting on 22 December in St Petersburg.[32] One or two avant-garde artists including Kul'bin were present and Smirnov's showing of Blaise Cendrars' poem *La Prose du Transsibérien et de la Petite Jehanne de France* must have made an interesting comparison with the revolutionary books which Russian Futurists had already published. Cendrars' poem was printed on a long piece of paper which unfolded like a scroll; the elaborate printing was accompanied by Sonia Delaunay's abstract, coloured, stencilled decoration. Kul'bin contributed decoration to one of the few coloured Russian Futurist books, *Te li le* which was perhaps produced in response to the French book, for *Te li le*, as the most recent book, was shown to Marinetti, the leader of the Italian Futurists, on his visit to Petersburg in January 1914.[33] In it, Rozanova's designs for poems provided a rival form of abstraction.

By the time Marinetti finally visited Russia early in 1914, the Russian Futurist movement had already taken a quite different direction from the Italian. Russian artists had responded to Western theories by developing their own. Thus in the occasional journal of the avant-garde Petersburg exhibiting society called the *Union of Youth*, a translation of the introduction to the catalogue of the Italian Futurists' exhibition of 1912 had been printed with the second part of an important essay entitled 'The Principles of the New Art'. It was written by Woldemārs Matveis (the theorist Vladimir Markov) who was also interested in Chinese poetry. He emphasised the role of the East as an inspiration for poetry and art and considered the principle of chance as an element of creation.[34] His essay ended with a reference to '*faktura*', a particularly Russian concept, (usually translated 'texture') which became a specific preoccupation of the avant-garde and was widely used among constructivist writers later on.

The following year, in March 1913, a third number of the *Union of Youth* included both a long review of Gleizes and Metzinger's seminal work, *Du cubisme* and an article by the painter Olga Rozanova.[35] In a review by Mikhail Matyushin, passages translated from the French book were, somewhat surprisingly, interspersed with excerpts from *Tertium Organum*, a mystical book by the Petersburg writer, P. D. Uspensky. The resulting personal interpretation of Cubism was relevant not only to Matyushin's

own painting but also to the development towards abstraction of other Russian artists, especially Rozanova and Malevich. Rozanova's own article in the same journal was illustrated with examples of her work and included 'abstract creation' as the third process of creation: the first two being 'intuitive principle' and 'individual transformation of the visible'. From her article there was only a short step to Larionov's definition of Rayism (*Luchizm*): 'Painting is self-sufficient; it has its own forms, colour and timbre. Rayism is concerned with spatial forms that can arise from the intersection of the reflected rays of different objects, forms chosen by the artists will.'[36] By the time this statement was printed, in July 1913, Larionov had already published a number of virtually non-objective illustrations in Russian Futurist books which supported his theory.[37]

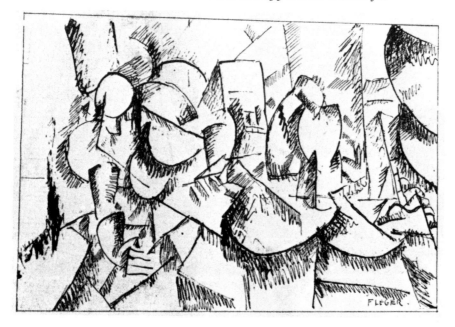

Fernand Léger
Etude de dynamisme linéaire,
Reproduced in *Montjoie!* no.8,
29 May, 1913, p.7

Revealing comparisons may be made between the illustrations and reproductions to be found in Russian avant-garde publications of 1913 with those in German and French journals. But of course most of the contemporary influence travelled from west to east because of the language barriers. In this respect, a new illustrated Parisian journal named *Montjoie!* was of the utmost importance for spreading new ideas throughout Europe from its first number published in January 1913. In March a supplement to cover the *Salon des Indépendants* enabled readers of *Montjoie!* unable personally to visit Paris to see good photographs of works shown there. By the end of the year paintings by Delaunay, Le Fauconnier, Gleizes, Metzinger, Roger de la Fresnaye, Jacques Villon and Fernand Léger had been reproduced in the journal.

Léger's work was given a particular prominence in 1913 for he gave a

Pablo Picasso
A relief reproduced in
Les Soirées de Paris,
no.18, 15 November, 1913

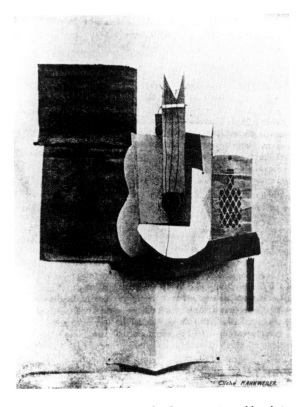

lecture at the Russian *Académie Vasiliev* in Paris which was printed both in Berlin in *Der Sturm* (in French) and in Paris, in *Montjoie!*.[38] Léger spoke of a new approach to 'realism' which he defined as 'pictorial realism' and described as 'the simultaneous ordering of three great plastic components: Lines, Forms and Colours'.[39] So Léger outlined a kind of realism related not to subject matter but to the constituents of the picture itself; furthermore in *Montjoie!* his lecture was accompanied by reproductions of his latest work which illustrated his tenets.

At about the same time, a second new, monthly French journal, *Les Soirées de Paris* began to broadcast information about avant-garde art and literature and, in a revised format, from November 1913, included photographs. Thus issue 18 carried excellent photographs of Picasso's 'Natures Mortes' among them four three-dimensional constructions which had not been exhibited outside Paris. They suggested the idea of the free movement of planes as autonomous elements and perhaps help to account for Malevich's painting 'The Guardsman' of early 1914. However, the majority of paintings being produced in Europe during 1913 that came close to Léger's formulations, seem to have been based on colour relationships (perhaps derived from Delaunay's 'laws') rather than on a structural tradition derived from Cubism.

This rather sweeping generalisation is made from the evidence of pub-

lished photographs of works included in exhibitions such as the comprehensive *Erste deutsche Herbstsalon* (First German Autumn Exhibition) held in Berlin during that year.[40] There were to be seen abstract or nearly abstract paintings by Kandinsky, Klee, Marc, Picabia, Delaunay, Bruce and Léger, all of which look non-representational in the reproductions printed in the catalogue. In fact, the titles today confirm that artists were usually working with a motif that can still be discerned in the pictures themselves. A rather different approach to abstraction was set out in an article published in *Montjoie!* in January 1914. Here Valentine St Point's 'Métachorie' was described in an issue devoted to the dance. Métachorie 'became the point of convergence of image, harmony, colour and number' and the article was illustrated by curious, geometricised diagrams by Baldo. But the geometric preoccupations of St Point and before her, of Kupka in his 'Amorpha' paintings, do not seem to have been generally shared at the time in France, judging by the next issue of *Montjoie!* which was devoted to the *Salon des Indépendants*. It contained photographs of paintings by the Delaunays, the American Synchromists and Baranov-Rossiné, which, though abstract-looking, were concerned with the implication of movement by colour rather than by geometric, abstract forms.

This *Salon des Indépendants* of March 1914 was the only occasion on which Kazimir Malevich contributed to an exhibition in Paris. Two of his three pictures were reproduced in a Russian journal,[41] although his work was barely mentioned in Paris. One of them, 'Samovar', was extremely close to Picasso and Braque's most hermetic Cubist paintings of two years before, including almost monochrome colouring. Another canvas which Malevich sent to Paris was his 'Portrait of a Builder Completed' which today looks a most original adaptation of Cubist ideas. Indeed, a comparison of this portrait with a Suprematist painting which Malevich showed among his first geometric abstractions in December 1915 proves his debt to a thorough study of Cubism. Nor was this a secret, for the title of the explanatory booklet which Malevich produced in 1915 to help justify his remarkable abstract pictures was *From Cubism to Suprematism: a new Pictorial Realism* (only in the later augmented edition did he alter the title to *From Cubism and Futurism to Suprematism . . .*).[42]

Yet Malevich's use of geometric forms follows neither directly from Cubism nor from the earlier preoccupations of Kupka whose 'Amorpha' had signalled a use of geometric form. As well as the extensive Russian background to the development of Malevich's Suprematism there seem to have been one or two further stimuli which reached Russia from abroad and contributed to his radical invention. For example in *Les Soirées de Paris* in 1914 a second lecture by Léger was published. Once more Léger had addressed a largely Russian audience at the *Académie Vasiliev*. He insisted again on the *realism* of the new kind of painting, describing it as a 'kind of

Kazimir Malevich
**Portrait of a Builder
Completed**, 1913
Oil on canvas,
$45\frac{1}{2} \times 27\frac{3}{4}$ (115.5 × 70.5)
Russian Museum, Leningrad

painting that is realistic in the highest sense'. Among other things he reassured his listeners that avant-garde art was for the artist's sake (rather than for art's sake). It is fascinating to speculate whether Malevich read Léger's sentence: 'He will not be original just because he will have broken up an object, or placed a red or yellow square in the middle of his canvas; he will be original by virtue of the fact that he has caught the creative spirit of these external manifestations.'[43] But although it might be tempting to read it as a prophecy of Malevich's 'Pictorial realism of a peasant woman in two dimensions' of 1915, which consisted in a slightly distorted red square painted on a white ground, such a literal transposition of ideas is far too simplistic an explanation.

Nonetheless between 1913 and 1915 Malevich was certainly searching for a formal vehicle for his complex philosophical thought and was open to a wide range of possibilities. Illustrations in C. Howard Hinton and Claude Bragdon's books on the fourth dimension[44] provided a justification for using geometric forms which had been considered too close to decoration

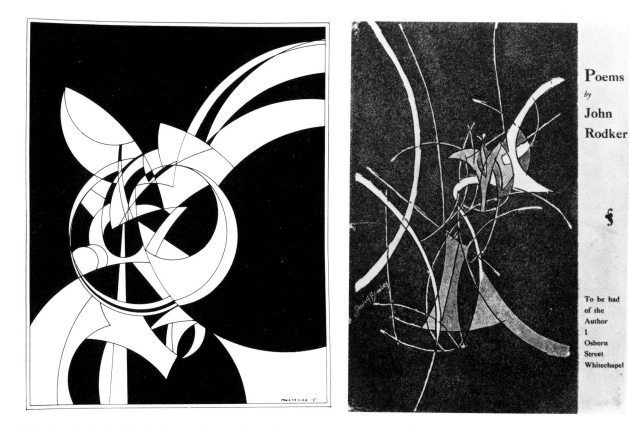

by Kandinsky in *On the Spiritual in Art* (see above). A further incentive and prototype was provided by the description of work by the English Vorticist group published in an article in a new avant-garde St Petersburg journal early in 1915.[45] This took the form of an interview with Ezra Pound and was accompanied by a single example of a Vorticist painting: a reproduction of Wyndham Lewis's 'Portrait of an Englishwoman'. In this picture the head of a woman could be seen to be composed from abstract, nearly geometric elements of a type which Malevich came to use in his suprematist paintings. The picture was quite probably reproduced directly from the Vorticist magazine *Blast* which became widely known in Russia.

Although I find such links convincing myself, I must point out that a parallel connection which can be found in the work of Alexander Rodchenko and a Vorticist book jacket may be due simply to a common source. In 1915 Rodchenko began to make geometric drawings with a compass and ruler. Some of them are very close to the cover of a small book of poems by the English poet, John Rodker, drawn in geometric curves by David Bomberg in 1914.[46] It is of course possible that a copy of the book was seen by Rodchenko but it seems more likely that a knowledge of Kupka's 'Amorpha' underlies both English and Russian variants.

Early in 1916 when Rodchenko exhibited his drawings (which, ad-

Above left
Alexander Rodchenko
Compass and ruler drawing,
1915
Indian ink on paper
Rodchenko Archive, Moscow
Photograph copyright
Museum of Modern Art,
Oxford

Above right
David Bomberg
Cover design for J. Rodker,
Poems, London, 1914

mittedly, were strikingly black on white like the description of Vorticist decoration in the interview with Pound cited above) there were already many precedents for variants of abstract art. In Russia itself, Ivan Puni (Jean Pougny) had exhibited a small plank of wood, painted green, in Petersburg in March 1915. Six months' later, Malevich had horrified even his friends by exhibiting exclusively geometric paintings. Furthermore, early in 1916 the poet Kruchenykh published a small edition of a book of visual poems, which consisted of collages of torn and cut tissue and other coloured paper and cloth arranged on pages of deep blue paper. Called *Universal War* its freedom of invention was only to be rivalled by Matisse in his much later collages.

O. Rozanova
Collage in A. Kruchenykh,
Universal War (Vselenskaya voina), Petrograd, 1916

Naturally on account of the European war which had broken out in 1914 the dissemination of information about the latest avant-garde events did not flow as freely as it had done in the preceding years. In fact in the case of one of the pioneers of abstraction, Mondrian, enforced stay in his native Holland (due to the outbreak of war coinciding with his absence from Paris) helped to bring about his particular experiments in abstract painting. Although he did not develop his mature style until towards 1920, it was born out of his close friendships with Dutch artists and writers. They formed an association which they named 'De Stijl' which, though on a reduced scale, parallels the development of abstraction among Futurist groups in Russia. It is an inescapable fact that the artists who were isolated from the horrors of the Great War were the ones who pursued the most relentless path to abstraction.

It can rightly be argued that there is a connection between the 'De Stijl' movement, which continued among the Dutch after the end of the war, and the constructivist movement which arose in Russia in the early 1920s, after the Revolutions of 1917. In spite of the contrast in background events, these connections were established in a manner very like pre-war ones. Once again crucial factors were material disseminated by publications, exhibitions and their catalogues and the travel of artists themselves. In this respect the Russian artist El Lissitsky played an important role, as did the Dutch Van Doesburg. The journals *De Stijl* and *Wendigen* in Holland, *MA* in Vienna, *Veshch/Gegandstand/Objet* in Berlin were distributed as widely as *Montjoie!*, *Der Sturm* and others had been earlier.

In a strange way history repeated itself before 1921 with the establishment in Russia and Germany of a type of art school very similar to those pioneered at the turn of the century in Germany – especially the Darmstadt artists' colony founded in 1899.[47] Kandinsky taught at post-revolutionary art schools in Moscow and then at the Bauhaus in Weimar, where the ideas and ideals of abstraction that had been put forward by teachers in Darmstadt and their friends, were brought to fruition, not only in the design field but also in fine art.

The dissemination of ideas about abstract art in England and America

Sara Selwood

> French art cannot get on without movements . . . We in England don't have movements if we can help it . . . in spite of the excitement we lose.
>
> (Laurence Binyon, *Saturday Review*, November 1910)

By 1914 England did have a movement, not a mere imitation of a foreign movement but a British one and an abstract one at that – Vorticism.[1] Wyndham Lewis, the Vorticists' leader, laid particular stress on two of its characteristics. He not only insisted that the movement should be regarded as independent of any foreign influence but also demanded the end of representational art. 'There should be a bill passed in Parliament at once FORBIDDING ANY IMAGE OR RECOGNISABLE SHAPE TO BE STUCK UP IN ANY PUBLIC PLACE.'[2]

Lewis's outburst is all the more extraordinary in that until about 1910 there had been little in the English art scene to inspire the growth of any new movement. The only alternative to the Academy and the New English Art Club was the Association of Allied Artists which held an annual jury-free exhibition, similar to that of the French *Indépendants*. Even if the general standard of paintings shown at the A.A.A. was low, the Association performed an important function in introducing foreign art into England. Between 1909 and 1913, no less a personage than Kandinsky exhibited with the A.A.A. on four occasions. Michael Sadleir remembered buying, at the 1911 exhibition . . .

> for a few shillings each half a dozen small square woodcuts by a Russian artist called Kandinsky. They were strange productions, semi-representational, and with an element of hieratic rigidity.[3]

Kandinsky was not the only artist willing to exhibit with the A.A.A.; in 1913 Brancusi contributed a 'Sleeping Muse' to the exhibition in the Royal Albert Hall.

The fact that foreigners were prepared to exhibit works in England at all represented something of a breakthrough. French artists, in particular, had been loth to exhibit in London because there was no market for their work.[4] But the unexpected financial success of Roger Fry's first Post-Impressionist exhibition of November 1910 opened the floodgates. Although plans for a *Blaue Reiter* exhibition 'had to be abandoned on

grounds of expense',[5] between 1912 and 1914 six small galleries mounted seven exhibitions which included not only the work of leading contemporary foreign artists but several abstract paintings: Carrà's 'Plastic Tendencies', Severini's 'Spherical Expansion of Light (Centrifugal)', and Balla's 'Abstract Dynamism'.[6] In March 1912 the Sackville Gallery took over the Parisian Galerie Bernheim-Jeune's exhibition of works by the Italian Futurist Painters. In April that year, the Stafford Gallery mounted an exhibition of Picasso's drawings and in October Roger Fry put on his *Second Post-Impressionist Exhibition* at the Grafton Galleries, which included no fewer than thirteen Picassos and four Braques. In March 1913, Gino Severini had his first one-man show in London at Marlborough's and the Grafton Group exhibited paintings by the American Max Weber as well as some of Michael Sadler's Kandinskys. In July, Brancusi and Kandinsky exhibited at the A.A.A. Kandinsky showed 'Improvisation No.29', 'Improvisation No.30 (Cannons)' and 'Landscape with Red Poplars'. In October, the Doré Galleries, in collaboration with Frank Rutter, put on a major Post-Impressionist and Futurist exhibition, which included examples of work by Delaunay, Picasso, Severini, Brancusi and Marc. In January 1914, some photographs of 'certain "sculpture" devised by M. Picasso by means of egg-boxes and other débris . . . [which] could not be trusted to cross the Channel without falling to pieces'[7] were shown at the second Grafton Group exhibition at the Alpine Club Gallery. In February, Kandinsky, Marc and Pechstein were among the contributors to the 'Exhibition of Modern German Art' at the Twenty-One Gallery and in April the Doré Galleries mounted a second Futurist exhibition including painting as well as sculptures.

Of all the examples of foreign art shown in London, it was undoubtedly Futurism, not only its paintings but also its ideas, that contributed most profoundly to the emergence of Vorticism. As early as April 1910, the spokesman for the Futurists, F. T. Marinetti, was attacking the beliefs and principles of the audience who turned out to hear him lecture at the Lyceum Club for Women. By August, his Futurist propaganda had even infiltrated the respectable leisure magazine, *The Tramp*.[8] In March 1912, Marinetti accompanied the Futurist exhibition to London and gave an introductory lecture on the Italian movement at the Bechstein Hall. It was, in his own words, 'a colossal success'. The exhibition inspired no fewer than 350 articles and 11,000 francs' worth of sales.[9] It also gathered a lot of support. The September issue of *Poetry and Drama* was exclusively devoted to Futurism, and the group of artists around Wyndham Lewis were happy to identify themselves with the Italian movement. Lewis even planned to publish a paper 'somewhat on the lines of the Futurist Manifestos'.[10] He held a banquet in honour of Marinetti and invited him to lecture at the new Rebel Art Centre, one of whose activities was to promote the principles of Futurism throughout England.[11]

But Marinetti overrated the success of his English 'Active Propaganda' campaigns. On 7 June 1914, together with Nevinson, one of Lewis's colleagues, he published an English Futurist manifesto complete with the unauthorised signatures of all the Rebel Art Group. Rather than consolidating his disciples, the publication of VITAL ENGLISH ART. FUTURIST MANIFESTO,[12] forced an irrevocable split between Marinetti and Wyndham Lewis's circle. In less than a week, Lewis had responded by officially announcing the existence of Vorticism and denouncing Futurism.[13] By 2 July, he had published his own manifesto in the first issue of his, now Vorticist, journal – Blast.

This reaction was, essentially, one of self-defence. As Richard Cork has pointed out, Wyndham Lewis, at this stage, was more concerned with attacking Futurism than making clear how he thought a Vorticist ought to paint or sculpt.[14] But, despite the derogatory references to Marinetti scattered throughout the first issue, the attitudes and formal layout which characterise Blast can be traced back to Futurism. There is a striking similarity between the sections entitled 'BLAST' and 'BLESS', and those called, 'MERDA' and 'ROSE', 'DISTRUZIONE' and 'CONSTRUZIONE' in Apollinaire's 1913 L'ANTITRADIZIONE FUTURISTA: Manifesto-sintesi, as well as the 'AGAINST' and 'WE WANT' parts of VITAL ENGLISH ART: FUTURIST MANIFESTO. Marinetti's 1910 Lyceum lecture, in which he mocked England and its nineteenth-century attitudes may even have inspired Wyndham Lewis's diatribe against his native country:

> BLAST First (from politeness) ENGLAND
> CURSE ITS CLIMATE FOR ITS SINS AND INFECTIONS . . .
> VICTORIAN VAMPIRE, THE LONDON cloud sucks the TOWN's heart.[15]

The fact that the type for the first issue of Blast was already set up before the Vorticists broke with Marinetti prevented Wyndham Lewis from making any major alterations, but some of the articles he wrote for other publications reveal his true feelings about Futurism. In contributions to New Weekly and T.P.'s Weekly, Lewis attacked the very foundation of Futurist theory – 'Automobilism' – a peculiar failing which stemmed from the 'extraordinary childishness of the Latins over mechanical inventions, aeroplanes, machinery etc'.[16] As he informed Marinetti:

> You Wops insist too much on the Machine. You're . . . always exploding about internal combustion. We've had machines here in England for donkey's years. They're no novelty to us.[17]

But despite appearances, Wyndham Lewis's polemic against Marinetti's Futurist theories was more than a slanging match. The differences between the English and Italian movements were philosophical. When the Futurist extolled the 'ivresse of travelling at a kilometre a minute' and claimed that things are only there when they go quickly, he elicited little response from Lewis. 'I loathe anything that goes too quickly,' he

explained. 'If it goes quickly, then it isn't there . . .' To Marinetti's despair, he quoted a line from Baudelaire's *La Beauté*: 'Je hais le mouvement qui déplace les lignes.'[18] Stimulated by his hatred of 'crap like Bergson',[19] Wyndham Lewis not only BLASTED the philosopher but dismissed as sentimental the Futurists' obsessive emphasis on Life, the Past and the Future, all of which they associated with art. 'With our Vortex, the Present is the only active thing,' he insisted. 'Life is the Past and the Future. The Present is art.'[20] Far from being caught up in a whirlpool of Futurist activity, the Vorticist could be found '. . . at the heart of the whirlpool', in the 'great silent place where all the energy is concentrated'.[21] Like the Futurist, he was symbolised as a weapon of destruction, but the privilege of his exalted position freed him from being 'the slave of Commotion'. He was instead 'its Master':

> The Vorticist does not suck up to Life
> He lets Life know its place in a Vorticist Universe![22]

If Wyndham Lewis refused to acknowledge the Vorticists' links with Futurism, he also denied any debt to either the Cubists or the Expression-ists. Even though the circle of artists around Wyndham Lewis had identi-fied themselves as 'Cubists',[23] Lewis had little patience with Cubist aesthetics. He felt that Picasso's notions about art were just about as fragile as his 'latest works . . . [which] do not even seem to possess the necessary physical stamina to survive'. Picasso's constructions were, he considered, unrelated to real life. They were not so much an interpretation of life, as 'little NATURES-MORTES . . . (and "DEAD" nature at that)'.[24]

Kandinsky, 'the only PURELY abstract painter in Europe', also came under attack.[25] Despite the fact that Wadsworth published a précis and commentary on Kandinsky's treatise *On the Spiritual in Art* in *Blast* No.1 and that Nevinson recommended the Russian's three paintings exhibited at the A.A.A. as some of 'the finest modern pictures I have seen',[26] Wyndham Lewis's objections remained steadfast. He despised Kandinsky's 'ethereal, lyrical and cloud-like' attitude towards painting:

> He is so careful to be passive and medium-like, and is committed by his theory, to avoid almost all powerful and definite forms, that he is, at the best, wandering and slack.

But Wyndham Lewis's greatest complaint was that Kandinsky refused 'to ACKNOWLEDGE that he had (by accident) reproduced a form in Nature'.[27] 'In what is one painting representative and another non-representative?', Lewis asked rhetorically.

> If a man is not representing people, is he not representing clouds? . . . masses of bottles? . . . houses and masonry? Or is he not representing in his most seemingly abstract paintings, mixtures of these, or of some-thing else? Always REPRESENTING, at all events.[28]

1. Wyndham Lewis
Red Duet, 1914
Chalk and gouache,
$15\frac{1}{8} \times 22(38.5 \times 56)$
Private Collection

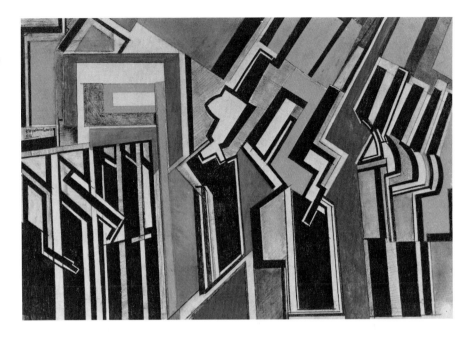

The fact that Kandinsky had never actually claimed that his paintings were abstract is irrelevant. What is important is Lewis's categorical denial of the possibility of abstraction, especially since some of his own works from about 1912–15 have been described as among the earliest examples of European abstract painting. According to Clive Bell, Lewis's 'Timon of Athens' drawings of 1912 were neither 'descriptive' nor depended 'for effect on association or suggestion'.[29] But can these drawings, or any of Wyndham Lewis's other work of the same period, actually be described as abstract? The Timon series was in fact originally commissioned to illustrate a new edition of Shakespeare's play. By far the majority of drawings in the folio are highly figurative, portraying characters and events in the tragedy. It is even possible to trace their stylistic origins: David Bomberg claims to have seen Lewis copy 'freehand without tracing' some of Boccioni's figures from the 1912 London exhibition catalogue.[30] Even highly geometrical works, like the lost 'Plan of War', were apparently just as illustrative. According to the critic Frank Rutter 'Plan of War', like other paintings whose titles were taken from a military text-book ('Slow Attack' for instance), was based on the 'familiar diagram of a battle which we see in history books'.[31]

Other works are, however, not so easy to account for. How did Wyndham Lewis first come to use the geometric forms which characterise the vignettes for 'Timon of Athens', a later drawing, also called 'Timon of Athens', 'Composition', 'Red Duet' (fig.1) and 'Portrait of an English-woman'? There can be no doubt that his experience as a designer of objects of applied art, first at Roger Fry's Omega Workshops and later at his own

Rebel Art Centre, encouraged him to abandon representation. As Fry pointed out, the artists who founded Omega, were 'by nature, predisposed to the study of pure design'.[32] Lewis's rationale that 'In a painting certain forms MUST be so' seems to confirm this.[33]

But whence did he derive his pictorial vocabulary? It is quite possible that Wyndham Lewis's hard-edged geometrical forms were inspired by his friend Ezra Pound's demands for a new poetry: 'austere, direct' and stripped of every pictorial convention. Pound himself certainly recognised the applicability of his aesthetic to painting:

> I found, suddenly, the expression. I do not mean that I found words, but there came an equation . . . not in speech, but in little splotches of colour. It was just that – a 'pattern' . . . I realised quite vividly that if I were a painter . . . I might found a new school of painting, of 'non-representative' painting, a painting that would speak only by arrangements in colour.[34]

It is no coincidence that Pound's new understanding of literature, inspired as he left the metro, should have appealed to Lewis. The most consistent image, in both Lewis's theoretical and fictional writings, is that of the machine. But unlike Pound, who thought that the admiration of machinery was simply 'natural',[35] Lewis believed it to be extremely significant. Despite his rebuke to Marinetti, he hailed the proliferation of mechanical inventions as the dawning of a 'New Order and Will of Man' and 'Machinery' as the 'greatest Earth-medium' which 'sweeps away the doctrines of a narrow and pedantic Realism at one stroke'.[36] The creative stamina of machinery presented the Vorticists with a challenge. 'We are proud, handsome and predatory', their leader claimed, 'we hunt machines, they are our favourite game. We invent them, then hunt them down'.[37] It was hardly surprising that Lewis had in his first manifesto picked on the image of 'Primitive Mercenaries in the Modern World' to describe the Vorticists.[38]

Only four months before, in January 1914, Lewis had attended a lecture by the English philosopher T. E. Hulme on 'Modern Art and its Philosophy'. The gist of the lecture was that the 'tendency towards abstraction', which the speaker felt characterised the 'present movement in Europe', could be compared with the geometrical art of the so-called primitives. Hulme's theories were totally foreign to the majority of his audience at Kensington Town Hall; they were, as he himself admitted, 'virtually an abstract of Worringer's views'.[39] Wilhelm Worringer, whose treatise, *Abstraction and Empathy*, was highly influential among artists abroad, had suggested that the stylistic peculiarities of primitive art do not result from a lack of technical ability but arise from a particular spiritual state: hostility. The primitive's 'urge to abstraction is', Worringer believed, 'the outcome of a great inner unrest inspired . . . by the phenomenon of the outside world; in a religious respect it corresponds to a strongly transcendental tinge to all notions. We might describe it as an immense spiritual dread of space.'[40] On

the other hand, the pre-condition to empathy, as reflected in the art of the Greeks, for instance, 'is a happy pantheistic relation of confidence between man and the phenomenon of the external world'.

For his part, Hulme not only recognised the relevance of this distinction to contemporary art but predicted that the new tendency towards abstraction would culminate

> not so much in the simple geometric forms found in archaic art, but in the more complicated ones associated in our minds with the idea of machinery.[41]

Artists would, in short, turn to man-made structures for inspiration rather than to nature. The 'specific differentiating quality of the new art would', Hulme guessed, 'be its "mechanical" appearance. Artists would seek to emulate "engineers'" drawings, where the lines are clean, the curves all geometrical and the colour laid on to show the shape of a cylinder.' The notion that the artist could impose the 'clear, hard and static' forms of machinery on his environment was crucial. He could transform the 'organic into something not organic' and 'translate the changing and limited into something unlimited and necessary'.

Although Hulme accepted that the basis of all plastic art rests on the 'possibility of ... [imposing] ... our own emotions ... into ... outside shapes and colours',[42] he was uneasy about total abstraction. 'Nature ... suggests forms which the artist can develop,' he pointed out, recommending that the painter should 'Put a man into some geometric form'. It will, he emphasised, lift 'him out of the transience of the organic'. Wyndham Lewis had done exactly this; as Hulme noted, his only 'interest in the human body' was in the 'few mechanical relations' he perceived in it: 'the arm as a lever and so on'.

The similarity between Hulme's and Lewis's theories was so great that the Vorticist was forced to comment:

> All the best things that Hulme said about the theory of art were said about my art ... We happened ... to be made for each other, as critic and 'creator'. What he said should be done, I *did*. Or it would be more exact to say that I did it, and he said it.[43]

It is also possible that Lewis's machine-anthropomorphism was inspired by one of the last unanimist poems by Marinetti's friend, Jules Romains:

> We shall be the playthings of wheels
> which think only of working well
> we shall be made of copper and iron[44]

Either way, Wyndham Lewis affirmed that his own work was essentially figurative. Even his most abstract paintings, like the 'Red Duet', are, as Richard Cork has explained, based on the human figure.[45]

How did other English artists respond to ideas about abstract art? David

Bomberg, Hulme's favourite painter, was one of the most advanced artists in London. His gradual progression towards abstraction, from 1912 to 1914, was everything Hulme could have wished. His preliminary drawings for 'In the Hold' and 'The Mud Bath' reveal a consistent development from the highly figurative to the highly abstracted. These series of studies are remarkable documents of early experiments with abstraction, not least because they pre-figure the Dutch artist Bart van der Leck's similar experiments of about 1916. Bomberg's manifesto, published on the occasion of his one-man show at the Chenil Gallery in July 1914, dogmatically asserted the importance of form rather than figuration:

> I APPEAL to a *Sense of Form* . . . In some of the work I show . . . I completely abandon *Naturalism* and Tradition. In other work . . . where I use Naturalistic Form, I have *stripped it of all* irrelevant matter . . . where decoration happens, it is accidental. My object is the *construction of Pure Form*, I reject everything in painting that is not Pure Form.

Difficult though it may be to recognise the original motif in the final painting, none the less, figurative references always remained the basis of Bomberg's large compositions. His series of 'Dancers', on the other hand, excluded all natural references. These smaller watercolours, begun in 1913, created a purely abstract equivalent of a dancer's movement. Like other Omega artists who pursued the same theme, Bomberg was inspired by the constant visits of Diaghilev's Russian Ballet to London. But, rather than reduce the dance to a series of formalised gestures like the anonymous craftsman of the Omega 'Desk with Inlaid Design' (fig.2), Bomberg synthesised several movements into one image. The formal similarity and the intention to convey rhythm shared by Bomberg's 'Dancer', c.1914 (fig.3) and Kupka's 'Amorpha, Fugue in Two Colours' of 1912 (illustrated on p.174) are too close to be coincidental. Even if Bomberg missed seeing the Czech artist's painting when it was exhibited at the *Salon d'Automne* of 1912, he may very well have seen the newsreel Gaumont made about Kupka's extraordinary abstractions.[46]

But even Bomberg, one of the most inventive and original English painters, was wary of the extreme consequences of abstraction. When Robert van't Hoff invited him to join the Dutch group, De Stijl, in 1919 Bomberg refused. He complained that their work depended basically on 'juxtapositions of form that found their way to Leyden via the cubists . . . but more elementary'. This could, he believed, only lead to the 'Blank Page'.[47]

One other group of English artists was also experimenting with abstraction at the same time as Lewis and Bomberg: the painters associated with the Bloomsbury circle. From about 1913 to 1915, Vanessa Bell, Duncan Grant and Roger Fry produced a number of completely non-objective works, which were among the most advanced paintings in

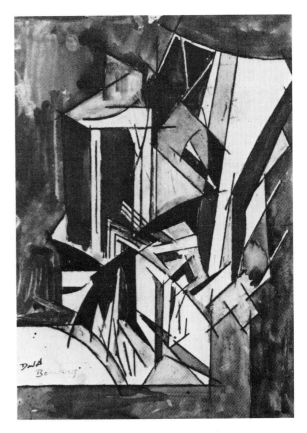

2. *Above*
Anon
Desk with inlaid design,
*c.*1913. Inlaid wood,
Lost

3. *Right*
David Bomberg
The Dancer, 1913–14
Watercolour and chalk,
$14\frac{1}{4} \times 10\frac{1}{4}$ (36 × 26)
Private Collection

Europe. Grant's work was extreme enough to be acceptable even to the Vorticists. He participated in their 1915 exhibition at the Doré Galleries. But, unlike those of their contemporaries who trod a consistent though problematic path to abstraction, Grant, Bell and Fry produced totally non-representational paintings apparently without any theoretical problems whatsoever. Furthermore, they were quite at ease working on highly abstract and highly representational paintings at the same time. In a letter to Roger Fry, Vanessa Bell described how Duncan Grant has 'started on a long painting . . . which is purely abstract'. In the next breath, she adds 'We have both started on a still life and on different landscapes . . . Duncan has begun to paint a picture of me in my red evening dress . . . We are doing two modern dress dancing figures . . .'[48]

This is hardly the statement of a confirmed abstractionist, nor a description of one. So what value did abstract art hold for the Bloomsbury painters? Vanessa Bell first ventured into abstraction with designs for the Omega Workshops, and it was in these that her assimilation of contemporary foreign developments in painting is revealed. Her reaction to Kupka's 'Vertical Planes III' (illustrated on p.175) which she saw in 1913 in the company of Fry, Grant and Clive Bell during one of their forays to

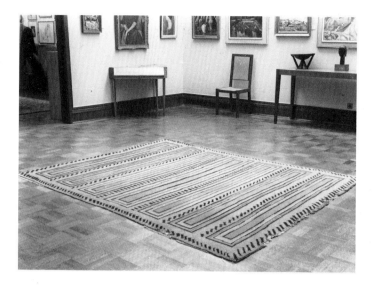

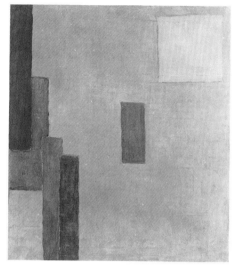

Paris was to produce a rug design (fig.4) based on similar rectangular forms. About two years later, she used the same design as the basis of one of her few abstract paintings, 'Abstract' (fig.5). There is little difference between the 'design' and the 'painting'.[49]

The fact that the Bloomsbury artists blurred the distinction between painting and design was not as surprising as it might seem. There was a theoretical justification for putting painting and design on the same level. In 1914 Clive Bell, Vanessa's husband, published a highly influential treatise called *Art*, in which he suggested that all great works of art, be they pots, dishes, figurines or paintings, have one particular quality in common. This 'purely aesthetic quality' was, he suggested, 'significant form': a quality which 'has to do with order, sequence, movement and shape'.[50] The notion of significant form implied that 'the representation of nature was entirely irrelevant' to art. It also confirmed the idea that a 'picture might be completely non-representative'.[51] Duncan Grant's 'Abstract Kinetic Collage Painting with Sound', also of 1914, is possibly the most obvious example of a painting based on 'significant form'. The painting, a long scroll, was meant to be viewed in continuous slow motion through an aperture, so that all seventeen different presentations of a group of seven rectangles could be seen in sequence. Slow music by Bach was supposed to accompany the passage of the painting.

What might have happened if the war had not supervened is open to question. In the event, the Bloomsbury painters were thrown back on their own resources after 1914. Vanessa Bell 'simply became bored by abstraction and found that she was much happier when able to draw on the infinite complexities of the visible world'.[52] Duncan Grant left his 'Abstract

4. *Above left*
Vanessa Bell
Rug design for Omega Workshops,
Courtauld Institute Galleries, London

5. *Above right*
Vanessa Bell
Abstract Painting, *c.*1914
Gouache on canvas,
$17\frac{3}{8} \times 15\frac{1}{4} (44 \times 38.7)$
Tate Gallery, London

Kinetic Collage' unfinished, with neither its kinetic device nor its music. Perhaps his attitude towards abstraction is best demonstrated by his addition, in 1918, of a white jug and lemon to one of his former abstract paintings (fig.6). The original composition, probably also based on Kupka's 'Vertical Planes III', is reduced to a merely decorative background.

Fry also revised his attitude towards abstract painting. As early as 1911, he had realised that the 'logical extreme' of contemporary French painting 'would undoubtedly be the attempt to give up all resemblance to form, and to create a purely abstract language – a visual music'.[53] As if to prove the point, he himself experimented with radically abstract paintings. But Fry was never entirely convinced as to the worth of total abstraction. He even doubted whether it was possible, since 'the slightest suggestion of the third dimension in a picture must be due to some element of representation'.[54] More important, Fry questioned the value of geometrical figures, the inevitable language of non-objectivity. If, as Bell suggested, the stimulation of aesthetic emotion by form is the one essential quality in a work of art, geometrical forms could hardly be recommended since they only produce a finite number of significant relations which are of little value, being easily repeatable.[55] 'What we desire in art', stated Fry, 'is the feeling of an inexhaustible wealth of significant relations . . . which are infinite in their possibilities.' This is why 'the greatest art seems to concern itself most with the universal aspects of natural form' and is 'the least concerned with particulars'. Ironically, the notion of significant form that had justified the Bloomsbury artists' venture into abstraction served to support the representational painting that supplanted it.

Abstract art stood potentially even less chance of being well received in America than in England. Even though Europe and America had close economic ties at the beginning of the twentieth century, artistically their links were rather more tenuous. Funds were certainly available for the great American collectors to buy contemporary European art, but their taste in general was conspicuously conservative, and had changed little since the nineteenth century. Even as late as 1910, collectors like A. J. Eddy and John Quinn had only ventured as far as purchasing examples of Impressionist and some Post-Impressionist painting.[56]

There were two reasons for this. The first was purely economic: as a result of the 1909 Tariff Act, a federal customs duty of 15 per cent was levied on all works of art less than twenty years old. 'Antiquities', on the other hand (paintings and other objects more than twenty years old), were allowed to enter the country duty free. The 1909 tariff not only dissuaded collectors from making widespread purchases of foreign contemporary art but made modern art a bad bet commercially for galleries and dealers.

The second obstacle to the dissemination of abstract art in America was American chauvinism and general ignorance of European cultural developments. Benjamin de Casseres, one of the first critics to write about

Duncan Grant
The White Jug, 1914
Oil on canvas,
41 × 16½ (104 × 42)
Private Collection

modern art in America, accused the American nation as a whole of complete cultural indifference:

> The rare, the strange, the beautiful, the new – whether in art or literature – is taboo to the American mind . . .

> This giant conspiracy of mediocrity, this race-thesaurus of the average, has in all ages been the sworn enemy of all that is new, radical, anti-academic, in art. Artistic respectability is the crime of the American. In the sphere of morals this spirit invents anti-vice societies to protect its own mind against its own pornographic instincts. In the sphere of art it shuns genius like a plague.[57]

Attitudes among painters were similarly unadventurous. The pheno-menon of contemporary painters in Europe and Russia forming splinter groups, exhibiting societies and 'secessions' and publishing their own manifestos was virtually unparalleled in the United States. The only exhibitions held in the first few years of the twentieth century to rival the National Academy were restricted to American artists and were, by European standards, retrogressive.

Considering the lack of any real artistic incentive in the United States, it was hardly surprising that many young artists went to Europe, as they had done in the nineteenth century. During the first two decades of the twentieth century, Paris offered American painters first-hand experience of some of the events and exhibitions that were to alter the course of painting. In 1907, Kahnweiler opened his gallery. In February 1909, the Futurists published their first manifesto in *Le Figaro*. The Section d'Or was formed in 1910, and in 1911 a 'Cubist' room was included in the *Salon des Indépendants*. In 1912, Gleizes and Metzinger published *Du Cubisme* and the Section d'Or and Futurists held their first Paris exhibitions.

But it was only towards the end of 1912 that American artists in Paris really became aware of abstract art. Morgan Russell, for one, recognised its potential straight away. In September 1912, he told himself

> to forget the object, yes to forget it – to put it out of our minds entirely and think only of planes, lines, colours, rhythms, etc. emotional visual quality . . .
> Keep the music at all costs – the palpitation or undulation – sacrifice the fact.[58]

Russell's desire to paint pictures in which musical components replaced conventional subject matter suggests that he was familiar with con-temporary French notions of abstraction. Kupka, for instance, was interested in the analogy between painting and music, which he tried to express in two works exhibited at the *Salon d'Automne* that year, 'Amorpha, Fugue in Two Colours' and 'Amorpha, Warm Chromatics'. Apollinaire considered Delaunay's paintings to be 'lyrical' and called them

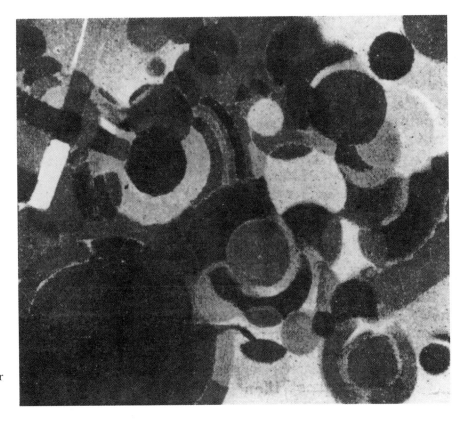

7. Arthur Burdett Frost Jnr
Suns,
Lost

'Orphic'. In an article, 'Reality, Pure Painting', he quoted the artist: 'We are no longer dealing here either with effects . . . or with objects . . . or with images . . . We are attaining a purely expressive art . . . the subject is harmonic proportion.'[59]

Delaunay's Orphic abstractions captivated the Americans. Arthur Burdett Frost Jnr wrote home: 'We are all interested in Delaunay. He seems to be the strong man who has grown out of Cubism.'[60] Even Leo Stein, who was 'not interested' in the development of abstraction, made an exception for Delaunay. In fact, it was at Leo and Gertrude Stein's apartment, 27 rue de Fleurus, that Frost and his compatriot, Patrick Henry Bruce, first met Delaunay in the spring of 1912. By 1913, they were considered adherents of his *école orphique*. Frost's painting 'Suns' (fig.7) and Bruce's 'Movement, Colour, Space, Simultanaeity' not only reveal a formal debt to Delaunay but also make use of his colour theories.

Russell and Stanton MacDonald-Wright had also met Delaunay and knew his work. But, unlike Bruce whose championship of the French painter became renowned, these two refused to admit that the movement they initiated in Paris in 1913 derived in any way from Delaunay's Orphism. They claimed to be unimpressed by Delaunay's efforts: his work was far too decorative, lacked volume and was not 'pushed far enough'.[61]

Nevertheless, similarities between the two movements are striking: their sources in scientific colour theory and their objectives were virtually the same. Like Delaunay, MacDonald-Wright sought to create pure harmony, purifying his 'art to the point where the emotions of the spectator will be wholly aesthetic, as when listening to music'.[62]

Other Americans encountered quite different influences in Paris. Some, like Marius de Zayas, Robert Coady and Max Weber, were particularly interested in the current theoretical ideas that they encountered. It was therefore no coincidence that, when Max Weber returned to the United States after spending three years in Paris, Alfred Stieglitz should have turned to him for tutelage and advice.

Alfred Stieglitz had originally set up the 'Little Galleries of the Photo-Secession' in 1905, with the specific intention of establishing photography as an independent and recognised art. But he soon realised how impoverished painting in the United States was. It occurred to him that he might be able to make artists completely revise their attitudes, or at least shake them out of their complacency, by introducing modern European art into America. Whatever response it might stimulate, Stieglitz believed that his duty was to educate American artists, and it was as an educational establishment that his gallery was able to import contemporary foreign art into the United States without having to pay the prohibitive customs duty. His gallery became famous as '291', having been named after its address, 291 Fifth Avenue.[63]

However, Stieglitz realised that he would not be able to reform American art simply by showing artists examples of contemporary European painting. They would have to understand the ideas upon which such painting was founded. To this end he transformed his sumptuous photographic magazine, *Camera Work*, into a journal containing more and more articles and reviews of interest to painters and sculptors.

Stieglitz's appreciation of modern art was, however, slow. He was bewildered by the first group of Cézanne watercolours he saw, and in 1908 considered Matisse's drawings to be 'abstract to the limit'.[64] But by 1911 his taste had sufficiently evolved for him to admire not only Cézanne but also Picasso. This change of faith was doubtless due to the influence of Max Weber, who lived on the premises at 291 for nine months after his return to New York from Paris. In fact, Stieglitz's understanding of French art generally was indebted to Weber: 'being very intelligent he became helpful in a way in clarifying my own ideas'.[65] Weber was probably the best informed person in New York about contemporary French aesthetics. Picasso, Delaunay, Rousseau, Gleizes and Metzinger counted among the friends he had made in Paris. Steiglitz certainly found Weber's ideas interesting, and between 1909 and 1911 he published three examples of the latter's theoretical writing in *Camera Work*.[66]

In March 1911, Stieglitz proudly announced the 'first Picasso one-man

show anywhere', to be held at 291. The exhibition, selected in Paris by Frank Burty Haviland, Marius de Zayas and Picasso himself, comprised examples that were intended to show the artist's development. They ranged from 'Harlequin' (c. 1905) to a group of early Cubist works. By now, Stieglitz admired Picasso's work so much that he purchased the most abstract work in the exhibition, the highly analytical 'Nude'. Most American critics failed to understand such works and hence were in no position to discuss them. Consequently, the most serious accounts of Picasso's work were those published by De Zayas in *Camera Work*. On the basis of interviews with the artist, he explained that Picasso:

> . . . receives a direct impression from external nature, he analyses, develops, and translates it, and afterwards executes it in his particular style, with the intention that the picture should be the pictorial equivalent of the emotion produced by nature.[67]

Picasso was, De Zayas pointed out, trying to return to the fundamentals of structure in painting, which he believed had been lost by the end of the nineteenth century.

From the spring of 1911, Stieglitz immersed himself in the pursuit of abstract art. The three weeks he spent in Paris with De Zayas completely reformed his taste; he now found Picasso a far more significant artist than Matisse. But whatever effect Stieglitz's visit to Europe had on his personal preferences, it convinced him of one thing: that modern European art was of very great importance and that it should be introduced to the American public. In August 1912 he devoted a special issue of *Camera Work* to modern art. It included Gertrude Stein's essays on Matisse and Picasso and full-page illustrations of work by those artists: Matisse's 'Joie de Vivre' (1905–6), Picasso's 'Daniel-Henry Kahnweiler' (1910) and his bronze 'Head of a Woman' (1909–10).

Up to this point Stieglitz had neither shown nor reproduced any abstract works. He was, however, well aware of ideas about abstract art and, to some extent, of the theoretical justifications for it. From the very start, Stieglitz and the writers who contributed to *Camera Work* suggested that art should express universal spiritual values. It was not a new idea. During the 1890s two art educationalists, Fenollosa and Dow, had suggested that American artists abandon strict representation and follow the 'Oriental Ideal' – combining spiritual value, in their work, with 'significant artistic form'. Dow even suggested to his students, that 'seeing visual relations was like hearing music'.[68] In 1906, Caffin, writing in *Camera Work*, took up this analogy and went so far as to suggest that artists should actually abandon representation:

> If painting is to maintain a hold upon the intelligence and the imagination, as magic does, and possibly poetry, and to grow forward in touch with the growing needs of humanity, it must find some fundam-

ental motive other than the appearance of the world . . . it must take on
something of the quality which is of the essence of music – the *abstract*.[69]

This startling realisation was prompted by Stieglitz's discovery of
Maeterlinck, whose ideas, like those of Bergson, were much discussed in
Camera Work. If Maeterlinck could deprive 'words to a certain extent of
their literary significance . . . investing them with . . . musical qualities',[70]
why could painters not do the same with images?

Maeterlinck's ideas had also exercised a profound influence on Kan-
dinsky, the leading European theoretician of abstract art. Not surprisingly,
Kandinsky's theoretical writings also appealed to Stieglitz. In the July
1912 issue of *Camera Work*, he published a brief extract from *On the
Spiritual in Art* in which the artist aired the ideas of abstraction.[71] This
was, incidentally, the first section of the book to appear in English; Sadler's
translation of the whole treatise was not published until 1914. In
September, Stieglitz received a copy of the recently published *Blaue Reiter
Almanac*, edited by Kandinsky and Franz Marc.[72] By October 1912, he was
fully converted to abstract art. He proclaimed the virtues of abstraction in a
letter to Heinrich Kuehn, an Austrian photographer, stating that: 'as the
world was at the threshold of a new social era, so the true medium of art
would be abstraction'.[73] Even Kandinsky had not been able to announce
the advent of abstraction with such certainty.

But how successful were ideas about abstract art in America by about
1912? The evidence of two painters in Stieglitz's immediate circle, Arthur
Dove and Marsden Hartley, suggests that artists, at least, were convinced
of the possibility of non-representational art. Unlike other painters who
exhibited at 291, Hartley had not yet visited Europe. His knowledge of
contemporary developments was restricted to whatever was available in
New York. He kept in close touch with Stieglitz, joined him and the other
artists for lunch at Holland House and participated in their discussions on
art and aesthetics. Most important, Hartley studied the exhibitions at 291.
The Picasso exhibition particularly impressed him. Apparently he visited it
daily, looking at the pictures for hours.[74] The small sample of modern art
that he was able to see in New York fired his enthusiasm. By 1911, he
believed himself to be 'one of the few artists who were effecting great
changes in American art'.[75] It was possibly true: Elizabeth McCausland
has suggested that Hartley painted 'Abstract Composition' (fig.8) in 1911,
before he visited Europe for the first time.[76]

Dove, on the other hand, had lived and worked in France from 1904 to
1909 showing little interest in what the Parisian art world had to offer.
However, after his return to the United States, he produced what William
Homer describes as 'an amazing array of abstract works'. Not only did he
know the theoretical articles published in *Camera Work*, he also discussed
abstraction with Max Weber. Weber remembers visiting Dove in 1911 and

8. Marsden Hartley
Abstraction, *c*.1911
Oil on board,
16¼ × 13¼ (41.2 × 33.5)
University Gallery, University of
Minnesota, Minneapolis, Gift of
Ione and Hudson Walker, 1961

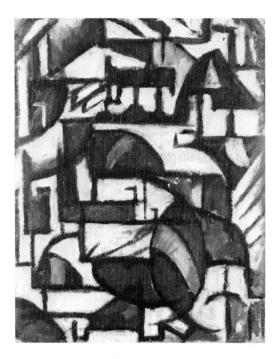

advising him *not* to paint what he actually saw.[77] Certainly, contemporary descriptions of his work conform to accepted European notions of abstraction. The critics who reviewed his 1912 exhibitions at 291 and at the Thurber Gallery in Chicago were assured that Dove's paintings were free from representational associations. Representation, the artist had informed them, could only obscure the true components of visual art – colour and form. His paintings were not only supposed to be 'disassociated from fact' but were, 'in their own peculiar way' meant to 'impress the eye'.[78] Harriet Munroe of the *Chicago Tribune* compared Dove's visual language to music. Another critic noted that Dove wanted to represent non-visual elements like energy. It was even reported that Dove refused to name his paintings because he objected to narrative in art.[79]

Dove's own justification of his paintings relied heavily on ideas which had been well aired in the Stieglitz circle. For example, when he explained the evolution of his abstractions to A. J. Eddy, the collector and admirer of Kandinsky in 1914, Dove used terms that can only have derived from Matisse's *Notes of a Painter*,[80] a text they knew very well. Having apparently realised that 'only a few forms and colours sufficed for the creation of an object' in art as well as in nature, he gave up 'trying to express an idea by stating innumerable little facts'. Facts, he had decided, had nothing to do with the art of painting. He also changed the way he observed things. He now looked 'subjectively', trying to 'remember certain sensations, *purely through their form and colour* . . . by certain shapes, planes, light or . . . lines'.[81]

One might imagine that Stieglitz's advocacy of modern art produced only a limited impact within his own circle. He himself recalled that *Camera Work* only reached a very small number of subscribers. However, by 1912 interest in contemporary developments was growing. The collector John Quinn was buying and selling examples of modern art through Martin Birnbaum, an agent for Scott and Fowles of New York. The American press carried articles about the latest developments in art abroad. The *American Art News*, for example, had a regular feature on the art world; its 'London Letter' of 26 October 1912 covered the *Second Post-Impressionist Exhibition*. Ten days previously the 'Paris Letter' had reviewed the first *Section d'Or Exhibition*. On 10 December, the same magazine carried an article on the Kandinsky exhibition at Walden's Der Sturm Gallery in Berlin. In 1912, *The Studio* also had an article on Kandinsky and the Munich *Neue Vereinigung*. Sometimes contributors to *Camera Work* wrote for the popular press; for instance, in February 1911 De Zayas published an article on 'The New Art in Paris' in the *Forum Magazine*. Various books, documents and journals with articles about modern art were imported: among them were, Meier-Graefe's *Modern Art*, *Le Futurisme* by Marinetti, 'The Initial Manifesto of the Futurists', *Cubism* by Gleizes and Metzinger and Herwarth Walden's *Der Sturm*. The English journals, the *Athenaeum*, the *Spectator* and *The Burlington Magazine* which had articles by Roger Fry and Clive Bell were also available. *The New Spirit in Drama and Art* by Huntley Carter, published in New York in 1913, included reproductions of work by Delaunay and Severini.

But what of painting itself? Although Americans may have been aware of the new art, they had, so far, had little chance of actually seeing any. However plans were afoot for the *International Exhibition of Modern Art*, to be held at the Armory of the 69th Regiment in New York from 17 February to 15 March 1913. A month before the exhibition opened a New York journalist noted:

> In America we are all ready for a general representation of modern art in its deeper aspects. We have long had the news of art from Europe. After the news follows discussion, after discussion the thing itself. Unless all signs fail, in this exhibition we shall come very close to the thing itself.[82]

How close did they come? The original intentions of the American Association of Painters and Sculptors who organised the exhibition were clear enough: to show work of 'progressive and live painters, both American and foreign – favoring such works usually neglected by current shows...' They had every opportunity of fulfilling those intentions. During a whirlwind tour of Europe, with stops in Cologne, The Hague, Munich, Paris and London, the society's spokesman, Walt Kuhn, and president, Arthur B. Davis, collected over 400 foreign loans. They even had the advantage of being able to import contemporary work into the country

free: John Quinn, their lawyer, had just won his long battle to have the federal customs duty on works of modern art repealed.[83]

However, there were considerable omissions. Christian Brinton, possibly the only critic to know the field well, questioned the absence of, among others, the Munich *Neue Vereinigung*, of the Futurists, of Marc and Burliuk.[84] Others noticed that the most advanced German artists were missing and that there was a very considerable French bias to the exhibition.[85] But perhaps the most remarkable omission was that of abstract art. There were no examples of European non-representational painting whatsoever.

Abstraction was only very gradually introduced into America. The Synchromists had an exhibition at the Carroll Galleries in March 1914. Their work, like that of Dove and Hartley, was included in the *Forum Exhibition of Modern American Painters* two years later. Hartley also had several one-man shows between 1914 and 1917.[86] Although a considerable amount of advanced European art was shown and discussed in New York, hardly any of it was abstract. In October 1913, the *New York Times* published an interview with Kupka: '"Orpheism" latest of Painting Cults: Paris School led by François Kupka holds that Colour affects Sense like Music.' In January 1917, the Vorticists held their second and final exhibition at the Penguin Club. Stieglitz hoped to have a Kandinsky exhibition but his plans never came to fruition.

Reaction to the introduction of abstract art varied considerably among American painters. Some, like Andrew Dasburg, James Daugherty and Thomas Hart Benton, were inspired to experiment with abstraction after the Synchromists' first exhibition in New York.[87] But Benton, who visited the exhibition 'nearly every day' was only half convinced by abstract art. 'I believe that the representation of objective forms and the presentation of abstract ideas of forms to be of equal artistic value.'[88]

Stanton MacDonald-Wright was rather more suspicious about total abstraction:

> In Russell's and my Munich, Paris and New York exhibitions, I had no non-representational works. Furthermore, I maintain that the themes that produce such works could well lead, in the hands of the inept, to aimless 'free' decoration, haphazard musical effect and, at worst, a distorted kaleidoscopic effect. As I remarked in the orginal Synchromist catalogue (1913), 'I find difficulty in imagining a form that is not the result of some visual or sensory contact with nature'.[89]

Even the painters in Stieglitz's circle, who worked in a highly original abstract idiom and were convinced that art should stem from 'inner experience', ultimately based their work on references to the natural world. As Hartley explained, 'the idea of modernity is but a new attachment to things universal – a new fire of affection for the living presence everywhere'. Not surprisingly, they were all influenced by

Kandinsky; they knew his 'Improvisation No.27' which Steiglitz had bought from the Armory show, and Dove and Walkowitz both owned copies of *On the Spiritual*. Dove also possessed the *Blaue Reiter Almanac*. Hartley and Kramer had even worked with Kandinsky in Germany.[90]

Other artists were less impressed by Kandinsky's ideas. Man Ray, for example, dismissed Kandinsky's insistence that artists should base their compositions on the psychological qualities of colour and form. Such qualities were basic to all painting; what really mattered was the 'vitality, the invention . . . and conviction of purpose' with which the artist used them.[91]

'Invention' and 'conviction' were extremely important to American painters. On the one hand, they were so far from the centres of European abstraction that they had to fall back on their own resources. On the other, they were encouraged by exhibition organisers and gallery owners to produce new, original and specifically American work. The *Exhibition of Contemporary Art* in 1914 and the *Forum Exhibition* in 1916 were both restricted to American nationals. Even Stieglitz denied being particularly interested in foreign art; his only intention in showing European art at 291 had been to stimulate American artists. Robert Coady also exhibited advanced European work at his Washington Square Gallery. But he positively discouraged Americans from emulating what they saw: 'When I . . . get a whiff of the pretence of the dirty little miserables who ape [a foreign] independence, something within me seems to cry "fake".'[92] His journal, *The Soil*, though possibly inspired by Apollinaire's *Soirées de Paris*, was dedicated to an understanding and definition of American art: 'Every American who wishes to become aware of America should read *The Soil*.'[93]

But what was the way ahead for abstract art in America? By 1916, the confusion wrought by the introduction of European art in addition to nationalist pressure had resulted in what the critic Willard Huntington Wright called 'The Aesthetic Struggle in America'.[94] Huntington Wright was personally convinced that the scientific exploration of colours and form represented the ultimate stage in artistic evolution. In fact, this 'scientific aesthetic' was not so much based on science, as such, as on the scientific or intellectual aspects of music, whose 'pleasure and significance' is 'primarily intellectual'. Painting could, Huntington Wright believed, 'be as pure as music' when colour is presented with the same scientific exactness as the harmonies of tone.[95]

One group of scientists wanted to eliminate intuition from painting entirely. Art, they thought, should be determined by strict scientific principles. Denman Ross suggested that:

There is no getting on properly . . . in any art without the metrical systems or modes, in which it is possible to think definitely and express oneself . . . No art . . . can be satisfactorily practised without constant

reference and obedience to mathematical principles, systems and laws.[96]

Maratta echoed the same sentiment:

> To produce harmony in a work of art we must use '*numbers*' and *metrology, the science of measuring* as all bodies and emotions are subject to numerical calculations.[97]

However, the notion that art should be a slave to science was anathema to Stieglitz and the artists in his circle: 'Science is vulgar, art is exalted'.[98] Ironically, the remedy which some like De Zayas believed might revitalise art fulfilled the worst fears of those scientists who criticised modern art as incompetent, childlike and ignorant. De Zayas suggested that modern artists should study primitive art. Like Robert Coady and the Parisian dealer Paul Guillaume, De Zayas believed that there was a strong relationship between the 'work of such primitive races as the African Negros . . . the Mexican Indians . . . and the art of to-day'.[99] In fact, one of the goals of De Zayas's Modern Gallery where he exhibited primitive and modern art together, and his journal, *291*, named after Stieglitz's gallery, was to 'illustrate the relationship between these things'. But there was one fundamental problem. Artistic evolution indicated that artists were trying to emulate the analytical procedures of science:

> The artist of to-day does not appeal to our sensual sense of pleasure or displeasure, but to our analytical faculties, not to our emotion but to our intellect.[100]

And yet De Zayas and Paul Haviland, who together wrote a book called *The Study of the Modern Evolution of Plastic Expression*, believed that the modernist should make artistic form a 'vehicle for psychology and metaphysics'. Primitive art was consequently important to twentieth-century artists because 'it is the most adaptable to the expression of feelings being essentially the imaginative form, and also the most simple and direct. Primitive art is the work most closely related to the feelings'.[101] Where modern artists went wrong, De Zayas thought, was when they tried to combine both primitive art and science. Believing themselves concerned with intellectual analysis they in fact used forms that aped rather than captured the spirit of primitive art. One is irresistibly reminded of the opening remarks of *On the Spiritual*, where Kandinsky observes the impossibility of attempting 'to give new life to artistic principles of the past'. It 'can only result in a work of art which resembles a still-born child'.

De Zayas also realised that although he had recommended that artists study primitive art it was wrong to expect modern artists to adopt primitive techniques. The vital and abstract qualities of child and primitive art derived from unconscious expression. The modern artists who suffer from 'Naive-mania or from Primitology and boast of taking the same attitude as

... the child' only succeed in producing 'childish art'. For unlike the child or the primitive, the modern artist

> is the prototype of consciousness. He works premeditatedly, he dislocates, disharmonizes, exaggerates ... He is an eclectic in spirit and an iconoclast in action.[102]

This failure should, De Zayas saw, have been expected. The White race, unlike the Black group who produced imaginative art, had always concentrated on representing realistic form. Photography now offered a scientific method for perfecting such expression. This was why artists had now turned to the culturally alien work of 'uncivilized peoples' for new inspiration.[103] Some American critics thought that this simply illustrated how the boundaries of tradition were constantly changing. De Zayas took a more pessimistic view: he thought that artists turn towards abstraction and their reliance on primitive geometrical forms signified the exhaustion of Western artistic expression. 'Art', he concluded, 'is dead'.[104] He was not quite correct. What had, in fact, died was American painters' compulsion to experiment with abstract art. By 1921 most advanced artists in the United States had rejected European notions of abstraction and had reverted to a highly representational and specifically American style of painting – Precisionism.

NOTES AND REFERENCES

The New Age: primal and mystic nights

NORBET LYNTON

[1] Between 1890 and 1920 references to 'the new age' and similar phrases, all implying fundamental change, are legion. *The New Age* was also, of course, the name of the journal, associated with Guild Socialism, edited by A. R. Orage from 1907–22. In preparation for points to be made later, I should like here to quote from an essay 'The New Age', referring to the modern world and to the journal, written in 1911 by Allen Upward, poet, novelist and author of *The Divine Mystery* (subtitled 'A Reading of the History of Christianity Down to the Time of Christ'). The essay opens: 'It is a sign of the times that so many of us should be busy in studying the signs of the times./In no other age since the birth of Christianity has there been manifested the same devouring curiosity about the future, and the same disposition to expect a new earth, if not a new heaven.' Orage, who later taught Gurdjieff's ideas, commissioned Upward to write a series of essays for *The New Age*, the first appearing in the January 1910 issue, expounding his interpretation of the roots of Christianity.

Writing this in the Year of the Child, I must add that Ellen Key and Victor Emmanuel III coincided in greeting the twentieth century as the Century of the Child.

[2] The Russian critic N. Popov was jailed in 1883 for praising Whitman's 'spirit of revolt and pride'.

[3] From the *Theory of Colour* (1810). I take the words in this form from Anton Webern's lecture 'The Path to the New Music', 1932, edited by Willi Reich and published by Theodore Presser Co., Pennsylvania, 1963.

[4] Ezra Pound in a letter to William Carlos Williams, 1908.

[5] This relevance begins to be doubted and sought in the eighteenth century, and claimed in various ways by the Romantics. Baudelaire prescribed it and by 1900 it is a conventional modernist slogan, as for instance in the inscription on Josef Olbrich's building for the Secession group in Vienna, opened in 1898: 'To the time its art/to art its freedom'. I do not know who first pointed out that the classical tradition itself represented a succession of innovations initiated by a revolutionary discovery.

Ezra Pound's ringing 'Make it New' stemmed, he said, from the bath of the founder of the Shang dynasty and thus datable to 1766 BC – an ancient imperative of renewal. Henry David Thoreau, in *Walden* (1854), associates the inscription with his own 'religious exercise' of getting up early and bathing in Walden Pond: 'They say that characters were engraven on the bathing tub of King Tching-thang to this effect: "Renew thyself completely each day; do it again, and again, and forever again"'.

[6] T. S. Eliot still argued for such a primitive/modern theatre in an article of 1923: 'The drama was originally ritual, and ritual, consisting of a set of repeated movements, is essentially a dance'; the modern theatre has 'lost the drum'.

[7] Cf. Bruno Taut, in the architectural magazine he edited, *Frühlicht* (First Light), 1920–4: 'What the day will bring – who knows! But we can sense the dawn . . . a cool, early morning breeze blows around us: who doesn't want to shiver must march. And we, and all those who march with us, see in the distance the early light of the awakening morning . . . first glimmerings of the exultant sunrise. Decades, generations – and the great sun of architecture, of the arts altogether, begins its triumphant course' (1921).

[8] T. E. Hulme, influenced by Wilhelm Worringer whose lectures he had attended in Berlin in the winter of 1912–13, equated Worringer's cultural polarity, *empathetic* and *abstract*, with *vital* and *geometric*, and called for a new classicism that would be 'austere, mechanical, clear cut and bare'.

[9] My understanding of Tatlin's Tower has been enriched by John Milner's discussion of it in his Ph.D. dissertation *Russian Constructivism: the first phase, Rodchenko and Tatlin*, London University, 1979.

The psychological background to early modern colour: Kandinsky, Delaunay and Mondrian JOHN GAGE

[1] H. G. Keller & J. J. R. MacLeod, 'The Application of the Physiology of Color Vision in Modern Art', *Popular Science Monthly*, LXXXIII, 1913, p.450ff.

² J. Cohn, 'Experimentelle Untersuchungen über die Gefühlsbetong der Farbenhelligkeiten und ihre Combinationen', *Philosophische Studien*, X, 1894, p.562ff. For the later controversy over this work, A. Minor, *Zeitschrift f.Psychologie*, 50, 1909, p.433ff. F. Stefanescu-Goanga, 'Experimentelle Untersuchungen zur Gefühlsbetonung der Farben', *Psychologische Studien*, VII, 1912, p.284ff.

³ E. Harms, 'My Association with Kandinsky', *American Artist*, XXVII, 1963, p.36ff. The edition of Goethe's *Farbenlehre* which Harms says Kandinsky was studying was that in *Kürschners Deutsche National-Literatur: Goethes Werke*, XXV (*Naturwissenschafliche Schriften* III [1891]), with an introduction and notes by Steiner. In his introduction Steiner used the term 'Inner necessity', which became a key concept in *On the Spiritual in Art*.

⁴ For a Delaunay study of 1912 from the glass at Laon (Bern, Kunstmuseum), S. Buckberrough, 'The Simultaneous Content of Robert Delaunay's Windows', *Arts Magazine*, September 1979, p.110, fig.10. At exactly the same time the Italian Divisionist painter Angelo Morbelli was addressing the problems of transparency, and saw the technique of glazing as the key to luminosity, referring as an example to mediaeval stained-glass (*Archivi del Divisionismo*, p.142f). The theorist of Divisionism, G. Previati, also gave a good deal of attention to transparency and glazing in 1906 (*Principi Scientifici del Divisionismo*, 1929, pp.77, 142ff.), and his account of a luminous landscape seen through a window (p.154ff.) may have been the starting-point for Giacomo Balla's late Divisionist work, *Window in Düsseldorf*, 1912 (M. Fagiolo dell'Arco, *Futur Balla*, 1970, pl.xiii).

⁵ F. Gilles de la Tourette, *Robert Delaunay*, 1950, p.50. A French psychologist had recently treated the night sky towards its zenith as the exemplar of depth: it seemed to be a gelatinous or glassy substance (E. Claparède, *Archive de Psychologie*, V, 1906, p.128, *cit.* Katz, 1911, p.67n).

⁶ For the textiles, M. Hoog, *Inventaire des Collections Publiques Francaises: Paris, Musée Nat. d'Art Moderne: Robert & Sonia Delaunay*, 1967, no.71; for the book-bindings, Paris, Bibliothèque Nationale, *Sonia & Robert Delaunay*, 1977, no.354ff.

⁷ Francastel, p.184. The most detailed technical analysis of the *Disc* in Albrecht, p.30ff.

⁸ V. Huszár, 'Iets over die Farbenfibel van W. Ostwald', *De Stijl*, I, 1917, p.113ff.

⁹ See *Composition VIII: The Cow*, 1917 (New York, Museum of Modern Art) and *Composition in Discords*, 1918 (Mrs M. Arp-Hagenbach), in J. Baljeu, *Theo van Doesburg*, 1974, pp.33, 36. In his *Principles of Neo-Plastic Art* (1925), 1969, p.15 and fig.1, Van Doesburg opted for the *three* primaries, red, yellow and blue, but it is not certain whether this represents his views in 1915 and 1917, when the MS was said to have been completed. I have been unable to consult the earlier versions of this text.

¹⁰ R. P. Welsh & J. M. Joosten, *Two Mondrian Sketchbooks, 1912–14*, 1969, p.21. Mondrian's reading of Kandinsky is suggested by his phrase 'an inner feeling of necessity' (p.44). But see also note 3 above.

¹¹ See R. P. Welsh, 'Mondrian and Theosophy', *Piet Mondrian: Centennial Exhibition*, New York, Guggenheim Museum, 1971, p.35ff. *Thought Forms* had been translated into Dutch in 1905.

¹² The first painting of the group to be based clearly on the three primaries plus black, white and grey seems to be Huszár's design for the cover of *De Stijl* (The Hague, Gemeentemuseum, no.559), signed and dated 1916.

¹³ *De Stijl*, I, 3, 1918, p.30, trans. Jaffé, pp.54–6. Schoenmaekers' doctrines had been published in *The New Image of the World* (*Het nieuwe Wereldbeeld*) 1915 and *Principles of Plastic Mathematics* (*Beginselen der beeldende Wiskunde*) 1916. For Kandinsky's reputation in Holland, W. Kandinsky, *Regards sur le Passé*, ed. Bouillon, 1974, pp.237f.

¹⁴ *De Stijl*, IV, p.30. This and other footnotes have not been included in Jaffé's translations.

¹⁵ See R. P. Welsh, *Piet Mondrian*, Toronto/Philadelphia/The Hague, 1966, espec. nos.84, 89; and *Piet Mondrian: Centienniel Exhibition*, New York, Guggenheim Museum, 1971, nos.69, 73, 75–7, 81, 89. See also Van Doesburg's *Composition XI*, 1918 (New York, Guggenheim Museum) and *Rhythms of a Russian Dance*, 1918 (New York, Museum of Modern Art).

FURTHER READING

General

J. A. Argüelles, *Charles Henry and the Formation of a Psychophysical Aesthetic*, 1972

V. K. Ball, 'The Aesthetic of Colour: a Review of Fifty Years Experimentation', *Journal of Aesthetics and Art Criticism*, 23, 1965, pp.441ff

E. G. Boring, *Sensation and Perception in the History of Experimental Psychology*, 1942

D. Katz, *The World of Colour*, 1935 (revised version of *Die Erscheinungsweise der Farben*, 1911)

Kandinsky

J. Eichner, *Kandinsky und Gabriele Münter*, 1957

K. Lankheit (ed.) *The Blue Rider Almanac*, 1974

S. Ringbom, *The Sounding Cosmos*, 1970

Delaunay

H. J. Albrecht, *Farbe als Sprache*, 1974

P. Francastel, *Du Cubisme à l'Art Abstrait: Les Cahiers Inédits de Robert Delaunay*, 1957

R. & S. Delaunay, *The New Art of Color*, ed. & trans. Cohen, 1978. Baden–Baden, Staatliche Kunsthalle, *Robert Delaunay*, 1976 (for Delaunay and Kandinsky).

G. Vriesen & M. Imdahl, *Robert Delaunay*, 1967

Mondrian

W. Ostwald, *The Color Primer*, 1969

W. Ostwald, *Lebenslinien*, 1926–7

H. L. C. Jaffé, *De Stijl*, 1970

Music and abstract painting: Kandinsky, Goethe and Schoenberg PETER VERGO

1 I am indebted to the various friends and colleagues who read and commented on drafts or parts of this essay, especially to Sara Selwood, Professor Anthony King, and Professor Kenneth Lindsay, also to Lyn Perkins, who typed much of it.

2 This essay takes no account of nineteenth-century interest in the phenomenon of synaesthesia, attempts to create a synthesis of the arts, or the analogy between music and painting as conceived by eighteenth- and nineteenth-century writers – topics which have been widely discussed elsewhere. See in particular A. G. Lehmann, *The Symbolist Aesthetic in France 1885–1895*, Oxford: Basil Blackwell, 1968, esp. pp.149ff, 194ff; Jack M. Stein, *Richard Wagner and the Synthesis of the Arts*, Westport, Conn.: Greenwood Press, 1973; H. R. Rookmaker, *Gauguin and 19th Century Art Theory*, Amsterdam: Swets and Zeitlinger, 1972, esp. pp.176ff, 210ff (hereafter: Rookmaker 1972); Otto Stelzer, *Die Vorgeschichte der abstrakten Kunst*, Munich: R. Piper & Co., 1964, esp. pp.117f, 130ff (hereafter: Stelzer 1964).

3 Bryan Magee in conversation with A. J. Ayer; see

Bryan Magee, *Men of Ideas*, London: BBC Publications, 1978, p.118.

4 L. Russolo, *L'arte dei rumori*, Milan: Direzione del Movimento Futurista, July 1913; extracts translated in U. Apollonio (ed.), *Futurist Manifestos* (London: Thames and Hudson) 1973, p.74f. See also the catalogue *Exhibition of Italian Futurism. Futurismo*, Newcastle-upon-Tyne/Edinburgh: Northern Arts/Scottish Arts Council, 1972–3, p.94f.

5 Quoted after Henry G. Gardiner, 'The Evolution of Abstract Painting', in the catalogue *Color and Form 1909–1914*, Fine Arts Gallery of San Diego, California, 1971–2, p.9.

6 London, Tate Gallery: T.1744. For a detailed description of this work, and the artist's intentions, see *Tate Gallery Biennial Report and Illustrated Catalogue, 1972–4*, p.160f.

7 Letter to Kandinsky, spring (?) 1912; quoted after Gustav Vriesen and Max Imdahl, *Robert Delaunay – Licht und Farbe*, Cologne: M. DuMont Schauberg, 1967, p.38.

8 Willard Huntington Wright, *Modern Painting, its Tendency and Meaning*, London: Allen Lane, 1916, p.298 (hereafter: Wright 1916).

9 'A Post-Cubist's Impressions of New York', *New York Tribune*, 9 March 1913; quoted after Judith K. Zilczer, *The aesthetic struggle in America 1913–1918: abstract art and theory in the Stieglitz circle* (Ph.D. dissertation, University of Delaware) 1975 (hereafter: Zilczer 1975). Zilczer devotes an important part of her dissertation (p.43ff) to a discussion of analogies between painting and music in the writings of artists and critics.

10 *Der Blaue Reiter. Herausgeber: Kandinsky, Franz Marc*, Munich, R. Piper & Co., 1912 (hereafter: *DBR*). An English edition, with commentary, has been published in the series 'The Documents of 20th-Century Art'; see *The Blaue Reiter Almanac, Edited by Wassily Kandinsky and Franz Marc*, documentary edition by Klaus Lankheit, New York: Viking Press, 1974 (hereafter: Lankheit 1974).

11 The evident similarities between Kandinsky's 'stage composition' *Der Gelbe Klang* and Schoenberg's *Die Glückliche Hand* have been discussed by several authors, most recently by Jelena Hahl-Koch, 'Kandinsky et le théâtre – Quelques aperçus', in the catalogue *Wassily Kandinsky à Munich*, Bordeaux: Galerie des Beaux-Arts, 1976, pp. 58–9 (hereafter: Hahl 1976).

12 Leonid Sabanejew, '"Prometheus" von Skrjabin',

DBR p.57ff. On the subject of colour organs, see A. Wallace Rimington, *Colour-Music. The art of mobile colour*, London: Hutchinson & Co., 1912. The idea of a 'colour keyboard' or *tastiera per luce* goes back at least as far as 1725. Its invention has often been credited to one Louis-Bertrand Castel (1688–1757); see Stelzer 1964, p.131. According to Stelzer, Castel's instrument was never actually built; the idea was, however, discussed and criticised by a number of writers, including the philosopher Moses Mendelssohn: see his *Ueber die Empfindungen* (Berlin: C. F. Voss) 1755 and *Bemerkungen . . .*, 1761, (hereafter: *BE*). Such experiments foundered ultimately on the rock of human subjectivity. In particular, there was a notable lack of agreement as to which colours corresponded to which musical tones. Worse still, hilarious stories are told of how audiences, asked to record their 'colour sensations' on listening, for example, to a Beethoven sonata, totally failed to notice when, after an interval, the same piece was played to them again in a different key. None the less, the idea of some 'correspondence' between colours and musical sounds continued to exercise a fascination for artists right up until the twentieth century. A. J. Eddy devotes a chapter to 'Color Music' in his book *Cubists and Post-Impressionism*, London: Grant Richards Ltd, 1915, p.140ff; here, Eddy writes that the time will come when 'the art of light music will be developed and taught in theory and practice . . . Why should not prizes be offered for color harmonies?' (pp.143, 145). According to Milton Brown, Wright 'ended by renouncing painting as outmoded, and heralding the color organ as the future instrument of visual expression'. (Milton H. Brown, *American Painting from the Armory Show to the Depression*, Princeton, 1955, p.160; hereafter: Brown 1955.) Eddy and Wright might have been disturbed to read a note in the magazine *291* (no.2, April 1915) under the heading 'Color Music', describing a concert given by the Russian Symphony Orchestra at Carnegie Hall on 20 March 1915. The concert was evidently intended to demonstrate the 'relationship of color to music'; the review observes, however, that 'nothing was proved' on this question, and that 'the experiment as it was performed was absolutely unsuccessful'.

13 Kandinsky, *Ueber das Geistige in der Kunst* (Munich: R. Piper & Co.) 2nd edn 1912, p.48, note 1 (hereafter: *UdG* 1912).

14 Thomas von Hartmann, 'Ueber die Anarchie in der Musik', *DBR*, p.43ff; Dr N. Kulbin, 'Die Freie Musik', *ibid.*, p.69ff.

15 Originally, the stress on music was to have been even greater: a draft table of contents lists a projected six articles on painting, as against no less than eight on music. See Lankheit 1974, pp.21, 244.

16 *DBR*, p.42.

17 See Sixten Ringbom, 'Art in "The Epoch of the Great Spiritual"', Occult Elements in the Early Theory of Abstract Painting', *Journal of the Warburg and Courtauld Institutes*, XXIX, 1966, p.389f; also John Gage in this volume, p.26 and note 3.

18 Goethe in conversation with Riemer, 19 May 1807; the reference given in *DBR* is to the edition by Franz Deibel and Friedrich Gundelfinger, *Goethe im Gespräch*, Leipzig: Insel Verlag, 3rd edn 1907, p.94.

19 J. W. von Goethe, *Maximen und Reflexionen*, hrsg. von Jutta Hecker, Leipzig, 1941, no.486. This thought was not peculiar to Goethe. Wackenroder in his essay 'Die Wunder der Tonkunst' wrote about the 'transformations' of the spirit: 'Die Sprache zählt und nennt und beschreibt seine Verwandlungen, in fremdem Stoff; – die Tonkunst strömt ihn uns selber vor'; quoted after Rookmaker 1972, p.212.

20 Arthur Schopenhauer, *Schriften über Musik*, hrsg. von Karl v. Stabenow, Regensburg: Deutsche Musikbücherei, 1922, p.159.

21 Arnold Schönberg, 'Das Verhältnis zum Text', *DBR*, pp.31–2.

22 W. A. Mozart, *Der Schauspieldirektor*, KV 486 (1786), *Terzett*.

23 Perhaps most familiar to the English reader will be the late Deryck Cooke's *The Language of Music*, London: OUP, 1959, and Leonard Bernstein's Charles Eliot Norton lectures of 1973, published under the title *The Unanswered Question. Six Talks at Harvard*, Cambridge, Mass. and London, England: Harvard University Press, 1976. Cooke's monograph, an epoch-making book in its day, reviews twentieth-century opinion as to the role of musical meaning, from Stravinsky's flat denial that music has the power to *express* anything at all, to the author's own passionately held belief that 'composers have consciously or unconsciously used music as a language, from at least 1400 onwards . . . that composers have set out to express emotion, and that listeners have felt it to be present in their music' (p.13f). The drawback of

Cooke's account is that he evidently feels 'musical meanings' to be in some way analogous to 'conceptual meanings'. Taking as his starting point music *with* a text – opera, *Lieder*, and so on – he attempts to show that a particular sentiment, expressed in words, is usually conjoined with a particular melodic or harmonic progression; he then goes on to consider whether the same sentiment may plausibly be linked with similar progressions where they occur in purely symphonic or instrumental music. Bernstein, in his 'Six Talks at Harvard' (hereafter: Bernstein 1976) takes a different approach. His thesis is that music does not *derive* its meaning from poetry or verse; he believes that music is *like* poetry, a form of metalanguage having its own, intrinsic meanings (a view held in common with Adorno and others), and that these intrinsic meanings are 'generated by a constant stream of metaphors, all of which are forms of poetic transformations' (p.131). Bernstein, whose elegantly illuminating account wears Chomskian linguistic theory on its sleeve, also adapts Chomsky's principle of 'transformational grammar' to show how music evolves from its own 'deep structure' (the 'chosen elements' being, in this case, key, metre and so on) to a recognisable 'surface structure' by transformational processes analogous to those of language.

24 Bernstein 1976, *ibid.*

25 Bernstein 1976, p.140.

26 Arthur Schopenhauer, *Die Welt als Wille und Vorstellung*, 1818 and subsequent editions, Book III, para. 52 (hereafter: *WaW*). The same passage is quoted by Schoenberg, 'Das Verhältnis zum Text', *DBR* p.28.

27 Téodor de Wyzéwa, 'La musique descriptive', *Revue Wagnérienne*, I, 1885, no.3, p.74f.

28 Richard Wagner, *Gesammelte Schriften und Dichtungen*, Leipzig, 1871–83, vol. III, pp.163–4. The same passage is quoted in the *Revue Wagnérienne*, *loc.cit.*, p.67 in a seriously misleading translation.

29 Wagner's theories were well known not only in France, through the *Revue Wagnérienne*, but also in Germany and in Russia. Kandinsky, in the Russian version of his 'Reminiscences' recalled his early admiration for Wagner, and how *Tristan* and *The Ring* 'held my critical faculties in thrall for many a long year'. (Kandinsky, 'Stupeni', in *V. V. Kandinsky. Tekst Khudozhnika*, Moscow: Izdanie Otdela Izobrazitel'nykh Iskusstv Narodnago

Kommisariata po Prosveshcheniyu, 1918, p.19, note.) His essay 'Ueber Bühnenkomposition' in *DBR* (p.103ff) also reveals his knowledge of the composer's theoretical writings.

30 P. G. Hamerton, *Contemporary French Painters*, London, 1868, p.37; quoted after E. H. Gombrich, 'The Vogue of Abstract Art', *Meditations on a Hobby Horse and other essays . . .*, London: Phaidon Press, 1963, p.147.

31 *Oeuvres Complètes de Charles Baudelaire. Curiosités Esthétiques. Notice, notes et éclaircissements de M. Jacques Crépet*, Paris: Louis Conard, 1923, p.97 (hereafter: Baudelaire, *Curiosités*).

32 Eugène Delacroix, *Oeuvres Littéraires*, ed. E. Faure, Paris, 1923, p.63f; quoted after Rookmaker 1972, p.15.

33 *UdG* 1912, p.51. The authenticity of the pronouncement ascribed to Delacroix is somewhat doubtful. It was originally cited by Baudelaire, who claimed he had written it down 'presque sous la dictée du maître', and taken up again by Signac in his essay of 1899, 'D'Eugène Delacroix au néo-impressionisme'; see the edition of Signac's essay by Françoise Cachin, Paris: Hermann, 1964, p.49 and note 56.

34 Hugo von Hofmannsthal, *Der Rosenkavalier* (1911), Act I, in *Gesammelte Werke* (Berlin: S. Fischer Verlag) 1934, vol. I, p.170.

35 Kandinsky, in particular, referred specifically to his own need to 'bridge the gap' between artist and spectator by means of objects; see Johannes Eichner, *Kandinsky und Gabriele Münter. Von Ursprüngen moderner Kunst* (Munich: F. Bruckmann) [1957], p.112 (hereafter: Eichner).

36 Wright 1916, p.291.

37 Kandinsky, letter dated 16 January 1937 to Hilla Rebay, cited by Angelica Zander Rudenstine in the catalogue *The Guggenheim Museum Collection, Paintings 1880–1945*, New York: The Solomon R. Guggenheim Foundation, 1976, vol.I, p.275 (hereafter: Rudenstine 1976).

38 Kandinsky, 'Malerei als reine Kunst', *Der Sturm*, vol.IV, nos.178–9, September 1913, pp.98–9.

39 Eichner, p.110.

40 Kandinsky, 'Rückblicke', *Kandinsky 1901–1913*, Berlin: Der Sturm, 1913, p.ix.

41 For example, at the fourteenth Vienna Secession exhibition in 1902, Josef Hoffmann created as part of the decorative scheme for the interior of the gallery, bas-relief panels (now destroyed) which appear from surviving photographs to be among the first entirely abstract sculptures. See Marian

Bisanz-Prakken, *Gustav Klimt. Der Beethovenfries*, Salzburg: Residenz Verlag, 1977, p.30 repr. These works bear a remarkable resemblance to the 'vertical block' compositions by artists like August Macke and Johannes Itten, produced more than a decade later.

42 E. Roditi, *Dialogues on Art*, London: Secker & Warburg, 1960, p.141f. On Kandinsky's relations with other *Jugendstil* artists see Peg Weiss, 'Kandinsky and the "Jugendstil" Arts and Crafts Movement', *Burlington Magazine*, vol.CXVII, no.866, May 1975, p.270ff.

43 Arthur Roessler, *Neu-Dachau* (Bielefeld/Leipzig: Velhagen und Klasing) 1905, p.125 repr.

44 August Endell, 'Formenschönheit und Dekorative Kunst', *Dekorative Kunst*, I (1898) no.1, p.75.

45 G. J. Wolf, in *Die Kunst für Alle*, 1 November 1910, pp.68–70.

46 *UdG* 1912, p.98.

47 Felix Mendelssohn-Bartholdy, letter to Marc André Souchay dated Berlin, 5 October 1842; quoted after Edward Lockspeiser, *Music and Painting. A Study in Comparative Ideas from Turner to Schoenberg*, London: Cassell & Co., 1973, p.9.

48 *WaW*, Book III, para. 52.

49 *Ibid*. The most evident manifestation of the inherently systematic character of music is the acoustic phenomenon called the 'harmonic series'. Every note, whether sounded by a flute, a violin, an organ pipe or whatever, contains other notes within it, known as 'harmonics'. These 'harmonics' are only partially heard under normal conditions (for this reason, they are also sometimes referred to as 'partial notes' or, more correctly, 'upper partials'); but their presence, in varying degrees of audibility, greatly affects the 'colour' of the note in question. More important, the 'harmonics' the ear distinguishes most easily are the octave, the fifth and the major third (the 'series' is completed by continuing upwards, filling in the remaining 'upper partials' in order of diminishing distinctness, see fig.6). Since these are the constituent notes of the major triad, it can be argued that the acoustic 'fact' of the harmonic series necessarily implies tonality (or at least a tonal centre), a sense of 'key'. This is the basis of Bernstein's argument regarding the inevitability of some form of tonal structure in music. (Bernstein 1976, p.325ff; also *ibid*. p.16ff for an admirably lucid account of the harmonic series and its significance.)

50 *BE*, p.87.

51 Denman W. Ross, *The Painter's Palette; A Theory of Tone Relations; An Instrument of Expression*, Boston/New York: Houghton Mifflin Co., 1919, v; quoted after Brown 1955, p.161.

52 Baudelaire, *Curiosités* p.281.

53 See John Gage, in this volume, p.24f.

54 Ernst Wilhelm von Bruecke, *Die Physiologie der Farben für die Zwecke der Kunstgewerbe . . .* (Leipzig) 1866 and subsequent editions. Several illustrated colour manuals were based on Brücke's theories; see for example *Farbenkreis . . . mit 20 Anwendungstafeln . . . nach Prof. Brueckes 'Physiologie der Farben'* (Vienna) 1877. Marc refers to Brücke's treatise, together with those of Wauwermanns and Bezold, in a letter to August Macke dated 14 February 1911; see *August Macke/Franz Marc: Briefwechsel . . . mit einem Vorwort von Wolfgang Macke*, Cologne: M. DuMont Schauberg, 1964, p.45 (hereafter: *MM Bfw*). Marc adds, however: 'Meine paar abergläubischen Begriffe über Farben dienen mir jedenfalls besser als alle diese Theorien.'

55 Letter dated Kandern, 14 July 1907 from August Macke to Elisabeth Gerhardt; quoted after the catalogue *Der Blaue Reiter: Sammlungskatalog 1*, Munich: Städtische Galerie im Lenbachhaus, 2nd edn 1966, p.89.

56 *MM Bfw*, p.40f.

57 See note 12 above.

58 Among Kandinsky's papers is a manuscript note which refers optimistically to recent experiments which had demonstrated the 'proximity between the vibrations of tones and colour radiations'. He also cites approvingly the work of the Russian teacher A. V. Zakharina-Unkovskaya, authoress of a 'method of colours, sounds and numbers, intended simultaneously to develop the hearing, sight, memory, intellect and powers of observation'. (*UdG* 1912, p.48, note 1; see also Hahl 1976, p.55f.) The idea of a 'scientific' relationship between colours and musical tones, on the basis of their respective wavelengths, also captured the attention of American pedagogues: on the Fenollosa-Dow education system see Zilczer 1975, p.49ff. The idea was not, however, a new one. Gauguin, for example, had written: 'la couleur . . . est vibration, de même que la musique', asking us to imagine 'la part musicale que prendra désormais la couleur dans la peinture moderne'. (M. Malingue, *Lettres de Gauguin à sa femme et à ses amis*, Paris 1946, CLXX; quoted after Rookmaker 1972, p.215.)

[59] Klaus Lankheit, Franz Marc's biographer, notes that Ostwald's theories enjoyed a considerable vogue in Germany at this time; and Marc himself observed: 'The theory of energy was a more powerful artistic inspiration to us than a battle or a rushing torrent.' Klaus Lankheit, *Franz Marc. Watercolours, Drawings, Writings*, London: Thames & Hudson 1960, pp.17–18.

[60] *UdG* 1912, p.45f; 76 and notes 1 and 2.

[61] *Ibid.*, p.73.

[62] Kandinsky's letters to Schoenberg are preserved in the Library of Congress, Washington. The first letter is dated 18 January 1911; as Hahl also observes (*op.cit.*, p.56 and note 13), its content makes clear there had been no previous contact between the two artists.

[63] *MM Bfw*, p.39ff.

[64] *Ibid.*, p.40.

[65] The composer Thomas von Hartmann, in an unpublished essay, remarked on Kandinsky's interest in the analogies between painting and musical theory; see Hahl 1976, p.55. Marsden Hartley, in a postcard to Stieglitz dated 16 February 1913, also refers specifically to the musical influence exerted by Schoenberg on Kandinsky; see Zilczer 1975, p.70 and note 68.

[66] Letter of 18 January 1911; quoted in part by Hahl, *loc.cit.*, p.56.

[67] Letter of 27 January 1911. Schoenberg's *Harmonielehre* was published in the course of the same year by Universal-Edition, Vienna (hereafter: *HL*).

[68] Arnold Schönberg, 'Ueber Oktaven- und Quinten-Parallelen', *Die Musik, Halbmonatsschrift mit Bildern und Noten*, X. Jahr (1910/1911) Heft 2, p.96ff; this 'pre-publication' differs in several unimportant respects from the final version of this chapter as published in the *Harmonielehre*.

[69] 'Paralleli v oktavakh i kvintakh', in the catalogue *Salon 2, mezhdunarodnaya vystavka (ustroitel' V. Izdebsky)*, Odessa, 1911, p.16ff.

[70] *MM Bfw*, p.40.

[71] Quoted after Willi Reich, *Schönberg, oder Der konservative Revolutionär*, Vienna: Fritz Molden, 1968, p.70 (hereafter: Reich 1968).

[72] 'Ueber Oktaven- und Quinten-Parallelen', *loc.cit.*, p.100.

[73] *MM Bfw*, pp.46–7.

[74] Bernstein 1976, p.193f.

[75] An examination of Schoenberg's theoretical writings of this period reveals, however, that the problem of construction was no less crucial to Schoenberg than to Kandinsky. On this question, the opinion of the present writer differs radically from that expressed by Hahl, for whom 'le problme "construction" devait être entre eux l'unique pierre d'achoppement', *loc.cit.*, p.58.

[76] *HL*, p.33.

[77] Reich 1968, pp.39–40.

[78] Rudolph Reti, *Tonality – Atonality – Pantonality*, London: Rockliff, 1958, p.40.

[79] Eichner, p.112.

Mathematics in early abstract art

LUCY ADELMAN AND MICHAEL COMPTON

[1] *Mercure de France*, Jan.1909, translated in *Braque*, Museum of Modern Art, New York, 1949, p.33.

[2] Speaking to Dora Vallier in 'Braque la Peinture et Nous', *Cahiers D'Art*, Oct.1954, p.16.

[3] Gleizes & Metzinger, *du Cubisme*, 1912, translation from R. L. Herbert, *Modern Artists on Art*, New York, 1964, pp.7–8.

[4] Linda Henderson, *The Artist, the 'Fourth Dimension', and Non-Euclidean Geometry 1900–1930: A Romance of Many Dimensions*, Doctoral dissertation, Yale, 1975. The artist who may have learned most about these matters according to Henderson is not treated here: Duchamp.

[5] Henri Poincaré, *Science and Hypothesis*, London, 1905, pp.55 and 69. French edition, Paris, 1902. Adolf Hildebrand in *The problem of Form in Painting and Sculpture*, 1907, p.31 (German edition 1893, French, 1903?), has a related formulation that also seems appropriate: 'To perceive in visual images the third dimension, however, we must imagine ourselves as changing our point of view and as getting merely a succession of disconnected, shifting views of the subject more or less in profile.'

[6] Gleizes & Metzinger, *loc.cit.*

[7] Charles Blanc, *Grammaire des Arts du Dessin* Paris n.d. (after 1880) p.27 quoting Bernardin de St Pierre. This book was a standard text book used by generations of art students and written by a Professor of the Ecole des Beaux Arts.

[8] Wendy Baron, *Sickert*, London, 1973, pp.67, 139, 142 and verbally.

[9] Werner Hoffman, *Turning Points in Twentieth-Century Art: 1890–1917*, 1969, p.253.

[10] W. Camfield, 'Juan Gris and the Golden Section', in

Art Bulletin, March 1965, pp.128–34. The analysis below is slightly different from his.

11 R. Welsh, 'Theo van Doesburg and Geometric Abstraction' in *de Stijl, Modernism in the Netherlands and Belgium in the first quarter of the century* ed. F. Bulhoff, The Hague 1976. T. Threlfall in 'Piet Mondrian, An untitled and unknown drawing circa 1918', *Art History* I.2, June 1978, pp.229–35, indicates a source for this kind of grid in an article by H. J. M. Walenkamp of 1904–5. This article seems even more relevant to the habits of van Doesburg and one of its illustrations corresponds exactly to his picture 'Arithmetic'.

12 Eugène Grasset, *Méthode de Composition Ornementale*, Paris, 1905, p.6.

13 J. F. W. von Bezold, *The theory of colour in its relation to Art and Art-Industry*, Boston, 1876, pp.76,77.

14 J. Baljeu's translation from *Eenheid* 392, 8 December 1917, in *Theo van Doesburg*, 1974, p.27.

15 *Op.cit.* pp.481 and 486 etc.

16 Van Doesburg, 'L'Evolution de L'Architecture vivante' in *L'Architecture Vivante*, Autumn and Winter 1925, pp.19–20.

17 From the French translation by J. C. and V. Marcadé of Malevich 'Du Cubisme et du Futurisme au Suprématisme' *passim*, in *K. Malevitch, De Cézanne au Suprématisme*, Paris, 1974.

18 S. P. Compton, 'Malevich and the Fourth Dimension', *Studio International*, April 1974, pp.190–5.

19 Claude Bragdon, *Man the Square*, New York, 1912, p.65.

20 Catalogue of *Last Exhibition of Futurist Paintings 0,10*, Petrograd, Dec.1915.

21 Rainer Crone in 'Malevich and Khlebnikov Suprematism reinterpreted', *Art Journal*, Dec.1978, pp.38–47.

22 From J. A. Richardson, *Modern Art and Scientific thought*, University of Illinois Press, 1971, p.106.

23 Quoted by L. D. Henderson in 'The Merging of Time and Space: "The Fourth Dimension" in, Russia from Ouspensky to Malevich' in *The Structurist* no.15, 1976, p.99.

24 K. Malevich, 'God is not cast down' in *Essays on Art*, vol.1, ed. Troels Andersen, Copenhagen 1968, p.213.

25 K. Malevich, Marcade *op.cit.*, pp.37 and 112. A rather different, English translation of the latter is given in Malevich *Essays, op.cit.*, p.117.

26 Marcadé *op.cit.*, p.122 and Malevich *Essays*, **op.cit.**, p.117.

27 Marcadé, *op.cit.*, p.56 and Malevich *Essays, op.cit.*, p.25. The word 'factura', texture, has a wider meaning comprising the artist's characteristic way of putting on paint.

28 K. Malevich, 'In Nature there exists . . .' from *The Artist, Infinity, Suprematism*, ed. Troels Andersen, Copenhagen, 1978, p.32–3.

29 K. Malevich, *Essays, op.cit.*, p.60.

30 Translation from Stephen Bann ed., *The Tradition of Constructivism*, London, 1974, p.7.

31 Ozenfant et Jeanneret, *Après le Cubisme*, Paris, 1918, p.12.

32 El Lissitsky, 'A and Pangeometry' 1925, translation from Lissitsky Kuppers, *El Lissitsky: Life and Letters*, Greenwich Conn., 1968, p.349.

33 Van Doesburg in *De Stijl* no.1, 1918, translation from *Principles of Neo Plastic Art*, 1966, postscript cy H. L. C. Jaffé, p.70.

34 Reyner Banham, *Theory and Design in the First Machine Age*, London, 1960, p.313.

35 Quoted in Banham *op.cit.*, p.188 from Van Doesburg's 'The Will to Style'.

36 Quoted in Banham *op.cit.*, p.159.

The abstract interior

JANE BECKETT

1 For a discussion of the Deutsche Werkbund see J. Campbell, *The German Werkbund*, 1979; for an account of the founding of the *Design and Industries Association*, see N. Pevsner, 'Patient Progress Three: The D.I.A.' in the *D.I.A. Yearbook* 1964/5; reprinted in *Studies in Art, Architecture and Design*, vol.II, 1968, pp.226/242.

2 Pamphlet published to accompany the Board of Trade exhibition, 'Exhibition of German and Austrian articles typifying successful design', held at the Goldsmith's Hall, London, March 1915.

3 H. Muthesius, *Das Englische Haus*, Wasmuth, Berlin, 1904, 1905 (3 volumes). English translation *The English House*, ed. D. Sharp, 1979, from which my translations are taken.

4 For a discussion of this concept see M. Girouard, 'The Victorian artist at home', part 1, *Country Life* CLII, 3934, 16 November 1972, pp.1278–81; Part 2, *Country Life*, 3935, 23 November 1972, pp.1370–4.

5 Muthesius, *op.cit.*, p.37.

6 P. Vergo, 'Gustav Klimt's Beethoven Freize', *Burlington Magazine*, vol.cx, no.839 (Feb.1973), pp.109–13.

7 See E. F. Sekler, 'The Stoclet House by Josef Hoffmann', in *Essays in the History of Architecture presented to Rudolph Wittkower*, 1969, pp.228–44.

8 M. Denis, *Theories 1890–1910*, Paris, 1912.

9 A. Aurier, 'Symbolisme et Peinture: Paul Gauguin', in *Mercure de France*, March 1891.

10 O. Wilde 'The critic as artist', in *Intentions*, 1891.

11 See P. Weiss, *Kandinsky in Munich*, Princeton, 1979.

12 Quoted in P. Weiss, *op.cit.*, p.119.

13 See *Ruckblicke*, 1913. 'The tables, the benches, the great oven, important in Russian peasant houses, the wardrobe and every object were painted with bright coloured, large figured decorations.'

14 W. Grohman, *Wassily Kandinsky*, 1959, p.174.

15 E. H. Gombrich *The Sense of Order*, 1979.

16 L. Appiganesi, *The Cabaret*, 1975.

17 Quoted in P. Vergo *Art in Vienna 1898–1918*, 1975 after Mrazek und Feuchtmuller, *Kunst in Oesterreich 1860–1918*, 1964, p.114.

18 *Prospectus Cave of the Golden Calf*, May 1912.

19 O. Sitwell, *Great Morning*, 1948, p.208.

20 V. Hunt, *The Flurried Years*, 1926.

21 R. Fry, *The Nation*, 20 July 1912.

22 Quoted in R. Cork, *Vorticism*, 1973, vol.I, p.301.

23 A. Haskell, *Ballet*, 1938, p.95.

24 *Lewis letters*, ed. Rose, 1963, p.79. Letter dated 12 April 1916.

25 P. Wyndham Lewis, *Rude Assignment*, 1935.

26 H. Ball, *Die Flucht aus der Zeit*, translated as *The Flight out of Time*, ed. J. Elderfield, New York, 1975, p.50.

27 For detailed discussion of the work of the Van Reeses, see H. Henkels, *Otto and Adya van Rees*, catalogue Gemeente Museum, The Hague, 1975.

28 A detailed account of the works exhibited in the Galerie Tanner, and of Arp's work in Zurich, in A. I. Grieve, 'Hans Arp and the art of Zurich Dada', in *Dada Spectrum*, ed. S. Foster and R. Kuenzli, Iowd, 1979 pp.175–205.

29 For a full discussion of the work of Dutch artists in Paris, see M. Hoogendoorn, 'Nederlanders in Parijs', *Museum Jornaal*, serie 17, no.6, (Dec.1972), pp.247–53.

30 Ball, *op.cit.*, p.53.

31 H. Arp, *On My Way*, New York, 1948, p.39.

32 The backdrops were probably made for the eighth Dada soirée of 9 April 1919. They were also important for Richter's development of the scroll. He recalls that he and Arp made sets for the soirée from long strips of paper, two yards wide, painted with huge black shapes, resembling giant cucumbers. These were subsequently attached to pieces of wood and rolled up. See H. Richter, *Dada Art and Anti Art*, p.70.

33 This idea was first formulated by my colleague Dr A. I. Grieve, see note 28. See also R. von Laban, *Choreographie*, erste heft, Jena, 1926.

34 I am indebted to Judith Collins who is preparing a dissertation on the Omega Workshops for her helpful discussion of their work.

35 See D. Robbins, 'The Abbaye de Creteil', *The Art Journal*, XXIII, 2 (Winter 1963–4) pp.111–16.

36 For a detailed discussion of the 'Maison Cubiste' see M. N. Pradel, 'La Maison Cubiste en 1912', *Art de France*, I, 1962, pp.172–86.

37 Published in H. G. Wells, ed., *The Great State*, 1912. Reprinted with alterations in *Vision and Design*, London, 1920 as 'Art and Socialism'.

38 This debt was acknowledged by Fry in an interview in the *Pall Mall Gazette*, 11 April 1913, p.3: 'Since Morris there has been no movement in decorative art'.

39 '"We have revived the old fashioned cross stitch. And here is a design for more embroidery." It consisted of flowers and vases and birds all very schematised and Post Impressionist.' *Pall Mall Gazette*, 11 April 1913, p.3.

40 See Q. Bell and S. Chaplin, 'The Ideal Home Rumpus', *Apollo* LXXX (Oct.1964) pp.284–91.

41 Letter to Fry. Mss. King's College Library, Cambridge, quoted in D. Sutton, *Letters of Roger Fry*, vol.I, p.40.

42 Now no longer extant. Published in the *Sketch*, 24 March 1914; the *Illustrated London News*, 7 March 1914; *Vanity Fair*, 25 June 1914.

43 P. Wyndham Lewis, introduction 'The Cubist Room' in catalogue, *Camden Town and Others*, Brighton, Dec./Jan.1913/14.

44 T. E. Hulme, 'Modern Art', *The New Age*, Jan.–July 1914.

45 R. Fry, 'The artist as decorator', *Colour Magazine*, April 1917, pp.92/3.

46 Letter from Charles E. White, Jr., to Walter Wilcox, 13 May 1904, quoted from 'Letters 1903–6', ed. Charles E. White, Jr., from 'The Studio of Frank Lloyd Wright', ed. N. E. Morris Smith, *Journal of Architectural Education*, vol.25, no.4 (Fall 1971), pp.104–12.

47 For a discussion of Kirchner's work in Dresden see D. Gordon, *Ernst Ludwig Kirchner*, London 1966; and by the same author 'Kirchner in Dresden' *Art Bulletin*, XLVIII, 1966, p.335ff.

48 See N. Troy, 'Piet Mondrian's atelier', *Arts Maga-*

zine, Dec.1978, pp.82/7 for a discussion of the Paris atelier.

49 'Natural and Abstract Reality'. An essay in dialogue form. In various issues of De Stijl, II.8 (June) 1919–III.10 (August) 1920. Translated in M. Seuphor, Piet Mondrian, pp.301–52.

50 'Bij Piet Mondrian', p.9, newspaper cutting in Documentation Archive, Gemeentemuseum, The Hague.

51 H. L. C. Jaffé, De Stijl, Amsterdam, 1956, p.5.

52 For a full discussion of Van der Leck's development see R. W. D. Oxenaar, Bart Van der Leck 1876–1958, Rijksmuseum Kroller Muller, Otterloo catalogue, 1976.

53 Op.cit., note 49.

Abstract art – a language?

STEPHEN BANN

1 C. Lévi-Strauss, in G. Charbonnier, Conversations with Claude Lévi-Strauss, London, 1969, pp.87, 75.

2 E. H. Gombrich, 'The Vogue of Abstract Art', in Meditations on a Hobby-Horse, London, 1963, p.149.

3 Ibid., plate 124: the painter in question, whose name has also been inverted, is Albert Besnard.

4 Saussure, who was born in 1857, gave three courses in general linguistics at the University of Geneva in 1906/7, 1908/9 and 1910/11. After his death in 1913, the lecture notes of his students were collated and the Cours de Linguistique générale was finally published in 1916. Cf. Saussure, Course in General Linguistics (trans. by Wade Baskin and intr. by Jonathan Culler), London, 1974. Jonathan Culler's Saussure (Fontana Modern Masters, 1976) is a concise and suggestive presentation of his work and its far-reaching implications.

5 Gombrich, op.cit., p.67. Reference is being made to a lecture on this particular painting by Professor L. D. Ettlinger.

6 Ibid., p.68.

7 Ibid., p.58.

8 C. Lévi-Strauss, Le Cru et le cuit, Paris, 1964, p.38 (my translation).

9 R. Jakobson, Essais de linguistique générale, Paris, 1963, p.214.

10 Cf. M. Pleynet, 'De Pictura', trans. in Visual Poetics (20th Century Studies 15/16), Dec.1976, p.113.

11 Cf. T. Adorno, Mahler – une physiognomie musicale (French trans.), Paris, 1976; Philosophy of Modern Music (English trans.), London, 1973. For the implications of Adorno's critique in the field of abstract art, see his passage on 'function' quoted in relation to Mondrian at a later stage in this article.

12 Cf. Marcelin Pleynet's perceptive comments in Documents sur 2/3, 1978, p.86. Specific reference is made to works by John Golding and Edward Fry.

13 V. Tatlin, 'The Work ahead of us' (trans. Troels Andersen), in The Tradition of Constructivism (ed. S. Bann), London, 1974, pp.12–14.

14 Saussure, op.cit., p.113.

15 T. Andersen, in Tatlin catalogue, Moderna Museet, Stockholm, 1968, p.6.

16 K. Malevich, Essays on Art 1915–1933, ed. T. Andersen, London, 1968, vol.1, p.55.

17 Ibid., p.120.

18 H. Damisch, 'Equals Infinity', in Visual Poetics, op.cit., p.67; cf. also the article 'Malevich, le carré, le degré zero' by Yve-Alain Bois, in Macula 1, Paris, 1976, pp.28–49.

19 Quoted in S. Lissitsky-Kuppers, El Lissitsky, London, 1968, p.350.

20 Cf. Wladyslaw Strzeminski, 'L'Unisme en peinture', trans. in Macula, op.cit., pp.14–27.

21 The Tradition of Constructivism, op.cit., p.20.

22 Cf. illustration in Tatlin catalogue, op.cit., p.64.

23 M. Bill, 'La Composition 1/1925 de Mondrian', in Macula, op.cit., pp.88–91.

24 A. Hill, 'Art and mathesis – Mondrian's structures', in Leonardo, no.1, 1968.

25 Adorno, Philosophy of Modern Music, op.cit., p.70.

26 M. Bill, op.cit., p.91.

27 Quoted in M. Pleynet, 'Mondrian vingt-cinq ans après', in Système de la peinture, Paris, 1977, p.130: this essay, which dates from 1969 and has to some extent been superseded by the author's later writings, is still indispensable for any reassessment of Mondrian's career.

28 Saussure, op.cit., p.120.

29 De Stijl 1, Oct.1917: doubtless this formulation owes much to Kandinsky, whom Van Doesburg described in the previous year as occupying the crucial place in the transition between 'abstract-romantic' and 'constructed' styles (see Van Doesburg, De nieuwe beweging in de schilderkunst, Delft, 1917, p.42: text dated May–Aug. 1916).

30 Cf. Joost Baljeu, Theo Van Doesburg, London, 1974, p.73.

31 *The Tradition of Constructivism*, op.cit., p.92: the manifesto was published in the first number of Hans Richter's magazine G (July 1923). I am indebted to Dr Peter Vergo for pointing out that Van Doesburg's use of the term 'figure-bass' (*generalbass*) derives in the first instance from Kandinsky's *On the Spiritual in Art*, and ultimately from German musical theory of the eighteenth and nineteenth centuries.

32 *Ibid.*, p.193.

33 Cf. R. P. Lohse, 'A Step Further – New Problems in Constructive Plastic Expression', *ibid.*, pp.277–83: also Hans Joachim Albrecht, *Farbe als Sprache*, Cologne, 1974; this is a useful didactic study of Lohse's work in relation to that of Delaunay and Albers.

34 It is perhaps worth restating at this point the respective definitions of the 'meta-linguistic' and 'poetic' functions of discourse, the 'code' and the 'myth'. Jakobson recognises that there is a possible confusion between them, and expresses the distinction in this way: 'We may notice that meta-language also makes sequential use of equivalent units, combining synonymous expressions in an equational sentence: A = A ("the mare is the female of the horse"). Between poetry and meta-language, all the same, there is a diametrical opposition: in meta-language, sequence is utilised to construct an equation, whilst in poetry it is the equation which serves to construct the sequence.' (Jakobson, *op.cit.*, p.220.) By analogy, we may contrast Van Doesburg's paintings of the Elementarist stage with the promise represented by the *Arithmetic Composition*. In the earlier phase, works have the character of *definitions*: they illustrate, with reference to an explicit theory of figure-basses, the principles of construction. (Or rather, they do so, while at the same time drawing attention to the numerous aspects which fall beyond the meta-linguistic analysis.) In the later work, however, 'equation' has primacy over 'sequence': that is to say, the relation of plastic elements *as given in the painting* (inscribed squares and tilted squares within an overall square format) appears to determine the overall order or sequence within the composition. As with the sentence, 'I like Ike', attention is focused upon the repetitions and differences of simple units, rather than upon the picture as an exemplification of pictorial language. In different ways, the work of post-war artists such as Lohse, Bill and Vasarely testifies to the fertility of this shift from a meta-linguistic to a poetic function.

35 Hugo Ball, *Flight out of Time – A Dada diary*, ed. J. Elderfield, New York, 1974, p.232. The subsequent quotation is taken from p.230.

36 A. Hill, 'A structuralist art?', in *20th Century Studies* 3, May 1970, p.107.

37 H. Damisch, 'Equals Infinity', in *20th Century Studies* 15/16, Dec.1976, p.66.

38 This project is implicit in the recent works of Jean-Louis Schefer: *L'invention du corps chrétien*, Paris, 1975; *Le déluge, La peste, Paolo Uccello*, Paris, 1976; *L'Espèce de chose Mélancolie*, Paris, 1978; an earlier text by Schefer which has been translated into English is 'Split colour/blur', in *20th Century Studies* 15/16, Dec.1976, pp.82–100.

39 R. Jakobson, *op.cit.*, p.217.

40 Nikolai Taraboukine, *Le dernier tableau*, ed. A. B. Nakov, Paris, 1972, p.153 (from text originally published by Proletkult in 1923). Taraboukine's analysis is confusing in that it claims: 'there can be no difference in principle between typical (painted) pictorial objects, pictorial objects composed of different materials (counter-reliefs) and finally objects with a utilitarian purpose' (p.154). This yoking together of Malevich, Tatlin and Rodchenko does, however, have the merit of transcending the level of personal conflict, and posing the non-mimetic category of 'Res-ism': the work of art as object. It is illuminating to compare Taraboukine's invocation of Bergson with Bachelard's references in the first chapter of *Le Matérialisme rationnel*. Bachelard discusses the Bergsonian concept of *homo faber* – man as craftsman – whose vision of the world is expressed in terms of geometric solids, and he contrasts it with the insights derived from modern engineering, where 'materiality' is prior to geometric construction. 'Bergson's *homo faber*, constrained within his simplistic intuitions of the geometric world of perfect solids, would be lost in the finesses of mesophysics, faced with the unexpected 'suppleness' of informed materialistic intuitions' (G. Bachelard, *Le Matérialisme rationnel*, Paris, 1953, p.14). In spite of Taraboukine, we could make out a case for Tatlin as a 'phenomenologist of materiality' along Bachelard's lines: Tatlin's 'intuitive' response to materials would imply precisely the rejection of *homo faber* and his ideal geometric world. And obviously such a critique would have further implications for the aesthetic of 'construction' among the abstract artists of the Modern Movement.

The ratification of abstract art

CHARLES HARRISON

1 The term 'realism' is not here used as it might be by 'socialists' to signify approval of Courbet. We need to gloss our use of the term, particularly in relation to the concept of materialism.

An epistemology *e* is materialist if and only if it satisfies criteria something like the following (it might be that in satisfying these criteria, *e* would lose all claims to being 'epistemology' in the traditional sense, but anyway):

1. It recognises the independent reality of the objects of knowledge. Now, 'independent reality' means 'independent of the "knowing subject"', of the process of production of that knowledge, and of the knowledge itself' (where the latter is interpreted as meaning the propositions which are that knowledge, the meanings of the sentences etc. in which that knowledge is conveyed).

2. That adequacy to (not, as such correspondence to) the object of knowledge (match with it?) is some sort of *final standard* by which the cognitive status of thought or theory (or?) can be sorted out and assessed.

3. That 'thought', ideas, 'knowledge' are independently real; i.e. not dependent upon thought; and

4. that they are not *sui generis* but *caused* in (social) activity or practice.

The first two criteria are '*realistic*'; the four of them together are materialistic (in a tentative and discursive sense) One might ask whether there is any ideology near to non-science that satisfies *any* of these criteria.

2 The use of the first person plural is not a mere rhetorical device. There is a connection between what is said in this essay and the discursive circumstances of its production.

3 As quoted by Troels Andersen, 'Malevich on "New Art"' in *Studio International*, September 1967. Andersen refers to articles published by Malevich in *Nova Generatsiya* between 1928 and 1930.

4 Recourse to the dictionary definition of the term 'heuristic' will not resolve the paradox involved in its appearance in this context. An heuristic is characteristically understood as a means to finding something out, a means of learning. But what is discovered or learned by means of an heuristic may not be the truth. Any ideology, if it is to have a continuing life, must have some means of becoming internalised by people, *whether the items of its constituent beliefs are true or false.* A dogma is indeed the more likely to be successful the more its heuristics are indistinguishable from effective means of learning the truth. It is generally assumed that 'art' is a means to enlightenment, and it is proposed by its protagonists that abstract art is an especially ineffable means to enlightenment. But what if abstract art were rather a particularly effective form of imposture?

We are talking about a learning process which takes place in respect of *objects* – formalities – which are supposed to remain unchanged and immutable in this process. There may be those who are so impressed by the sensitivity of their own sensations 'in front of' these objects that they fail to understand how abominable this is as a notion of learning. Dogmatic idealism, in the shape of a formalist sense of the truths of mathematics, is one thing. But the 'truths' of Wassily Kandinsky or Kasimir Malevich . . .?

To appreciate the relevance of the concept of heuristic to the context in which we are using it is to entertain the idea that what is normally topicalised as the extension of sensibility may instrumentally be the means to increase and further to institutionalise a *credulous congregation.'*

5 For a more considered discussion of the issues raised in this paragraph see *Art–Language*, vol.4 no.4, passim.

6 Stephen Bann, *The Tradition of Constructivism*, London, Thames and Hudson 1974, introduction, pp.xxix–xxx. The reference is to 'The Work Ahead of Us' by Tatlin, Shapiro, Meyerzon and Vinogradov, printed in Bann's book, pp.11–12. Michael Compton has objected that '. . . a political revolution could be anticipated by a pictorial one if a certain value is given to the word "anticipate" and the characteristics of the two "revolutions" are formulated in a specific way.' It should be clear from the run of the text that such an objection cannot be considered as substantial in so far as it is logically continuous with just those idealist forms of justification and of special pleading which we have been concerned to argue against.

REFERENCES

Kandinsky
Concerning the Spiritual in Art, Munich, 1912

Mondrian

'Natural Reality and Abstract Reality', *De Stijl* 1, 1919

'Plastic Art and Pure Plastic Art', *Circle*, London, 1937

Malevich

The Non-Objective World, Munich, 1927

Manifesto 1 of *De Stijl*, 1918

Statement by the International Faction of Constructivists, 1922 (reprinted in Bann *op.cit.*)

Gabo

'Russia and Constructivism' (interview with Lassaw and Bolotowsky), 1956, in *Gabo*, London, 1957

(It should be recognised that quotations from all but the last of these texts are quotations from translations. While some available translations are open to strong criticism – notably those from Kandinsky – we would not expect that a revised translation would render any of the above secure from the kinds of objection expressed in this essay).

Cubism and the possibility of abstract art

CHRISTOPHER GREEN

1 Cf. John Golding, *Cubism, a History and Analysis, 1907–1914*, London, 1968, pp.114–16; Robert Rosenblum, *Cubism and Twentieth-Century Art*, New York, 1976, p.71. Both these books give excellent accounts of the development of Picasso's and Braque's Cubism, though with less stress on the 'synthetic' character of Cubism between 1910 and 1912 than here.

2 Guillaume Apollinaire, 'Les trois vertus plastiques', *Catalogue de la IIIe Exposition du Cercle de l'Art Moderne*, Le Havre, 1908; in *Apollinaire on Art: Essays and Reviews, 1902–1918 by Guillaume Apollinaire*, ed. Leroy C. Breunig, translated by Susan Suleiman, London, 1972, p.47.

3 Quoted in William Rubin, *Picasso in the Collection of the Museum of Modern Art*, with additional texts by Elaine L. Johnson and Riva Castleman, New York, 1972, p.72.

4 Guillaume Apollinaire, 'Du sujet dans la Peinture moderne', *Les Soirées de Paris*, Paris, 1 February 1912; in Apollinaire, *op.cit.*, pp.197–9.

5 Guillaume Apollinaire, *Les Peintres cubistes: méditations esthétiques*, Paris, 1913; Introduction by Leroy C. Breunig and J-Cl. Chevalier, Paris, 1965, p.57.

6 The fullest account of Duchamp's develpment is Arturo Schwartz, *The Complete Works of Marcel Duchamp*, New York, 1969. The most important primary sources are *Le Marchand du sel*, écrits de Marcel Duchamp, ed. Michel Sanouillet, Paris, 1958; and Pierre Cabanne and Marcel Duchamp, *Dialogues with Marcel Duchamp*, New York, 1969. On all the Orphist painters much is to be found in Virginia Spate, *Orphism: The Evolution of Non-figurative Painting in Paris, 1910–1914*, Oxford, 1979.

7 Interview with James Johnson Sweeney, *Bulletin of the Museum of Modern Art*, vol.13, no.4–5, 1946; in *Le Marchand du sel*, *op.cit.*, p.110.

8 Guillaume Apollinaire, *Les Peintres cubistes*, *op.cit.*, p.91.

9 *Ibid.*, pp.91–2.

10 *Ibid.*, p.91.

11 Marcel Duchamp, 'La Mariée mise à nu par ses célibataires, même', in *Le Marchand du sel*, *op.cit.*, pp.35–6.

12 Pierre Cabanne and Marcel Duchamp, *op.cit.*, p.39.

13 *Ibid.*, p.43.

14 The fullest account of the development of Picabia is William A. Camfield, *Francis Picabia. His Art, Life and Times*, Princeton, 1978. Other useful publications in which some primary material can be found are William A. Camfield, *Francis Picabia*, Solomon R, Guggenheim Museum, New York, 1970; and *Francis Picabia*, Galeries Nationales du Grand Palais, Paris, 1976.

15 Cf. 'How New York Looks to Me', *New York American*, 30 March 1913, magazine section, p.11.

16 *Ibid.*, p.11.

17 No Divisionist paintings by Léger are known to have survived, but there is evidence that he passed through a Divisionist phase, cf. Christopher Green, *Léger and the Avant-Garde*, London and New Haven, 1976, pp.7–8.

18 The fullest account of the development of Delaunay between 1910 and 1914 is Gustav Vriesen and Max Imdahl, *Robert Delaunay. Light and Colour*, Cologne–New York, 1967. The most important primary source is Robert Delaunay, *Du Cubisme à l'art abstrait*, ed. Pierre Francastel, Paris, 1957.

19 Delaunay, *Du Cubisme à l'art abstrait*, *op.cit.*, p.62.

20 *Ibid.*, p.97.

21 Robert Delaunay, 'La Lumière', 1913, in Vriesen and Imdahl, *op.cit.*, p.6.

22 Imdahl deals with the details of his colour theory with great clarity, see Vriesen and Imdahl, *op.cit.*

23 *The Three Windows, the Tower, and the Ferris Wheel*, 1912, oil on canvas, 51 × 77 ins, Collection Mr and Mrs William A. M. Burden, New York.

24 Blaise Cendrars's most important early 'simultanist' poem, *Prose du Trans-sibérien et de la petite Jehanne de France*, was given a colour accompaniment by Sonia Delaunay early in 1913.

25 For a full account of Léger's development between 1909 and 1914, see Christopher Green, *Léger and the Avant-Garde, op.cit.* More introductory are Douglas Cooper, *Fernand Léger et le nouvel espace*, Geneva-Paris, 1949; and Pierre Descargues, *Fernand Léger*, Paris, 1955. The most important primary source is Fernand Léger, *Functions of Painting*, London-New York, 1973.

26 Fernand Léger, 'Les Origines de la peinture et sa valeur représentative', *Montjoie!* Paris, 29 May and 14–29 June 1913; in *Functions of Painting*, *op.cit.*, p.7.

27 See Christopher Green, *op.cit.*, pp.61–9.

28 *Ibid.*, pp.68–9.

29 Fernand Léger, 'Les Réalisations picturales actuelles', *Les Soirées de Paris*, no.25, 15 June 1914; in *Functions of Painting*, *op.cit.*, p.16.

30 The fullest accounts of Kupka's development are Denise Fédit, *L'Oeuvre de Kupka*, Paris, 1966; Ludmila Vachtová, *Frank Kupka, Pioneer of Abstract Art*, New York and Toronto, 1968 (translated from the Czech by Zdoněk Lederer); *František Kupka, 1871–1957*, Solomon R. Guggenheim Museum, New York, 1975.

31 A particularly valuable discussion of Kupka's interest in these themes is to be found in Margit Rowell, 'František Kupka: A Metaphysics of Abstraction, *František Kupka, 1871–1957, op.cit.*, pp.47–80.

32 There are four manuscripts, all written between 1910 and 1914. See *František Kupka, 1871–1957, op.cit.*, pp.60–1, footnote.

The spread of information leading to the rise of abstract art in Europe

SUSAN COMPTON

1 Peg Weiss, *Kandinsky in Munich – the Formative Jugendstil years*, Princeton University Press, 1979, p.20.

2 *Idem.*, chapter 1. This quotation, p.16 and note 44.

3 Robert C. Williams, *Artists in Revolution. Portraits of the Russian Avant-Garde, 1905–1925*, London, Scolar Press, 1978, p.62.

4 See article by Meda Mladek, 'Central European Influences' in *František Kupka 1871–1957*. Exhibition catalogue, Guggenheim Foundation, New York, 1975, pp.13–37.

5 Peg Weiss, *Kandinsky in Munich, op.cit.*

6 English translation in Peg Weiss, *Kandinsky in Munich, op.cit.*, p.23–4.

7 *Die Dekorative Kunst*, Nov. 1897, English translation in Peg Weiss, *Kandinsky in Munich, op.cit.*, p.26.

8 V. Kandinsky, *Über das Geistige in der Kunst*, Munich, 1912, p.115; English translation in Peg Weiss, *Kandinsky in Munich, op.cit.*, p.116.

9 A. Endell, 'Möglichkeit und Ziele einen neuen Architektur' in *Deutsche Kunst und Dekoration I*, 1897–8, p.152; English translation in Peg Weiss: *Kandinsky in Munich, op.cit.*, p.39.

10 Forty-two drawings by the Dresden artist Katharine Schäffner were published in a portfolio by Ferdinand Avenarius: *Eine neue Sprache?42 Zeichnung von Katharine Schäffner*, Munich: George D. W. Callwey Verlag, n.d.; see Peg Weiss, *Kandinsky in Munich, op.cit.*, p.207 note 55 and plates 87–9.

11 English translation in Alfred H. Barr Jr., *Matisse, His Art and his public*, London: Secker & Warburg, 1975, p.61.

12 *English translation in Apollinaire on Art, Essays and Reviews 1902–1918* ed. by LeRoy C. Breunig, 'The Documents of 20th century Art' (New York: The Viking Press) 1972, p.38.

13 Michel Seuphor, *Piet Mondrian, Life and Work*, London: Thames & Hudson 1957?, p.70–1.

14 I am indebted to Peter Vergo for pointing out this fact to me.

15 Maurice Vlaminck, *Portraits avant décès*, Paris: Flammarion, 1943, p.105; another account in: *Dangerous Corner*, London: Elek Books, 1961, p.71.

16 Information conveyed by Douglas Cooper in a seminar given at the Courtauld Institute of Art, University of London, 1968.

17 'Matiss o Moskve' in *Utro Rossii*, 27 October 1911; English translation in Yu. Rusakov: 'Matisse in Russia in the Autumn of 1911', *Burlington Magazine*, May 1975 (20th century special number) p.288.

18 'Kubizm' speech by Goncharova given at Knave of

Diamonds' debate, 12 February 1912; quoted in B. Livshits: *Polutoraglazyi Strelets*, Leningrad, 1933; English translation in *Russian Art of the Avant-Garde: Theory and Criticism 1902–1934* ed. John E. Bowlt, New York: Viking Press, 1976, p.78.

19 The catalogues of the collections of Ivan Morozov and Sergei Shchukin are reproduced by V. Marcadé: *Le Renouveau de l'Art Pictural Russe* (Lausanne: L'Age d'homme) 1971, pp.271–7.

20 See Eli Eganbyuri (Ilya Zdanevich) *Nataliya Goncharova. Mikhail Larionov* (Moscow: Munster) 1913, introduction.

21 Benedikt Livshits, *Polutoraglazyi strelets*, *op.cit.*, English translation Benedikt Livshits, *The One and a Half-eyed Archer*, translated, introduced and annotated by John E. Bowlt, Newtonville Mass: Oriental Research Partners, 1977, pp.43–4 and 132–4.

22 This and other catalogues reproduced by Donald E. Gordon: *Modern Art Exhibitions 1900–1916*, 2 vols., Munich: Prestel Verlag, 1974.

23 Kupka: letter to Arthur Roessler, 6 October 1910, see *František Kupka 1871–1957*, *op.cit.*, p.36.

24 *Apollon*, 1911 no.5 and 1914 no.3, St Petersburg.

25 See Peg Weiss, *Kandinsky in Munich*, *op.cit.*, p.67.

26 V. Kandinsky, *Rückblicke* in 'Kandinsky 1901–1913', Berlin, *Der Sturm*, 1913; English translation: 'Kandinsky: Reminiscenses' in *Modern Artists on Art* ed. Robert L. Herbert, New Jersey: Prentice-Hall Inc., 1964, p.26.

27 See Jonathan Fineberg, 'Les Tendances Nouvelles and Kandinsky' in *Art History*, vol.2, no.2, June 1979, London: Routledge & Kegan Paul, pp.221–46.

28 English translation: *Russian Art of the Avant-Garde*, ed. by John E. Bowlt, *op.cit.*, pp.19–23.

29 The text of this lecture was not published until 1914: *trudy Vserossiiskogo s'ezda khudozhinikov v Petrograde, dek. 1911-yanv. 1912 gg.*, Petersburg, 1914.

30 See G. Vriesen, & M. Imdahl, *Robert Delaunay: Light and Colour*, New York: Abrams, 1967.

31 English translation: *Apollinaire on Art: Essays and Reviews 1902–1918* ed. LeRoy C. Breunig, The Documents of 20th century Art, New York: Viking Press, 1972, p.264.

32 See *Apollon*, Jan–Feb. 1914, no.1–2, p.134.

33 See N. Khardzhiev, V. Trenin: *Poeticheskaya kul'tura Mayakovskogo*, Moscow, 1970, p.315 note 75.

34 English translation in *Russian Art of the Avant-Garde*, ed. John E. Bowlt, *op.cit.*, pp.25–38.

35 See M. Matyushin, 'Of the Book by Gleizes and Metzinger Du Cubisme' translated as Appendix B by L. Henderson in *The Artist, 'The Fourth Dimension', and Non-Euclidean Geometry 1900–1930: A Romance of Many . . .* vol.1 (published on demand by) University Microfilms International, Ann Arbor, Michigan, USA, London, 1979, pp.493–507. See also Olga Rozanova: 'The Bases of the New Creation and the Reasons Why it is Misunderstood' in *Russian Art of the Avant-garde*, ed. John E. Bowlt, *op.cit.*, pp.103–10.

36 *Idem.*, p.93.

37 See reproductions in Susan P. Compton: *The World Backwards: Russian Futurist Books 1912–16*, London: The British Library, 1978.

38 *Der Sturm*, August 1913, no.172–3 and *Montjoie!* 29 May 1913 and 14–29 June 1913.

39 English translation in 'Functions of Painting by Fernand Léger' ed. by Edward G. Fry, *Documents of 20th century Art*, New York: Viking Press, 1973, pp.3–10.

40 See Donald E. Gordon: *Modern Art Exhibitions 1900–1916*, *op.cit.*, vol.2.

41 *Ogonek* no.15, 13 April 1914; photographs reproduced by Troels Andersen; *Malevich*, Stedelijk Museum, Amsterdam, 1970, p.9.

42 See K. Malevich: *Ot kubisma k suprematizmu: novyi zhivopisnyi realizm*, Petrograd: Zhuravl, 1915, translated into French in *K. Malévitch: De Cézanne au suprématisme*, ed. Jean-Claude and Valentine Marcadé (Lausanne: L'Age d'Homme) 1974, pp.37–43 cf. 'From Cubism and Futurism to Suprematism The New Realism in Painting' translated in *K. S. Malevich Essays on Art 1915–1933*, vol.1, ed. Troels Andersen, London: Rapp and Whiting Ltd, 1969, pp.19–41.

43 *Les Soirées de Paris*, 15 June 1914, no.25; English translation: 'Contemporary achievements in painting' in *Functions of painting by Fernand Léger*, *op.cit.*, pp.11–19.

44 C. Howard Hinton: *The Fourth Dimension*, New York & London, 1904; also Claude Bragdon: *A Primer of Higher Space (The Fourth Dimension)*, New York, 1913.

45 See Maria Vengerova, 'Angliiskii futuristy' in *Strelets. Sbornik pervii*, Petrograd, 1915, pp.93–104; the review was published in February.

46 See *Poems* by John Rodker, edition of fifty copies published privately in 1914 by the author, with grey and white cover, designed by David Bomberg; the copy in the British Library is stamped with the acquisition date '14 October 1914'.

[47] See Peg Weiss, *Kandinsky in Munich*, op.cit., pp.61–3.

The dissemination of ideas about abstract art in England and America

SARA SELWOOD

I would like to thank friends and colleagues who helped me in various ways while I was writing this essay: Michael Compton, Anne d'Harnoncourt, Professor Anthony King, Lyn Perkins, Judith Rosenthal, Professor Irving Sandler, Terry Tostevin of the Inter-Library Loan Department, Essex University Library, and Jackie Veitch. I am especially indebted to Peter Vergo, who read and discussed the manuscript with great patience.

[1] It is not entirely clear either what were the origins of the term 'Vorticism' or which artists merit the name 'Vorticist'. Although Aldington, Arbuthnot, Atkinson, Brzeska, Dismoor, Hamilton, Pound, Roberts, Saunders, Wadsworth, and Wyndham Lewis signed the manifesto published in *Blast* no.1, 20 June 1914, the movement was hardly close knit. Aldington recalled that 'Mr. Lewis . . . carefully and wittily compiled a series of manifestos, to which we . . . all gleefully applied our names'. Roberts insisted that he had 'personally signed nothing'. David Bomberg, Alvin Langdon Coburn, Jacob Epstein, Christopher Nevinson and Dorothy Shakespear can be counted among the 'allies' of Vorticism. See the catalogue, *Vorticism and its Allies* (The Arts Council of Great Britain, 1974). Regarding the name, Vorticism, it has been suggested that the poet Ezra Pound first coined the word in a letter to William Carlos Williams in December, 1913: 'You may get something slogging away by yourself that you would miss in the Vortex.' By the 'Vortex', he was presumably referring to London, the 'whirling force' which drew some of the most innovatory foreign talent, for instance Brzeska, Epstein and Pound himself into 'an energetic synthesis'. The critic, Frank Rutter, categorically stated that the Vorticists' name was 'derived from a term used in the preface to Boccioni's book on Futurism, where the emotional state of the Futurist is described as being a "Vortex"'. There is no doubt that the term has Futurist connections: between 1913 and 1914 Balla executed several works which contain the word *vortice* in their titles. Others are specifically called *Vortice*. (M. Drudi Gambillo and T. Fiori (eds), *Archivi del Futurismo*, vol.2, Rome, 1962, p.156, nos.85, 85a; p.157, no.98, 107ff.) For a full discussion about the origins of the name, Vorticism, see Richard Cork, *Vorticism and Abstract Art in the First Machine Age*, 2 vols, London, 1976, pp.254–7 (hereafter: Cork 1976).

[2] Wyndham Lewis, 'A Review of Contemporary Art', *Blast* no.2, July 1915, p.47.

[3] Michael Sadleir, *Michael Sadler, a Memoir by his Son*, London, 1949, p.237.

[4] A. Ludovici, *An Artist's Life in Paris and London, 1870–1925*, London, 1926, p.184.

[5] Sadleir, op.cit., p.239.

[6] All these paintings were exhibited at the second exhibition of the Futurists, held at the Doré Galleries, April 1914.

[7] The *Athenaeum*, 10 January 1914. Quoted by Richard Shone, *Bloomsbury Portraits*, Oxford, 1976, p.130 (hereafter: Shone 1976).

[8] In August 1910, Marinetti's 'Futurist Venice' letter was published in the *Tramp*: 'Burn the gondolas, those swings for fools and erect up to the sky the rigid geometry of large metallic bridges and manufactures with waving hair of smoke, abolish everywhere the languishing curves of the old architecture'. The editor, Douglas Goldring, even published extracts from the 1909 Futurist manifesto, commenting 'Is this not thrilling?'. Quoted in Cork 1976, p.22.

[9] F. T. Marinetti to F. B. Pratella, 12 April 1912, Gambillo and Fiori, op.cit., vol.I, p.237.

[10] C. R. W. Nevinson, *Paint and Prejudice*, New York, 1938, pp.57–8.

[11] The Rebel Art Centre's official prospectus announced the foundation of an art school. The starting point of the teaching would be 'based on principles underlying the movements of Painting, known as Cubist, Futurist and Expressionist'. Quoted in Cork 1976, p.157.

[12] *Vital English Art* (Handbill), London, Tate Gallery. Extracts were published in the *Observer*, 7 June 1914.

[13] In an open letter published in the *New Weekly*, 13 June, the *Observer*, 14 June, and the *Egotist*, 15 June, Aldington, Atkinson, Bomberg, Brzeska, Etchells, Hamilton, Pound, Roberts, Wadsworth and Wyndham Lewis announced that they did not 'agree with the Futurism of Sig. Marinetti' and wished to dissociate themselves from the 'Vital English Art' manifesto. William C. Wees, 'England's Avant-Garde: The Futurist–Vorticist Phase', *Western Humanities Review*, XXI, 1967, p.124.

[14] Cork, 1976, pp.248–9.

[15] 'Manifesto', *Blast* no.1, 20 June 1914, p.11.

[16] The two articles by Wyndham Lewis referred to are 'Automobilism', *New Weekly*, II, 20 June 1914, p.13 and 'Futurism and the Flesh', *T.P's Weekly*, XXIV, 11 July 1914, p.49. Both articles are quoted by William C. Wees, *Vorticism and the English Avant-Garde*, Manchester, 1972, p.114 (hereafter: Wees 1972).

[17] Wyndham Lewis, *Blasting and Bombardiering*, London, 1937, pp.37–8.

[18] *Ibid.*

[19] Ezra Pound, 'This Hulme Business', *Townsman*, 11 January, 1939, p.15. Quoted by Wees 1972, p.78.

[20] Wyndham Lewis 'Our Vortex' in 'Vortices and Notes', *Blast* no.1, p.147.

[21] Douglas Goldring, *South Lodge. Reminiscences of Violet Hunt, Ford Maddox Ford and the English Review Circle*, London, 1943, p.65. Quoted by Cork 1976, p.254.

[22] Wyndham Lewis, *op.cit.*, p.148.

[23] In 1913, Bomberg, Epstein, Etchells, Hamilton, Nevinson, Wadsworth and Wyndham Lewis exhibited in the 'Cubist Room' of the Brighton 'Exhibition of the Camden Town Group and Others'. The Rebel Art Centre was also known as 'The Cubist Art Centre Ltd'.

[24] Wyndham Lewis, 'Relativism and Picasso's Latest Work' in 'Vortices and Notes', *Blast* no.1, pp.139–40.

[25] Wyndham Lewis, 'A Review of Contemporary Art', *Blast* no.2, p.40.

[26] C. R. W. Nevinson, 'Vital English Art – A Lecture Delivered by Mr Nevinson at the Doré Galleries', *The New Age*, 18 June 1914.

[27] This and the previous quotation come from Wyndham Lewis, *op.cit.*, p.40.

[28] *Ibid.*, p.42.

[29] C. Bell, 'The English Group', catalogue introduction to *The Second Post-Impressionist Exhibition*, Grafton Galleries, 1912.

[30] David Bomberg, unpublished memoirs, 1957. Owner, Mrs Lilian Bomberg. Quoted by Cork 1976, p.28.

[31] Frank Rutter, *Some Contemporary Artists*, London, 1922, pp.182–3. Quoted by Cork 1976, p.164.

[32] Roger Fry, 'Omega Workshops Ltd, Artist Decorators', *Omega Workshops* (Brochure) n.d. London, Tate Gallery.

[33] Wyndham Lewis, 'Fêng Shui and Contemporary Form' in 'Vortices and Notes', *Blast* no.1, p.138.

[34] Ezra Pound, 'Vorticism', *Fortnightly Review*, 1 September 1914. Quoted by Cork 1976, p.24.

[35] Ezra Pound, *The New Age*, 11 February 1915.

[36] 'Manifesto', *Blast* no.1, p.39.

[37] Wyndham Lewis, 'Our Vortex' in 'Vortices and Notes', *Blast* no.1, p.148.

[38] 'Manifesto', *Blast* no.1, p.30

[39] The lecture was delivered to The Quest Society. It is published in T. E. Hulme, *Speculations, Essays on Humanism and the Philosophy of Art*, ed. Herbert Read, London, 5th edn. 1958, pp.73–109 (hereafter: *Speculations*). This particular quotation comes from p.82.

[40] This and the following quotation come from Wilhelm Worringer, *Abstraction and Empathy, A Contribution to the Psychology of Style*, originally published Munich, 1908. Translation by Michael Bullock, 3rd edn, London, 1967, pp.24–5.

[41] This quotation and those in the following paragraph come from Hulme, *Speculations*, pp.97ff.

[42] T. E. Hulme, 'Modern Art', IV, 'Mr David Bomberg's Show', *The New Age*, 9 July 1914.

[43] Wyndham Lewis, *Blasting and Bombardiering*, p.106.

[44] Jules Romains, *La Vie unanime*, originally published Paris, 1908. Re-edited Paris, 1926, p.99.

[45] Cork 1976, p.338.

[46] Gaumont newsreels filmed Kupka's two paintings shown at the *Salon d'Automne*, 1912. The film was shown all over Europe and America. See catalogue of the exhibition, *František Kupka 1871–1957. A Retrospective*, New York, Solomon R. Guggenheim Museum, 1975, p.311.

[47] David Bomberg to Siegfried Giedion, 27 July 1953. Quoted by William Lipke, *David Bomberg. A Criticism of his Life and his Work*, London, 1967, p.49.

[48] Vanessa Bell to Roger Fry, 25 August–17 September 1914. Quoted by Shone 1976, p.138.

[49] I should like to thank Dr Christopher Green for discussing this point with me.

[50] J. K. Johnstone, *The Bloomsbury Group*, London, 1954, p.59.

[51] Roger Fry, 'Retrospect', *Vision and Design*, London, 1920, p.238.

[52] Quentin Bell, 'In Perspective', the *Spectator*, 6 November 1976, p.35.

[53] Roger Fry, 'Preface' to the catalogue of *The Second Post-Impressionist Exhibition*, Grafton Galleries, 1912.

[54] Roger Fry, 'Retrospect', *Vision and Design*, p.238.

[55] 'We feel at once that a work of art has an idea that is intelligible, and that it is infinite in its possibilities. It is this feeling of infinity which gives to

the embodied idea its organic completeness and uniqueness, and distinguishes it from a geometrical figure which is finite and capable of repetition.' Roger Fry, cited by Johnstone, *op.cit.*, p.57.

56 For details of American art collections see Aline B. Saarinnen, *The Proud Possessors*, New York, 1958.

57 Benjamin de Casseres, 'American Indifference', *Camera Work* no.27, 1909, p.24.

58 Morgan Russell, Notebook. Quoted by Gail Levin, *Synchromism and American Colour Abstraction, 1910–1925*, New York, 1975, p.18 (hereafter: Levin 1975).

59 Guillaume Apollinaire, 'Reality, Pure Painting', (originally published in *Der Sturm*, December, 1912). Translated, *Apollinaire on Art: Essays and Reviews 1902–1918 by Guillaume Apollinaire* ed. Leroy C. Breunig, New York, 1972, pp.262–5.

60 Arthur Burdett Frost Jnr to his mother. Reed Collection. Quoted by Levin 1975, p.37.

61 Statement by Russell, 6 July 1912. Quoted by Levin 1975, p.24.

62 Statement by Stanton MacDonald-Wright in the catalogue of *The Forum Exhibition of Modern American Painters*, New York, Anderson Galleries, 1916, n.p. (hereafter: *The Forum Exhibition*, 1916).

63 For a full description of Alfred Stieglitz and 291, see W. I. Homer, *Alfred Stieglitz and the American Avant-Garde*, London, 1977 (hereafter: Homer 1977).

64 Edward Steichen to Alfred Stieglitz, 1908, Alfred Stieglitz Archive, Yale University Library. Letter reproduced in A. J. Barr, *Matisse: His Art and His Public*, New York, 1974, p.113. Stieglitz's reaction to seeing Cézanne watercolours for the first time is described by Dorothy Norman, 'From the Writings and Conversations of Alfred Stieglitz', *Twice a Year* no.1, Fall/Winter, 1938, p.81. According to Norman, Stieglitz found it difficult to see anything in the watercolours at all. On being told the price of a single work, 1,000 francs, he replied: 'You mean a dozen . . . Why, there's nothing there but empty paper with a few splashes of colour here and there.'

65 '. . . Weber gave me an opportunity to enlighten myself in a way in which I couldn't otherwise in America.' See Norman, *op.cit.*, p.83.

66 Weber's contributions to *Camera Work* comprise: 'Chinese Dolls and Colorists', *Camera Work* no.31, July 1910, p.51; 'The Fourth Dimension from a Plastic Point of View', *Camera Work* no.31, July 1910, p.25; and 'To Xochipilli, Lord of Flowers',

Camera Work no.33, January 1911, p.34.

67 Marius de Zayas, 'Pablo Picasso', *Camera Work* no.34–5, April-July 1911, p.66.

68 Lawrence B. Chisholm, *Fenollosa: The Far East and American Art*, New Haven, 1963, p.231.

69 Charles H. Caffin, 'Of Verities and Illusions – Part II', *Camera Work* no.13, January 1906, pp.43–4.

70 Sidney Allan, *Camera Work* no.7, July 1904, p.25.

71 'Extracts from "The Spiritual in Art"', *Camera Work* no.39, July 1912, p.34.

72 Homer 1977, p.160.

73 Alfred Stieglitz to Heinrich Kuhn, 14 October 1912. Alfred Stieglitz Archive, Yale University Library. Quoted by Homer 1977, p.75.

74 Alfred Stieglitz to Marsden Hartley, 26 October 1923. Alfred Stieglitz Archive, Yale University Library. Quoted by Homer 1977, p.154.

75 Marsden Hartley to Norma Berger, 2 April 1911. Alfred Stieglitz Archive, Yale University Library. Quoted by Homer 1977, p.155.

76 Elizabeth MacCausland, *Marsden Hartley*, Minneapolis, 1952, p.19.

77 Homer 1977, p.114.

78 'Art and Artists', *Chicago Evening Post*, 16 March 1912. The critic who quoted Dove's ambition to capture energy in his paintings was H. Effa Webster, 'Artist Dove paints Rhythms of Colour', unidentified clipping, March 1912, Arthur Dove Papers, Archives of American Art. Both references come from Judith K. Zilczer, *The aesthetic struggle in America 1913–1918: abstract art and theory in the Stieglitz circle* (Ph.D. dissertation, University of Delaware, 1975) pp.205–6 (hereafter: Zilczer 1975).

79 H. Effa Webster, Chicago *Examiner*, 15 March 1912. Quoted by Homer 1977, p.121.

80 Homer 1977, p.121.

81 A. J. Eddy, *Cubists and Post-Impressionism*, Chicago, 1914, p.48.

82 'Next Month's Exhibition of the American Association of Painters and Sculptors', *New York Times*, 5 January 1913, V. 15:4. Quoted by Zilczer 1975, p.14.

83 For an account of the full story of the Armory show see Milton W. Brown, *The Story of the Armory Show*, New York, 1963.

84 C. Brinton, 'Evolution Not Revolution in Art', *International Studio*, 49, April 1913; xxvii–xxxv.

85 'It will be said, quite justly, that while this exhibition is dubbed international, it centres about and plays upon, with particular persistence, the art of France.' Guy Pène du Bois, 'The Spirit and

Chronology of the Modern Movement', *Arts and Decoration* (Special Exhibition Number), March 1913, p.178.

86 Between 1914 and 1917 Marsden Hartley had the following one-man shows in New York: 12 January–14 February 1914, 291; January 1915, The Daniel Gallery; 4 April–22 May 1916, 291; 22 January–7 February 1917, 291. For listings of exhibitions in New York, 1910–25, see 'A Selective Checklist' by Judith K. Zilczer in the exhibition catalogue *Avant-Garde Painting and Sculpture in America, 1910–1925*, Wilmington, Delaware Art Museum, 1975.

87 'I could not accept the repudiation of all representational art, which was the core of the Synchromist dogma, but its procedures were interesting enough to induce experimentation,' T. H. Benton, *An American in Art: A Professional and Technical Autobiography*, Lawrence, 1969, p.33.

88 T. H. Benton, statement in the catalogue, *The Forum Exhibition*.

89 'The Artist Speaks, with a note on Synchromism by Barbara Rose', *Art in America*, 55, May 1967, pp.70–3.

90 The subject of Kandinsky's influence on American artists has been fully discussed by Sandra Gail Levin, *Wassily Kandinsky and the American Avant-Garde: 1912–1950* (Ph.D dissertation, Rutgers University, New Brunswick, New Jersey, 1976).

91 Man Ray, statement in the catalogue of *The Forum Exhibition*.

92 Robert Coady, 'The Indeps', *The Soil*, Vol.1, 5, 1917, p.203.

93 Henri Pierre Roché, *The Blindman* no.1, 10 April 1917, p.205.

94 Willard Huntington Wright, 'The Aesthetic Struggle in America', *Forum*, LV, February 1916, pp.201–20. For a full discussion of the aesthetic struggle see Zilczer 1975.

95 Willard Huntington Wright, *Modern Art, Its*

Tendency and Meaning, New York, 1915, p.10.

96 D. W. Ross, *The Painter's Palette; A Theory of Tone Relations; An Instrument of Expression*, Boston/New York, 1919, p.41. Quoted by Milton W. Browne, *American Painting from the Armory Show to the Depression*, Princeton, 1955, p.161 (hereafter, Brown 1955).

97 H. G. Maratta, 'A Rediscovery of the Principles of Form Measurement', *Arts and Decoration*, April 1914, pp.231–2. Quoted by Brown 1955, p.161.

98 H. J. Seligman, ed., *The Letters of John Marin* (letter of 22 July 1913) n.p. Quoted by Brown 1955, p.161.

99 This and the previous quotation come from '291 and the Modern Gallery', *Camera Work* no. XLVIII, October 1916, pp.63–4. For a full discussion about the relationship between De Zayas's Modern Gallery and Stieglitz's 291 see, 'The De Zayas–Haviland–Meyer Circle: The Magazine 291 and The Modern Gallery', Homer 1977, pp.190–6. And for a discussion of De Zayas's role in promoting primitive art in America see Judith Zilczer, 'Primitivism and New York Dada', *Arts Magazine*, 51, May 1977, pp.140–2.

100 Marius de Zayas and Paul Haviland, *A Study of the Modern Evolution of Plastic Expression*, New York, 1913, p.11.

101 *Ibid.*, p.20.

102 Marius de Zayas, 'The Sun has Set', *Camera Work* no.39, July 1912, p.21.

103 De Zayas developed this idea in *African Negro Art: Its influence on Modern Art*, New York, 1916. Among the critics who believed that advanced art represented the culmination of artistic evolution were Huntington Wright, *op.cit.*, and Arthur B. Davis, who published a 'Chronological Chart showing the Growth of Modern European Art', *Arts and Decoration* (Special Exhibition Number, March 1913) p.150.

104 Marius de Zayas, 'The Sun has Set', pp.17–21.